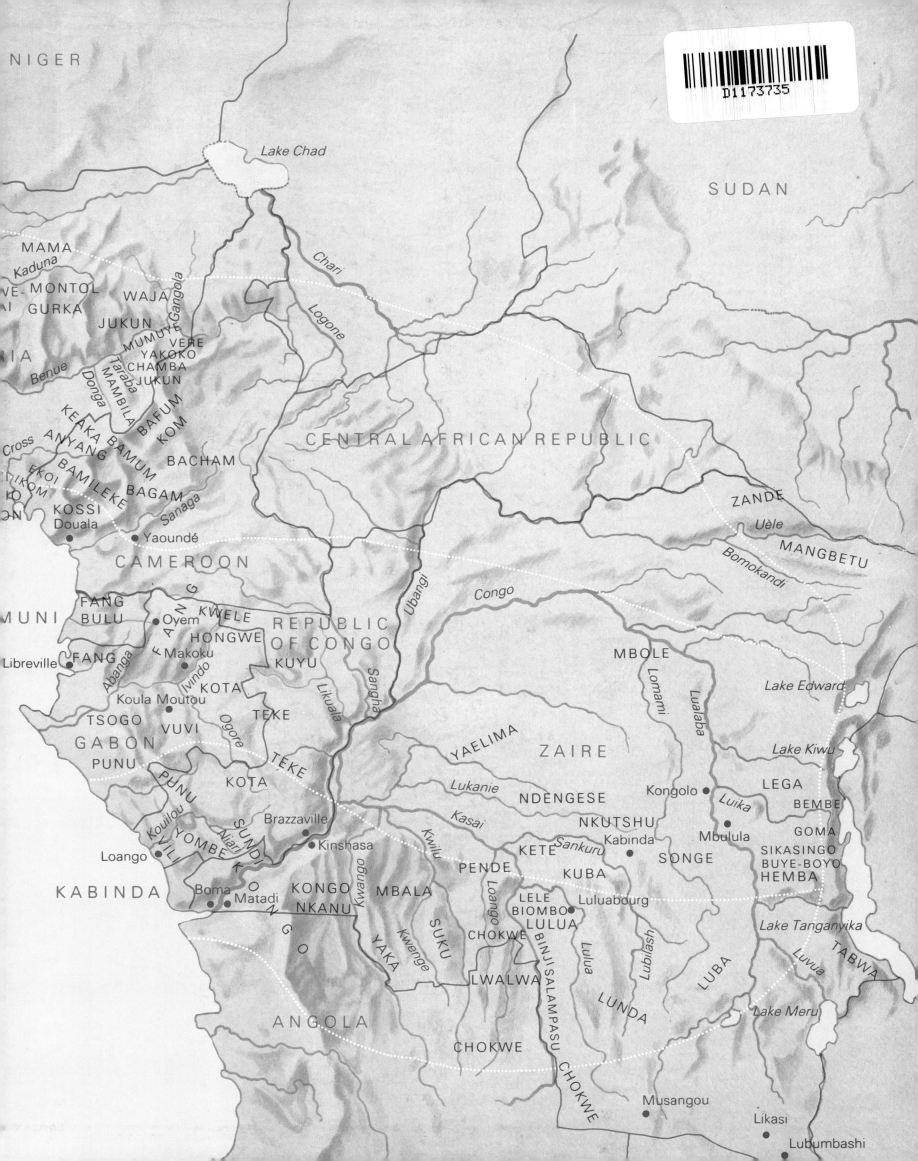

NIGER

Lake Chad

SUDAN

MAMA
Kaduna
VE- MONTOL
GURKA
RIA
Benue
JUKUN
MUMUYE VERE
YAKOKO
CHAMBA
JUKUN
Donga
Taraba
MAMBILA
KEAKA BAMUM KOM
Cross
ANYANG
EKOI
KOM
BAMILEKE
BAGAM
KOSSI
Douala
BACHAM
Sanaga

Chari

Logone

CENTRAL AFRICAN REPUBLIC

ZANDE
Uèle
MANGBETU
Bomokandi

Yaoundé

CAMEROON

MUNI
FANG
BULU
FANG
Libreville
Oyem
Makoku
Abanga
Koula Moutou
Iwindo
TSOGO
VUVI
GABON
PUNU
PUNU
Kouilou
Loango
VILI
YOMBE
Boma
Matadi
KABINDA

KWELE
HONGWE
KUYU
KOTA
TEKE
KOTA
TÉKE
SUNDI
Brazzaville
Kinshasa
KONGO
NKANU

Ubangi
Congo

MBOLE
Lomami
Lualaba
Lake Edward

REPUBLIC
OF CONGO

Likuala
Sangha

YAELIMA
ZAIRE
Lake Kiwu

Lukanie
NDENGESE
Kongolo
Luika
LEGA
BEMBE
Kasai
NKUTSHU
Kabinda
Mbulula
GOMA
SIKASINGO
BUYE-BOYO
HEMBA
Sankuru
SONGE
KETE
KUBA
PENDE
Loango
LELE
BIOMBO
Luluabourg
Kwilu
Kwango
MBALA
SUKU
CHOKWE
LULUA
BINJI
SALAMPASU
Lulua
Lubilashi
Lake Tanganyika
YAKA
Kwenge
LWALWA
LUBA
Luvua
TABWA
LUNDA
ANGOLA
CHOKWE
Lake Meru

Musangou
Likasi
Lubumbashi

AFRICA

TRIBAL ART OF FOREST AND SAVANNA

ARNOLD BAMERT

AFRICA
TRIBAL ART OF FOREST AND SAVANNA

with 210 color plates

THAMES AND HUDSON

Translated from the German
Afrika: Stammeskunst in Urwald und Savanne
by James Ramsay
Photographs taken by the author
Layout by Theo Frey and Lothar Wojzich
Maps by Hermann Schelbert

© Walter-Verlag AG, Olten 1980
English translation © 1980 Thames and Hudson Ltd, London

First published in the USA in 1980 by
Thames and Hudson, Inc.,
500 Fifth Avenue, New York, New York 10110

Library of Congress Catalog Card Number 80-50800

Filmset in Great Britain by Tameside Filmsetting Limited,
Ashton-under-Lyne, Lancashire
Colour plates originated in Italy by La Cromolito, Milan
Printed and bound in Switzerland by Walter-Verlag AG,
Olten

Dedicated to the memory of
my friend Gottfried Künzi

CONTENTS

FOREWORD Many books on Black African art have appeared in recent years, and there is still room for more! We in the West are still a long way from even partial coverage and representation of the great artistic heritage of Africa. Thus there is full justification for any new book that may deepen and elaborate our understanding of this tradition – counting as it does among the finest ever achieved by mankind.

Both in the introduction and the captions Arnold Bamert conveys his own enviable familiarity with African art factually and with real personal enthusiasm. Picasso's complaint that modern man and modern civilization are sadly in need of inspiration in no way applies to the author of this book.

Two things make this book particularly valuable, however. In it we see works (from various private collections) that have hitherto never been published, or the existence of which was doubted or not previously known about. Fine new material like this is extremely welcome, especially in a field not immediately compatible with our own geographic–historical, psychological–sociological backgrounds.

The quality of the colour photographs is also very impressive. Sculpture, according to Auguste Rodin, is a 'play of forms and light': Arnold Bamert here, with each object, seems to have found precisely the right light to bring out its form as clearly and vividly as possible. Each plate becomes a picture for meditation, and this in turn fires inspiration. Text and illustrations therefore combine harmoniously and fruitfully. The book is beautiful in European aesthetic terms, and beautiful too in African terms – working powerfully on any who have eyes to see.

<div align="right">Luitfrid Marfurt</div>

INTRODUCTION The lack of written traditions means that much of our gauging and evaluating of African art, religion and old ways of life has to be done in the dark. The African continent, especially Black Africa, has been explored relatively late, and often with inadequate tools. It is thus hardly surprising that one is often forced to resort to assumptions, guesswork and hypotheses. Yet new research constantly brings new results and knowledge. Excavations bring to light fresh material that provides links with older societies. But much will remain unknown. Many Central African tribes still today jealously guard their ancient customs and rites from the eyes of strangers. Few scientists and explorers have so far succeeded in establishing unequivocal results and solid facts. All too often findings prove invalid. Over-demanding researchers are fobbed off with inaccurate or even false information. So the fact that some of the captions in this book are more or less hypothetical should cause no great surprise.

African art has found a place in many museums throughout the world today. New collections are started and new museums built almost from one day to the next. These compete with each other, and an ever wider public becomes interested. It is thanks to early collectors that posterity will be able to appreciate at least this not insignificant corpus of African art-works – the peril from which they rescued them corresponding in each case to the climate of the country of origin: damp, insects and the often unfavourable conditions in which they were kept normally allowed them only a short life.

Less than a hundred years ago these ethnological curiosities stored away in museums were considered clumsy, even ugly and obscene works. Such 'horrors' were seen to testify to great artistic gifts only by artists at the beginning of this century. They convey genuine harmony and a feel for proportions. Their beauty and power and often masterly realization of form gave impetus to our artists in their search (already, unconsciously, long under way) for new modes of expression. Rather than on objects themselves, they began to concentrate on pure ideas and the relationships between objects. African art afforded eloquent witness to the truth that greater artistic tension and power can be achieved very often through what is not expressed (abstraction), exaggeration, and addition of 'materials', than through faithful naturalistic representation.

A glance at the map at the beginning and end of this book will show that the area of interest to us here is in effect the tropical rain-forest and the humid savannas to north and south of it. Only here and there, notably to east and south, is this area extended. In

the centre live the farmers and hunters, who only rarely move about. These are the creators of the works dealt with in this book. In the arid plains, steppes and deserts live the wandering nomads and herdsmen, whose greatest wealth is their cattle. In accordance with their way of life they carry around with them as few things as possible, to avoid unnecessary ballast. With few exceptions they have no plastic art. Their sense of beauty expresses itself in artefacts such as decorative, leather and textile work.

Much of Black African figurative art conveys a force which is hard to define, and which can only be explained in terms of its religious or magic cult functions. Even with the best intentions we are hardly able to penetrate any way at all into this mystic world.

Figures, masks and utensils thus first and foremost serve a cult. In order to fulfil their purpose they must reflect the traditional notions and customs. Deviation from the norm would anger the supernatural powers, and excite their displeasure. The work is commissioned by the chief of a tribe, acting as an individual, or frequently for the community. If the sculpture is destined for cult use, tradition and religious prescriptions must be observed and fulfilled. In general the wood-carver (who may also be a black-smith) executes the work. Despite being tied to definite traditional forms, within the given boundaries the artist can allow his imagination free rein. Consistency in form and style enables the expert to attribute works to this or that tribe or area.

According to ancient African belief there exists in every person, every animal, indeed in everything, a power that influences and conditions life. The supreme God is inaccessibly remote. He has contact with humans through the spirit world expressed through all things and in the souls of forbears. These supernatural powers are honoured, and union is sought with them. Traditional belief has it that the dead live on beyond the grave. But their souls or spirits can stay on for a certain length of time with the living. In order to avoid revenge for neglect or any wrong they may have suffered, it is vitally important to establish a good relationship with them. An illness is never ascribable to chance, but is always the result of some misdeed. Through sin-offerings an attempt is made to re-establish the former state of happiness – to appease the super-natural powers. This happens mostly in conjunction with dancing and practice of magic. Dancing plays a major role in Black African life. Certainly it is an expression of sheer joy in life. Often, however, it is also a more or less unconscious attempt to please the ancestral spirits, and to woo their good graces. One could perhaps describe it as prayer to the supernatural powers.

It has often been said of the Black Africans that they have no conception of 'beauty', even that they have no words for such a concept. Yet they are able to distinguish very clearly between a beautiful and a bad work of art, even in the terms of our aesthetic. Above all, though, they see beauty in the fulfilment of intended purpose. If a bush-spirit mask awakens fright, or if another disfigured with yaws, for instance, drives away witches or a disease, then it is beautiful. Aesthetics – beauty in general – are evidenced also by critical selection by society. One could argue endlessly over whether a perfectly carved Baule figure (pl. 67) or a primordial carving from the Mama (pl. 107) is the more beautiful. But there is no doubt that each work illustrated here possesses a certain beauty capable of firing 'inspiration'.

Bidyogo

The Bissagos Islands off Guinea–Bissau (formerly Portuguese Guinea) constitute the westernmost point of the Black African art world. They are inhabited by the Bidyogo, an extremely matriarchal tribe, and indeed women have often risen to chieftainship. Their religious and mythical cults are still perfectly preserved, and their secrets remain secret even today. Their magnificent buffalo masks, beautifully carved spoons and covered dishes, and figures have rightly attracted the interest of art lovers.

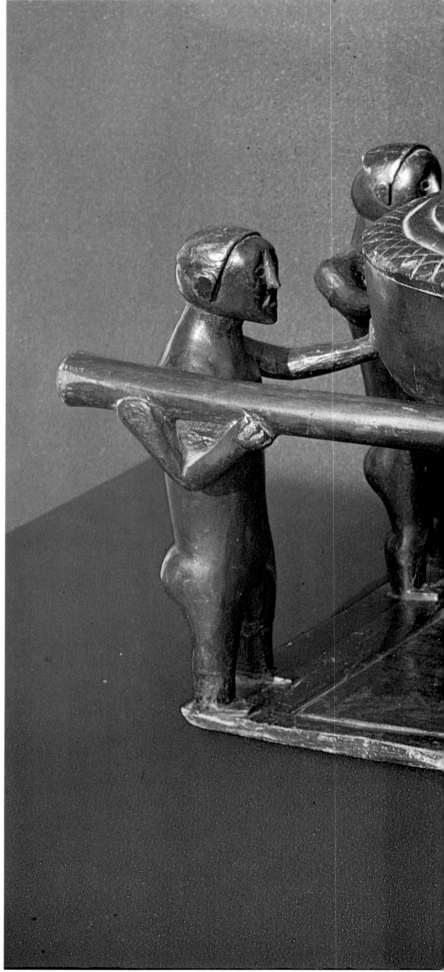

1 Bidyogo covered vessel

Wood, 30 cm high, 40 cm long, Bissau. It would have served as the food-bowl of an important person. A masterpiece, superb simply in terms of craftsmanship, carved from a single piece of wood (except for the lid), like nearly all African work. This is a rare example of Bidyogo carving.

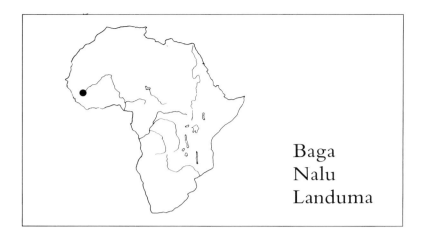

Baga
Nalu
Landuma

Guinea, on the western edge of the Central African rain-forest, is inhabited by three peoples, the Baga, Nalu and Landuma, who have similar cultures, and styles in art that are often almost indistinguishable. They are settled around the capital Conakry and on the lower Nuñez, where they have been for some considerable time. The Simo secret society controls everything, including the rites of birth, circumcision and death, for which it also specifies what masks and cult instruments are to be used.

2 Baga cult instrument

Wood, 70 cm high, 108 cm long, Guinea. This figure, called Anok, is an important figure to the Simo secret society. The stylized human head, the long beak and the curved standing leg ending in the base all create an unusually well-balanced whole. Small antelope horns with magic substances are introduced into the triangular openings, to increase its power. In its dimensions, too, an uncommonly fine work.

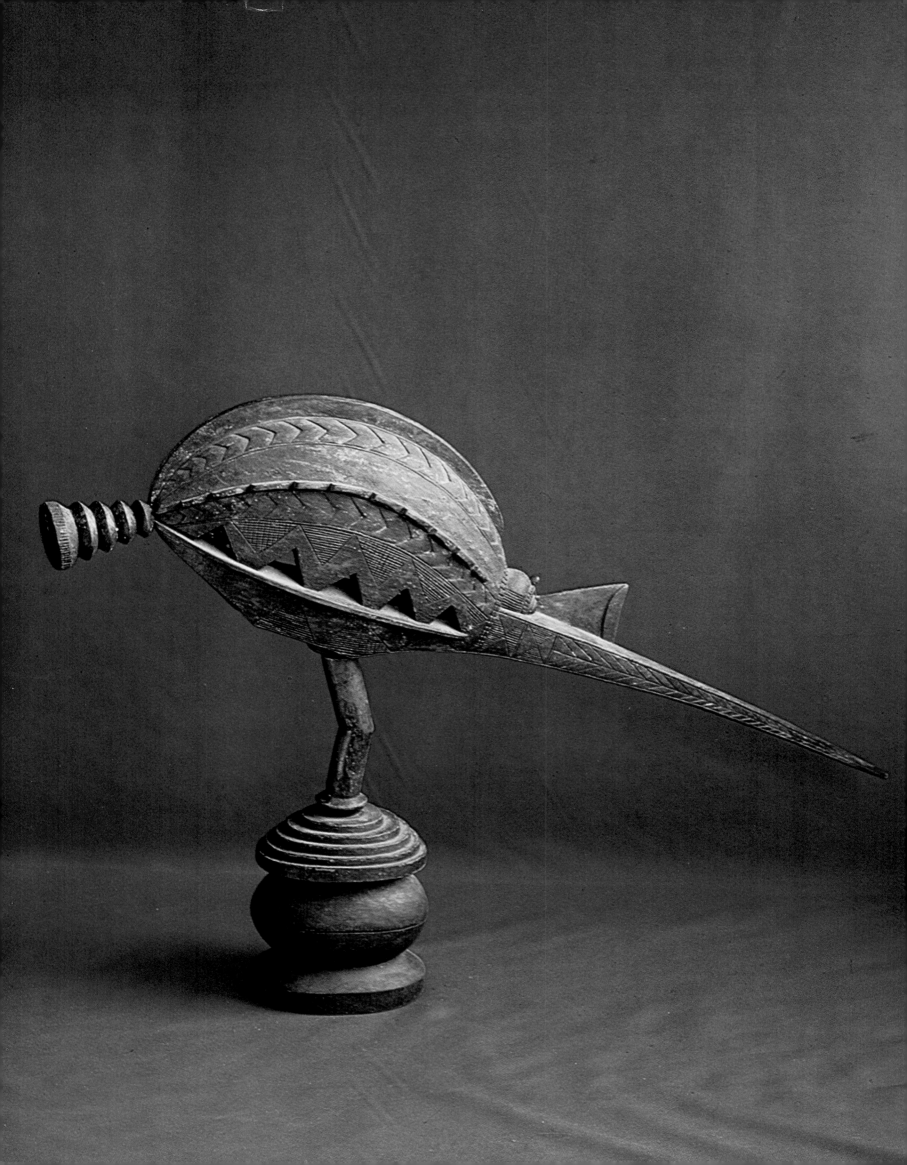

THE FETISH Fetishes or magic figures are in a special category apart. They are figures hung about with, or filled with, magic substances and objects endued with peculiar powers. Or they might just be a calabash or piece of wood. Usually the medicine-man (who is seldom a talented carver) produces them. When he is also a craftsman, then the shape of the figure enhances its magic power and effectiveness. Normally they are protective, but in certain circumstances they can be aggressive.

Nail fetishes are a genre on their own, intended to deflect danger. Nails or pieces of iron driven into the figure will, it is hoped, destroy an imagined or actual enemy. It seems certain that through hypnotic-magic agencies and deep-seated beliefs this aim is often fulfilled. Presumably the medicine-man can contribute in one way or another.

Similarly intended fetishes are also to be found in the past: baked clay figures shattered in order to bring about the death of someone in bad odour.

3 Baga fetish figure

Wood, 86 cm, Guinea. This female figure with slender body, long neck decked with rings, and large head, is sitting on an enormous phallus. It is thus a fertility symbol of primary significance. The deep hole in the head was at one time full of magic substances. A rare figure of magical potency.

6

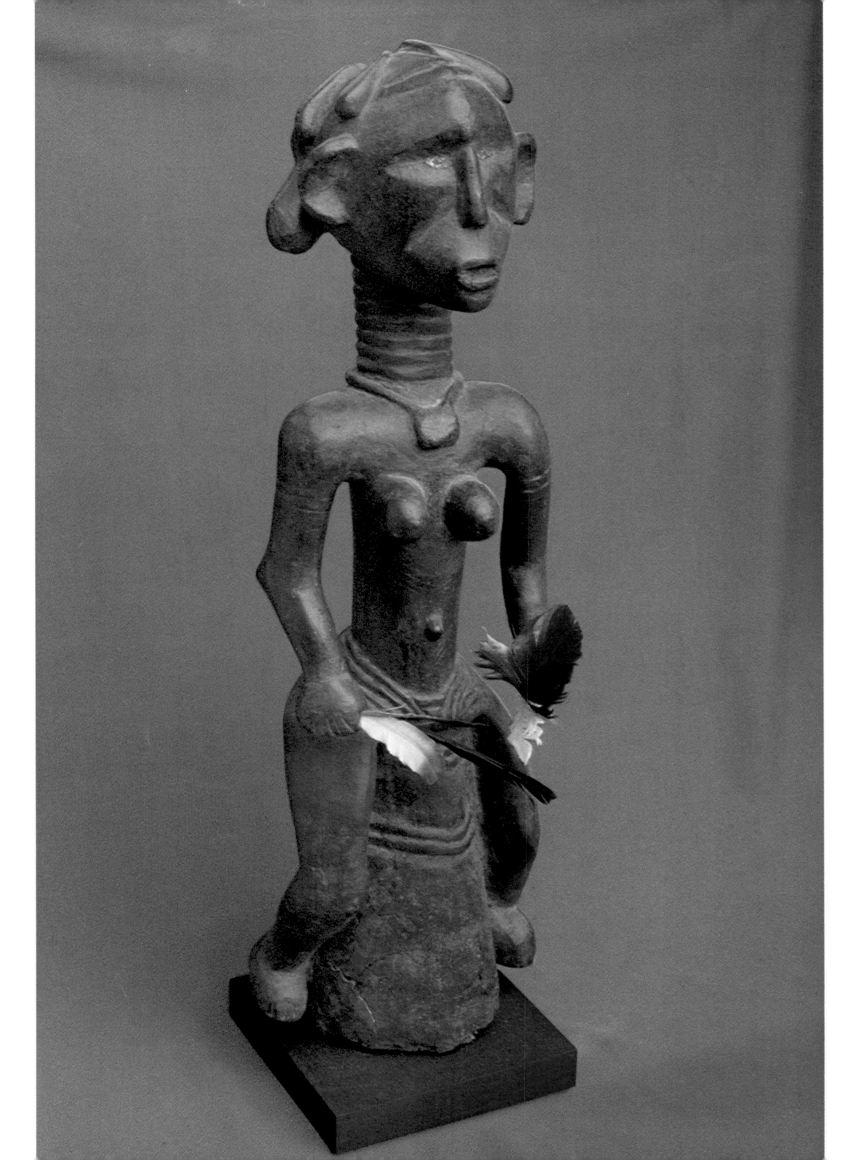

THE MASK The mask plays an unusually important part generally in African social life. Thanks to the forces indwelling in it, it contributes to the smooth running of society, as it were assuming the function and duties of our civil authorities – being responsible for peace and order, officiating as arbitrator, preventing illnesses, driving away witches, uncovering thieves, and taking care of sanitation.

4 Landuma mask

Wood, 51 cm, Guinea. This zoomorphic Numbe mask, worn slanting forwards at sowing and reaping ceremonies, is a work of great artistic worth – an abstract, surrealistic object of intense expressive power. During the rest of the year it was housed in a special construction at the entrance to the village as protection against spirits.

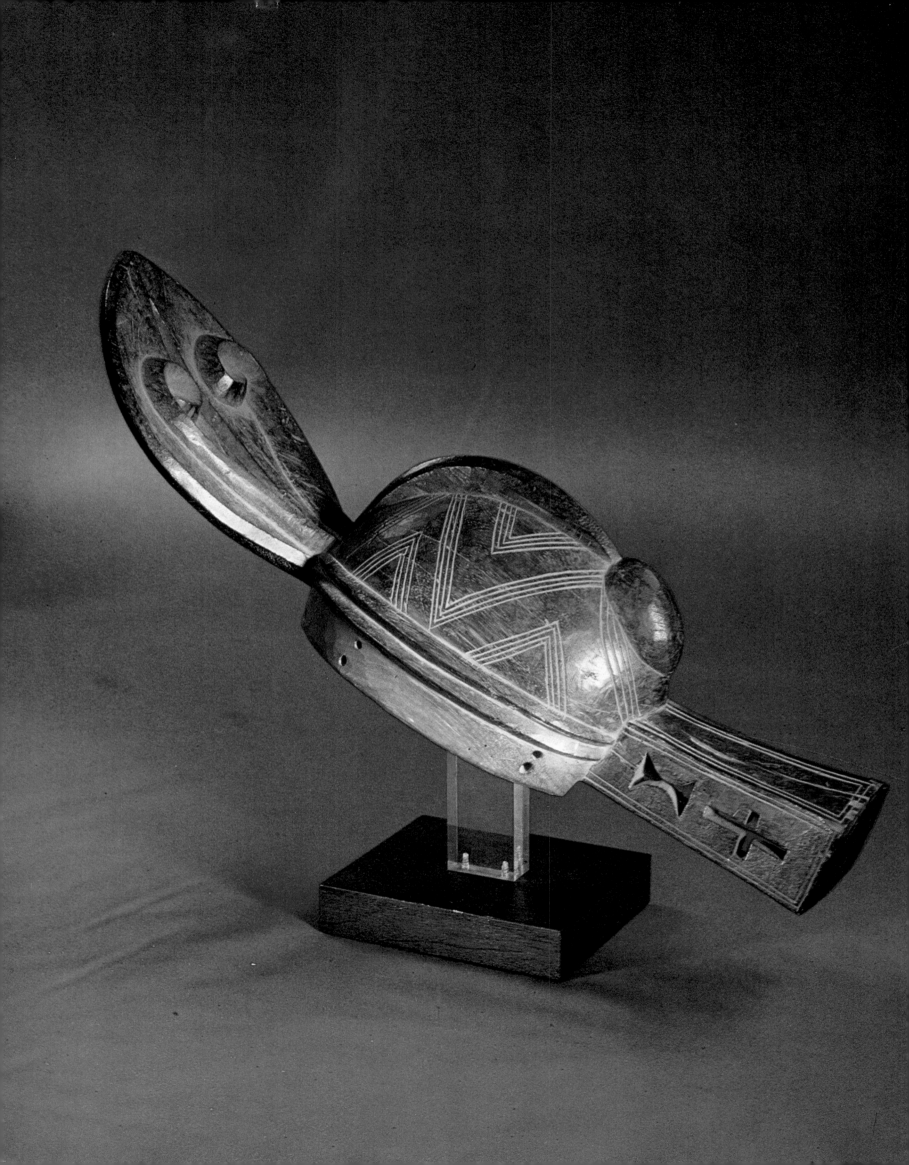

5 Nula mask

Wood, 125 cm, south-west Guinea. This dance-mask (called Banda), vividly unreal and surreal in composition, incorporates various elements suggesting power: crocodile, antelope, human face and chameleon. Worn horizontally, on the head, it is a symbol of high rank in the powerful Simo secret society, which orders and governs all aspects of life. The Nula live in the marshland of the lower Nuñez.

10

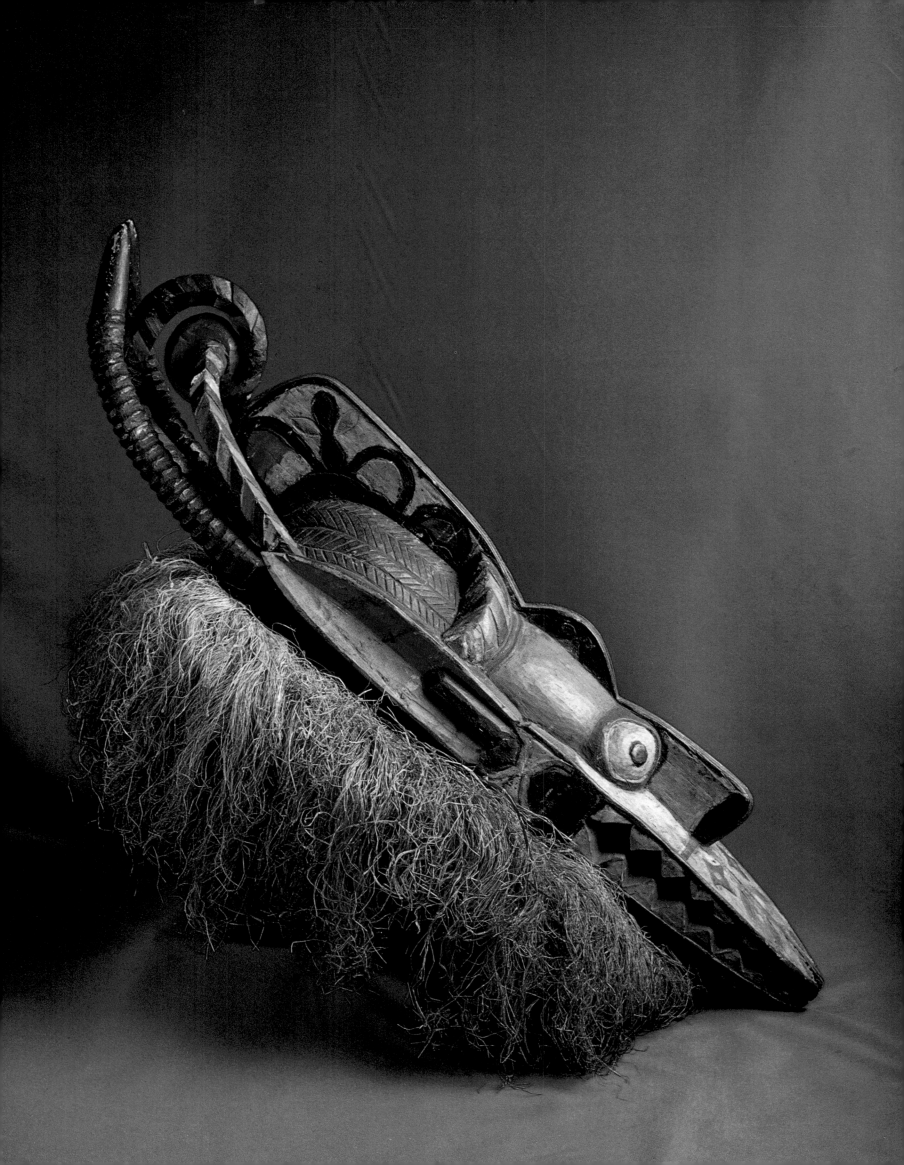

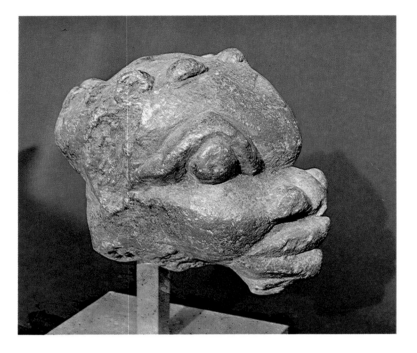

6 Kissi stone figure

9.5 cm, Sierra Leone/Guinea. Soapstone (steatite) Pomdo figure with forward extended mouth and protruding eyes – typical characteristics of the late style. The slight round depression on the head is surrounded by a circle of humps indicating decoration or hair.

Kissi

On the eastern and northern borders of Sierra Leone and over a considerable area of Guinea, in Mende and Kissi country, stone figures have been found among agricultural communities. It is still not known who sculpted these figures, and their date is uncertain. The Mende call them Nomoli, the Kissi Pomdo. They have been dated to the 16th or 17th century, and tentatively ascribed to the kingdoms of the Bullom in the south and the Temne in the north. They are still today placed out in the fields, where they are held responsible for a good harvest. If the harvest fails they are whipped.

The Kissi have very few wooden figures.

7 Kissi fetish figure

Wood, 29.5 cm, Sierra Leone/Guinea. Whenever a new hut or village was envisaged this ancient and powerful fetish was set up in a specially built hut. Intended to drive away evil spirits, it is festooned with suitable magic substances. Two large panther's teeth, seven antelope horns, three pieces of iron, cowries, glass beads and two pouches containing magic agents hang down from it.

These Kissi fetishes represent powers of the first rank, and are resorted to in all kinds of day-to-day problems, from illness to lawgiving. They are great rarities in our collections.

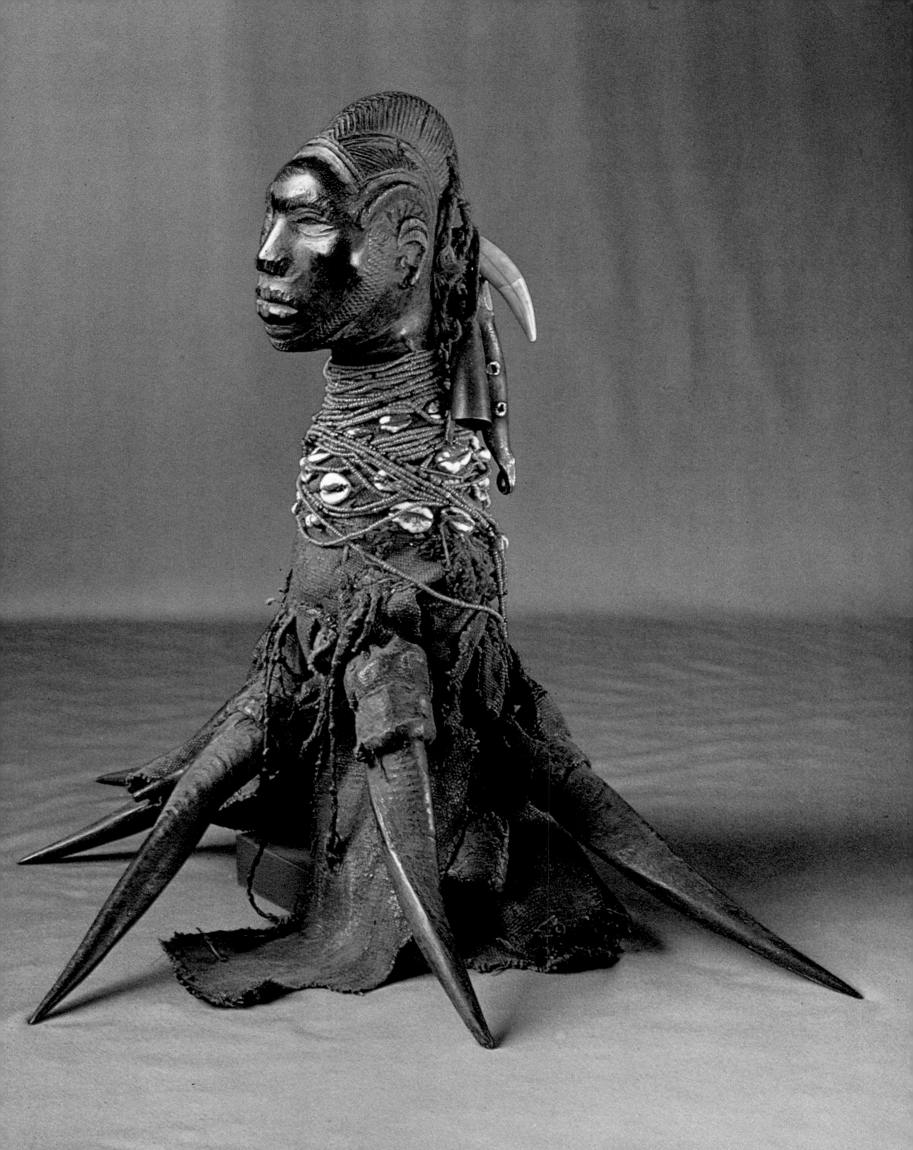

The Kissi style unites the Mende in the centre of Sierra Leone, the Temne on the south-west coast, and, flanked to the north by the Gola, the Vai on the coast close to the Liberian border.

The Mende helmet-masks belonging to the Bundu women's secret society, which are kept in the bush school, are famous. They are characterized by highly imaginative hairstyles, small faces and thick necks heavily adorned with rings. Their often large-scale Minsereh figures reveal similar traits, and are intended to safeguard health. They belong to the Yassi divination society.

Temne figures resemble those of the Mende, but retain their own individual style.

Among the Vai the Sande society fulfils the same role as the Bundu society. Their Sande masks have features in common with those of the Mende.

Mende
Temne
Vai

THE MEDICINE-MAN

In our superficial view the medicine-man is something of a charlatan. However, it has long been recognized that he comes from the intelligentsia, and is chosen by the elders because of his special abilities. He has very considerable knowledge of the healing properties of plants. His gifts of psychological empathy and his personal knowledge of individuals, developed over the course of time, enable him to help his brothers in the tribe and rid them of diseases and fears. Through ritual ceremonies and songs, linked with dances, he is in contact with spirits and ancestors. He punishes, quietens and dispels cares.

With the help of the oracle he counsels those who seek advice. As he knows his people very well he is highly successful in

8 Mende figure

Wood, 47 cm, Sierra Leone. This quite markedly female figure is fascinatingly conceived (especially the long arms), the whole forming a closed oval shape. The numerous particularly beautiful decorative scarifications on the back, the small head on the thick neck, the classic Mende hairstyle, and the typical stuck-out bottom combine to make it a distinguished work.

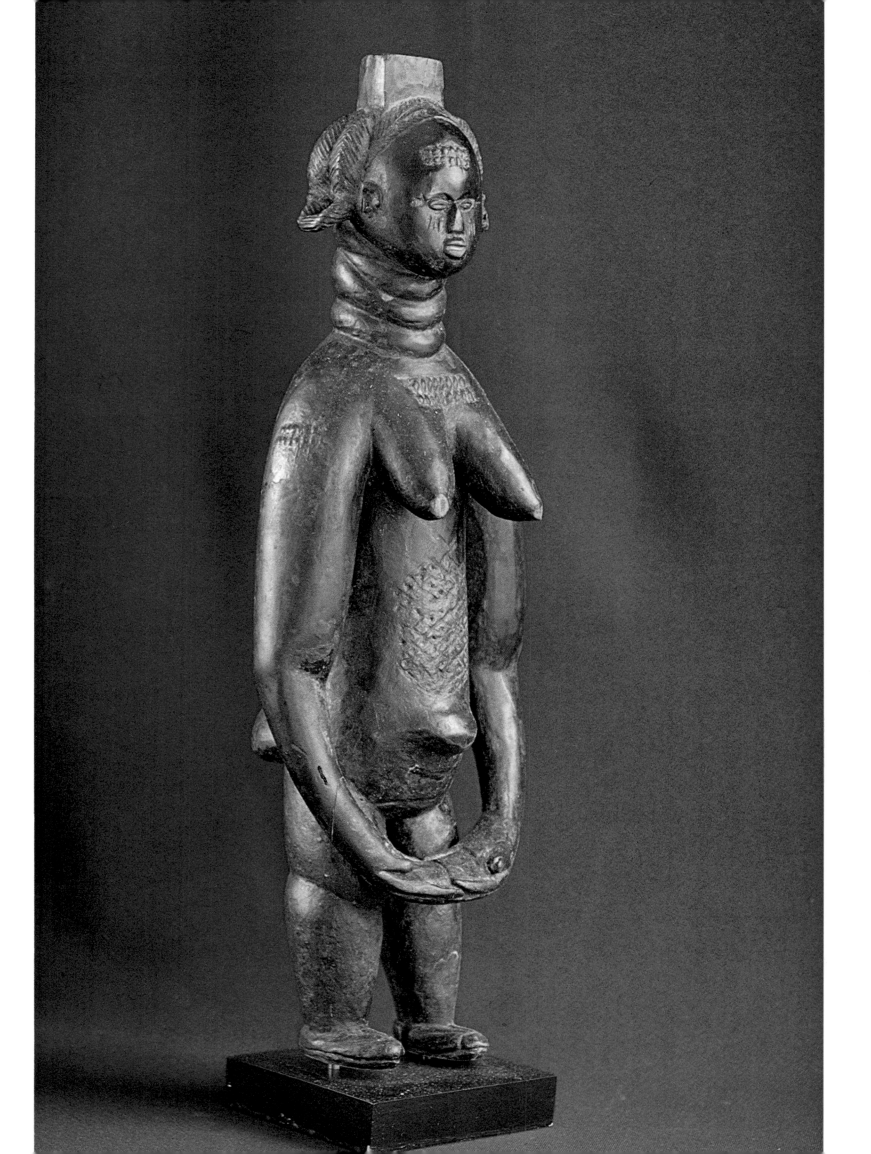

this. Thus in the tribal hierarchy he occupies an important position beside the chief.

One or two examples will best illustrate how the medicine-man operates. When one of the tribe is ill he purges him of his illness. The sick man must help establish the identity of the spirit responsible for the sickness. The medicine-man determines through the oracle who is causing the evil. By dance, hypnosis and trance he acquires control of the now known spirit in the patient's body, making it visible either by a drawing in sand or through a crude clay figure. The sick man must destroy this visible representation. Then the evil spirit leaves his body, and he is fully restored to the community.

Here is an instance of how a woman was cured of psychogenic sterility. She had been ten years without having a child (this is looked upon very seriously in Africa, and often justifies divorce). A medicine-man took her in care for three days. In a dance to drumbeats gradually working up to double pulse speed, the formation and secretion of certain hormones which had prevented conception, it is presumed, became

regularized. Scientific experiments in this direction have apparently produced similar, if not identical, results.

For fever the dance rhythm is slower than the normal pulse rate. This aims to calm the patient and normalize his blood flow. For rheumatic illnesses it is the other way round. We take hot baths, ray therapy, and other such heat-producing procedures for treatment. The medicine-man reaches similar ends by substantially accelerating the usual dance rhythms and thereby raising the body temperature, thus effecting relief from, or healing of, the ailment.

In the twenties our scientists still had no antidote to the bite of Africa's most deadly snake, the mamba. The members of the snake society among the Wanyamwesi, near Lake Tanganyika, know of an antitoxin made from plants which protects them from all snake bites. It took years for the plants in question to be revealed and the antidote extracted in pure form. It is assumed that during the painful rituals at the various solemnities connected with initiation into higher rank, the members were inoculated with this antitoxin by the medicine-man.

9 Temne mother and child

Wood, 48 cm, Sierra Leone. A fine example of consummate Temne art. The subtle figure seated on a chair with the child nestling close to her forms an impressively tight-knit composition.

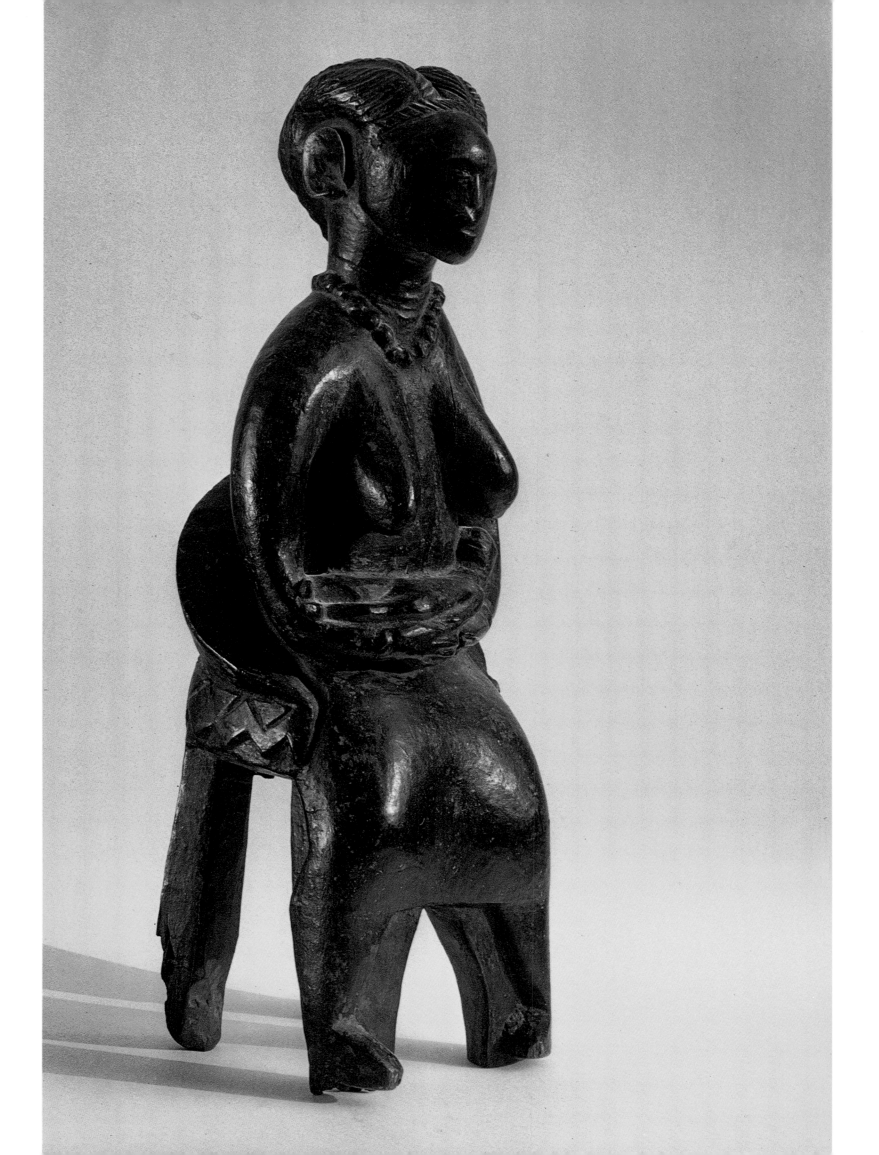

10 Temne helmet-mask

Wood, 36 cm, Sierra Leone. A powerfully expressive, unreal, cubist architectonic design. Worn almost horizontal on the head. The rectangular protruding mouth, like a fish-basket which stretches right across the whole mask, is concealed by a thick black moustache of animal hair. A rare Temne polychrome piece.

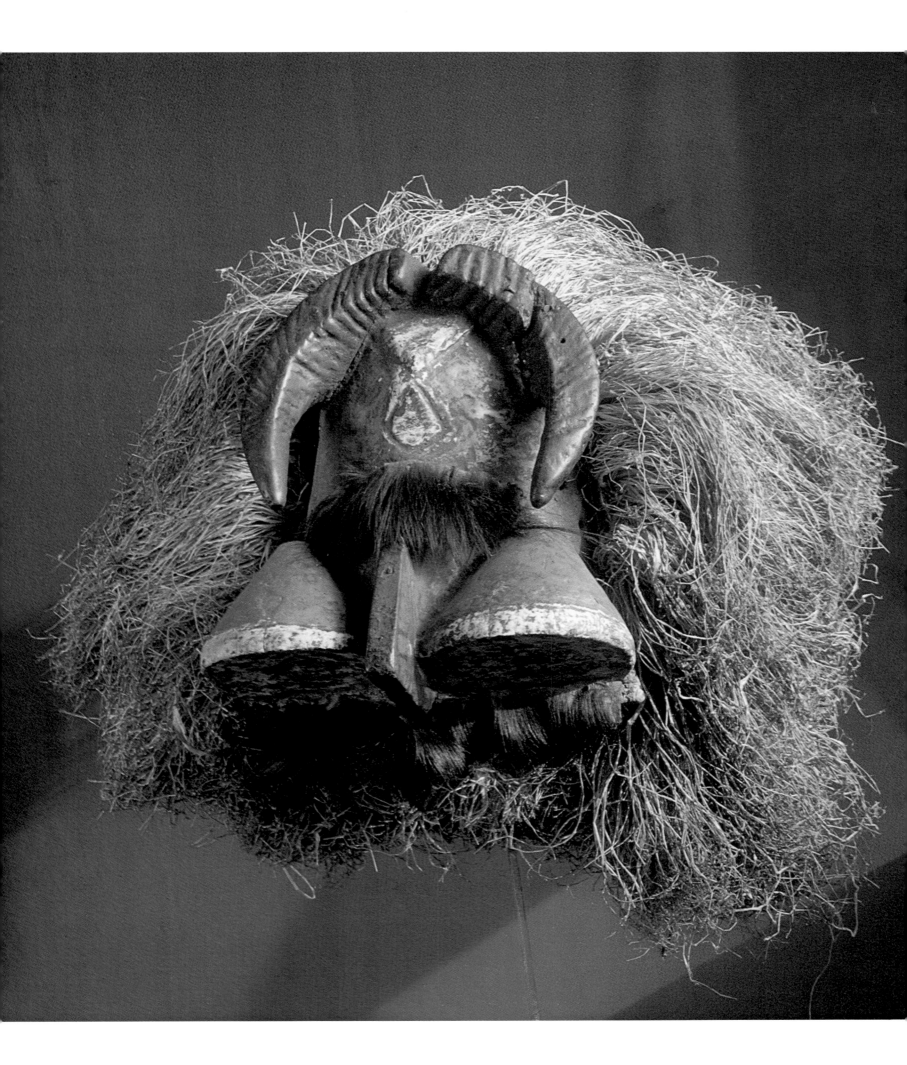

11 Vai helmet–mask

Wood, 72 cm, Liberia/Sierra Leone. This extremely unusual black-coloured mask (male, though for a female society) symbolizes the protective spirit of the Sande women's secret society. This spirit presides over young girls during their training in womanly duties. It appears together with a female mask in the dances at celebrations of girls' coming to womanhood. The female mask has a woman's face, while the male is adorned with severely geometrical markings.

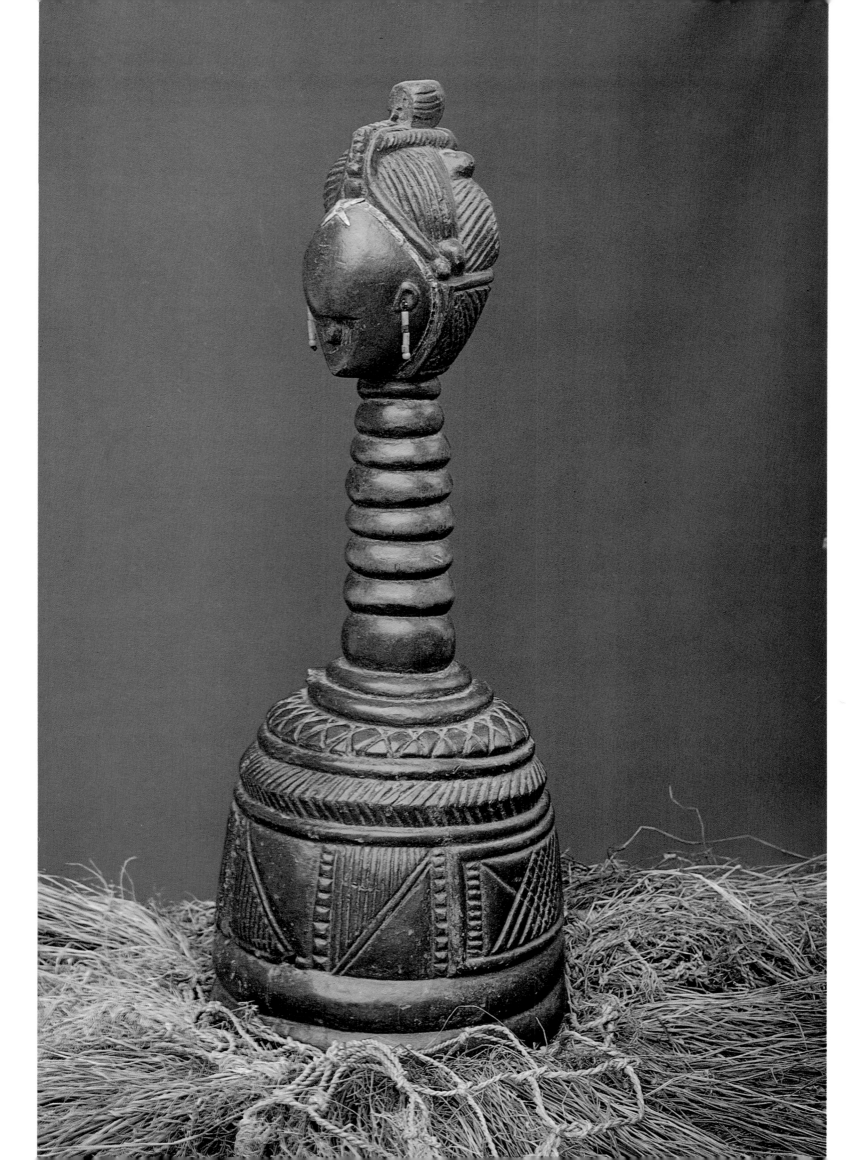

Toma

The Toma, like many other tribes, are not confined within arbitrarily drawn political borders. They live chiefly in Guinea, but also spill over into Sierra Leone and Liberia. Their almost classically cubist flat Landa masks, with domed forehead and straight nose, are typical, and fascinate through their abstract design.

12 Toma stone figure

23.5 cm, Guinea. Toma figures are very rare. Placed on a legless body, the classic Toma face is here somewhat less abstract than on most masks. Its age and purpose are not known. The left hand side of the figure has been damaged.

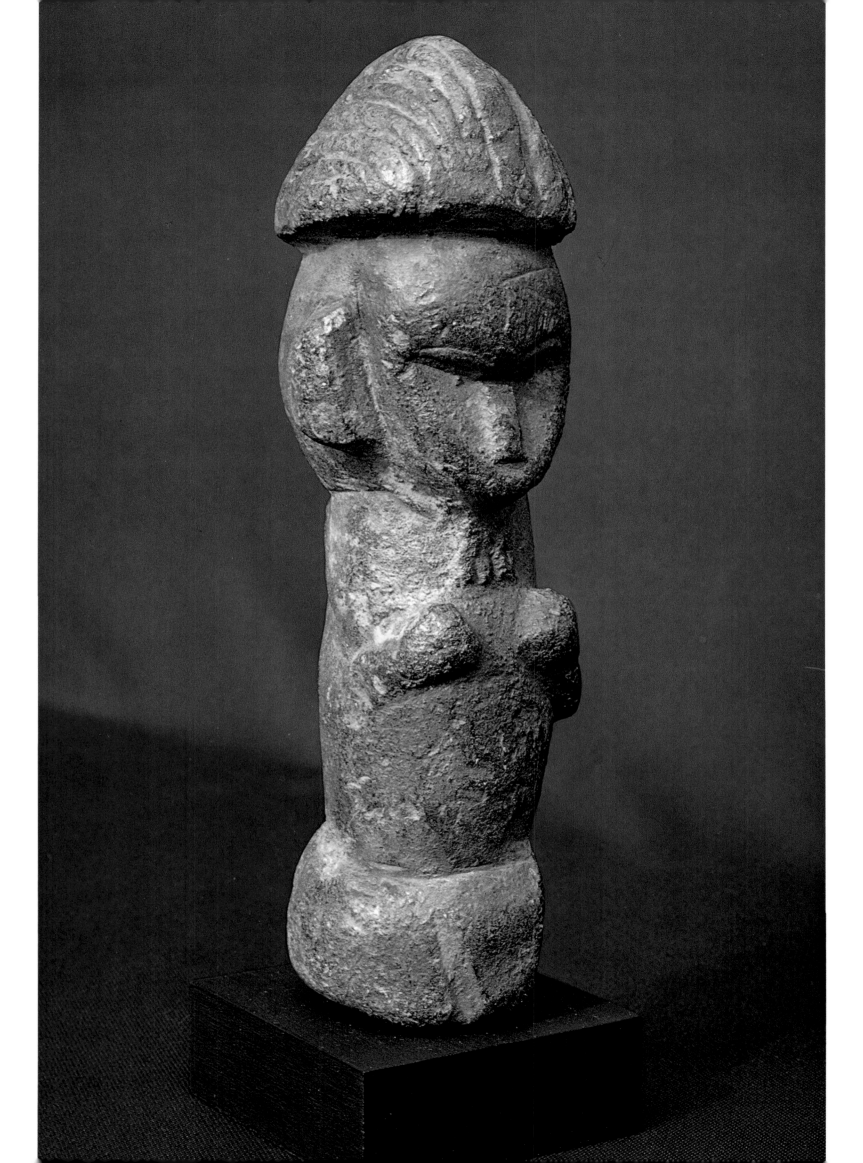

Bassa
De

The Bassa (not to be confused with the Bassa in Cameroon) and the De belong to a single tribal group, and live on the Liberian coast, around the capital Monrovia. Culturally they have been influenced from the west by the Mende and Vai, and from the east by the Dan. As the Dan influence is particularly marked, the masks were for a long time attributed to them. As the masks of both peoples show on the back no sign of having been worn they have often been considered forgeries. Such suspicions were proved to be groundless when it was discovered that these masks were worn attached to a basket-like mount.

13 Bassa figure

Wood, 104 cm, Liberia. Despite the facial similarities to Dan masks, stylistic differences are evident, above all in the hairstyle.

Although the Bassa were a patriarchal society, the tribal mother nevertheless played an important role. After the migration to the tribe's present locality it was up to her to find the still only partially known edible plants in their new home. The exaggeratedly long arms and hands of this very rare figure give appropriate embodiment to this idea. There are virtually no written studies of Bassa art.

24

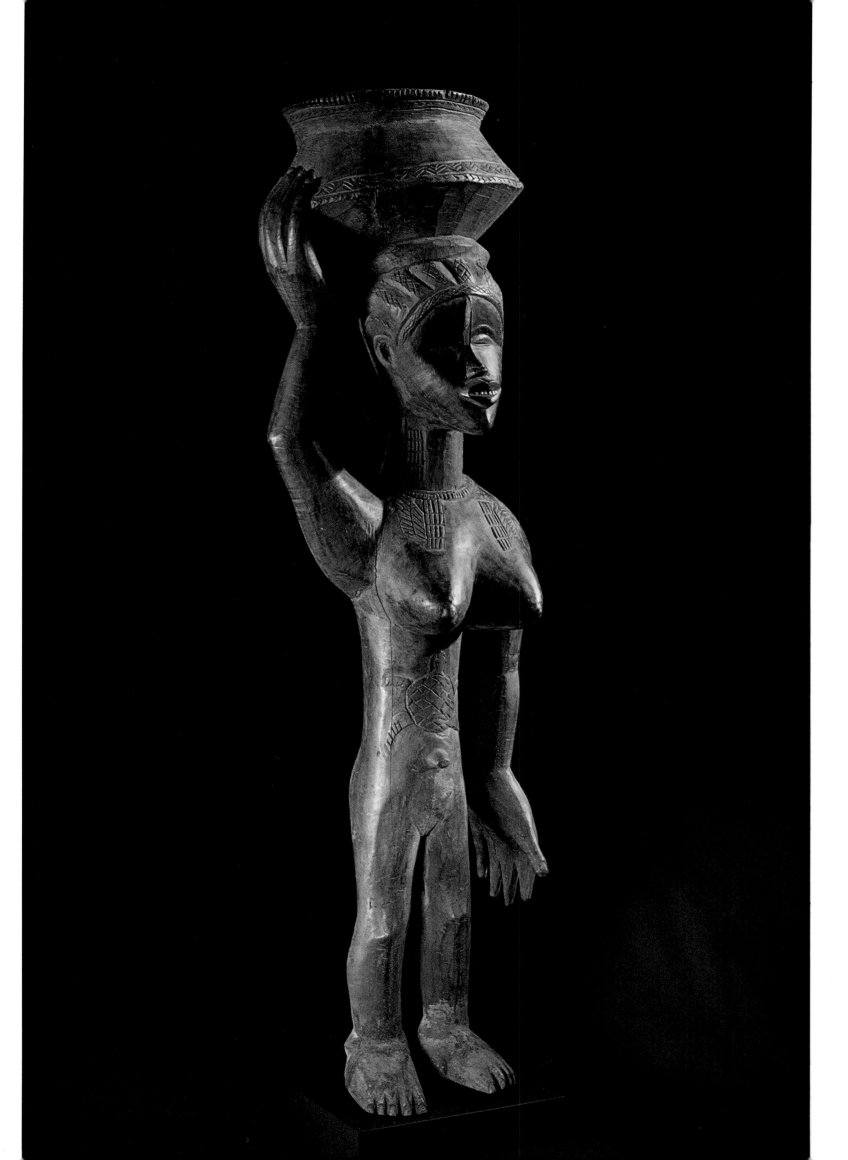

14 De ancestral figure

Wood, 23.5 cm, Liberia. A subtly delicate, harmonious figure of a young woman. Set above a long body wrapped with a cloth, the head, with the mitre-like hairstyle, is peculiarly dominating, and has special charm. The legs go footless into the base of the statuette. The long, beringed neck is adorned with a string of white glass beads, the torso with black. A highly unusual and beautiful figure of De artistry.

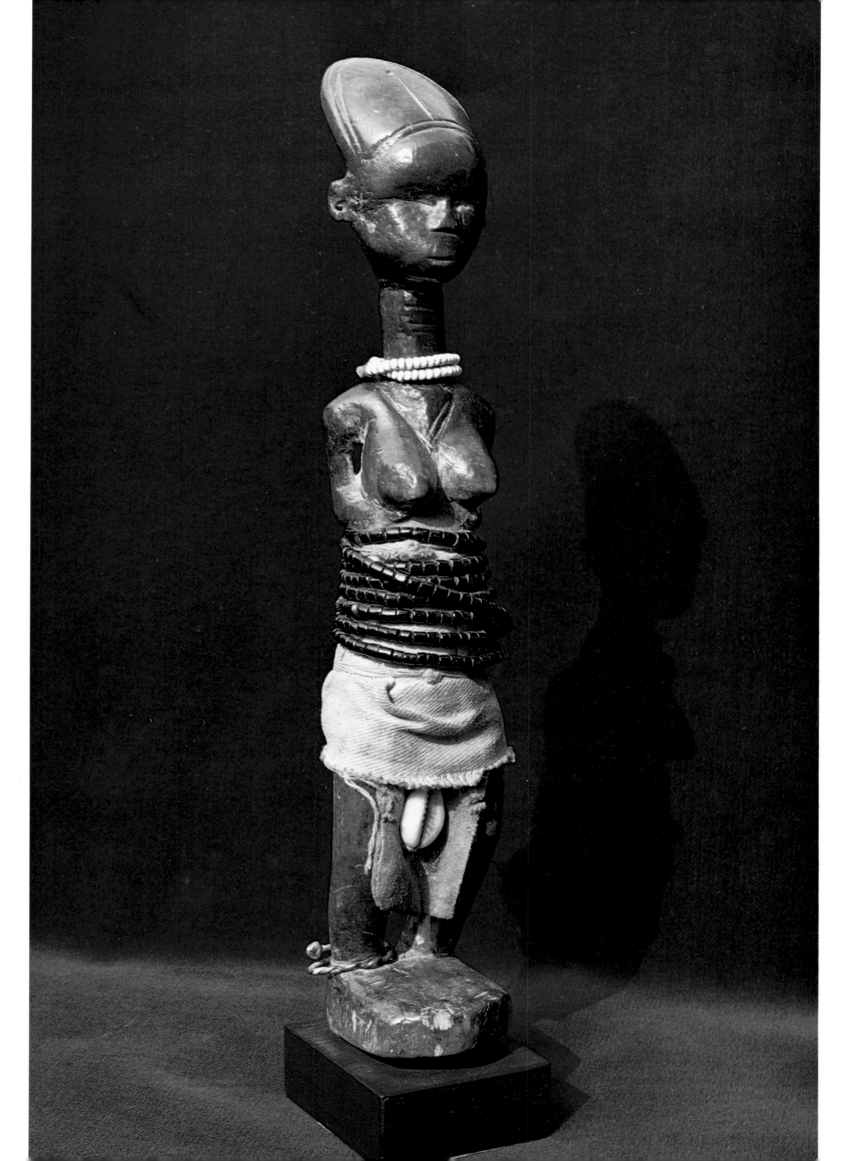

Bambara
Guandussu
Minianka
Malinke

The Bambara, Guandussu, Minianka, Malinke and Marka form an important group in African art. They inhabit large areas of Mali, Guinea and even of Senegal. The stylistic influences stem from the Bambara, who live on the upper Niger and from the River Bani region in Mali down into Guinea. Their life is governed by numerous secret societies. Their creator-god Faro taught them to cultivate the fruits of the earth, including grain, and gave them a sense of responsibility towards their fellow humans. He lets his will be known through the oracle.

Their masks and figures are famous, and the styles widely varied – which with a people a million or so strong is hardly to be wondered at. All modes of artistic expression are to be found, from subtle realism to abstract sculptures and masks. Best known perhaps are the Tyi Wara dance headdresses.

15 Bambara Segou fetish

Wood, 59 cm, Mali. This deeply revered, and at the same time feared, fetish figure from Segou (once an illustrious kingdom) is laden with powerful substances. Cowries, black glass beads, bits of coloured cloth, twisted leather thongs, loosely intertwined strands of thread, lengths of animal hair bound together, and two horns from a particular goat-like animal lent it such force that no one dared touch it. It was held in extreme awe, and is one of the rarest and most important of Bambara cult figures. The curious headwear was made especially for these figures.

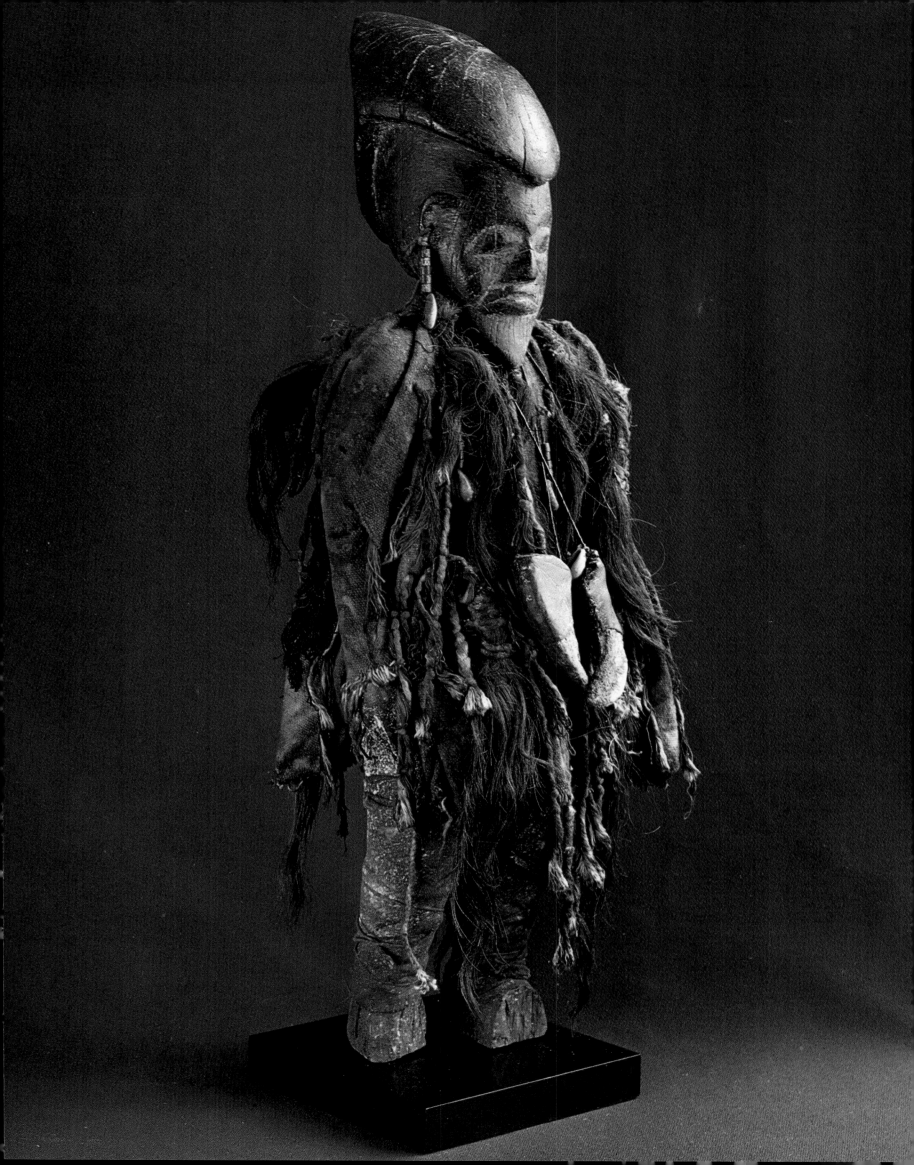

16 Bambara ancestral figure

Wood, 59 cm, Mali. This female ancestral figure, classically Bambara in style, thin and strikingly elongated, is typical of the art of the Western Sudan. The geometrical scarifications decorating the whole figure are skilfully integrated with the physical proportions. The whole stands in balanced, static harmony. An outstanding example of autonomous African tribal art.

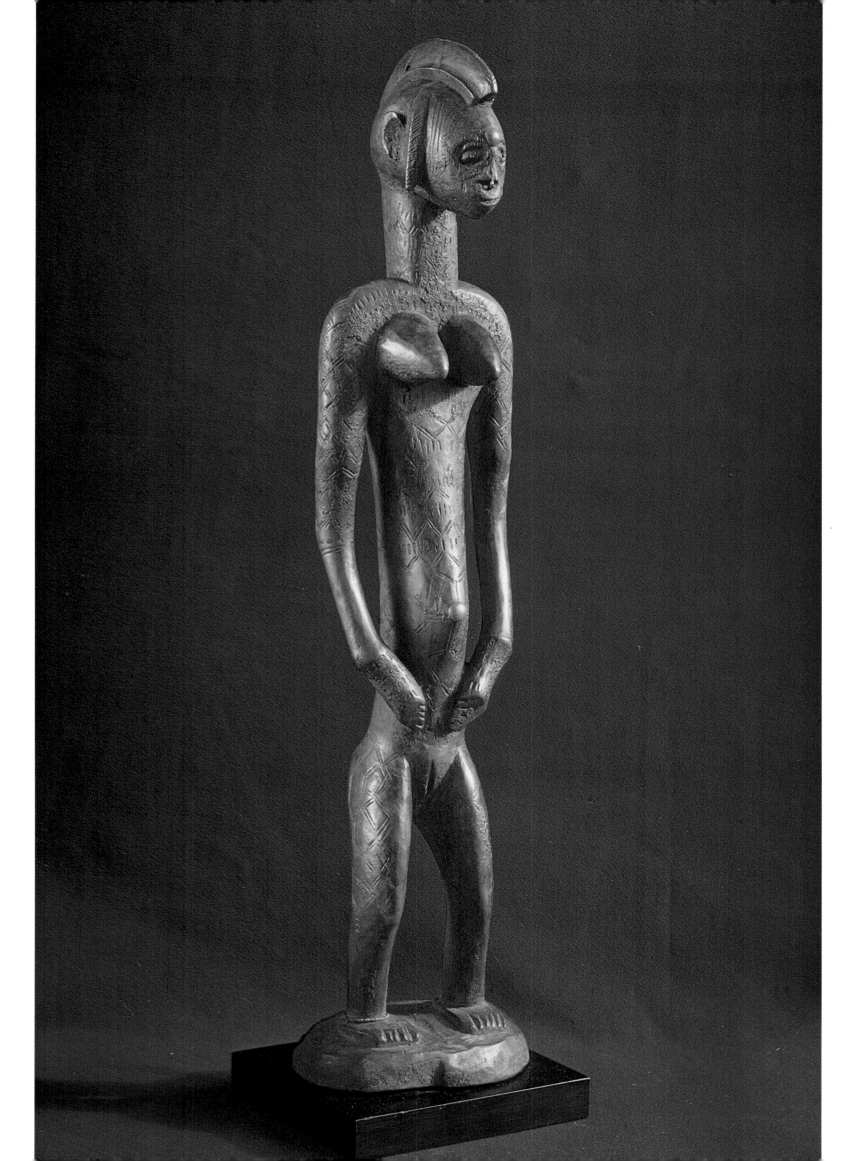

17 Bambara hyena mask

Wood, 45.5 cm, Mali. This dynamic hyena mask, of considerable artistic merit, could easily have influenced Modigliani. The long vertical of the heavily stylized, noble face, with the dominating nose, is further enhanced by the grooved cheeks. A compelling masterpiece of Bambara work.

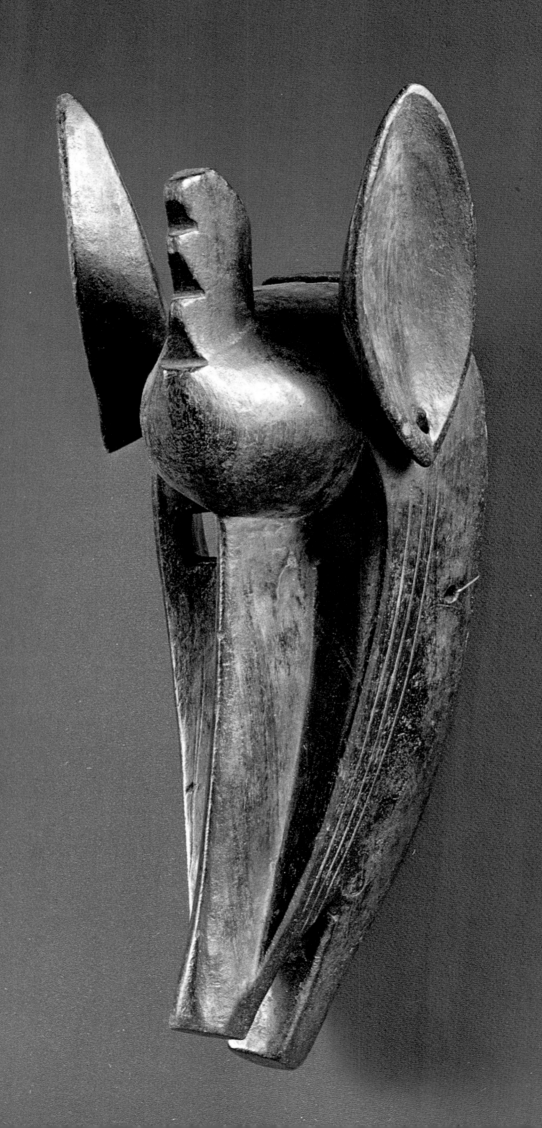

THE FIGURE Unlike the horrific 'commotion' of the masks, the figures convey stillness. They are generally peaceful (often owing to the form of the raw material, the tree trunk or branch). Ancestral figures play a significant part in the worship of ancestors, the souls of the dead inhabiting them for a long or short space of time. They are looked after, and often fed and clothed, and advice is sought from them. The good graces of the ancestral spirits or souls are wooed with sacrificial offerings. Like masks they are important for health, good harvests, luck in the hunt, and many other human and social needs.

18 Guandussu ancestral figure

Wood, 58 cm, Mali. The Guandussu were the aristocrats of the Bambara, and this splendid figure has a regal bearing. There are no unnecessary details; the tight, strongly abstract form is impressive. A very rare and fascinatingly beautiful figure.

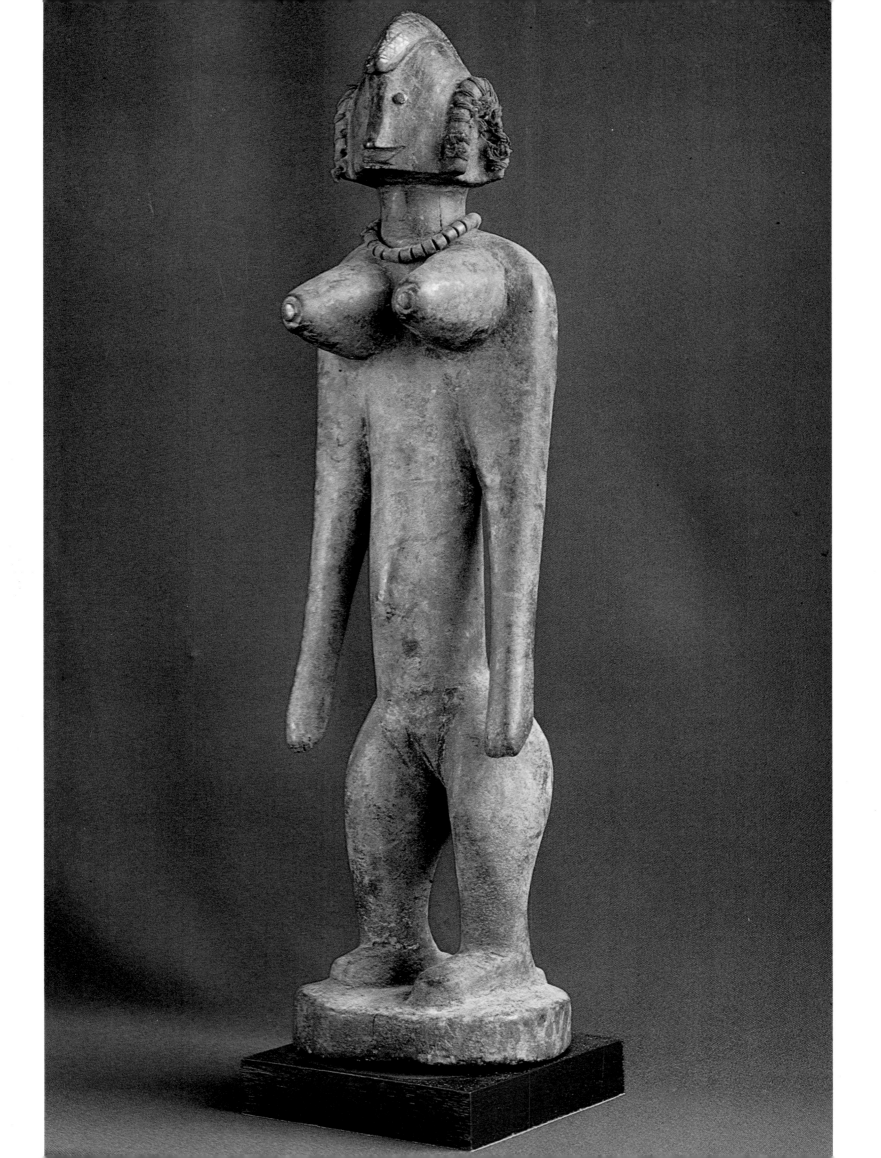

19 Minianka antelope headdress

*Wood, 87 cm, Mali. This wonderfully stylized
female Tyi Wara dance headdress is one of the
most beautiful of all Bambara art works.
(Stylistically the Minianka belong to the
Bambara; ethnically to the Senufo.) These
headdresses are worn by dancers in pairs at
sowing and harvest time, and are to guarantee a
good harvest.*

*The horns distinguish sex – the male curving
backwards, and the female vertically erect. The
female usually carries her young on her back.
This example is a quite especially beautiful one
from the Sikasso area.*

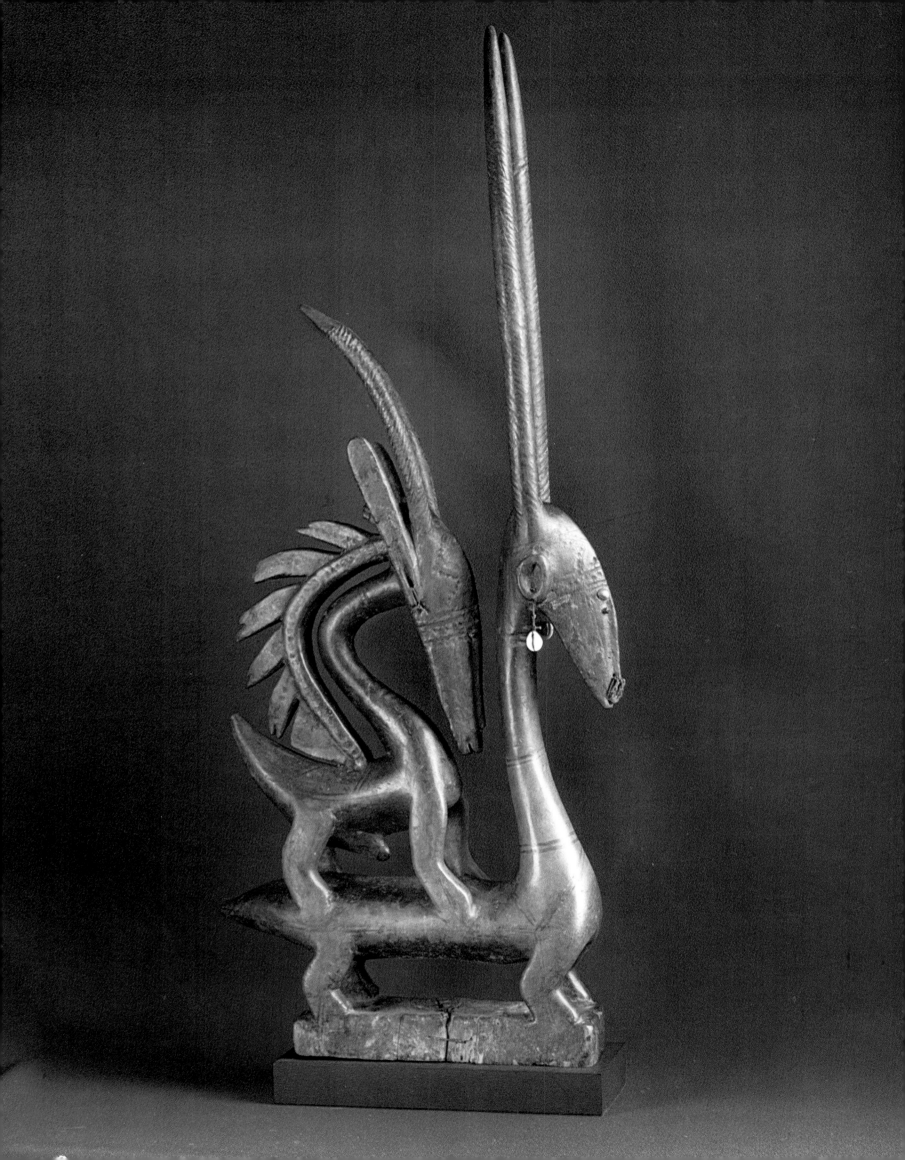

20 Malinke ancestral figure

Wood, 56 cm, Mali. A heavily stylized figure with narrow head and body, both projecting forward into a sharp edge. The parallel lines of head and chin, the breasts thrusting out from the shoulders, the forearms and the thighs are formally interesting, and reveal great mastery. The figure is seated on three other highly stylized, backwards-looking figures.

The Malinke live south-west of the Bambara in Mali and Guinea, and in the southernmost parts of Senegal.

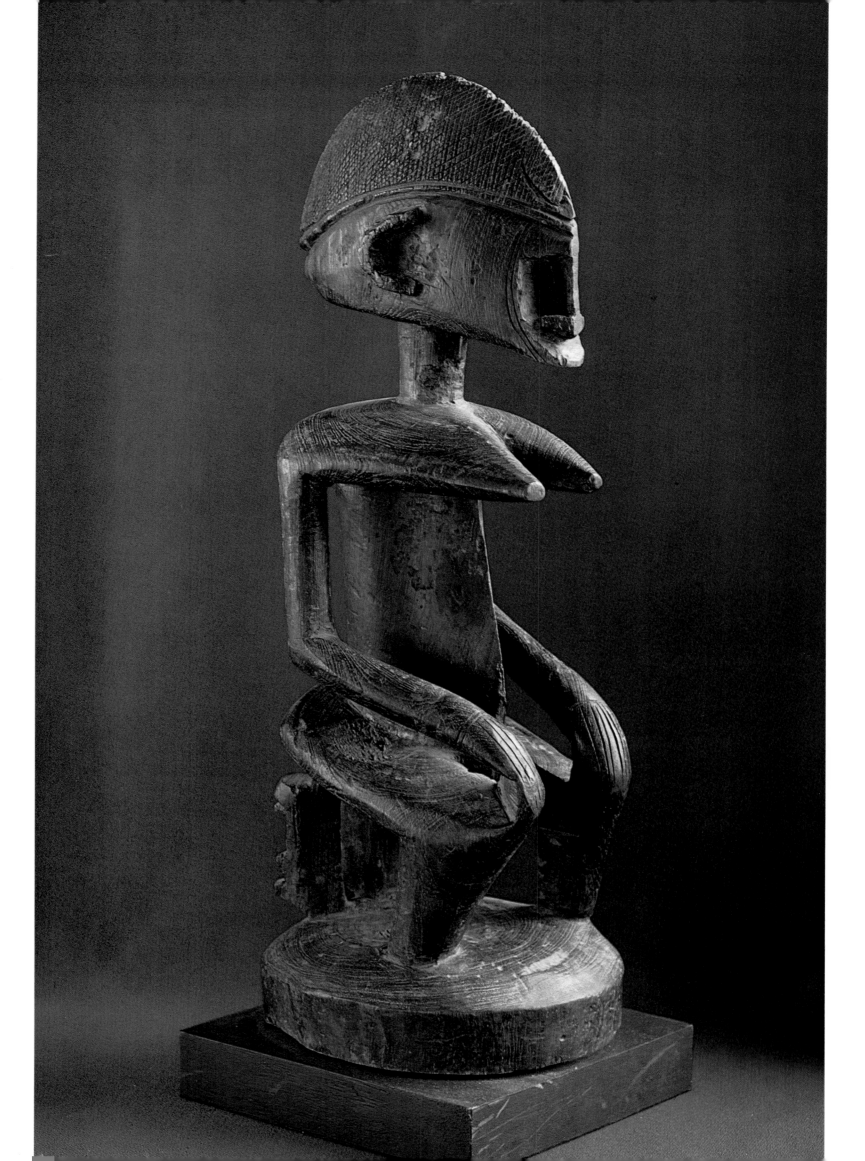

Djenne

A totally original kind of art comes from the inland delta of the Niger in Mali, where it splits into several tributaries, and together with the nearby River Bani causes flooding in the rainy season. The Djenne terracottas (so named after the main place where they were found) have been discovered in burial mounds. Who made them is a matter of guesswork, but they can be dated between the 12th and 14th centuries. Mali was in medieval times one of the most powerful empires in West Africa. In the 13th century it took over from Ghana its trade in gold dust. The pilgrimage to Mecca, probably in 1324, of the Emperor of Mali, Mansa Musa, during which he distributed gold so lavishly that its price in the Near East was severely affected for some considerable time, went down in world history. Today the Bozo live in the area where these terracottas were found. It is not known to what extent the earlier Soninke contributed to the making of them.

21 Djenne terracotta

21 cm, Mali. This static, splendidly constructed, kneeling terracotta figure is a classic example of Djenne art. Round holes appear under the projecting navel, on the shoulders and over the covered thighs. To judge from the evidence, they were probably for sacrificial purposes, to be filled with blood. The neck is adorned with a snake, whose head comes down to between the breasts. Scarifications, arranged in a square, can be seen on the temples.

40

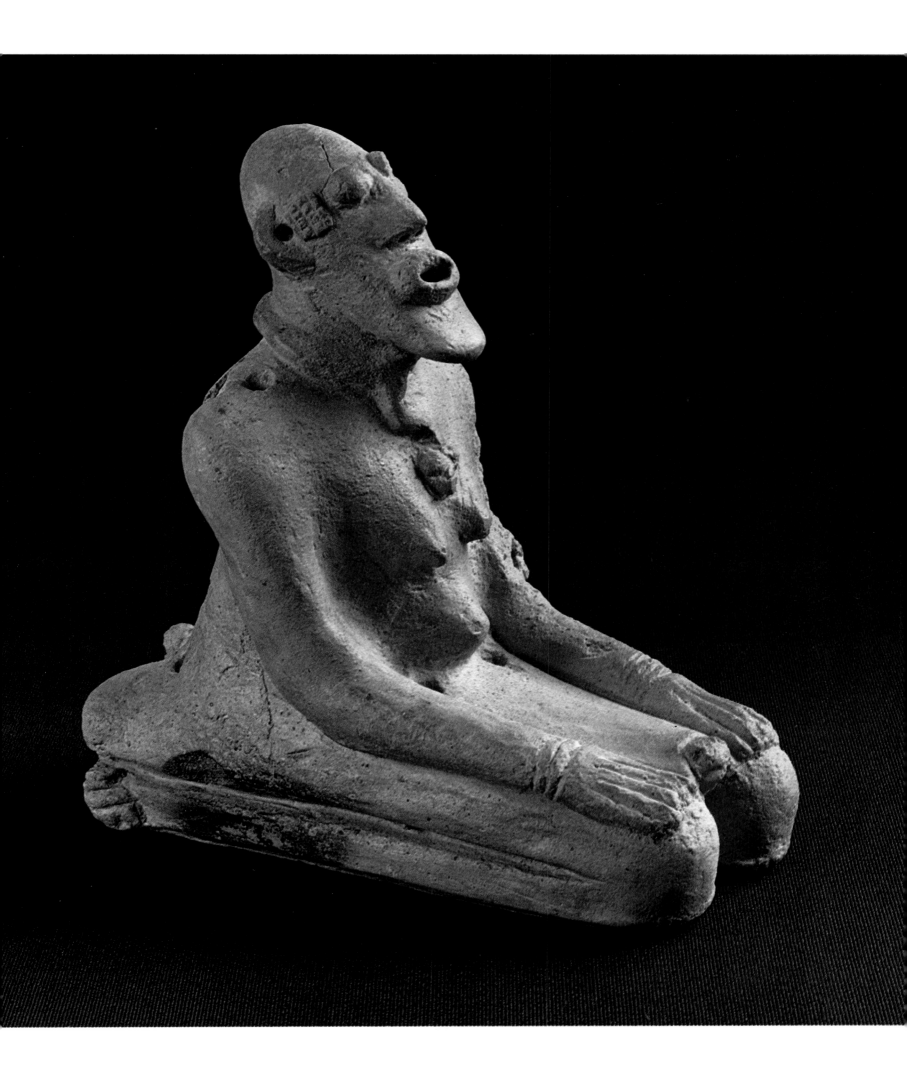

22 Djenne terracotta

27 cm, Mali. Female figure, offering the child her breast with her left hand, and clasping it protectively with her right. Highly three-dimensional scarifications are visible over her eyes and on her temples.

Representations of mothers with children have been attributed to the influence of the first Europeans in the 15th century. This mother and child, dating from rather earlier, clearly indicates that such was not the case.

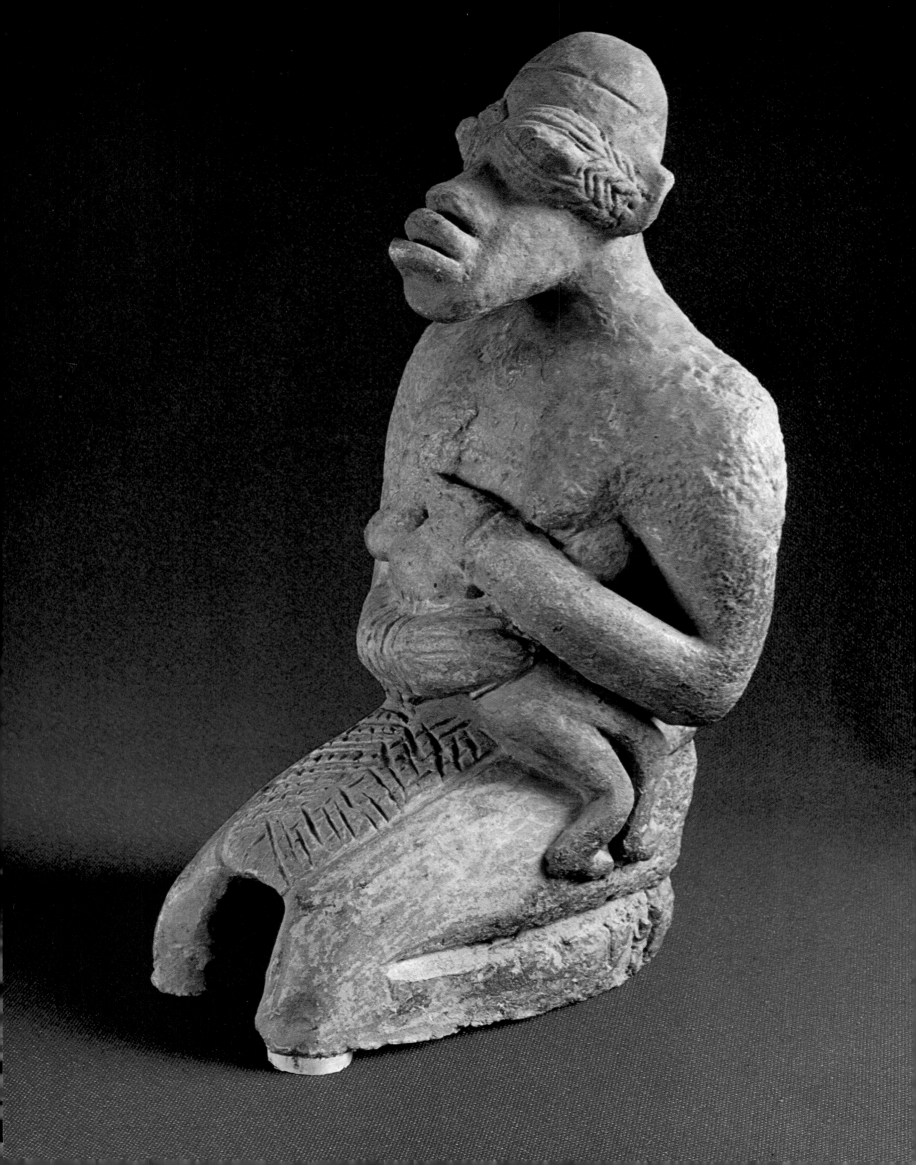

Djenne terracotta

20.5 cm, Mali. This archaic, severely eroded figure has a monumental air. It served as a cult figure, an ancestral figure, and a protective figure.

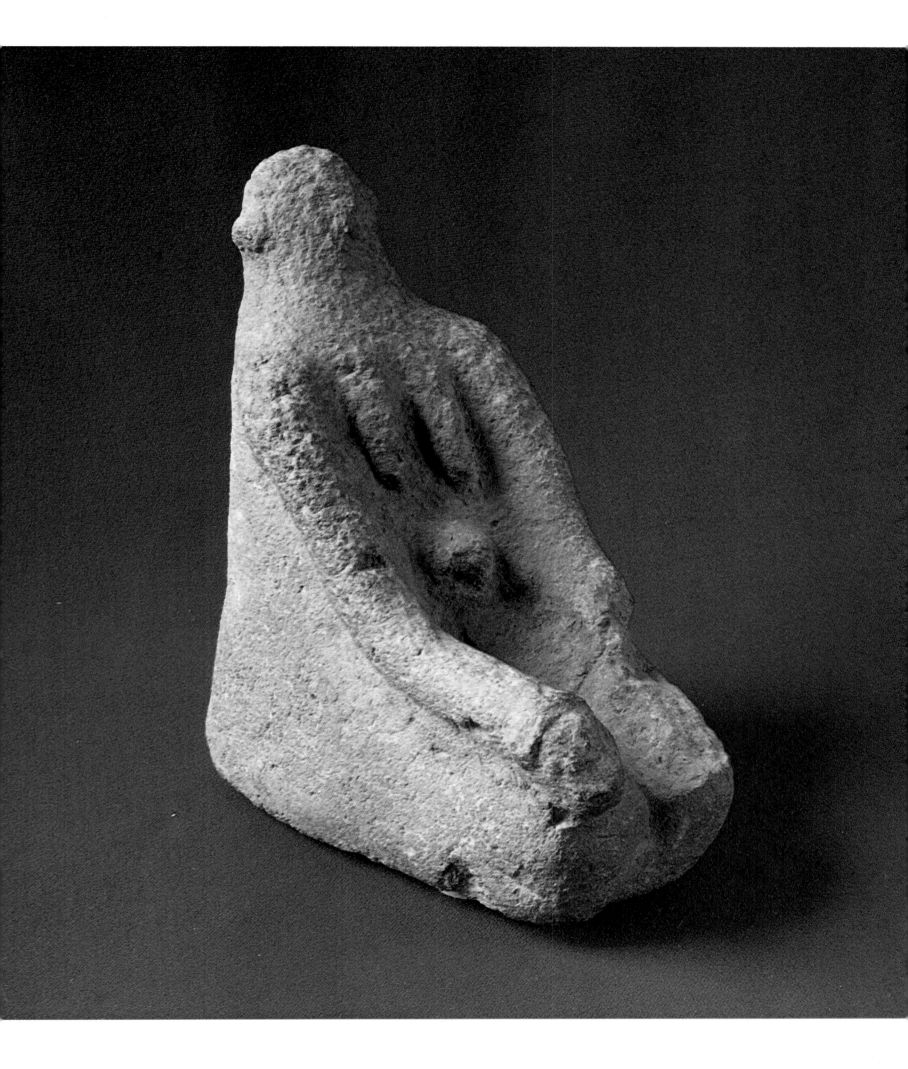

Dogon

The Dogon, who according to ancient sources migrated from the Nile valley to the Bandiagara Escarpment in the Niger region, live south-east of Timbuktu in Mali. Driven to move by Islam, they in turn drove out their predecessors in this area, the Tellem. The Tellem sculptures that have been discovered, heavily encrusted with age, in caves are evident forerunners of Dogon art. It is believed that these Tellem were related to the Kurumba, who today live in Upper Volta, and who call themselves Tellem. Figures described thus are dated to the 13th century, but figures today described as Tellem are often probably Dogon works conceived entirely along Tellem lines, and thus can hardly in fact be called Tellem.

Europeans came to know about Dogon art relatively recently. It is astonishingly abstract and geometrical. The carvings, made from very hard wood, are the work of smiths, who constitute a much feared caste. The masks are the work of young members of society.

The figures – ancestral couples, mounted figures, granary doors and support pillars for cult buildings, to name but a few – together with the masks are among the best works of African art.

The rather rare brasses are also the work of the smiths, who at the same time occupied the position of the Hogon, or priest. The highly venerated figures are handed down within the family. For a while they accompany the dead, whose souls can reside in the ancestral figure. They also play an important role at births and harvest time. There are fully a hundred different types of mask. Though enormously varied, they resemble the figures in conception – thus are abstract, with cubist elements. Many

24 Dogon ritual chain

Iron/stone, approx. 113 cm, Mali. Hogon priest's cult chain with polished neolithic and belemnite stones. One of the most important objects in Dogon ceremonials. From the roughly worked links of the iron chain hang flat iron rings, then five bell-shaped stones of different kinds. These have particularly interested experts. From what the Dogon say, they are partly meteoric, or they come from where meteorites fell to the ground. Very special properties are ascribed to them.

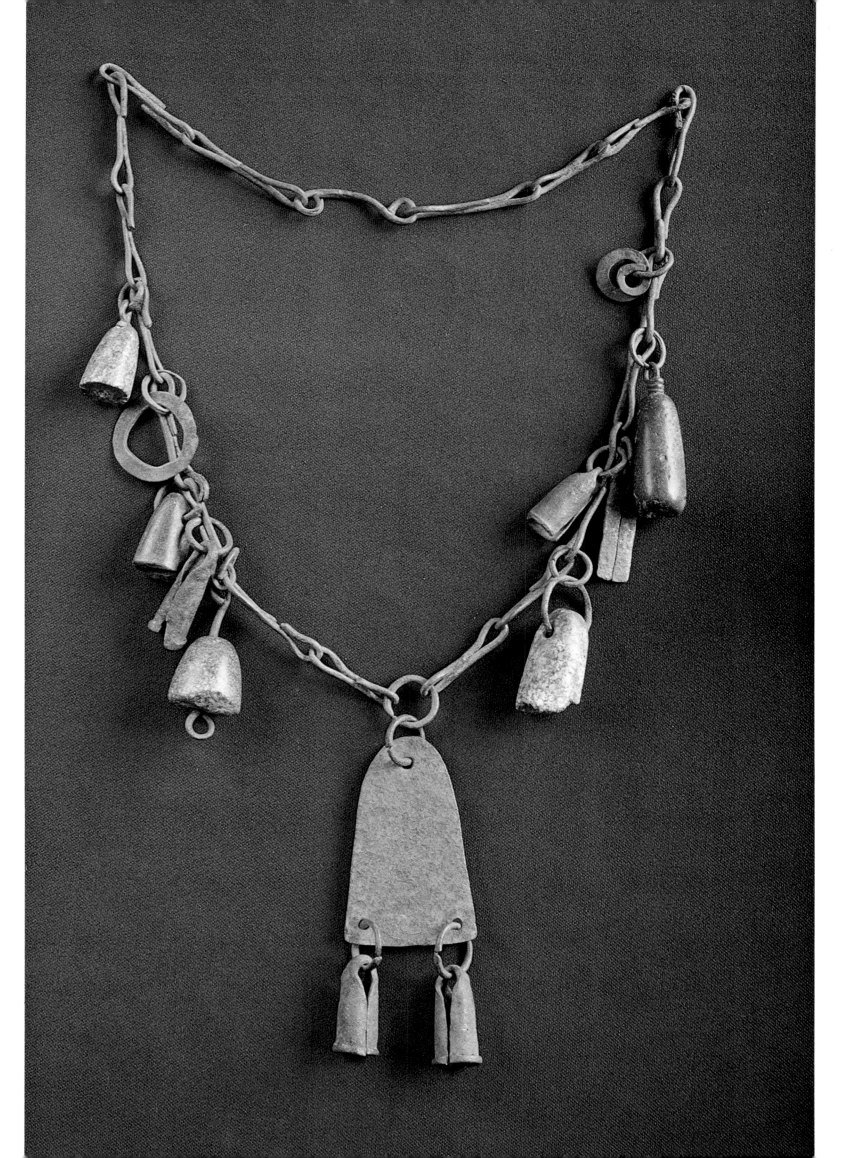

play a leading part in the ancient Dogon cults. The box-like masks reflect the architectonic qualities of their stone houses. Dogon ironwork is also of great charm and interest.

The Dogon possess a philosophy which a team of researchers has been able to reveal to us, having gained access to the secret knowledge that the Dogon high priests had jealously guarded for centuries.

It is accepted that the Dogon arrived in their present area of settlement, from the Nile valley and across the Sudan, many hundreds of years ago. With them to their new home they brought their store of secret knowledge, and integrated it into their religion. Modern scientists were amazed that they knew, for instance, of the existence of Syrius B in the constellation of Canis Major. We came to know of it only with the most sophisticated optical instruments of the new era. They have clearly known for a long time that the orbit of the satellite Syrius A takes fifty years. They also say that Syrius B revolves on its own axis once a year; and this they celebrate in the Bados rite. Every fifty years, corresponding to its orbit, they hold the Sigui celebrations. They maintain also that Syrius B is the smallest and heaviest star, made of the metal Sagala, 'which weighs as much as all the iron on earth'. According to them there is also a Syrius C, that is four times as light, and that takes a mere thirty-two years in its orbit around Syrius A. Modern science has so far found no trace of Syrius C, but its existence cannot be conclusively denied.

How did the Dogon come to know too that our world is dead, that Saturn has a ring, and that Jupiter has four moons (which appear in their drawings)? Again, they have long known that stars do not describe a circle, but revolve elliptically around other stars.

Surely Galileo would have been treated differently by the Dogon?

25 Dogon iron sculpture

20 cm, Mali. This warrior, brandishing shield and spear, astride a flat, elegantly curving edge of iron, symbolizing lightning, appears to be advancing towards something dangerous and threatening. An exceptionally elegant, magnificently thought up work. A vision of the rider of the Apocalypse indeed!

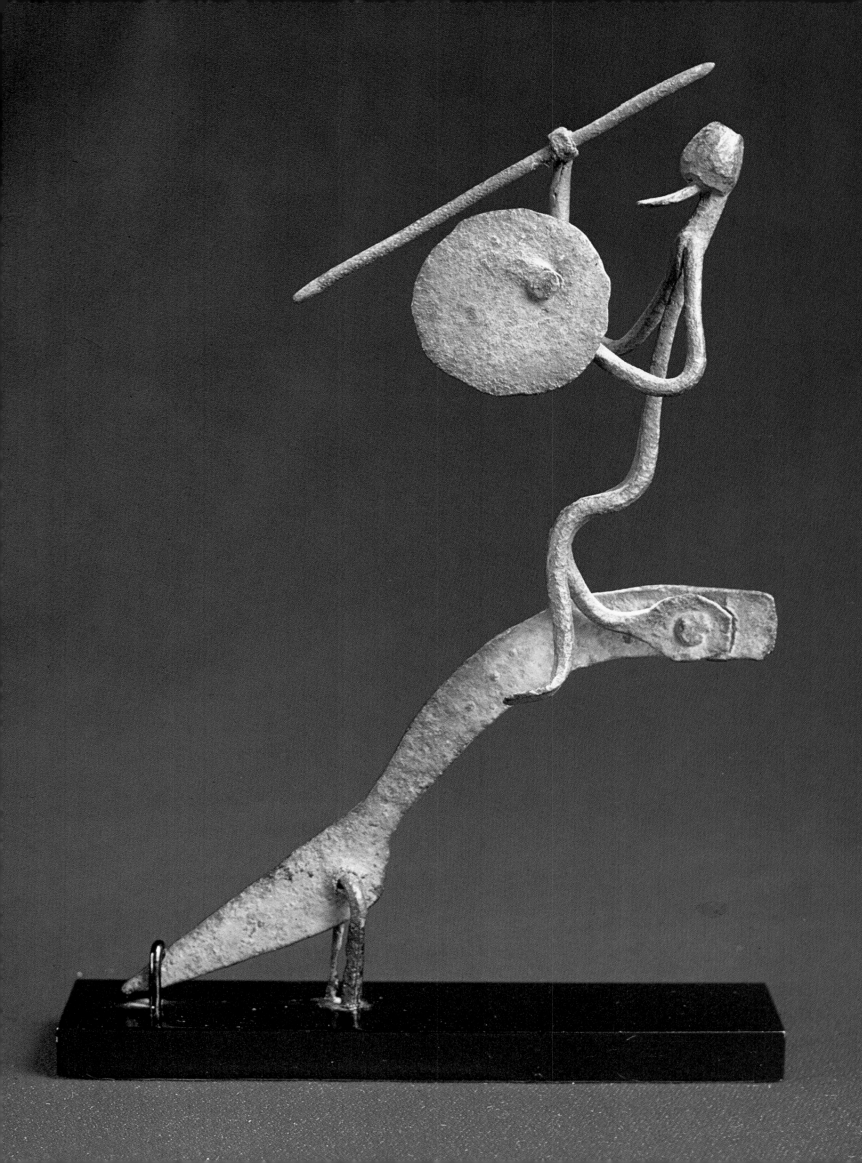

26 Dogon rider

Wood, 32.5 cm, Mali. This mythic equestrian figure in classic Dogon style comes from the Bandiagara region. Horse and rider form a supreme, single whole, and have become almost centaur-like. Despite its small size, its bold and artistically very beautiful composition conveys packed, controlled power.

50

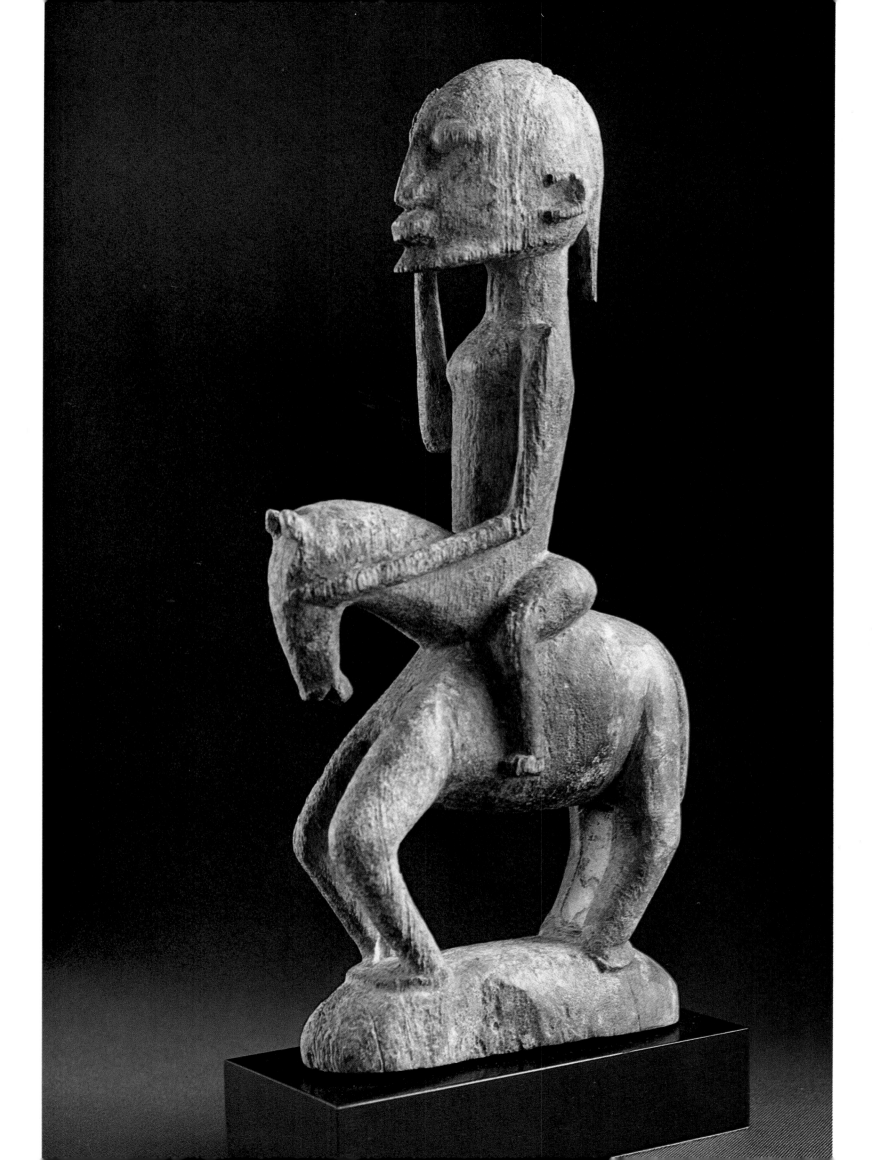

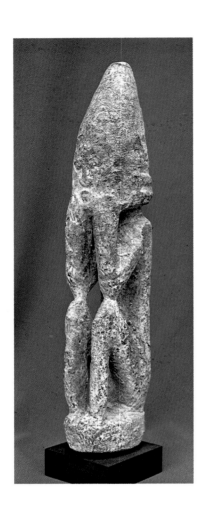

27 Dogon ancestral figure

Wood, 42.5 cm, Mali. The pointed hood distinguishes the Hogon priest (who is at the same time smith and carver). He is a medium between heaven and earth, living and dead. Through the sacrificial encrustation it looks almost like stone. Its taut attitude, and the opposing movement of the arms and legs, make it a powerful figure. The shape of the hood is symbolic of the earth created by the god Amma in the form of an egg.

28 Dogon ancestral figure

Wood, 86 cm, Mali. The head of this old, iron-hard, heavily encrusted figure follows the natural shape of the wood in its almost humble slight forward bow. Many of these figures are only rarely, for certain specific festivals, taken out and honoured with sacrifices. Sand is mingled with the rough sacrificial patination – thus probably, when not in use, it is kept in the sand.

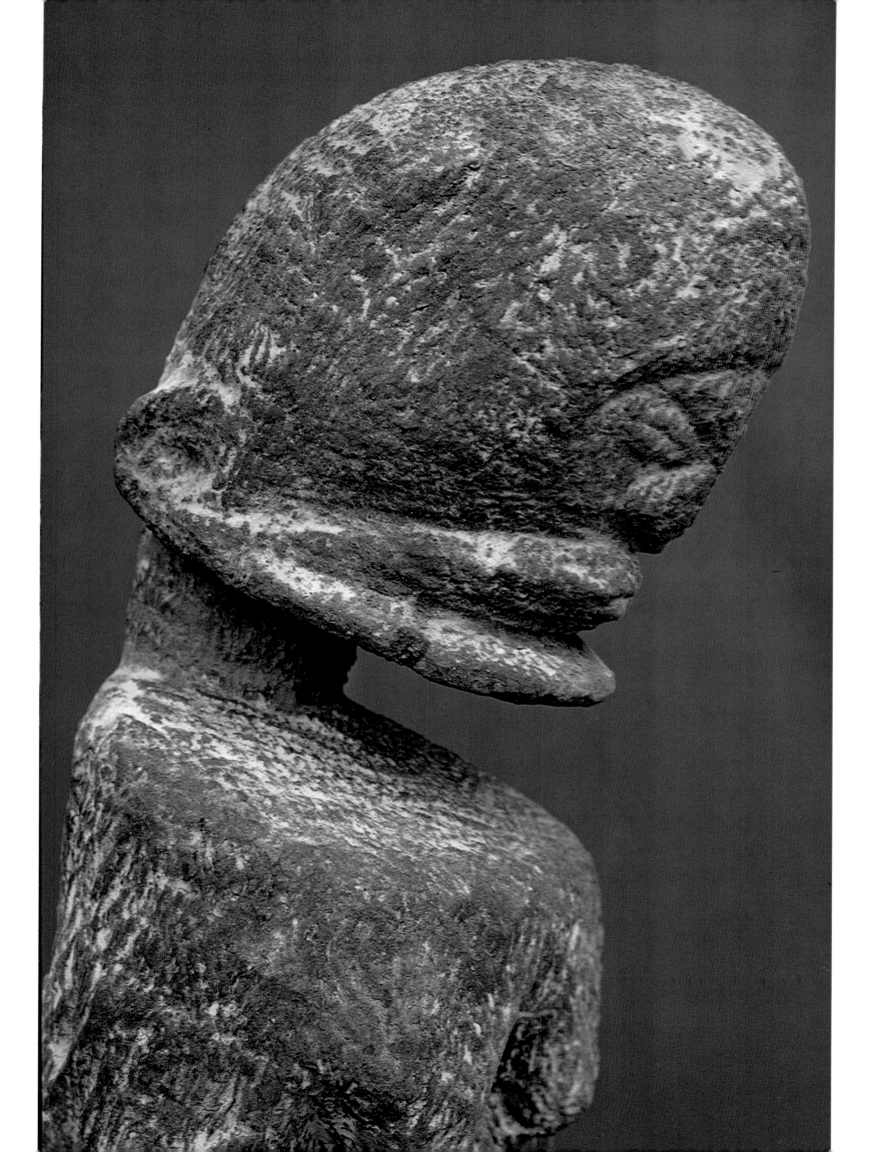

29 Dogon Satimbe mask

Wood, 75.5 cm, Mali. A female figure dominates this strictly cubist mask, which is an embodiment of Dogon architectural style. The woman is one of the sacred Yasigin, who alone can be received into the men's Awa society.

The head is classically Dogon, but the thin forearms are attached at the elbows, which is unusual in African figurative art.

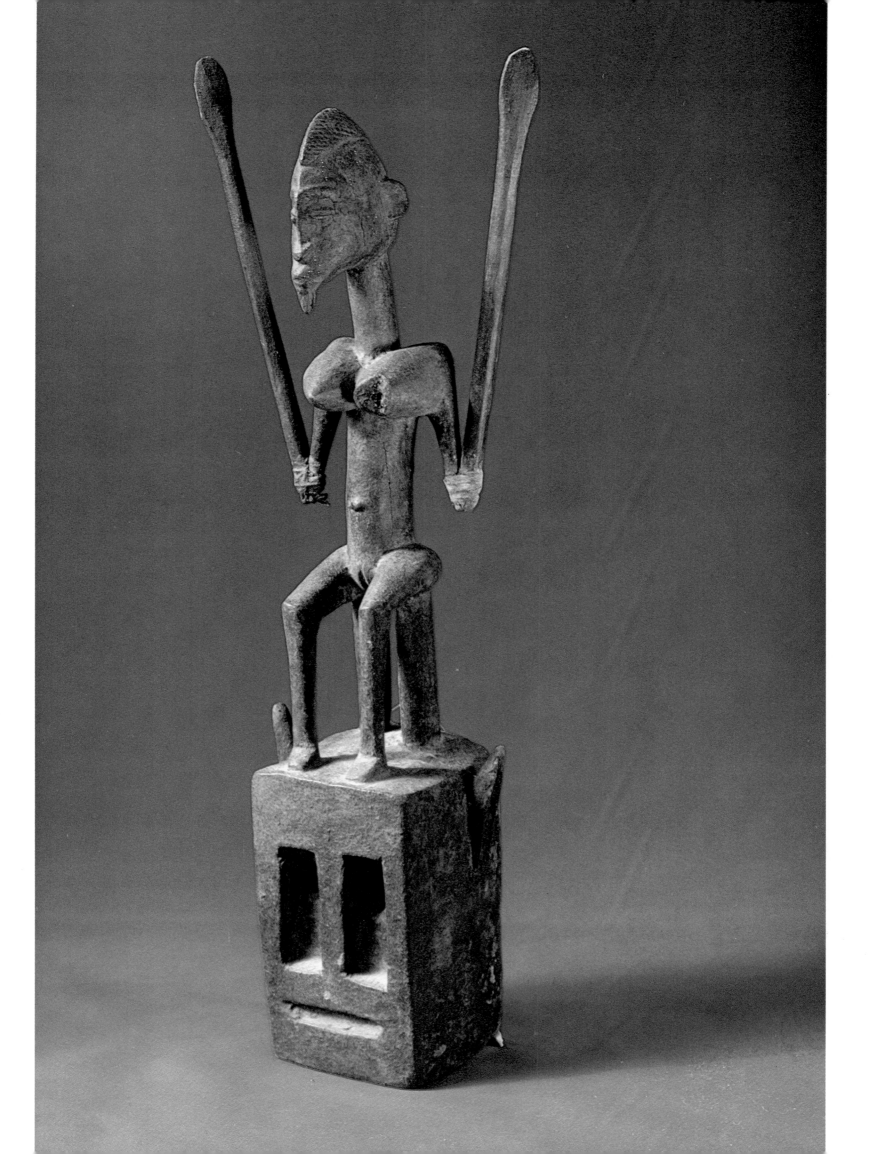

30 Dogon monkey cult mask

Wood, 34 cm, Mali. An aesthetically quite especially beautiful Dogon face mask. Everything about it is masterly, harmonious and well balanced. The concave face with its imposing vertical axis carries architectonic conviction. The 'skin' is a fine, flaky, dark brown to blackish sacrificial crust.

56

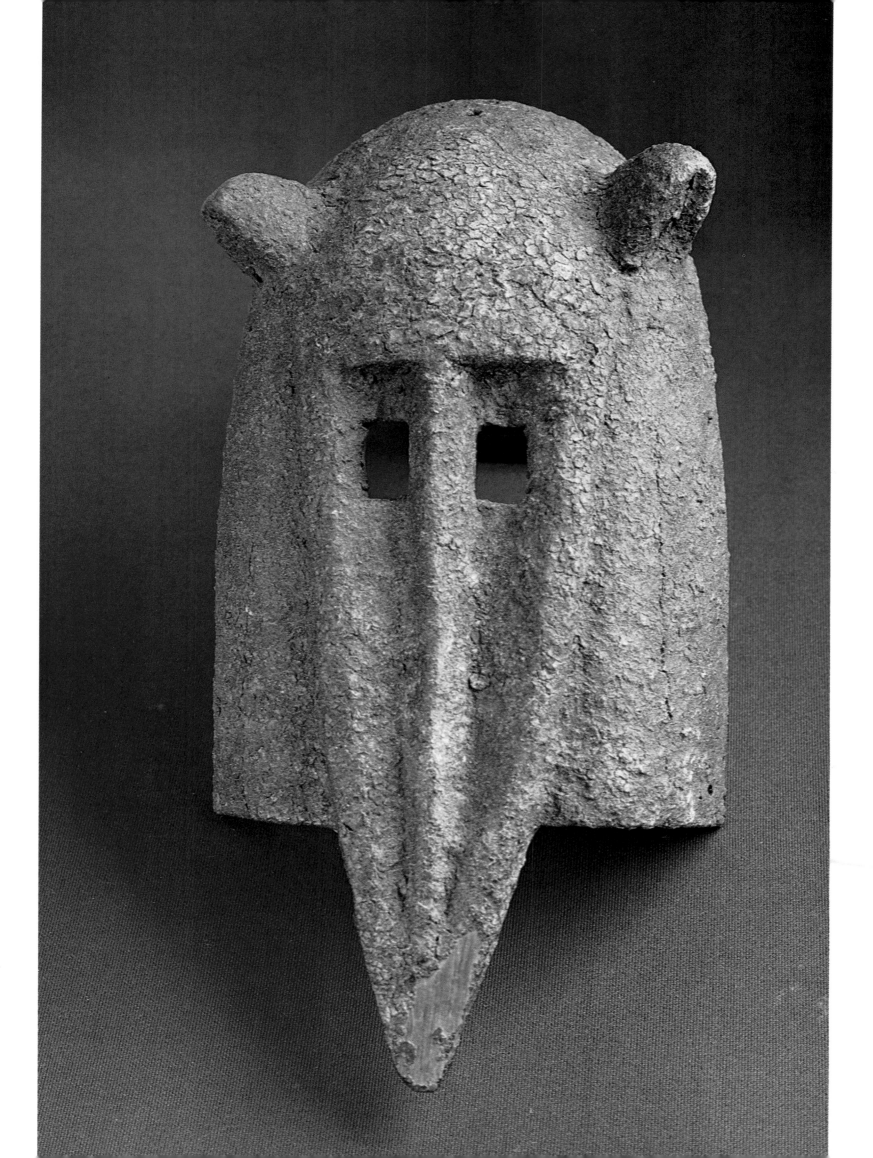

31 Dogon stone figure

12 cm, Mali. This compact, thick-set, rather phallic stone sculpture, showing all the signs of early Dogon art, is an important cult object. The left half of the head has a thick sacrificial encrustation of blood. It served as an agricultural fertility symbol – male sperm being put on the fields during the rites.

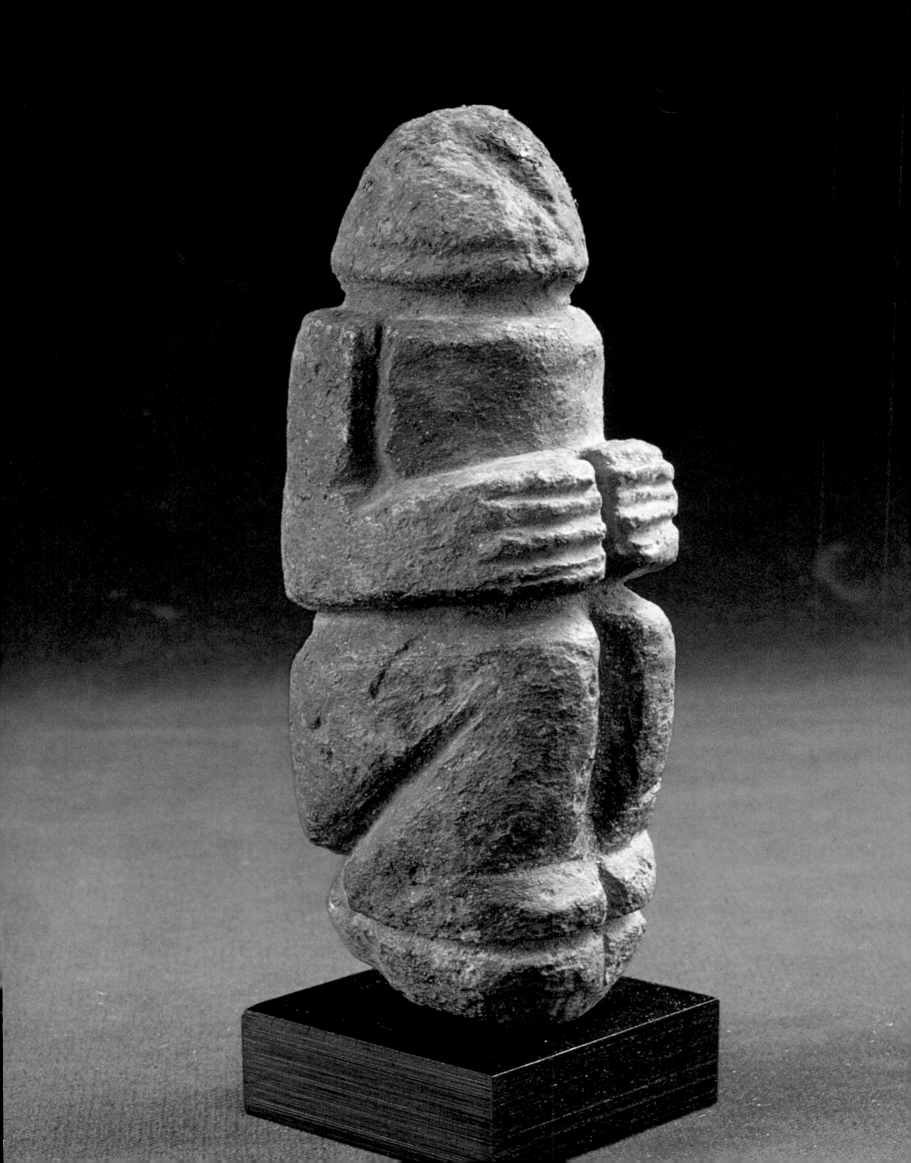

Bobo
Gurunsi
Abron

In south-western Upper Volta and partly in the neighbouring Ivory Coast we find the Bobo, Gurunsi and Abron (the latter mainly in Ghana). Together with the Bozo, Nunuma, Nafana and others, they share certain elements of style which set them all in the same artistic group, although ethnically they belong to quite different stocks.

The Bobo are divided into the southern Bobo-Fing, around Bobo-Diulasso, and the

32 Bobo-Bwa fire-watcher's mask

Wood, 42/67 cm, Upper Volta. The tight form here is different from this tribe's usual wide outspreading butterfly masks. The reasons for this are functional. The fastest runner wore it, and alerted all around when fires broke out. He was also responsible for seeing that all herdsmen's fires were out at night. A beautiful and rare piece, it combines practicality with subtly integrated decoration. The downward curving nose is also classic (being identified as, amongst other things, a phallic symbol and a witch's prong). Typical, too, are the large, ringed eyes and the round mouth. The beardlike appendage is made of plant fibres.

60

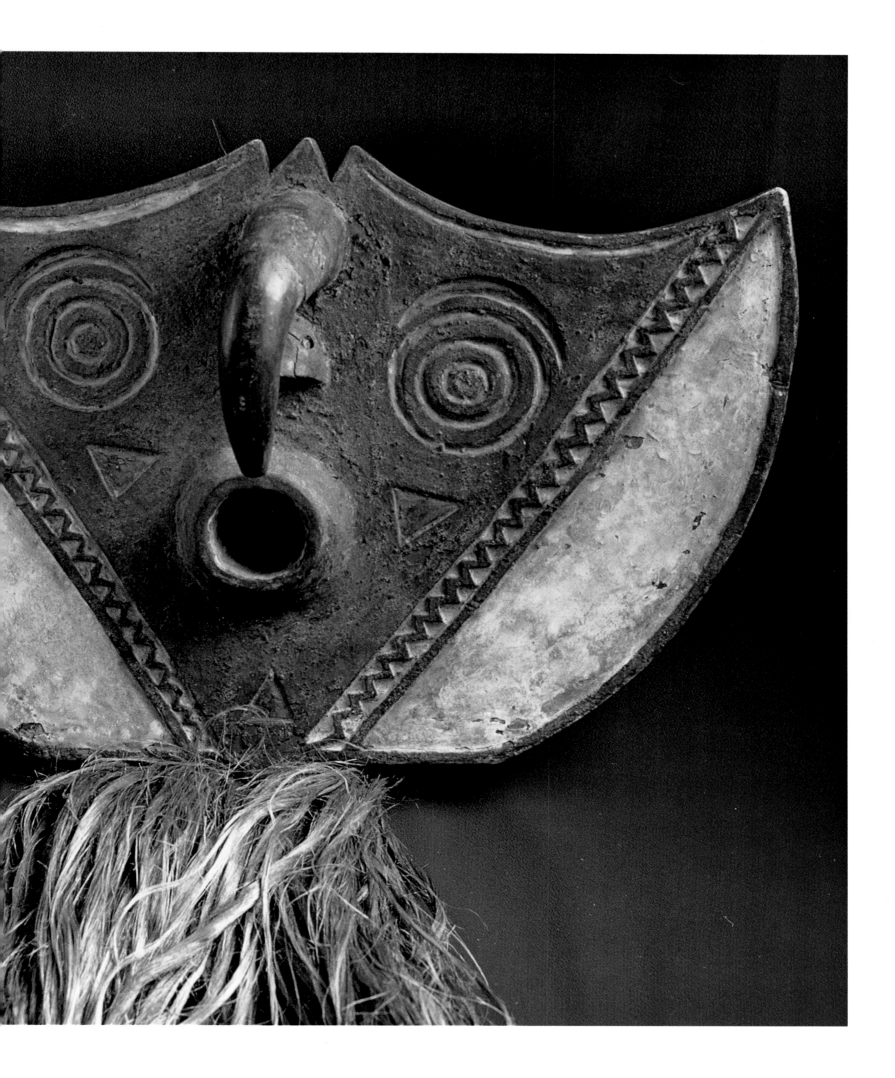

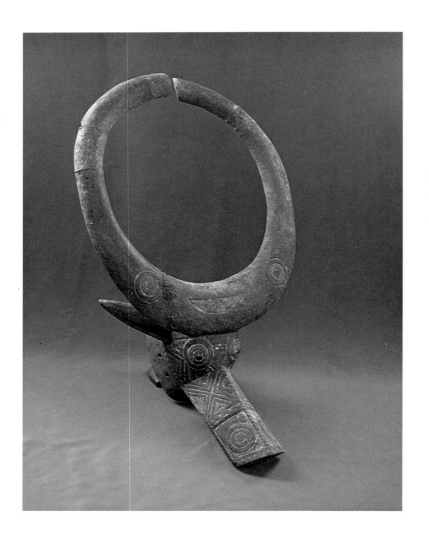

northern Bobo-Ule or Bwa. The Bobo-Fing are known for their realistic masks, and the Bwa, like the Gurunsi on the border between Upper Volta and Ghana, for their board-like butterfly masks.

The southernmost group, the Abron, are not often to be found in collections, but they produce splendid, stylistically beautiful work.

33 Bobo-Bwa buffalo mask

102 cm high, 63 cm wide, Upper Volta. This monumental bull mask of Bobo-Bwa (also known as Ule) workmanship, outstandingly symbolizes vitality and contained, controlled strength. The horns, curving in to form a circle, stand on a powerful bull antelope's head. The piece is imbued with primeval force, and commands respect. From an aesthetic point of view also it is convincing in every way. It is, furthermore, very ancient and precious, and has been used in rituals over the years.

34 Bobo-Fing ancestral figure

Wood, 66 cm, Upper Volta. This extenuated figure, with its fascinatingly unusual proportions, slim and slender, standing as if on stilts, is a bold composition with a strikingly expressive head.

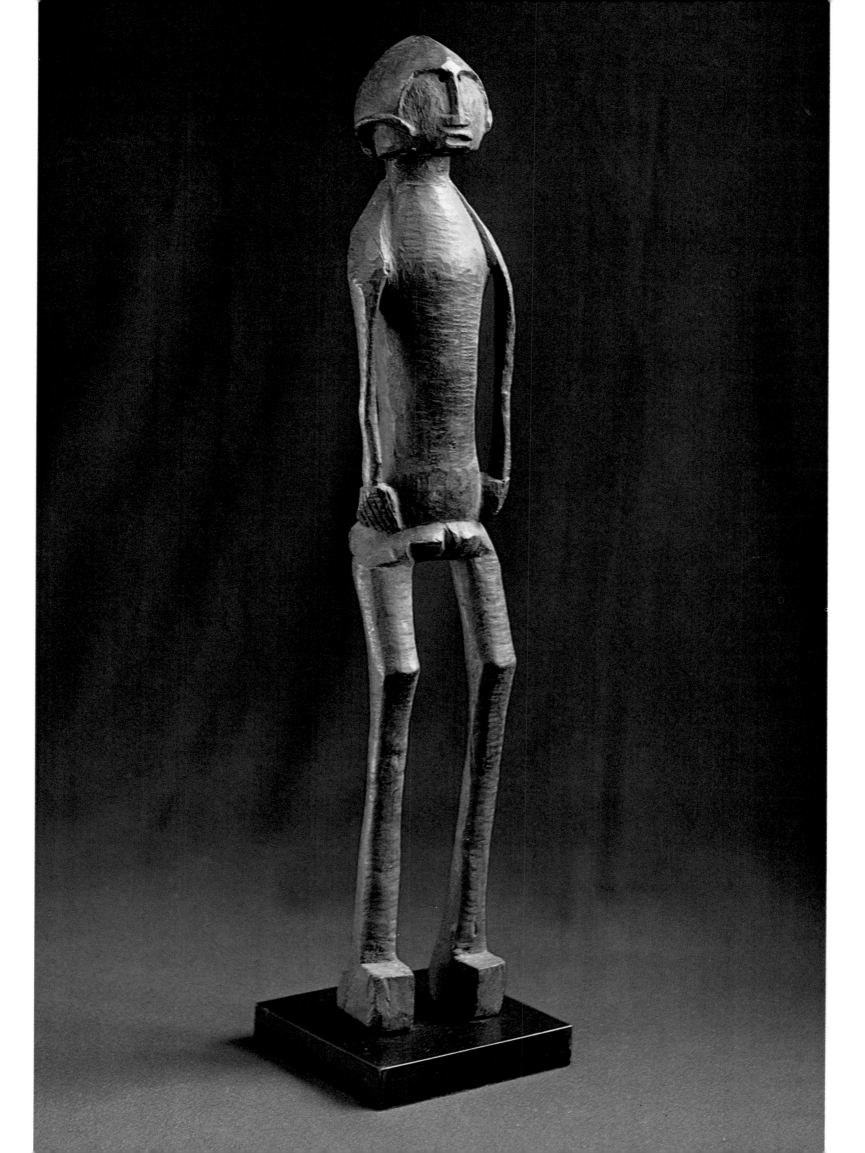

35 Bobo–Bwa butterfly mask

Wood, 133 cm, Upper Volta. From the village of Nuna, north of Bobo-Diulasso. On the front there are two stylized human figures framed with geometric patterns. One of the two sets of eyes is looking into the present, the other into the future. The back of this unusual mask shows two black and white chequered crocodiles — symbols of tenacity, strength and longevity.

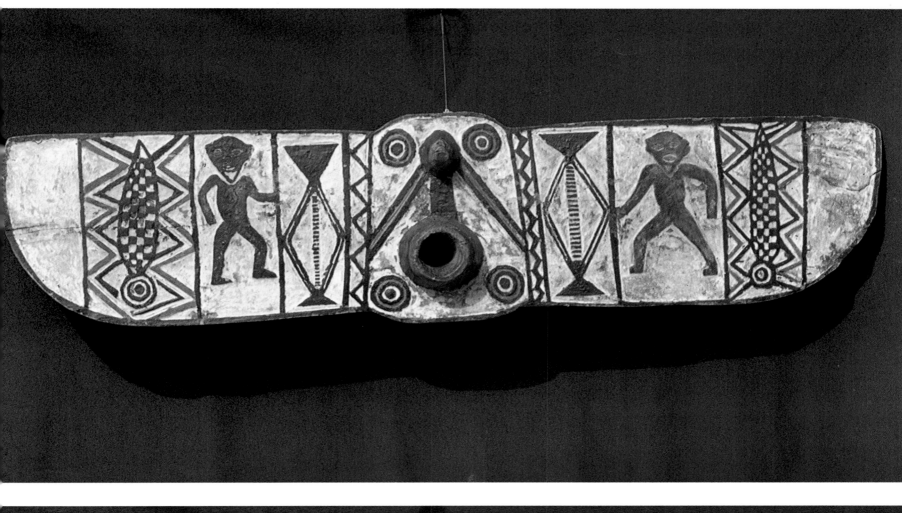
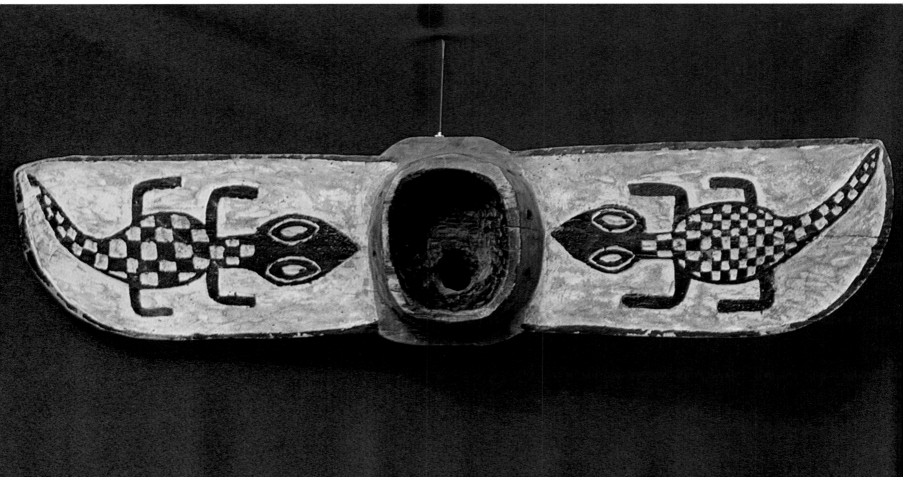

36 Gurunsi mask

Wood, 36.5 cm, Upper Volta/Ghana. A tight-knit zoomorphic piece, likewise with two sets of eyes (the significance of which is explained in the caption to the preceding illustration). This highly abstract carving is a very uncommon type of mask for this region.

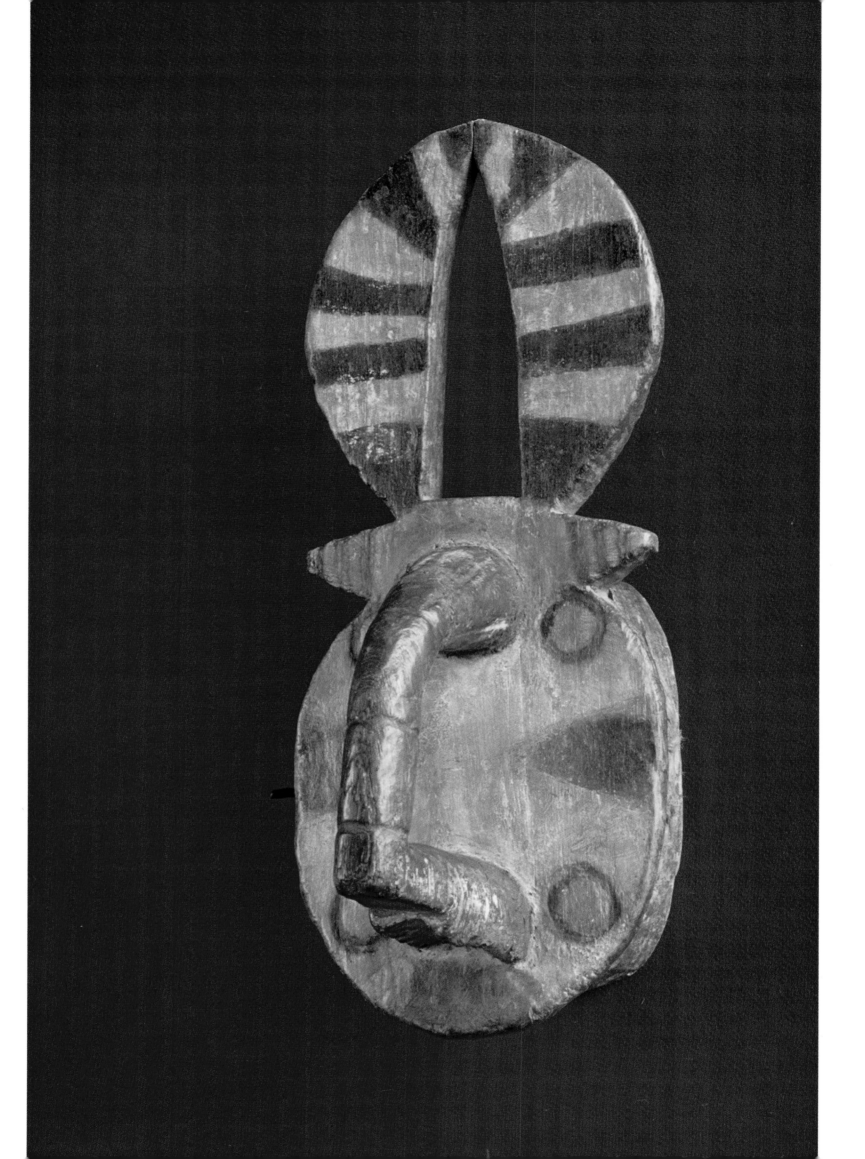

37 Abron buffalo mask

Wood, 68 cm, Ghana. A very special mask, artistically, from this tribe settled north of the Ashanti. It is worn slightly sloping. It has two sets of eyes, one visible from the front, the other from the side. So modern in feeling is it, it might be by Picasso. The subtle handling of the colour is flawless.

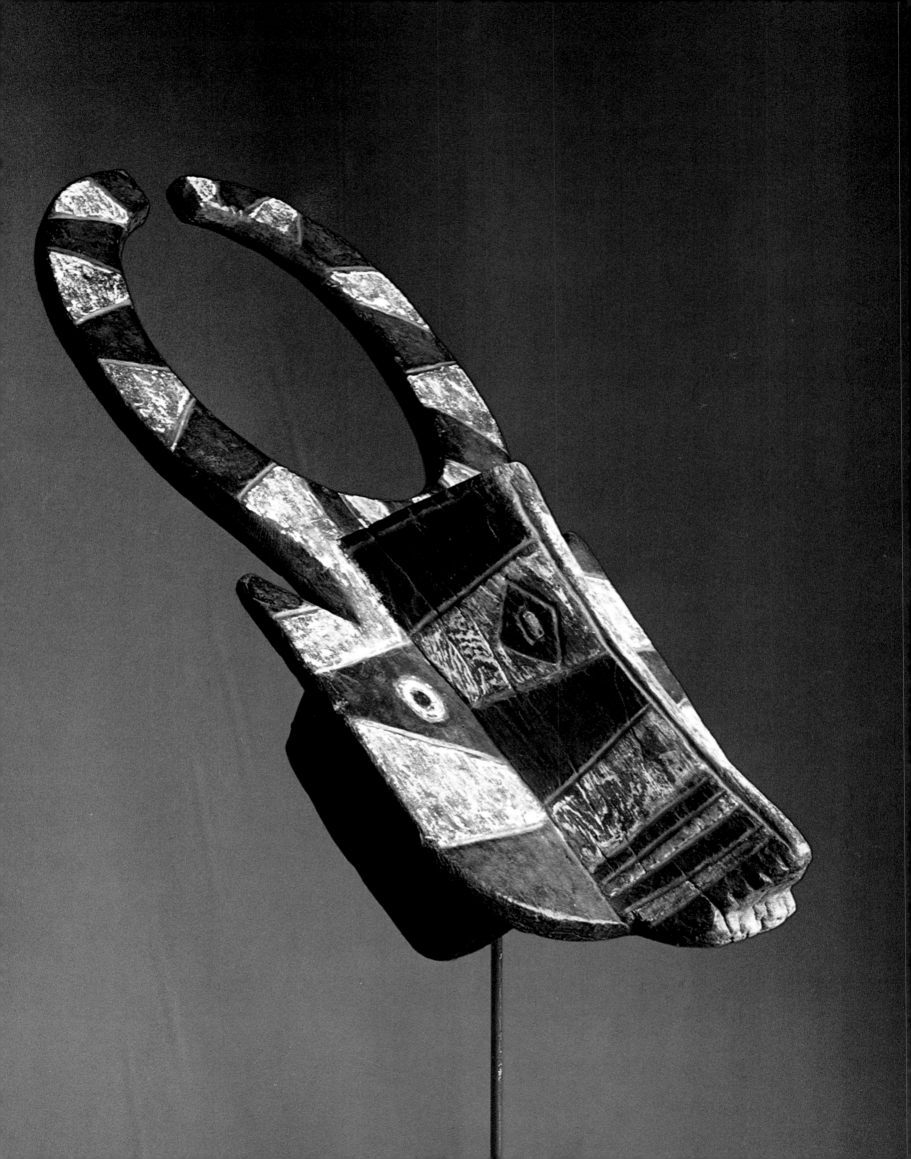

Mossi
Kurumba

By far the largest people in Upper Volta with an ancient sacral culture and kingdom are the Mossi, who have preserved their old religion and been only very little influenced by Islam. Their art is varied, and betrays the proximity of the Dogon and the Bambara.

Their northern neighbours, the Kurumba, are said to have given them their masks and figures. The former are a combination of abstract face and naturalistic figure super-structure. Mossi dolls are highly abstract, and reveal Kurumba influence.

The Kurumba live right up in the north of Upper Volta. The Dogon still today call them Tellem, and there is probably some blood relationship between them. Both their figures and their masks are astoundingly abstract, and normally marvellously colourful. Their headmasks in the form of stylized equine antelopes' heads are famous. Less well known are their masks of office, which point to the Dogon, and show great imagination.

38 Mossi antelope mask

Wood, 91 cm, Upper Volta. A highly stylized mask with triangular eyes and continuous indented vertical bridge for nose and mouth. Above it a small antelope head with elegantly curved horns. Set back and rising above this, we find a stylistically pure Mossi figure. The discreet colouring of the mask contrasts sharply with the gleaming dark brown male figure. It belonged to the N'Goro Naba (or King) of Kudugu, sixty miles west of the capital Wagadugu, and gave him power over his people. According to ancient belief, if it broke the king would lose his power, and a new one would have to be made immediately. This was occasioned in this case by the breakage of the right horn (here restored).

The male figure set up like this and the hard wood of a specific tree were reserved for the king.

39 Mossi antelope mask

Wood, 100 cm, Upper Volta. This belongs with the king's mask, and is similarly made of hardwood. As the king's mask had to be replaced, this too had to go. It was designed for the king's spokesman, the Griot, who is also the guardian of traditions. The human figure here is female. The people heard the king's commands through the mouth of the Griot. This mask is somewhat gentler in its forms, and the flat horns soar up, signifying growth. The round, ringed eyes show the influence of the nearby Bobo.

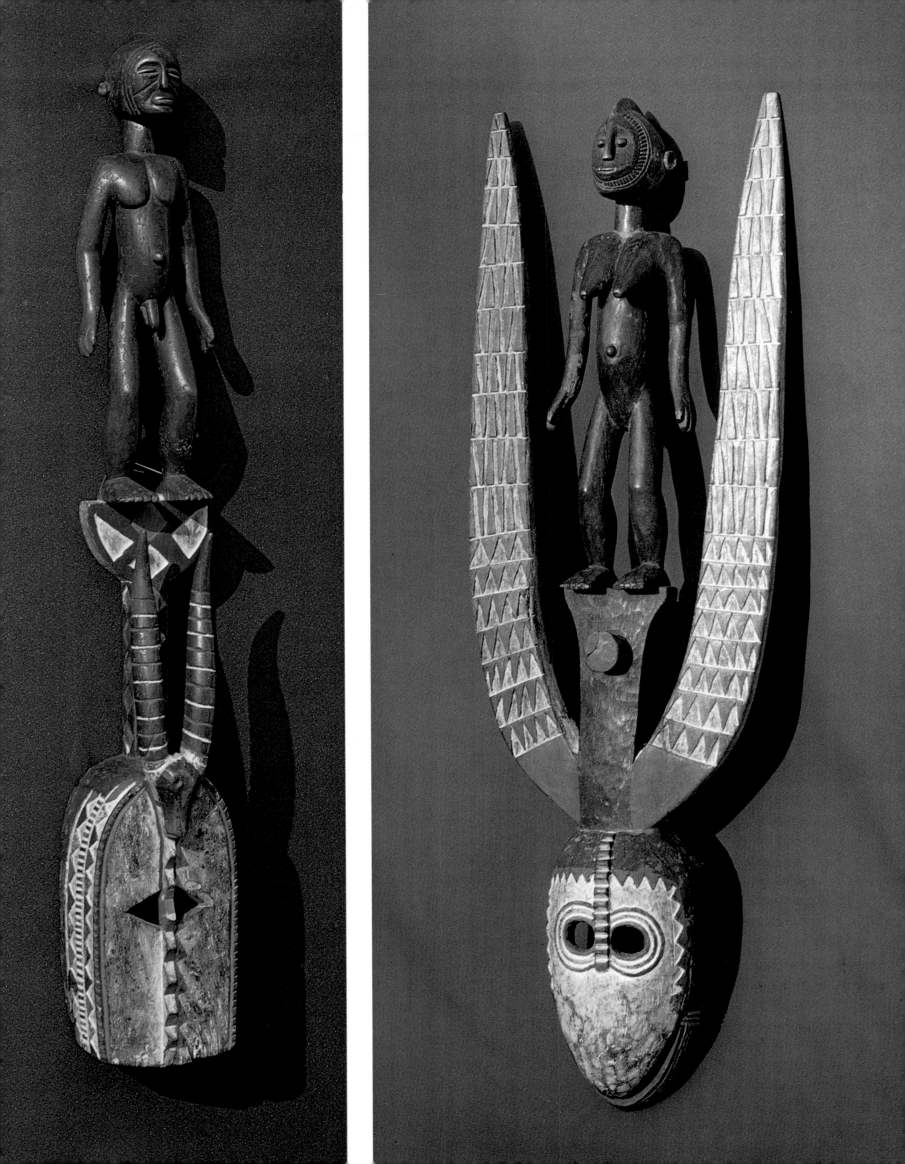

40 Kurumba mask

Wood, 100 cm, Mali. This graceful, highly abstract antelope mask, with its extended, delicately curving horns, is one of the oldest and most beautiful of all known examples of this rare Kurumba mask style. The superb curve of the horns is effectively counter-balanced by the opposite shaping of the head. The coloured markings are wonderfully integrated in the conception of the mask as a whole.

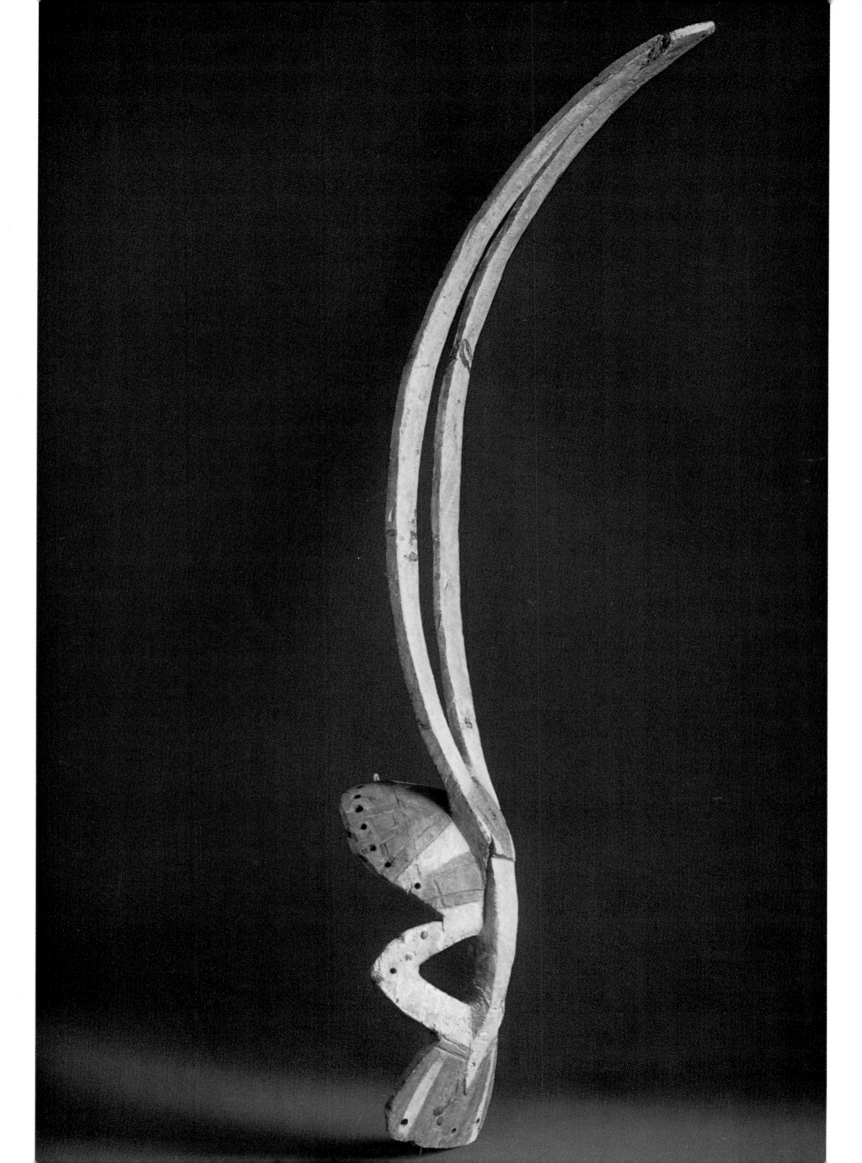

Lobi

The Lobi live in the south-western part of Upper Volta, which lies like a wedge between Ghana and the Ivory Coast, and spill over its borders. We know of no Lobi masks. Their figures, however, occupy a unique position in African art. These are strikingly static, peaceful and confident. They are protective figures, and stand in front of, inside, and over houses.

41 Lobi figure

Wood, 76 cm, Upper Volta. This head, showing traces of severe erosion, has a distinctively spiritual, stern expression. The elliptic shape of the projecting, half-closed eyes is mirrored in the slightly pouting mouth, and both are joined by the straight, firmly shaped nose. The highly simplified ears are perfectly in keeping with the imaginative conception of the piece. An example of beautiful form.

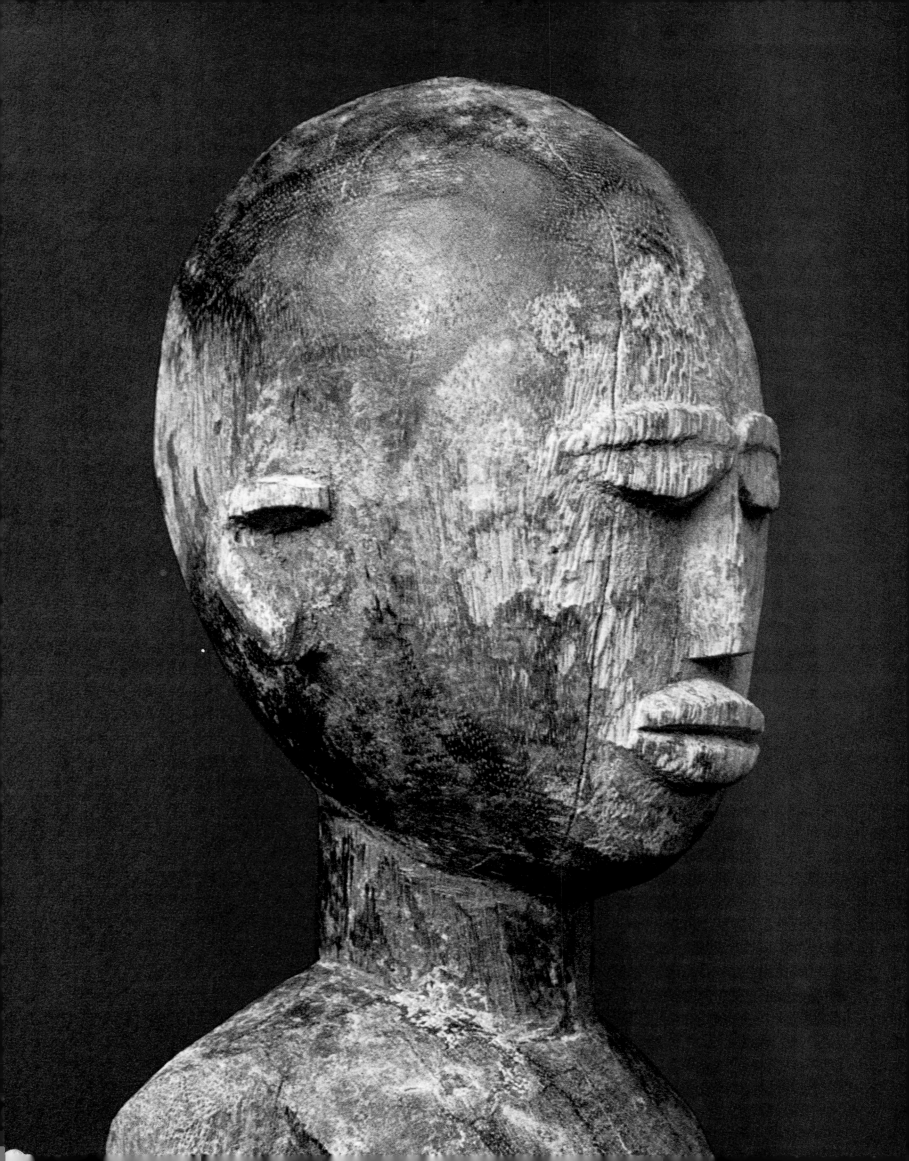

Senufo
Jimini
Dabakala

The Senufo, who probably originated from the north, live in the northern Ivory Coast and in parts of Mali and Upper Volta. All their social and religious life is controlled by the Poro or Lo secret society, the aim of which is to lead men out of their imperfect state towards a better ethical and social existence. It sees to it that the old traditions are preserved. Acceptance into the society entails long terms of tests and probation, and each stage is celebrated with masked dances and the relevant rites. These are

42, 43 Senufo guardian figure

Wood, 168 cm, Ivory Coast. This monumental Nanfere figure in hardwood comes from the north-east of the Ivory Coast, from a village called Tie'Mara, in the Korhogo region. It serves the Poro society – standing, usually in pairs, outside the house of a recently deceased dignatory, to receive gifts. With the proceeds the society provides the necessary animals for sacrifice at the funeral. The whip over the right shoulder is a symbolic reminder for those who try to avoid giving a gift. The swords on either side characterize the figure as a guardian. It is still used in the cults of the Poro society, whose influence continues to be very great. Even today practically no decision is taken without its approval.

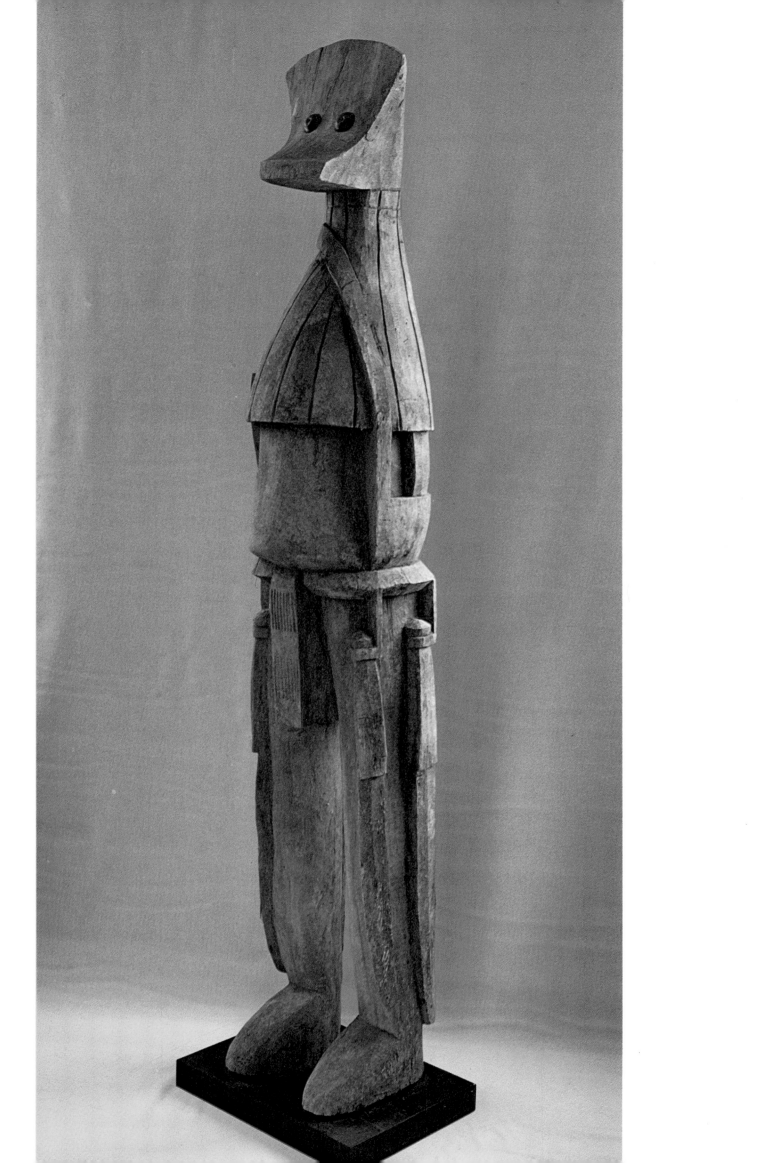

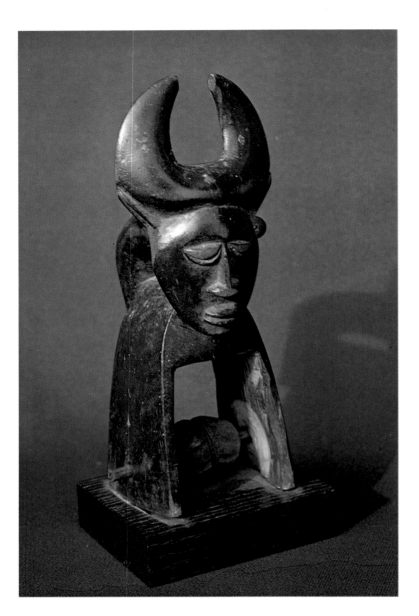

forbidden to women, who have their own cult places and bush schools for girls.

The makers of all cult figures are the Kule, who belong to a dreaded secret society. Their works are distinctively stylized and lively, their main characteristics being the usually birdlike, crested hairstyle, projecting jaws (prognathy), and full, pointed breasts coming forward from broad shoulders. Their masks are extremely varied. Every shade of expression and every purpose – from subtlety to terrifying zoomorphism – is catered for.

East of the Senufo, on the west bank of the Comoé, lives the related tribe of the Jimini, who are today considered as an independent people. Also within the sphere of Senufo influence are the Dabakala to the south, who were formerly considered as being Senufo.

44 Senufo heddle pulley

Wood, 16.5 cm, Ivory Coast. A cord leads over this pulley, which is hung above the loom, to the heddles, which the weaver moves up and down with his feet. The Africans' sense of beauty is eloquently manifest here in the beautiful carving of a purely functional object.

Shaped in the form of a human head with buffalo horns, it is a fine example of small-scale Senufo art.

45 Senufo mother and child

Wood, 51 cm, Ivory Coast. A very old mother figure in the classical style. Everything about it asserts the magnificence of Senufo art. Almost the whole body is adorned with stripe-like scarifications, and both arms have decorative bracelets.

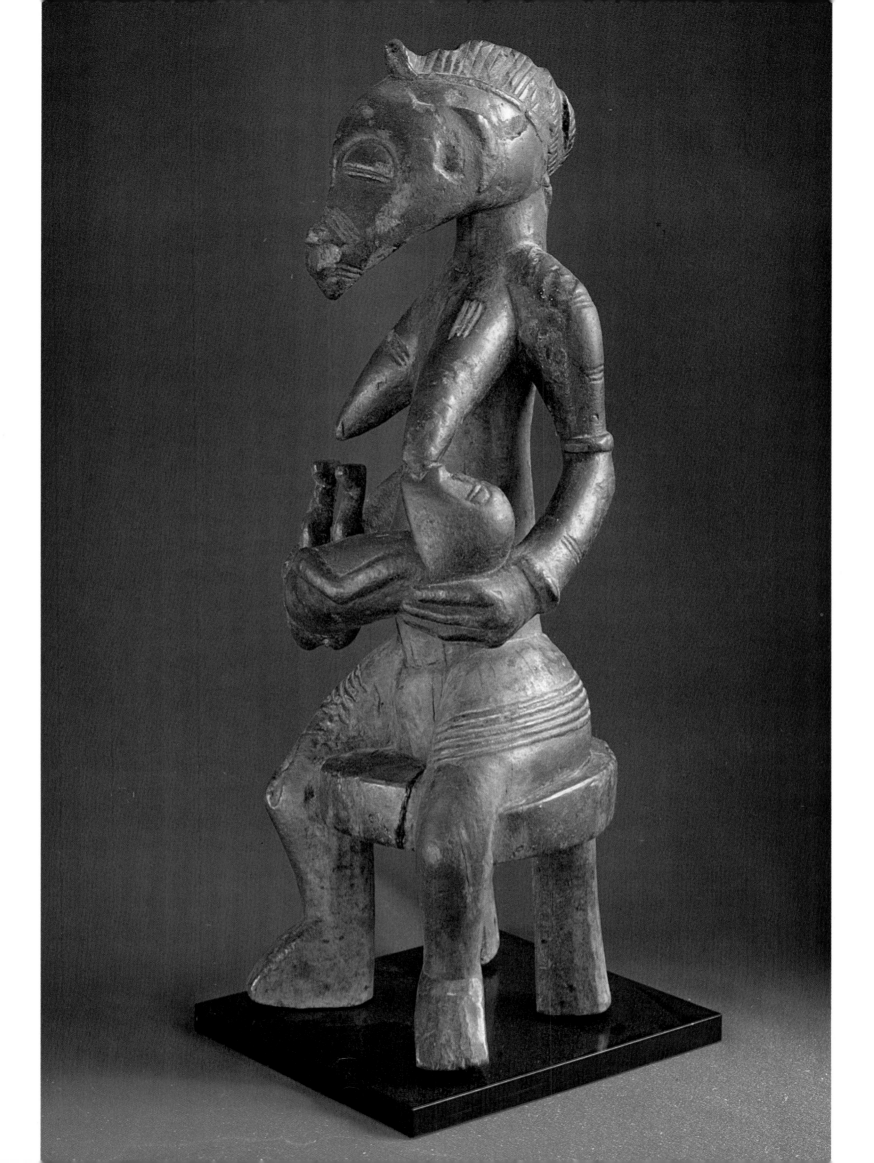

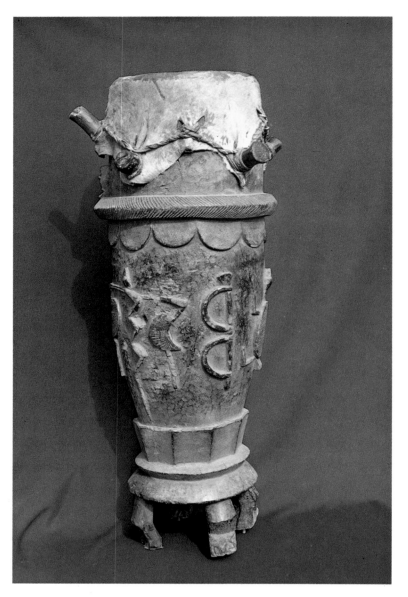
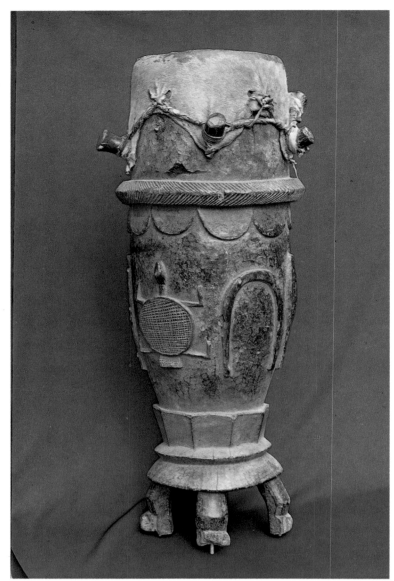

46, 47, 48 Senufo drum

Wood, 90 cm, Ivory Coast. This drum, known as Plievo, comes from the north of the country, and was used at burials. It stands on short, stylized human legs. The well-proportioned body of the instrument is decorated in strong relief with various symbols of power – a snake, a crocodile, a bird, slave shackles, a tortoise, and a musical instrument shaped like a horseshoe, an emblem of sovereignty. The skin, tightened with the help of wooden pegs, is that of an antelope. A finely balanced, beautiful example of Senufo craftsmanship.

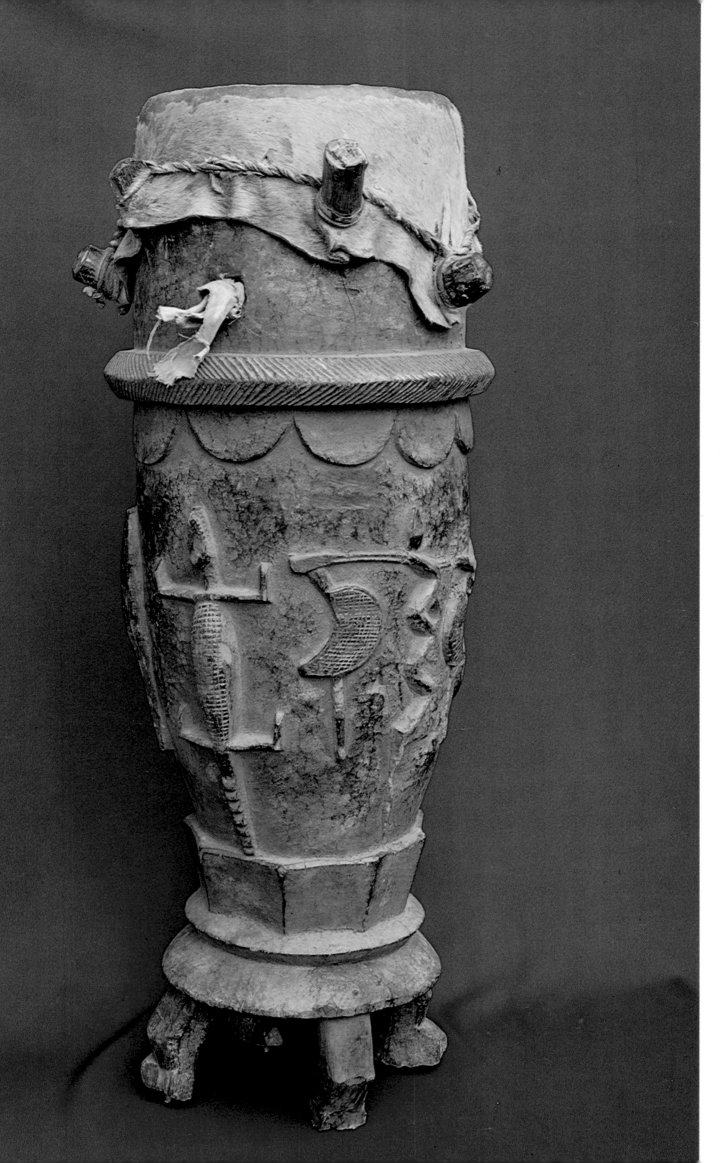

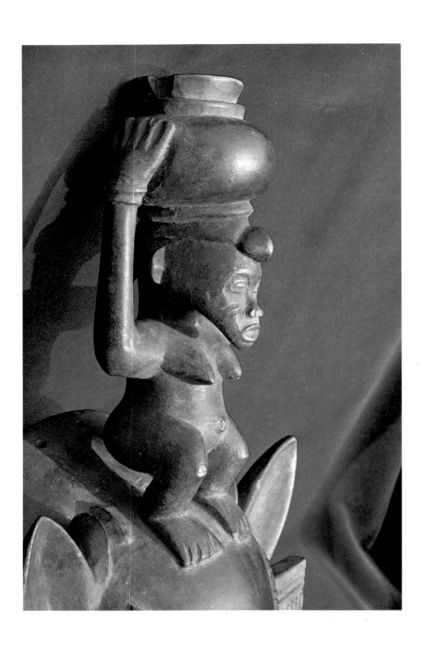

49 Senufo Kpelihe mask

Wood, 37.5 cm, Ivory Coast. Kpelihe masks represented the face of a dead person, and were regarded with dread. The figure on this one is a classic type, and is skilfully integrated with the vertical axis of the mask. Beautiful genuine Kpelihe masks are almost impossible to find on the market now.

50 Jimini mounted figure

Wood, 39 cm, Ivory Coast. This highly abstract figure has been reduced to essentials. It represents one of the few known carvings totally in the style of this tribe. The Jimini belong to the Senufo, who live north-west of them. Their eastern neighbours are the Abron, in Ghana.

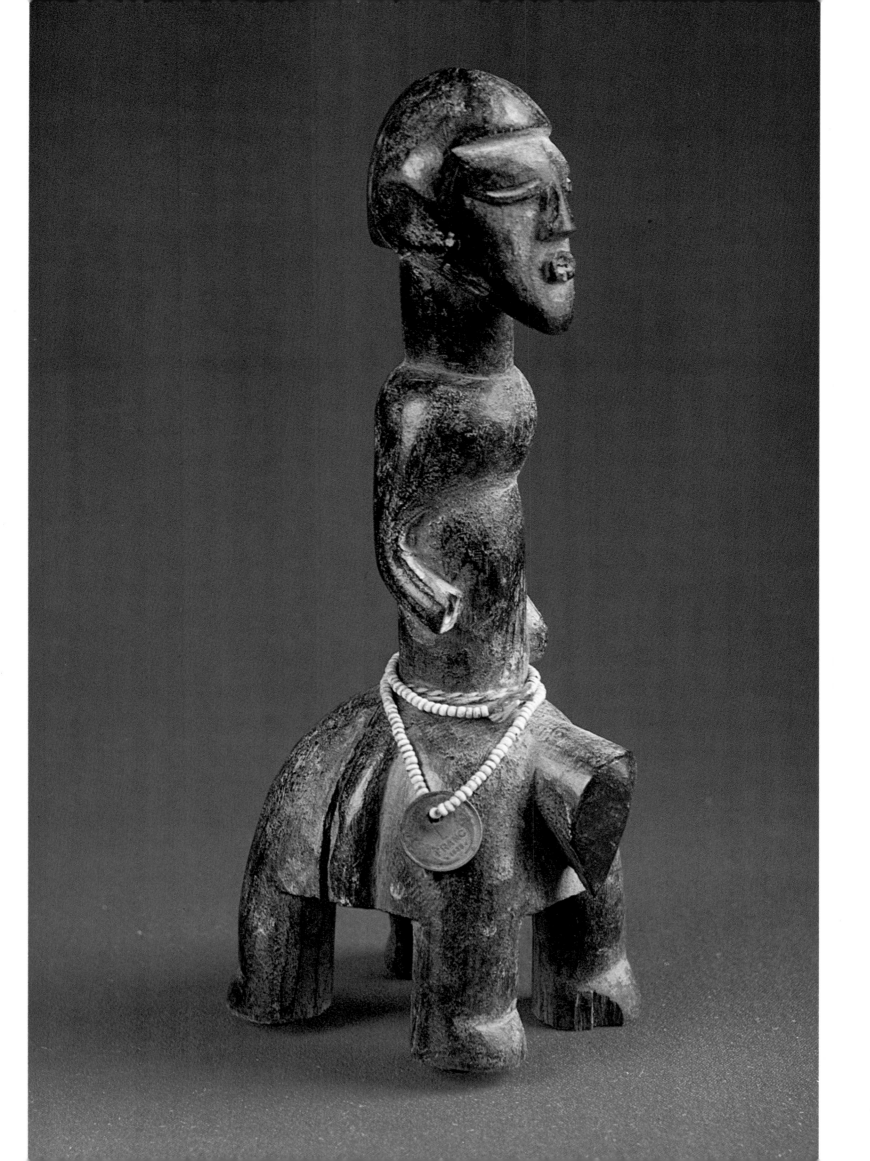

51 Dabakala (?) mask

Wood, 36 cm, Ivory Coast. A very linear, peculiarly beautiful mask. The volute curls of hair evoke the baroque, and contrast strongly with the earnest face. The whole is a successful unity. An old and aesthetically very considerable work.

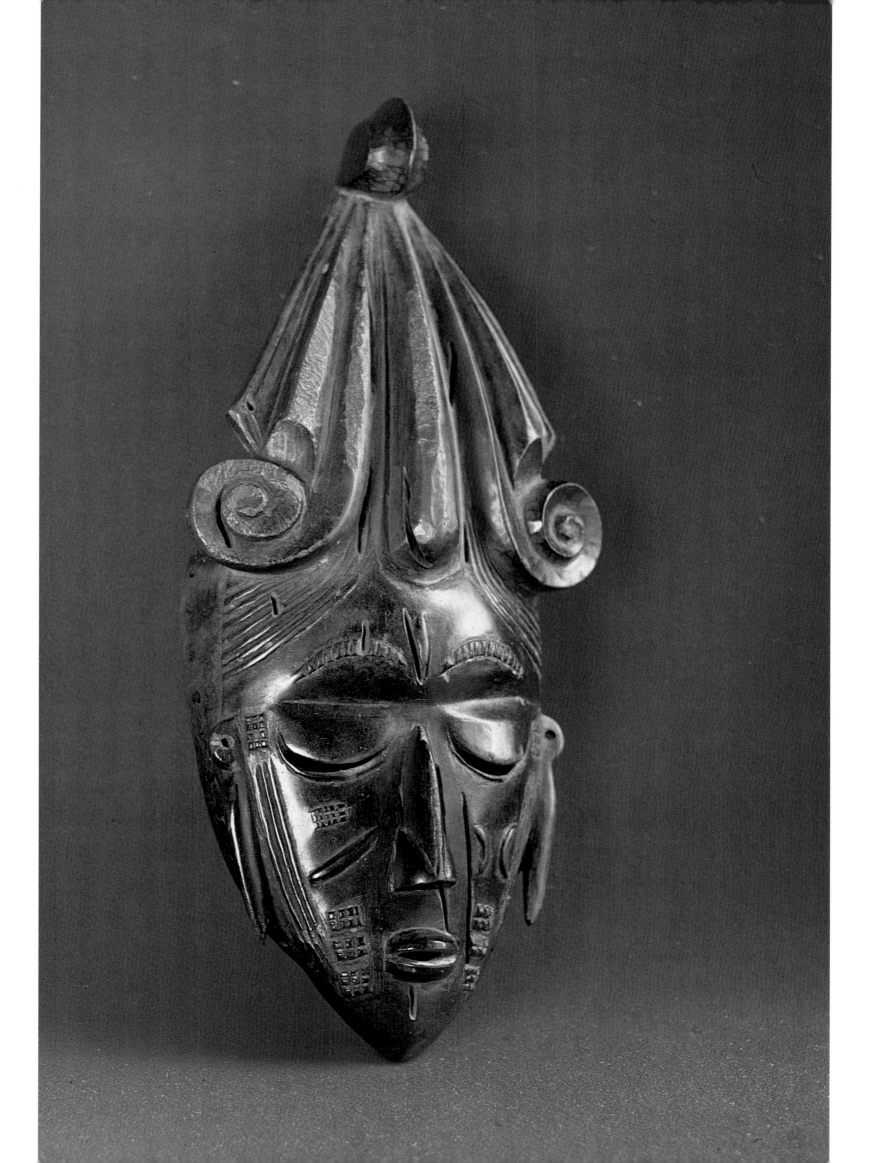

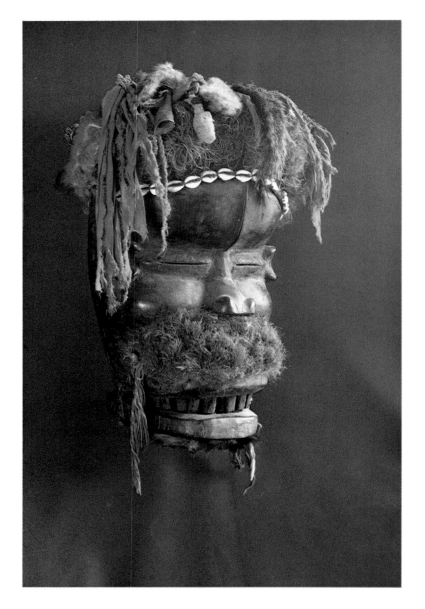

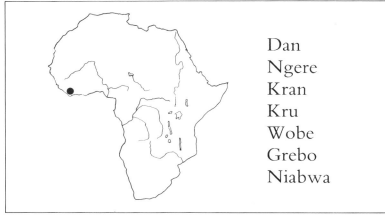

Dan
Ngere
Kran
Kru
Wobe
Grebo
Niabwa

The Dan–Ngere group form an important artistic area, embracing a large circle of neighbouring peoples, who influence their art. These include among others the Yakuba, Dan, Kran, Kru, Wobe, Grebo and Niabwa, and in a sense too the Bassa and De, with whom we have already dealt.

All are exceptional carvers, and their masks are among the most beautiful in West Africa. Precise categorization is made difficult by the vast number of types. As with most other peoples, all social and religious life is controlled by secret societies. Their masks enormously outnumber their figures.

52 Dan judgment mask

Wood, 41 cm, Liberia. The movable jaw with strong teeth is to be found on masks which are used in arbitration in disputes and war. However, the little magic horns, the pieces of cloth, and the little bits of wood indicate that it is also a fetish. The effect of this huge southern Dan mask, with the vertical scarification on its forehead, is completed by a piece of hide below the jaw and the vegetable-fibre moustache.

53 Dan mask of a woman

Wood, 24 cm, Liberia/Ivory Coast. Simply the embodiment of beauty. This mask comes from the northern Dan. The velvety black patina of the face, the high rounded forehead, delicate eyebrows, almost closed eyes, and beautiful sensual mouth are characteristic of the classic northern Dan style.

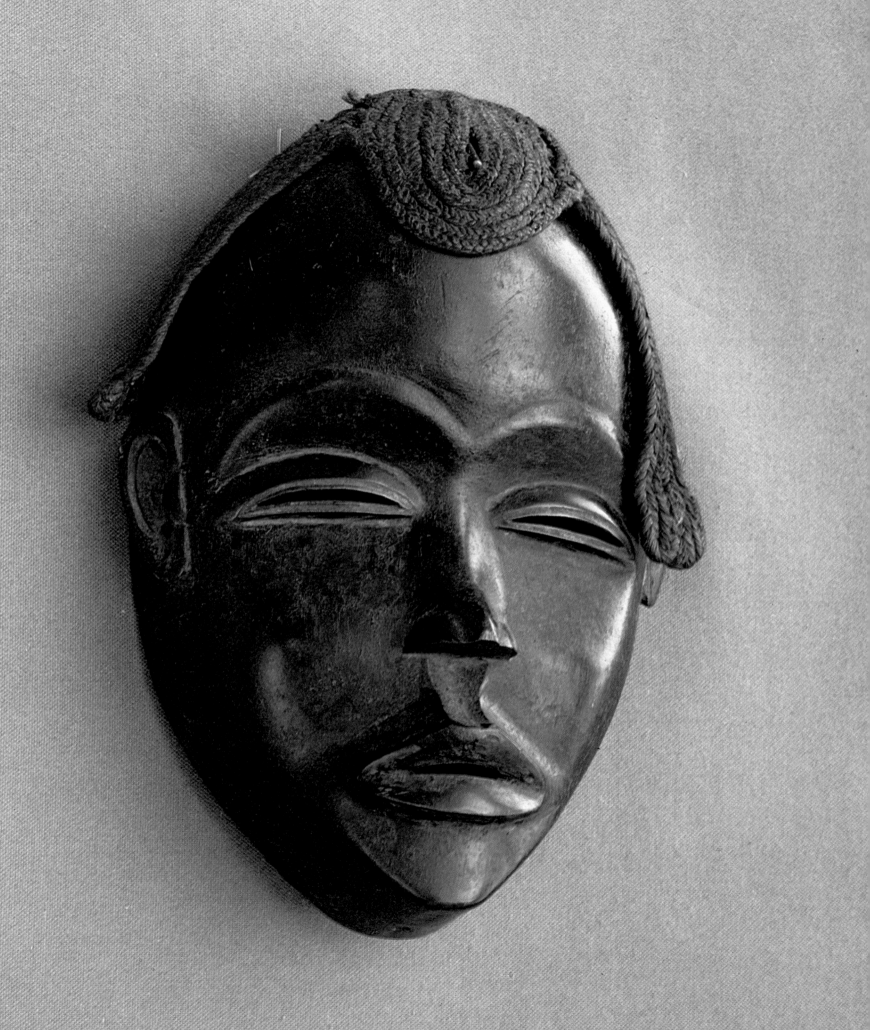

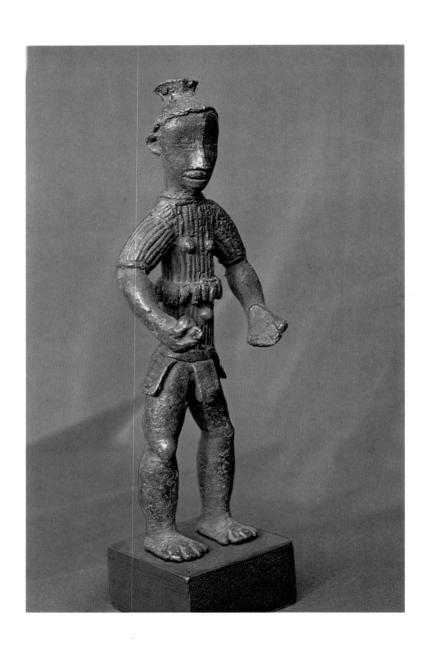

54 Dan bronze figure

21 cm, Ivory Coast. A fine example of the cire perdue *technique, with a certain movement that contrasts with the stillness of the wood carvings. Dan bronzes are few and far between, and it would seem that metal casting among the artistically very talented Dan is doomed to extinction.*

55 Mano mask

Wood/material, 24 cm, Liberia. This small, extremely expressive Mano dancing mask (the Mano come from the eastern Nimba mountains) conveys unusual power. Quite unreal, it yet is a masterly, balanced work of art. It is covered with the red material from which French uniform trousers were made.

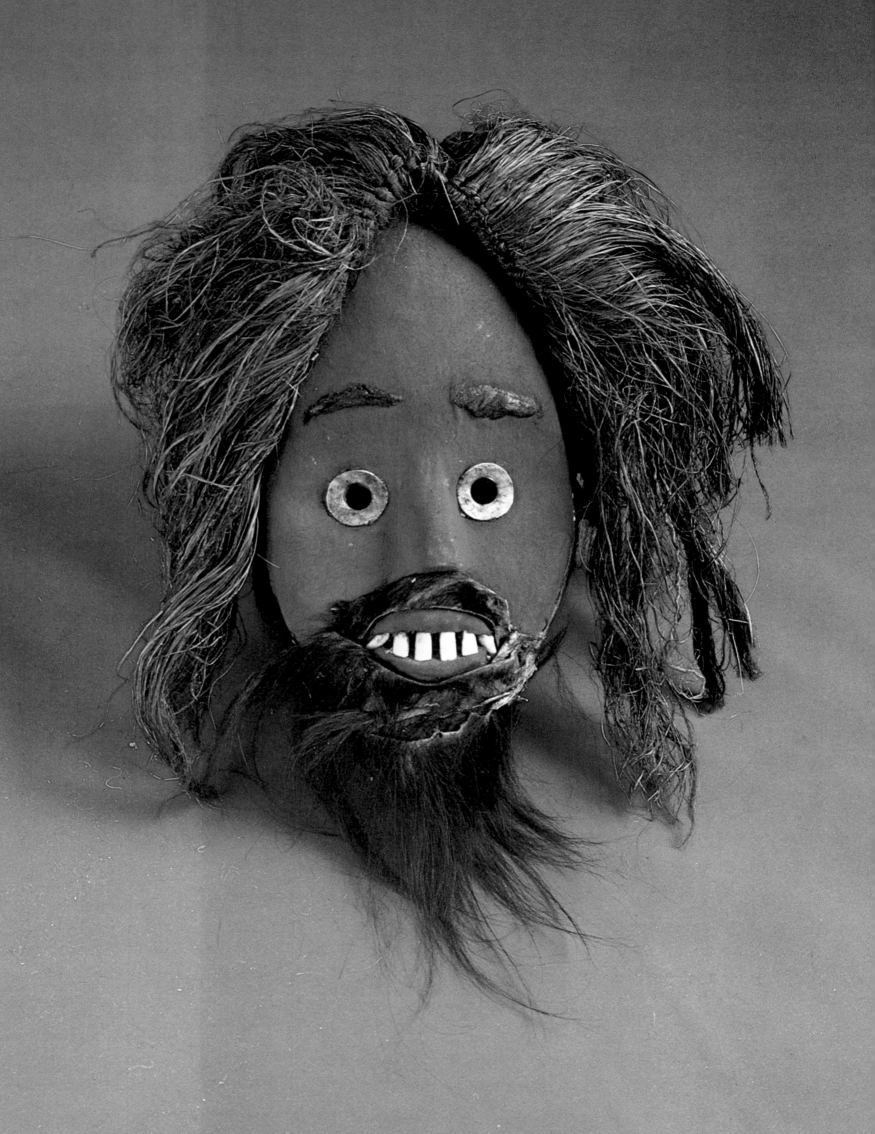

56 Kran mask

Wood, 22 cm, Liberia. Known as Kran in Liberia, the same tribe is called Ngere further east on the Ivory Coast border. This is a fire-watcher's mask (the job of the fire-watcher is described in the caption to plate 32). It comes from the Danané region halfway up the Cavally. The row of stylized medicine horns on the forehead, the asymmetrical eyebrows, with the vertical scarification coming down between them, and the whole effect of the mask make it a rare and beautiful example of Kran art.

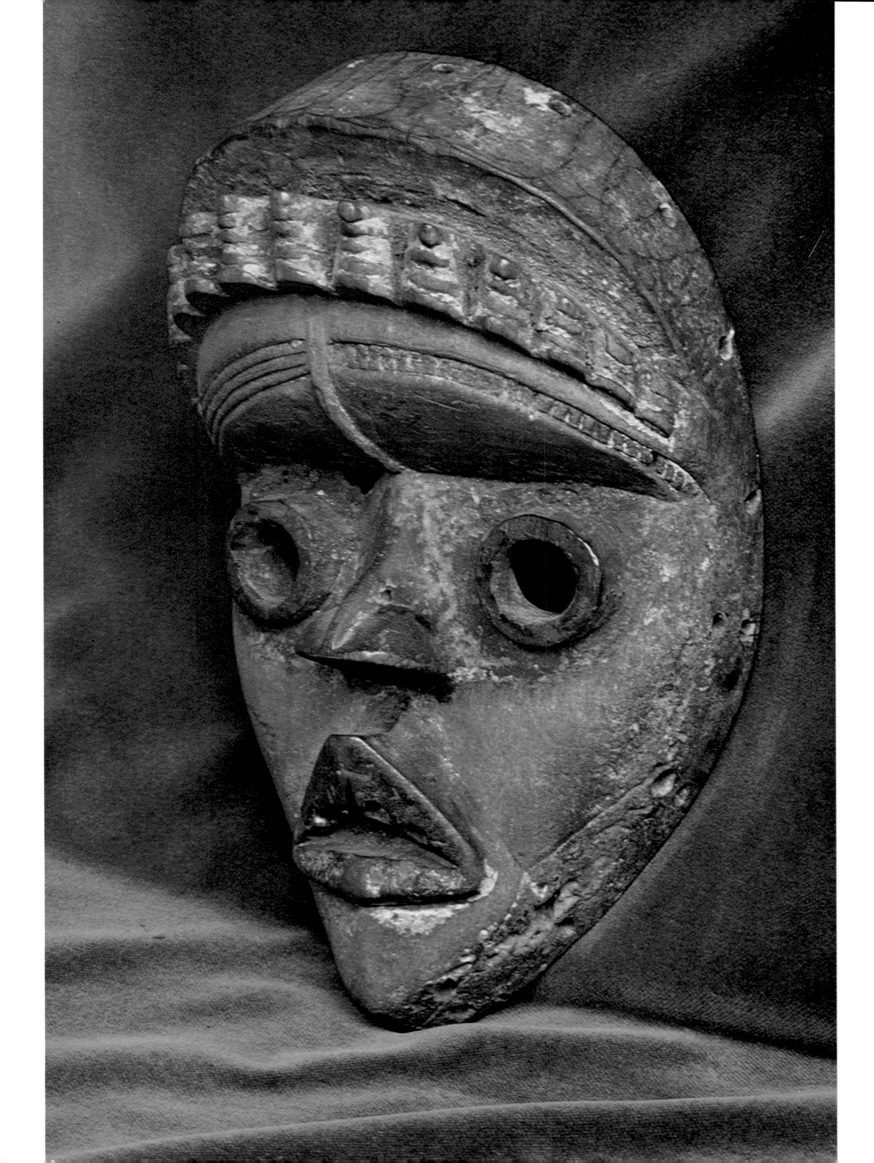

57 Ngere mask

Wood, 41 cm, Ivory Coast. Everything about this powerful, fearsome mask is exaggerated: prominent, wide nose, tubular eyes, great thick-lipped, open mouth with metal teeth, the red tongue behind, the huge bushy eyebrows, and the animal hair everywhere. The wooden boar's teeth emphasize the demonic effect of this splendid mask.

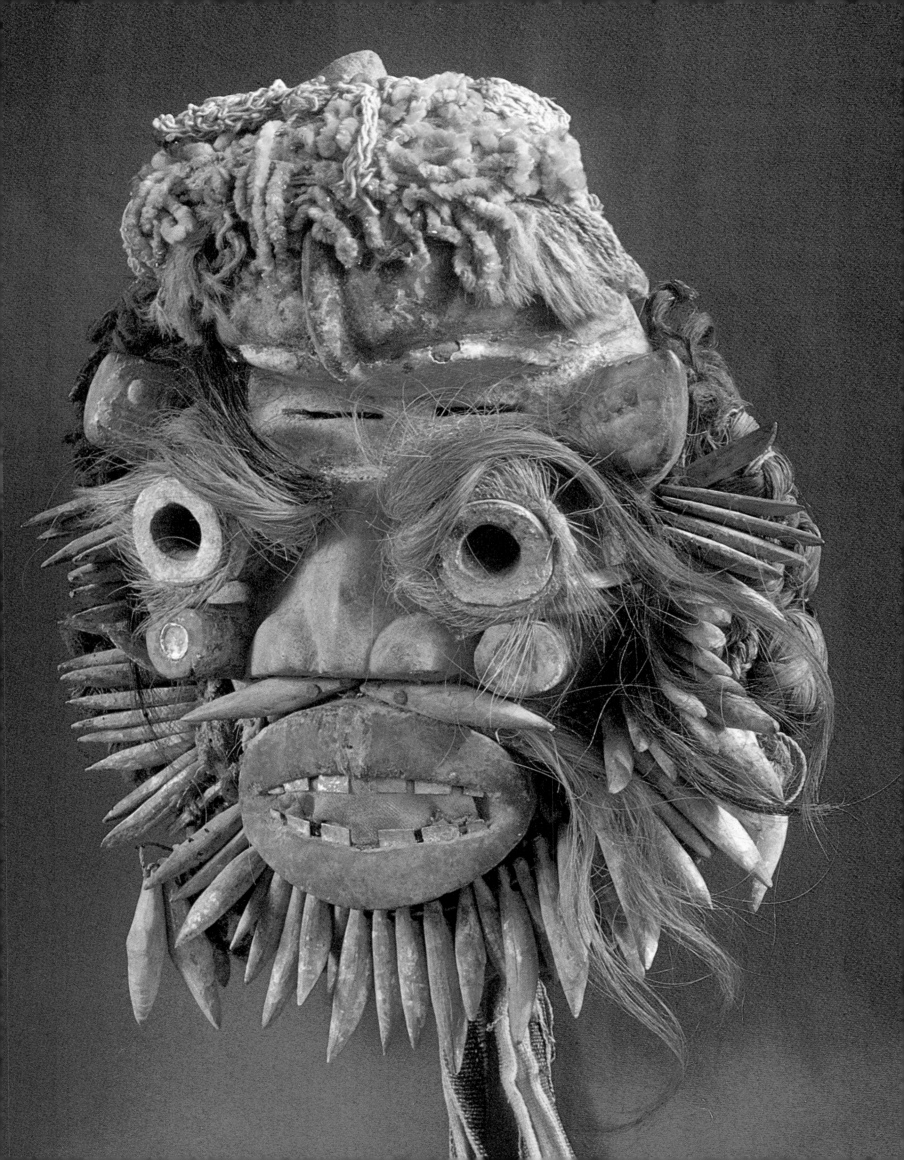

58 Kru dance-staff

Wood, 35 cm, Liberia. A small coastal tribe in south-eastern Liberia, near the Grebo and south of the Kran, who all live within the sphere of Ngere influence.

A classic example of a fully cubistic work. No wonder the great painters at the beginning of this century were impressed and influenced by such works. With the simplest means this face has the greatest possible impact.

94

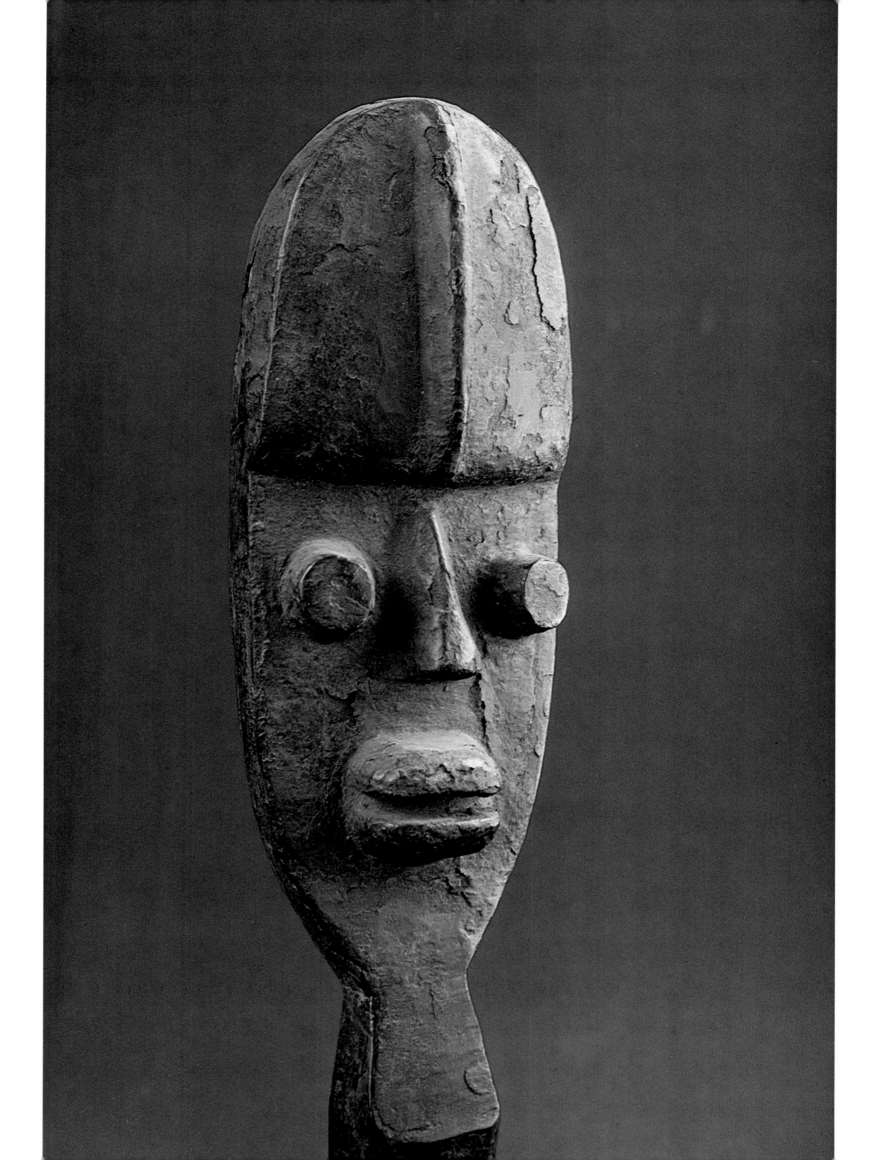

59　Wobe mask

Wood, 25 cm, Ivory Coast. Again, all the features of this face are exaggerated, and thus particularly impressive. The large, forward-thrusting lips, the wide-spreading nostrils, and the great rounded, projecting eyes make it a work of exclusively Wobe art, despite the Dan influence.

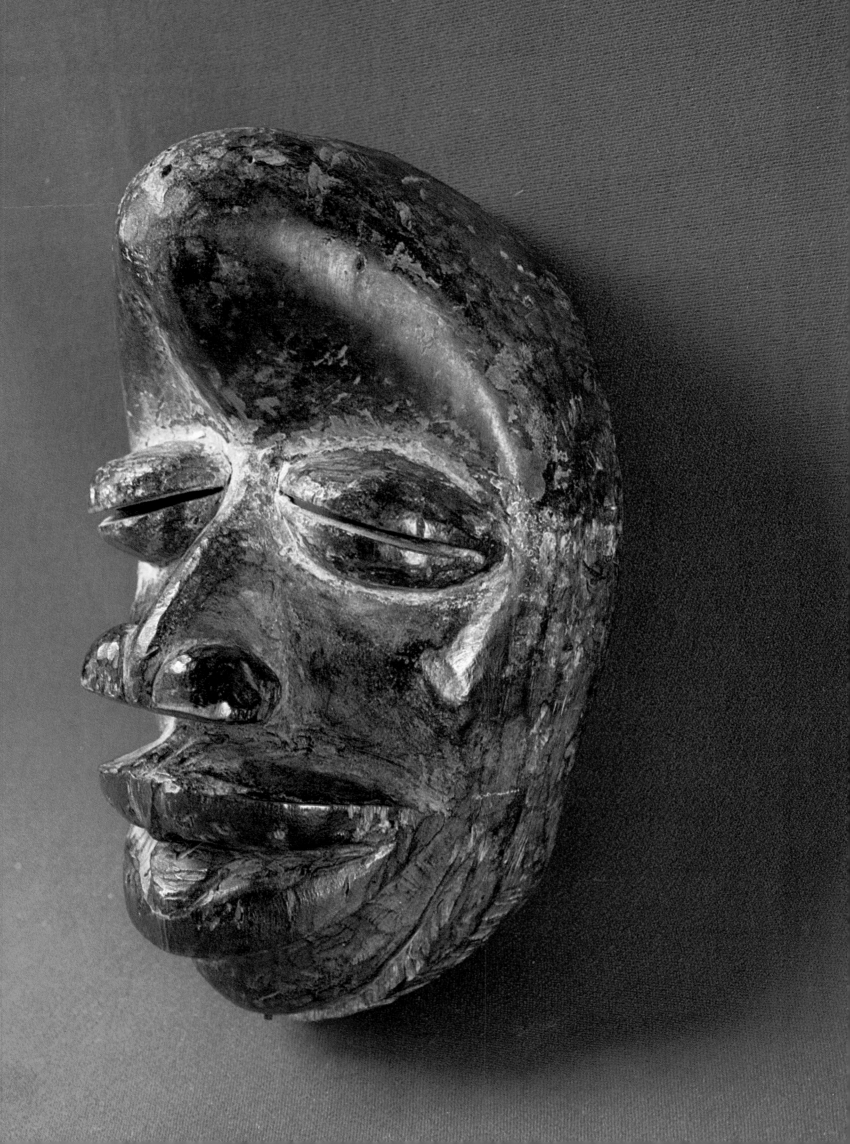

60 Grebo figure

Wood, 59 cm, Liberia. An extremely rare female ancestral and cult figure from this tribe. Face and body are beautifully shaped and modelled, and form a perfect equilibrium. The hair is real hair. Typical of the area too is the panther-tooth necklace. The large, noble head, together with the powerful neck, make up about a third of the whole figure.

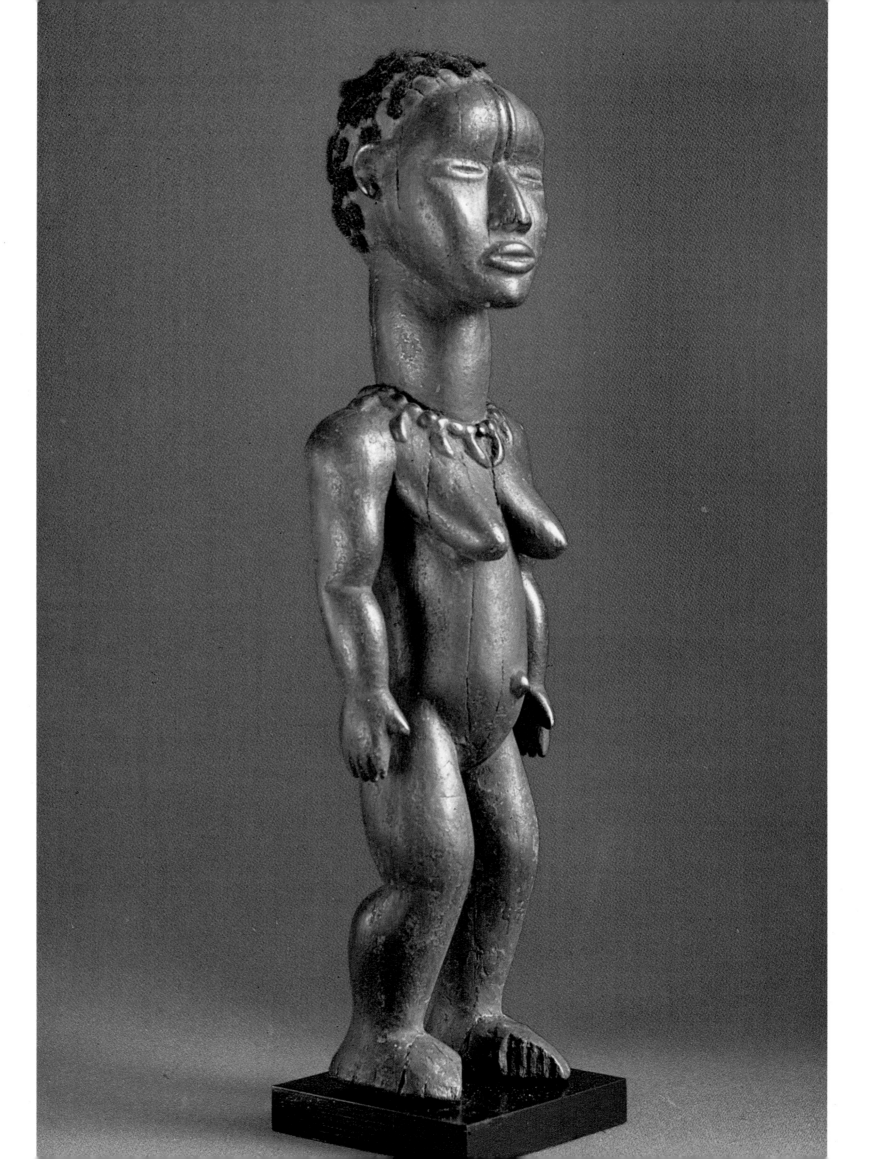

61 Niabwa mask

Wood, 40.5 cm, Ivory Coast. This mask (the Niabwa are influenced by the Ngere, who live to the south of them) is pure cubism. The face is split into squares, circles, ovals and straight lines. Stylized boar's tusks have replaced eyebrows and cheeks. The crescent-shaped horns and the ridges of the face are adorned with brass nails, which further increase the almost uncanny effect of this classic Niabwa face.

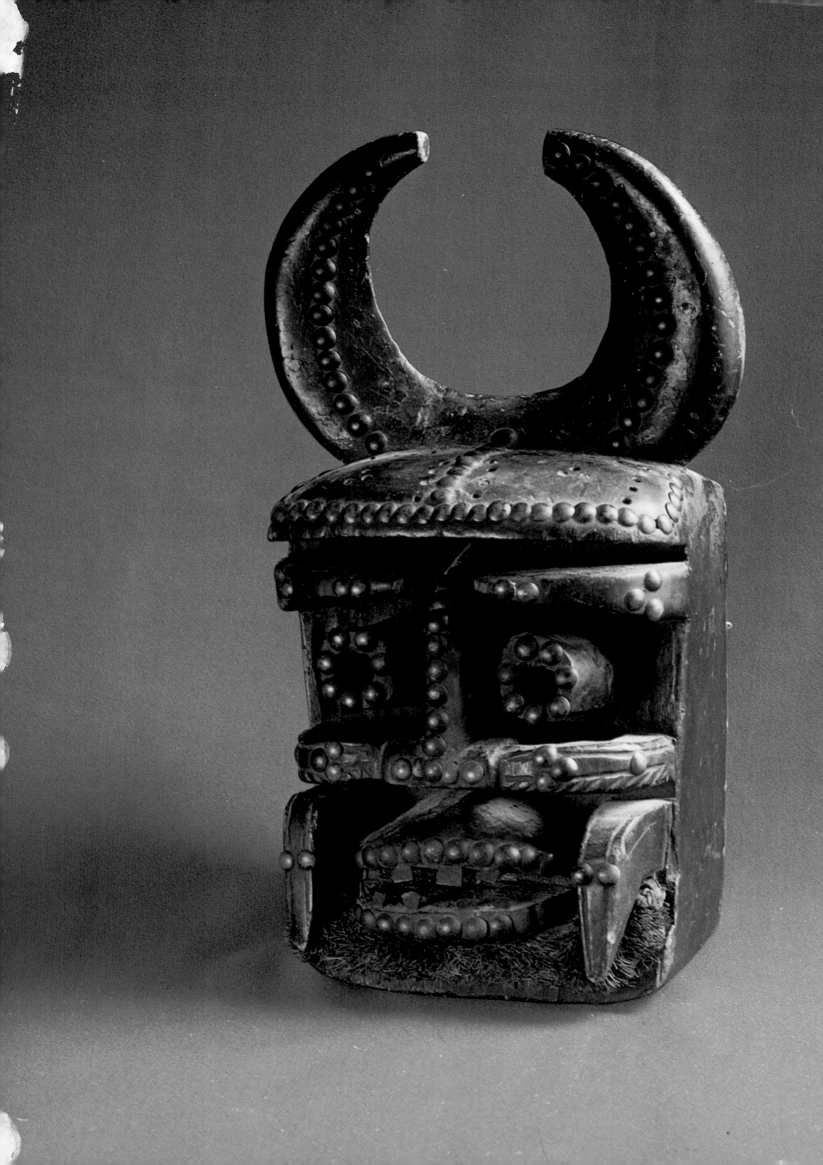

Baule
Guro
Yaure
Atie
Anyi
Laka
Krinjabo

We are all too prone to judge African art entirely according to our own concepts, differentiating between beautiful and ugly, and readily forgetting that different peoples may have different concepts of beauty. However, if beauty as we understand it does exist among certain peoples, then we shall certainly find it among the Baule, Yaure and Guro in the Ivory Coast. These would also in a broader sense include the Akan peoples to the east – the Atie, Anyi, Laka and others. In his book entitled *Black Eros* Boris de Rachewiltz mentions a Laka tribe living on the Logon in Cameroon/Nigeria. According to the collector of figure no. 85 this must

indeed be a reference to the Laka, though to a small and hitherto almost unknown people on the Comoé. He lived many years among them in the Ivory Coast, and according to his testimony brought four works of the Laka to Europe.

The Baule are not only skilled carvers of masks and figures. Their drums, thrones, fly-whisk handles, often plated with gold, and many ordinary everyday objects are also famous. At the same time they are superb goldsmiths and bronze workers.

Guro face masks are decidedly three-dimensional and sculptural. Guro style is particularly evident in their anthropomorphic heddle pulleys.

The Yaure share characteristics of style with the Baule and Guro, and their masks are some of the finest in this group.

The Atie and Anyi, to the east of these other three, reveal Baule group influences, as do the Ashanti east of them. Almost nothing is known about the Laka.

In the Krinjabo region, on Anyi territory, terracottas have been found (mostly on graves), dating from the 17th century and later. They are named after the area.

62 Baule (Ashanti ?) bronze figure

34.5 cm, Ivory Coast. A classic female figure, of unusual size, representing a dignatory, and seated on a stool that shows Ashanti influence. In her right hand she holds a ceremonial sword, and around her waist there is a richly decorated belt for her apron. Scarifications appear on her face, breasts and left upper arm. Delicately cast miniature ceremonial swords are commonly to be found as gold-weights (p. 302).

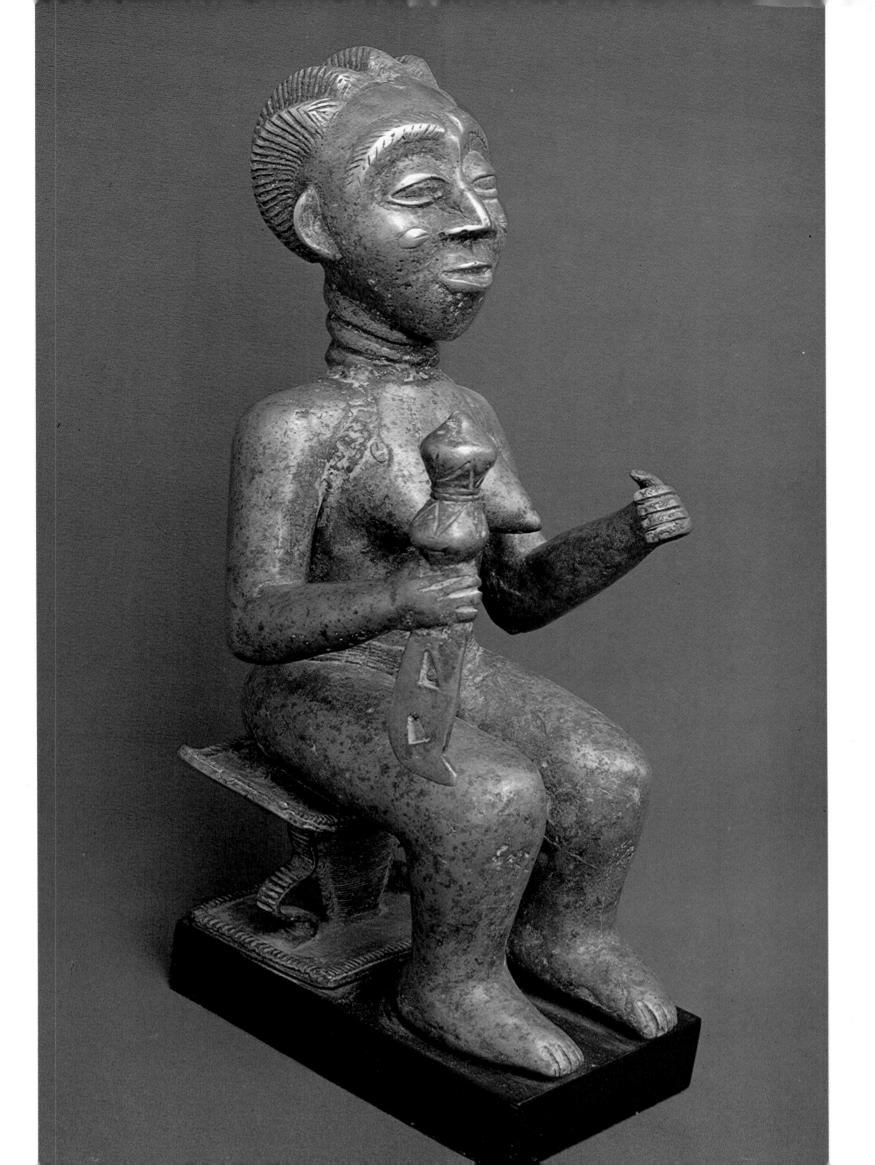

SCARIFICATION The custom of scarification may have aesthetic and social, as well as basically religious, reasons. In tattooing, colour is simply injected into the skin, where it remains visible for the rest of the person's life, without leaving much of a scar.

In Africa scarification is as a rule produced by often very painful, deep cuts in the skin. The ashes of plants are then applied to the wounds to prevent them from healing over without leaving a scar. The point of this is to achieve as striking and prominent scars as possible. All sorts of variations are to be encountered, from simple straight lines to often highly imaginative patterns.

In certain tribes scar patterns serve as identification marks (pl. 63). On women they are often concentrated around the genital areas, and thus have a not inconsiderable erotic value (pl. 181). On men the navel is often the centre of their scarification ornaments. Scarifications can also be signs of tests of courage that have been undergone, or of the individual's position among his people. It is not inconceivable that the medicine-man might put magic substances into the scar wounds to provide long-term protection against certain diseases or poisons.

Scarifications are in many ways decorative, but they can also in part be a substitute for clothing.

63 Baule ancestral figure

Wood, 29 cm, Ivory Coast. This regal figure has exceptional dignity and noble bearing. Every inch shows the hand of a master craftsman. The subject's origins can be traced by the especially beautiful scarifications.

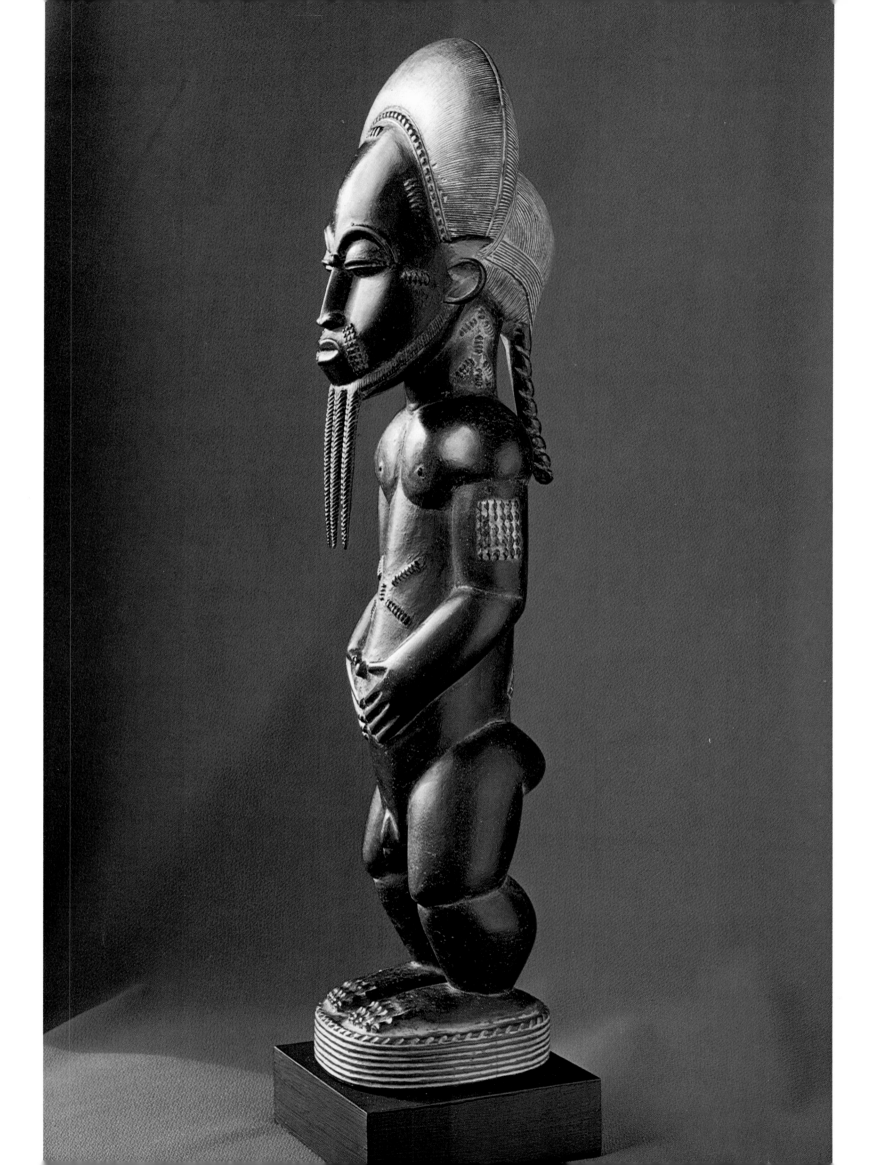

68–73 Baule decorative gold pendants

Ivory Coast. Some of the most beautiful Baule art work is in gold. Each of these six pieces is a work of art. Even in terms of craftsmanship they are superb. There is written evidence that they date from the last century. However, to the expert the exceptionally fine wax threads employed are evidence enough to date them. They were made by the cire perdue *method (pp. 302–3). Because of general wearing away they are all a five-carat gold alloy, except for plate 72, which is ten-carat.*

68 Stylized bird *50 × 81 × 30 mm*
69 Stylized ram mask *85 × 80 × 15 mm*
70 Two crocodiles crossed *73 × 72 × 12 mm*
71 Large ram mask *102 × 105 × 30 mm*
72 Face mask *64 × 41 × 26 mm*
73 Ancestral pair *80 × 62 × 16 mm*

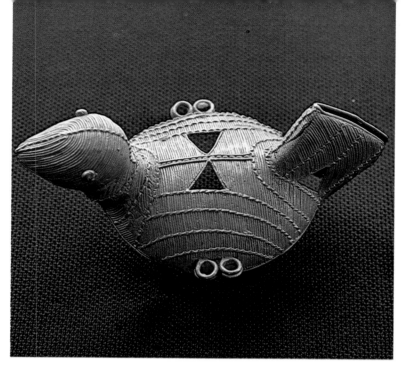
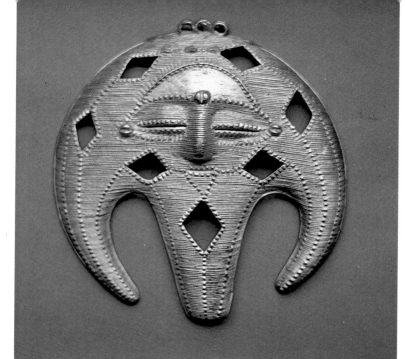
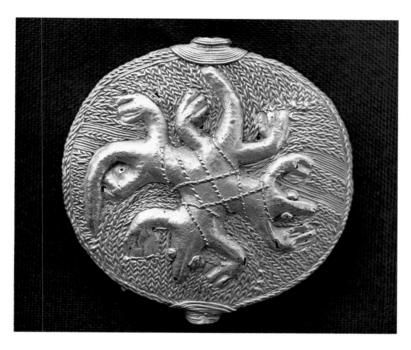
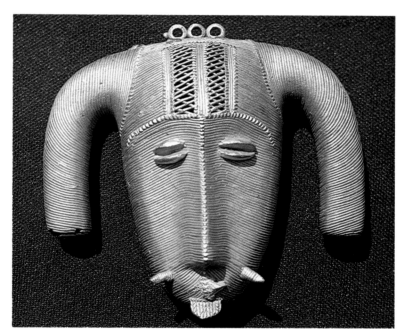
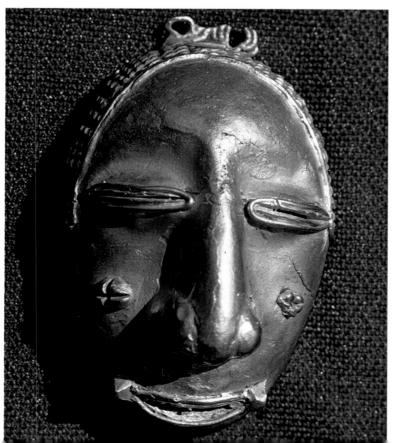
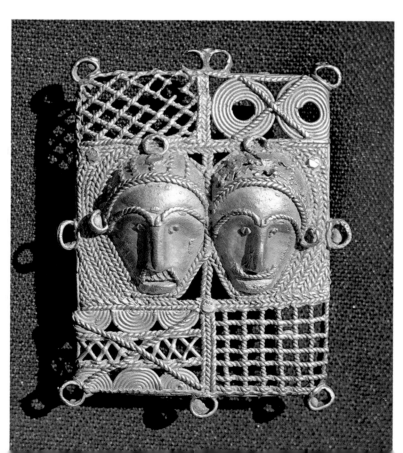

74　Yaure mask

Wood, 34 cm, Ivory Coast. By naturalistic standards this mask (especially the bird looking elegantly down at the face) is a highly refined abstract work. A compelling example of Yaure art. The Yaure form the link between the Baule and the Guro.

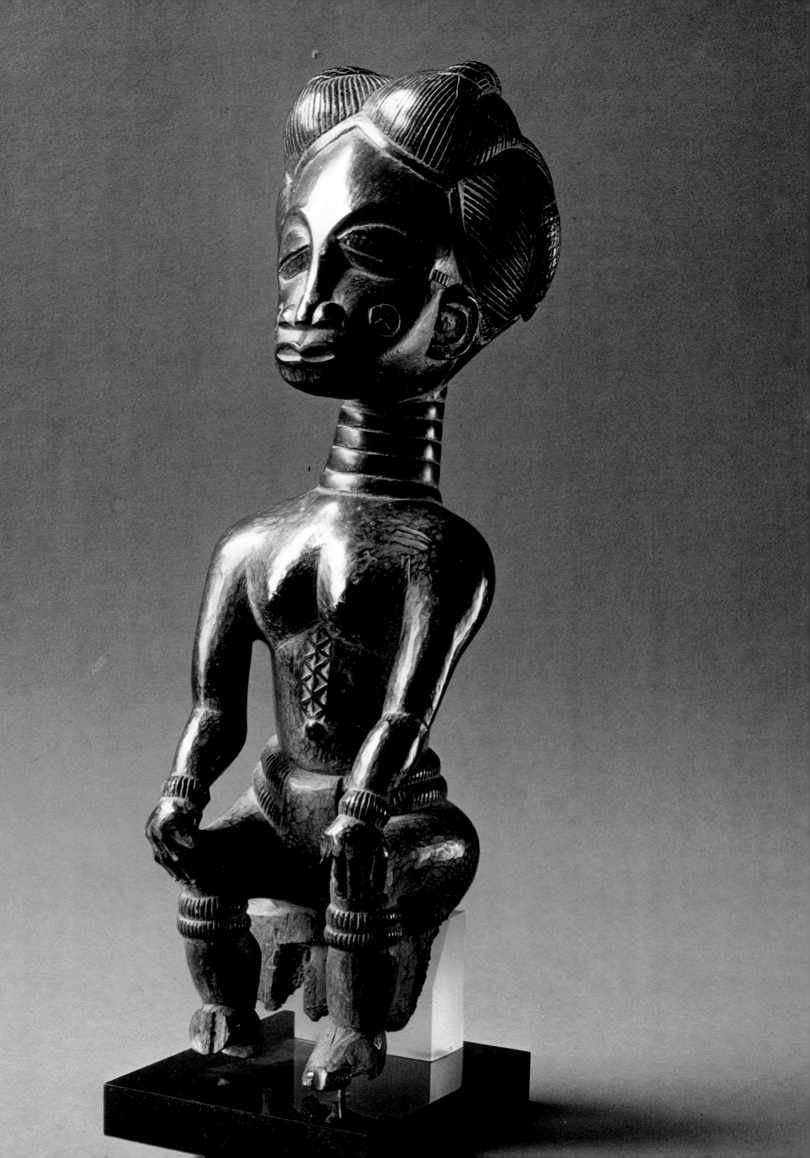

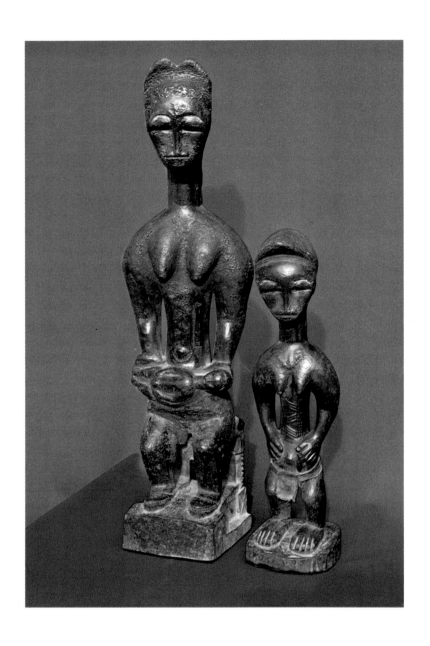

64 Baule figures

Wood, 32 cm and 48 cm, Ivory Coast. Two figures by the same artist. Both have the typical rather flat, almost two-dimensional Baule face. The mother's hands are linked beneath the baby she is carrying. The daughter is wearing a cloth apron that looks almost like leather. Both represent a rare Baule type.

65 Baule mask

Wood, 31 cm, Ivory Coast. A classic, stylistically pure mask of great elegance. The tripartite hairstyle, still showing traces of white earth, makes a happy contrast with the beautiful red patina of the long, oval face.

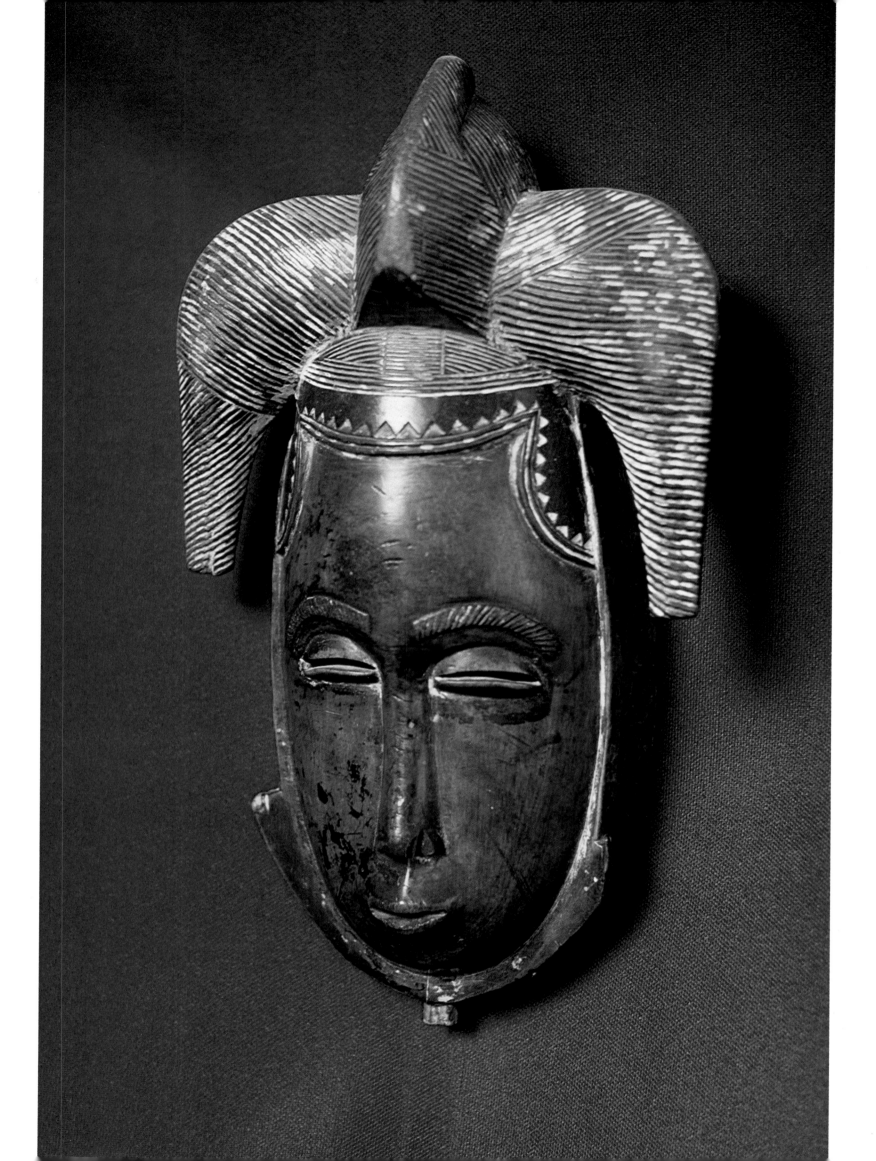

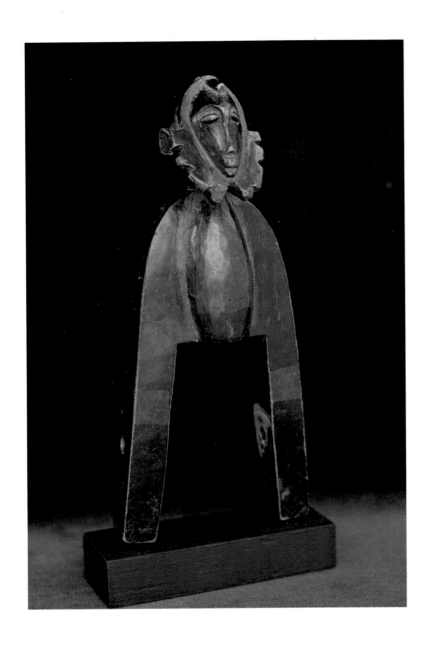

66 Baule heddle pulley

Wood, 18.5 cm, Ivory Coast. Heddle pulley in the form of an abstract figure. Of the head only the ears and the hair – looking like a comb – are visible. The interesting feature of this pulley is the mask attached to it. In style this is reminiscent of Guro work.

67 Baule ancestral figure

Wood, 50.5 cm, Ivory Coast. A composition of great beauty and finished artistry, with refined, restrained scarifications on the body. The pigtail hanging from the delicately worked hair-do is balanced by the three-stranded beard, the curve of which is continued in a masterly way in the face and the neatly combed hair.

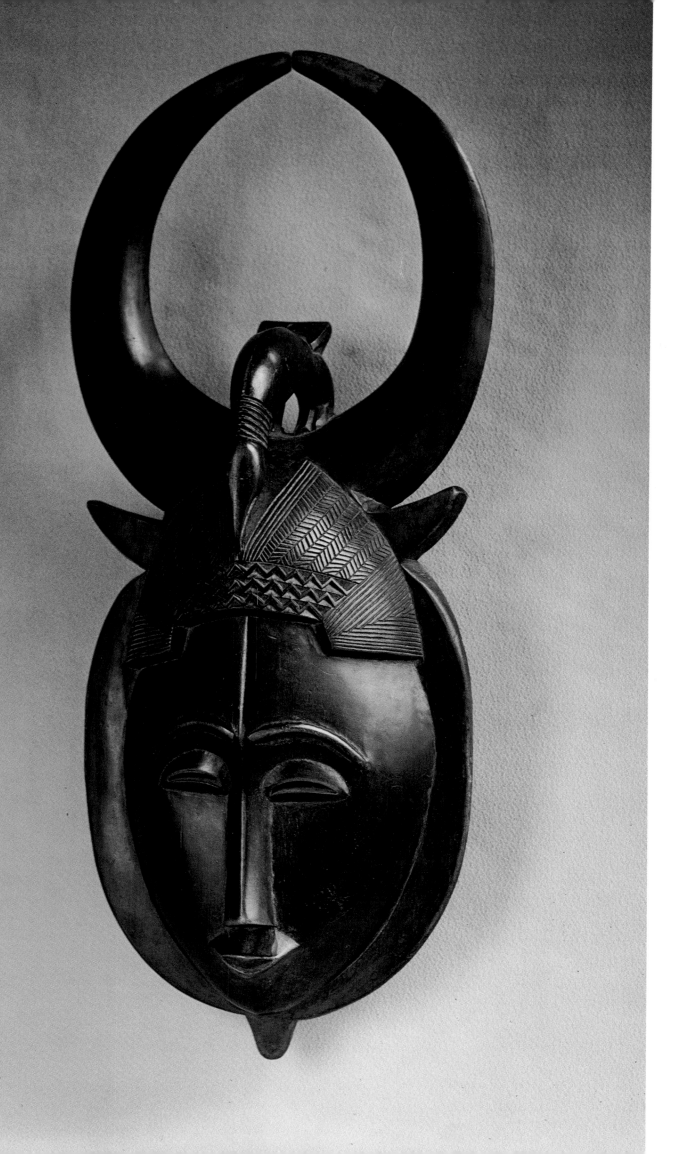

75 Guro mask

37.5 cm, Ivory Coast. This face narrowing at the bottom and canted slightly forward, towards the mouth, is typical of Guro art. A mask of inimitable gracefulness, with elegantly curved horns.

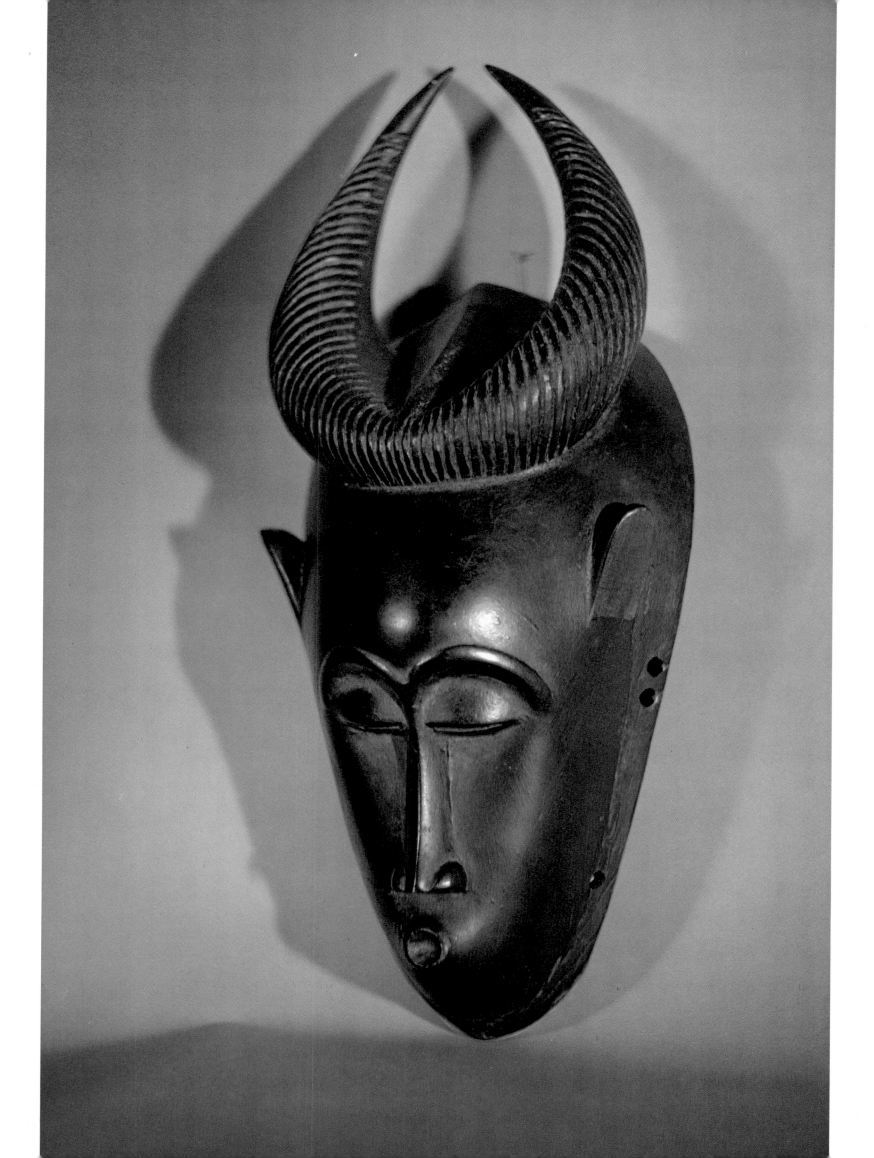

76 Anyi ancestral figure

Wood, 36 cm, Ivory Coast. This figure has a shiny patina and white paint around the eyes and on the shoulders and breast. It is seated, puppet-like, on a two-legged stool. An unusual Anyi figure.

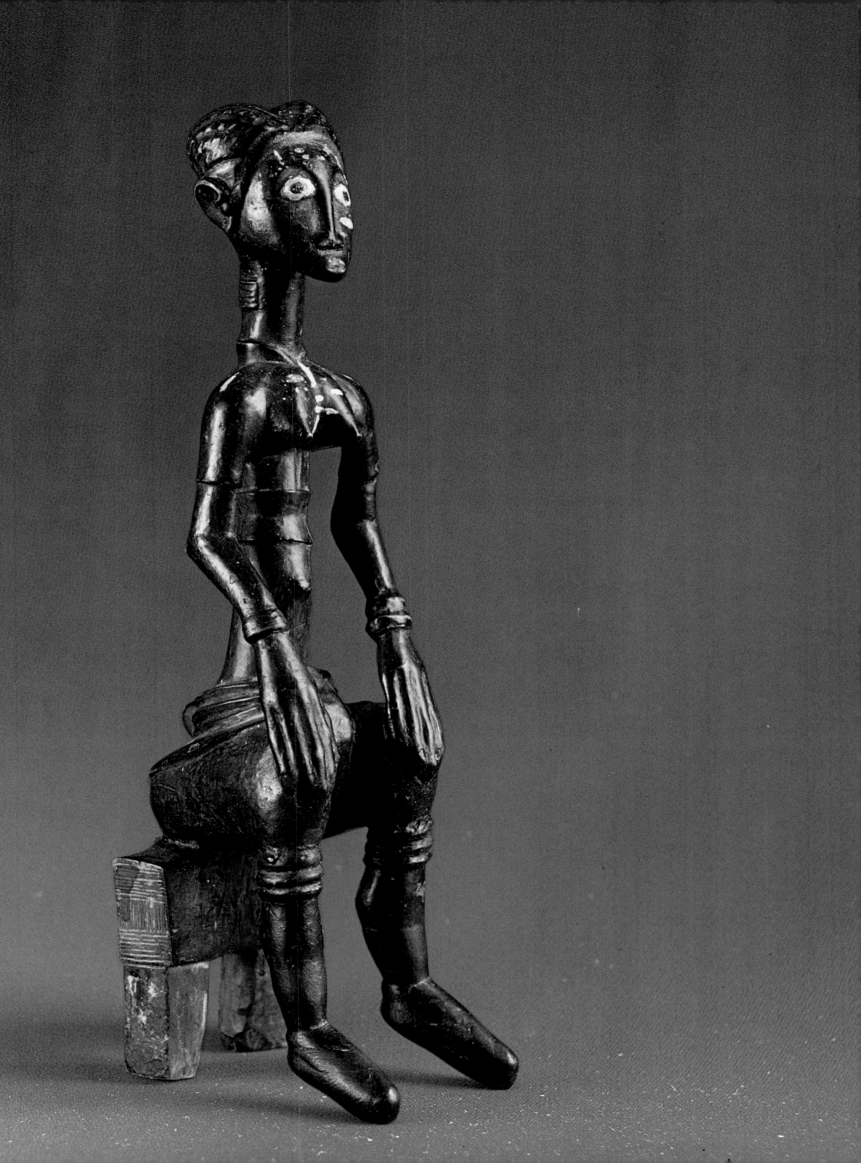

 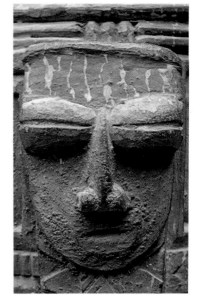

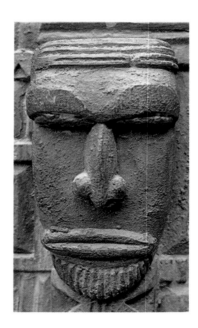 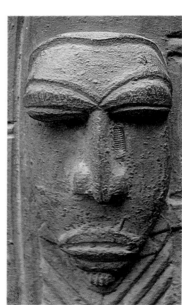

77–82 Atie drum

Close-ups of the six heads on the upper part of the drum. Each head is between 8 and 10 cm high.

83 Atie drum

Wood, 170 cm, Ivory Coast. The small Atie tribe, settled north of the capital Abidjan, has never produced a great deal. All the more remarkable, therefore, is this magnificent drum, which first arrived in Europe in 1926, and which since then has remained with the same family. It was used to call the members of the tribe to important gatherings.

The carving, on several planes, varies from deep and shallow relief to fully sculptural, only partly stylized figures which, despite their apparent crudeness, contribute to form a harmonious, well-balanced whole. It is probably one of the most beautiful, if not the most beautiful, of all Atie drums, and aesthetically is exceptionally fine.

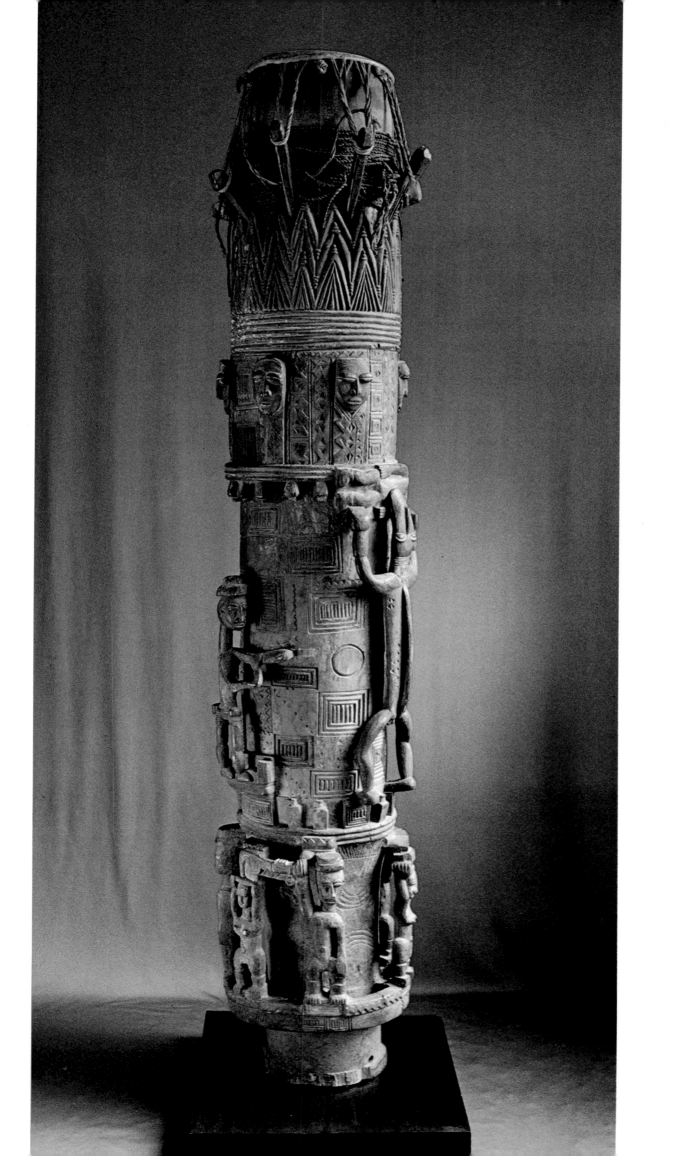

THE HERMAPHRODITE

Representation of hermaphrodites is common to many peoples, and for Africans has a basis in mythology. Their ancient traditions have it that humans were originally androgynous – a view that can be supported anatomically.

Adolescents, between the ages of about 10 and 15, in many tribes go to a bush school for a period which can last for months or even years. Entry into this is a symbolic death: he or she dies to family and to the village. They learn how to prepare fields, to sow and reap, to clear land, to hunt, to dance, to build houses, and much else besides. They are taught their rights and duties in and towards society, and given sexual instruction. They often have to undergo many painful tests, so that they become tried and strong in courage. Through circumcision the man loses his 'female' foreskin (vagina), and the woman her 'male' clitoris (penis). Only now is the adolescent fully either a man or a woman. They are reborn, and often take another name. Then they are ready to assume their social responsibilities.

84 Krinjabo terracotta

43.5 cm, south-eastern Ivory Coast. The strong-featured face looking upwards at an angle, the ringed hair, the beringed neck, and the roughly intimated limbs here are typical of Krinjabo figures. They are thought to have been made by the widows of kings for their lords' graves. For the most part only heads have been found. This complete figure is thus a rarity. Though it is a mother and child, the adult clearly has a beard. It is therefore hermaphrodite.

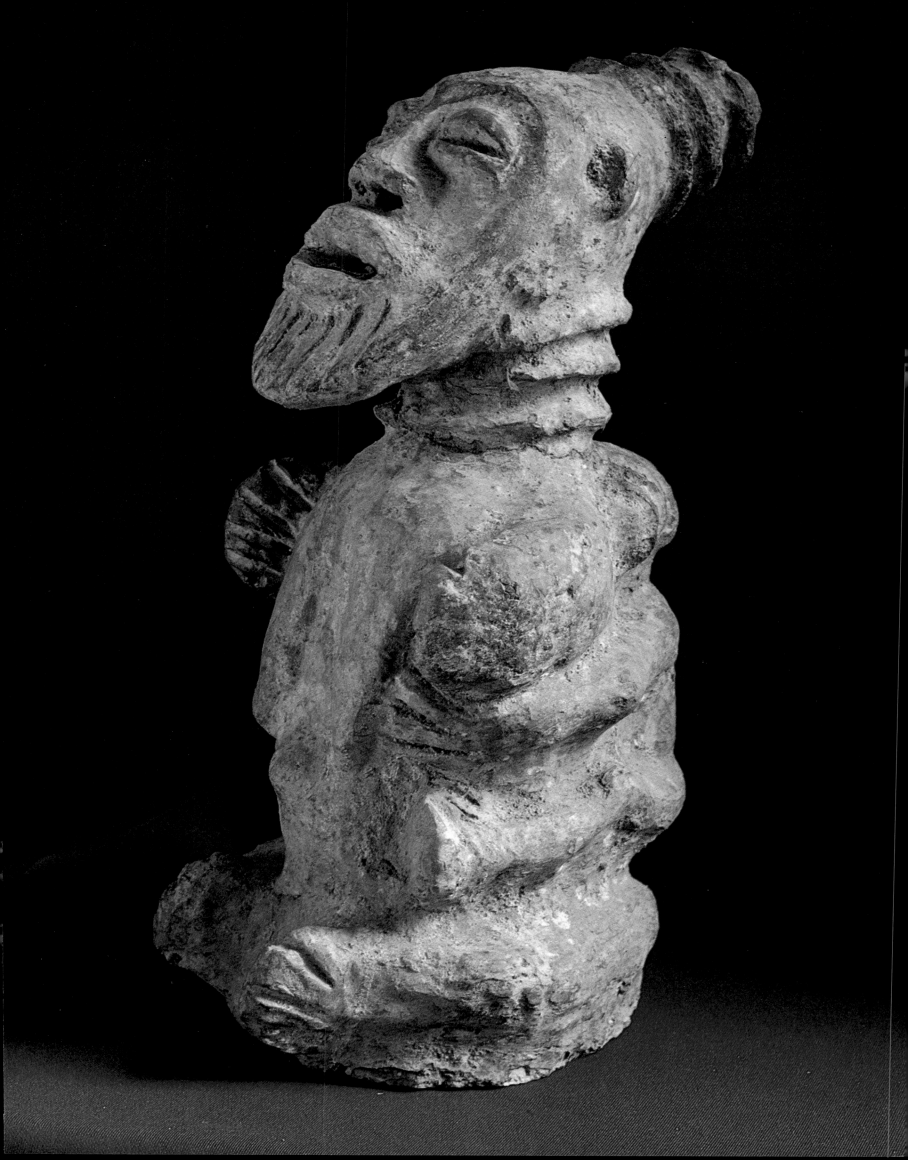

85 Laka ancestral figure

Wood, 73 cm, Ivory Coast. This authoritative seated figure, with its natural light patina, comes from the Buguanu district on the middle reaches of the Comoé. Almost nothing is known about the small Laka tribe, yet this very uncommon work conveys tremendous serenity and dignity.

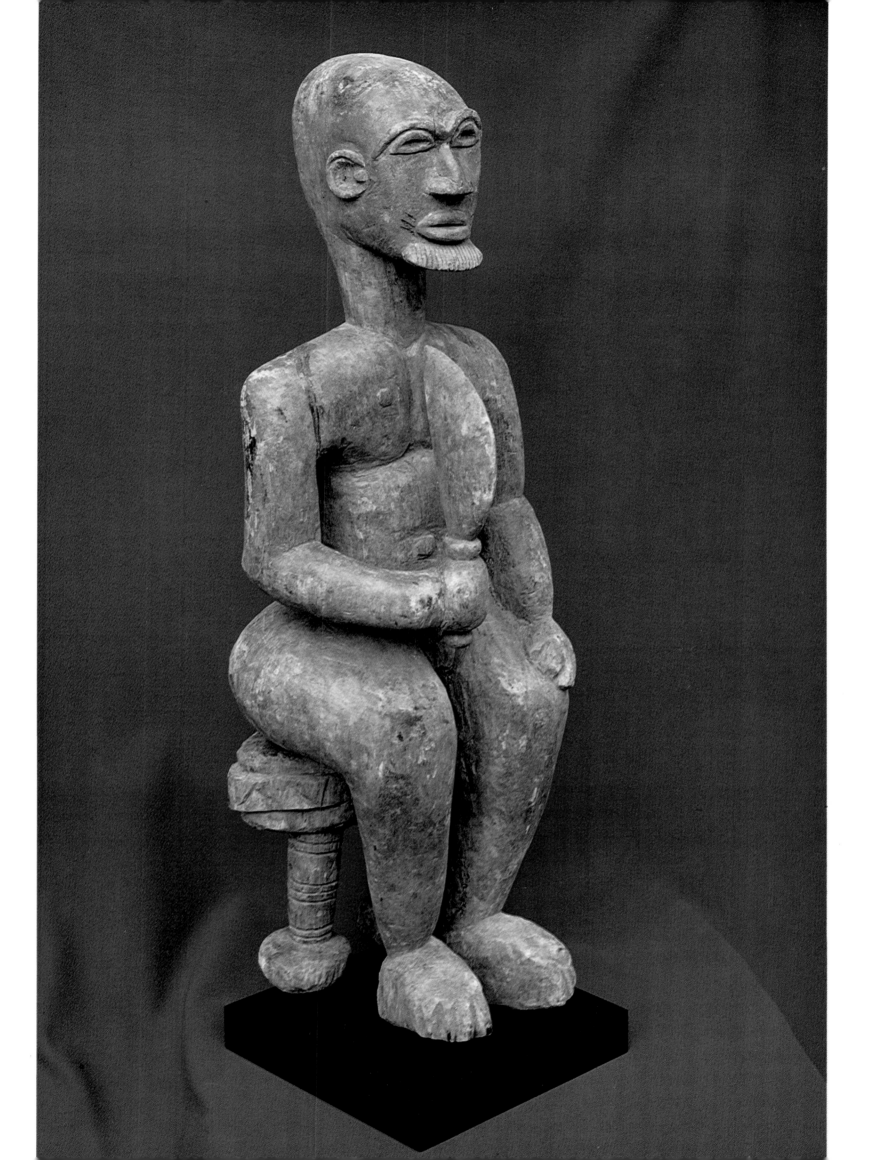

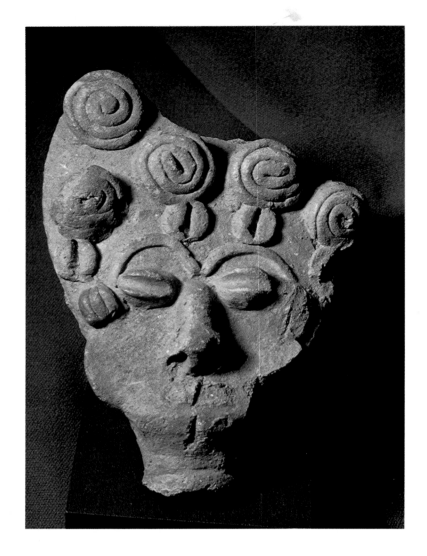

Ashanti
Fante

Ashanti, in Ghana, which presumably took its name from the ancient, illustrious empire of Ghana in the west, was famous for its divine kingship, its wealth and its well-ordered society. Travellers' reports over the centuries give us a picture of the exceptional splendour and artistic activity of the country. Court art dominated. The weavers', goldsmiths', brass-workers' and carvers' guild was highly esteemed. So it is not surprising that the name Ashanti calls to mind, among other things, the metal weights used for weighing the gold dust that served as money. They are hardly distinguishable from those of the Baule, which were probably inspired by the Ashanti (p. 302).

Their Akuaba dolls are famous. With their round, disc-like faces and long necks,

86 Ashanti terracotta

15 cm, Ghana. This kind of figure, representing a deceased member of the tribe, was placed on the dead person's grave.

87 Ashanti figure

Wood, 64 cm, Ghana. This figure of a proud dignatory was once painted – or so we may assume from the faint greenish and odd brownish patches on it. Traces of gold on the headband and the bracelet on the left arm indicate that they were previously gilded. The sandals, of layered, tooled leather, are typical of what was worn in the country. A beautiful, rare Ashanti carving.

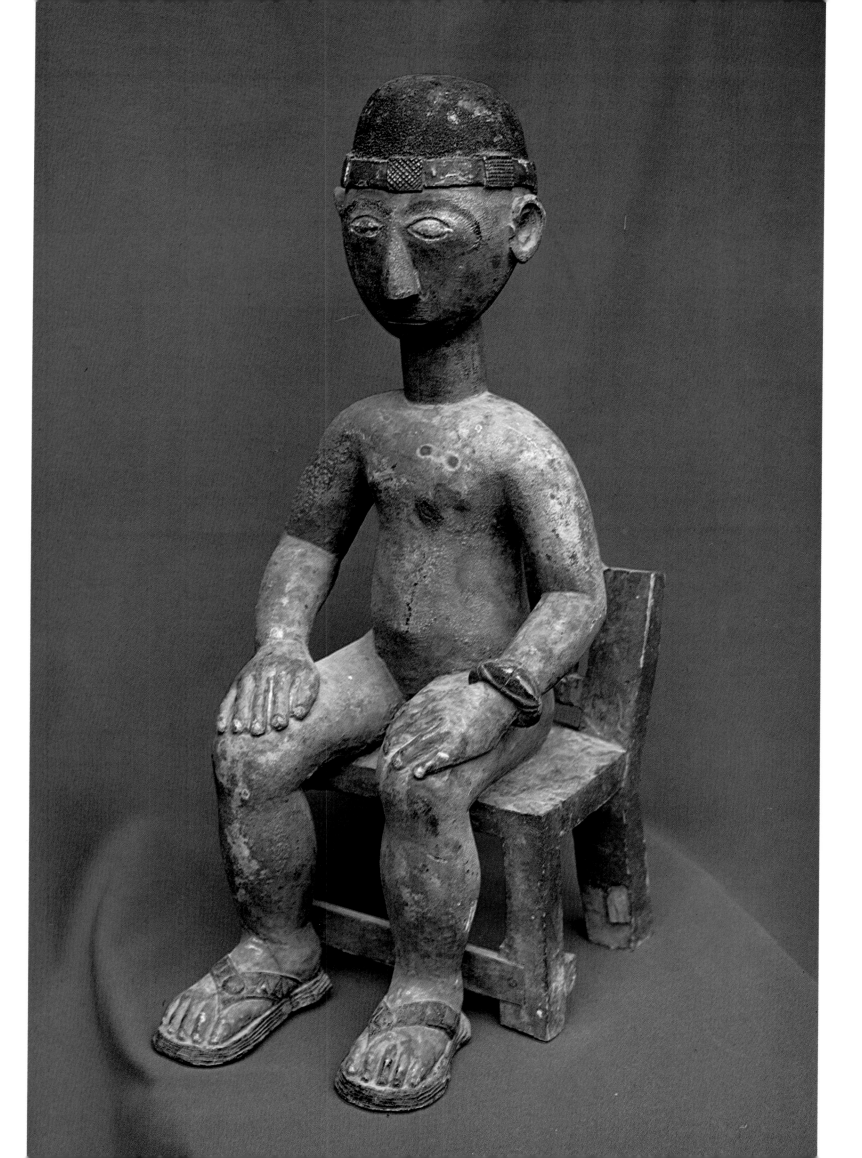

they were worn by girls and by pregnant women in order to have children who would reflect this ideal of beauty. Their richly decorated *cire perdue* Kuduo (used to contain gold) are also famous.

Their marvellous cloth, made of various materials, further testifies to their craftsmen's skill.

The Fante, south of the Ashanti, have a doll similar to the Akuaba, but with tall, square head. We know of few Fante figures, and no Fante masks to speak of.

88 Fante mother and child

Wood, 33.5 cm, Ghana. This splendid, sculpturally 'felt', white-painted figure has a beautiful hair arrangement of three pairs of cone-shaped tresses. Four square scarifications appear below the beringed neck, and are repeated at the nape. A rare, stylistically beautiful composition.

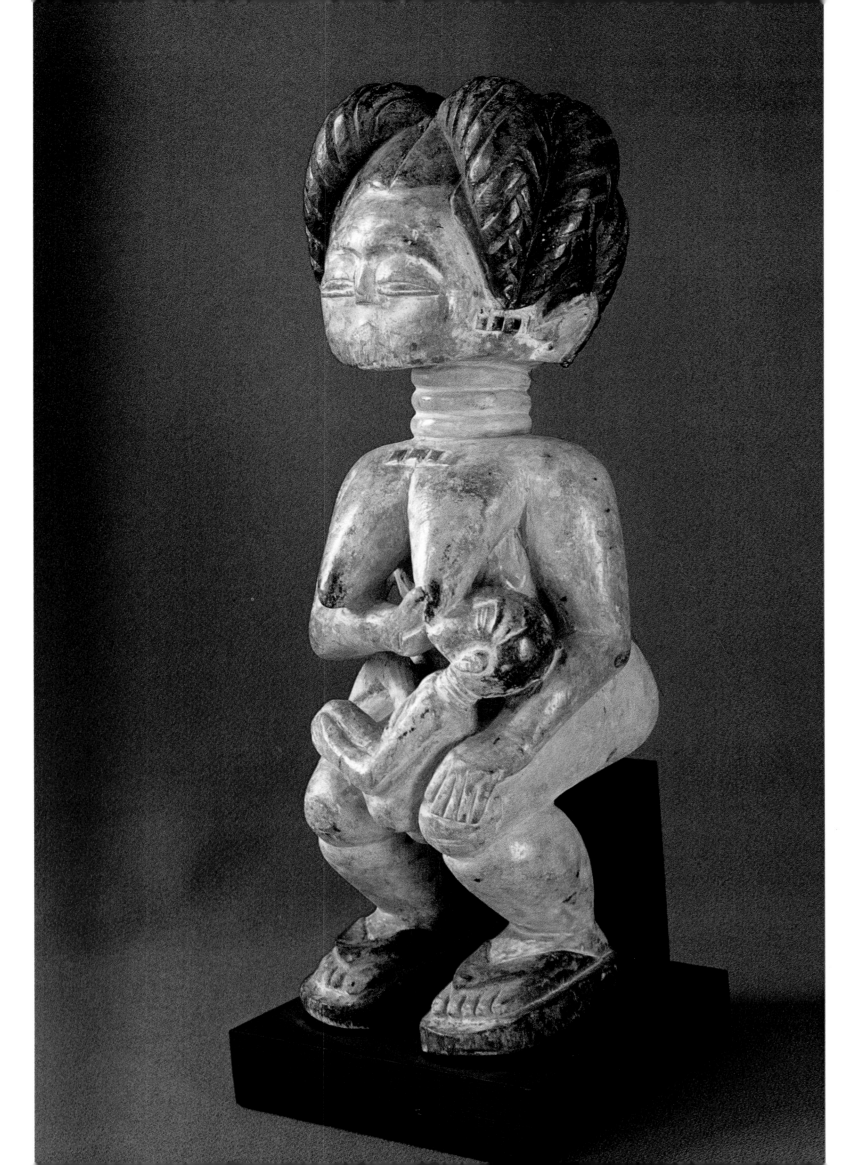

Fon

On the coast of Dahomey live the Fon, who were originally part of the Yoruba, but who gained their independence some 300 years ago and became very wealthy thanks to the slave-trade. Like most divine kingdoms in Africa, it was an attractive place for artists and craftsmen. Their immensely varied metal figures are famous, though they hardly represent a unified style. Wooden figures are rare.

89 Fon mother and child

Wood, 32 cm, Dahomey. The child in this highly stylized carving rests in its mother's V-shaped arms. The whole figure is covered with a black patina. From the long, pointed cap to the wide skirt it is decorated with little snail shells, cowries, seeds, what appear to be nut-shells, and red, white, black and blue glass beads. An unusual, original and very fine piece.

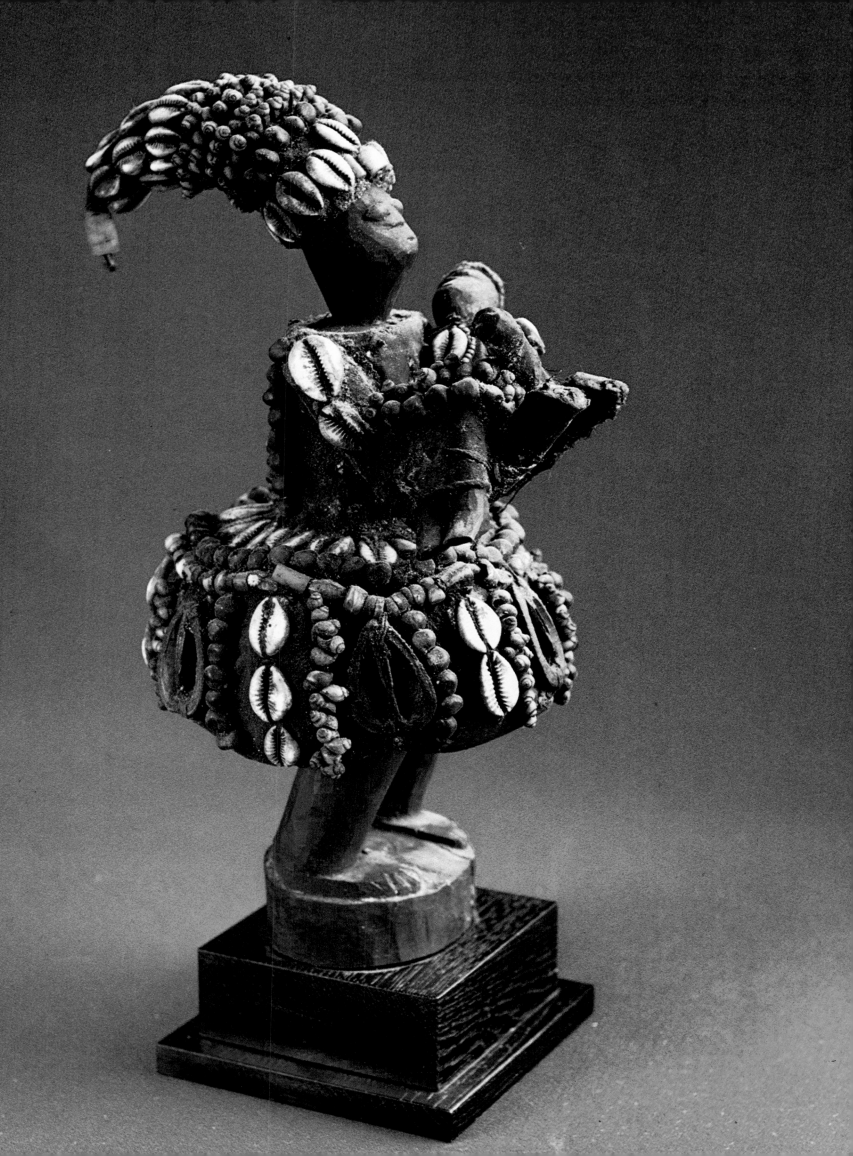

Nok
Benin

The oldest examples of African art, after those from the Nile valley, are the terracottas discovered in excavations. The Nok culture derived its name from the tin-mining village of Nok on the Bauchi plateau in Nigeria, where the first piece was found, and is estimated to have existed 1800 to 2500 years ago. Heads and the occasional whole figure range from heavy stylization to realistic representation.

The Ifa era, starting some thousand years later, in south-western Nigeria, produced magnificent, almost exclusively naturalistic portrait art, which through certain similarities of style hints at a connection with the Nok. Their stone, clay and bronze figures and heads are famous worldwide.

The bronze-art of Benin, south of Ife, with its figures, heads and plaques decorated with scenes, and ivory work – especially the delicately carved elephant tusks – leave no room for doubt about its connection with Ife. The purely court art of Benin started at the beginning of the 14th century, and was in its heyday from the 16th to the 18th. During this period works were produced which rival the very best Italian bronze work. As far as quality and technique go, modern productions are, with some exceptions, often only plagiarisms of former glory.

Further bronze and stone finds have been made at Igbo-Ukwu in Ibo country (Niger delta), in northern Nigeria (Tsoede bronzes), and at Esie in Yoruba country. These present further puzzles, but can be seen as linking the various artistic periods in Nigeria.

90 Nok terracotta

25 cm, Nigeria. A stylistically pure work of the early period, about 2500 years old. With its triangular eyes, extenuated nose, and mouth beautifully curving, uninterruptedly, into a flanged 'neck', it stands as a magnificent example of Nok culture, modern and beautiful even to our eyes.

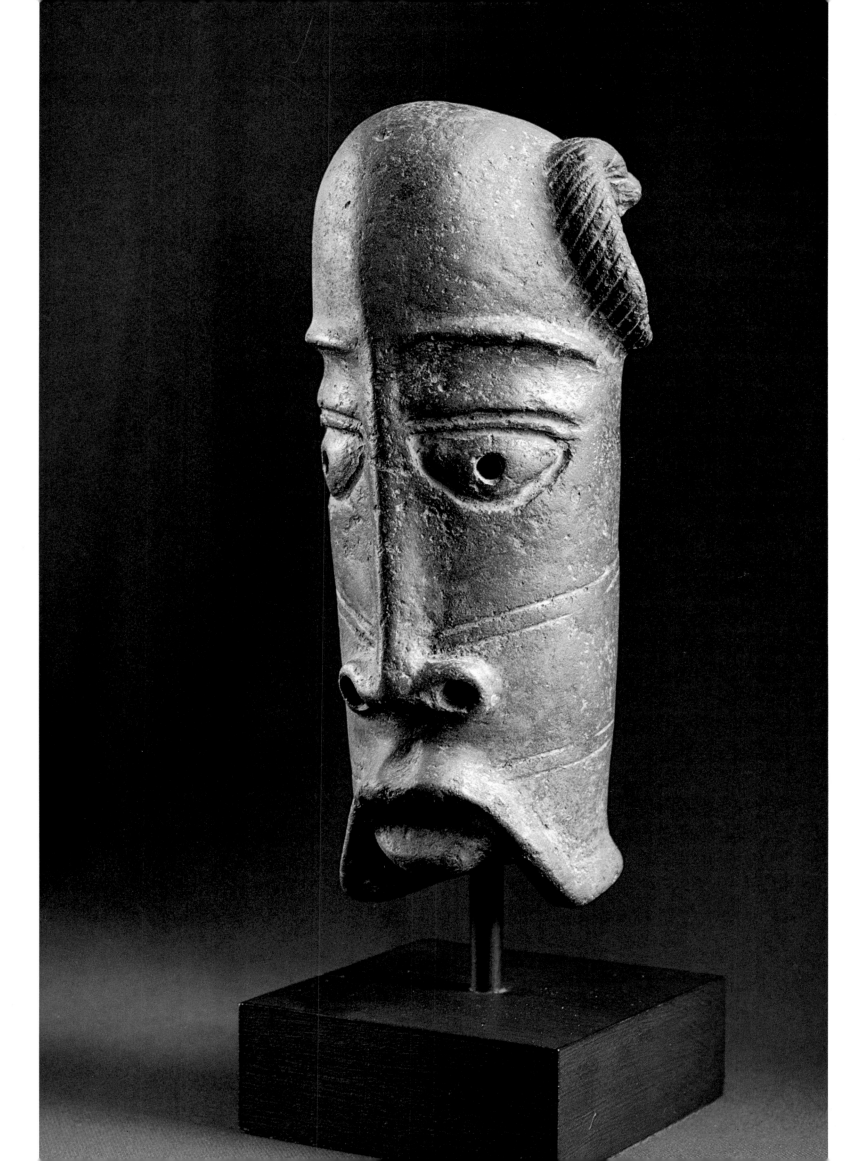

91 Benin bronze head

36 cm, Nigeria. Commemorative head of an Oba of Benin, which adorned the royal altar. Following contemporary fashion, the neck and chin are entirely concealed by chains of semi-precious stones. The winged cap with decorative pearls lends the sculpture great dignity and elegance. It is typical of late Benin style.

132

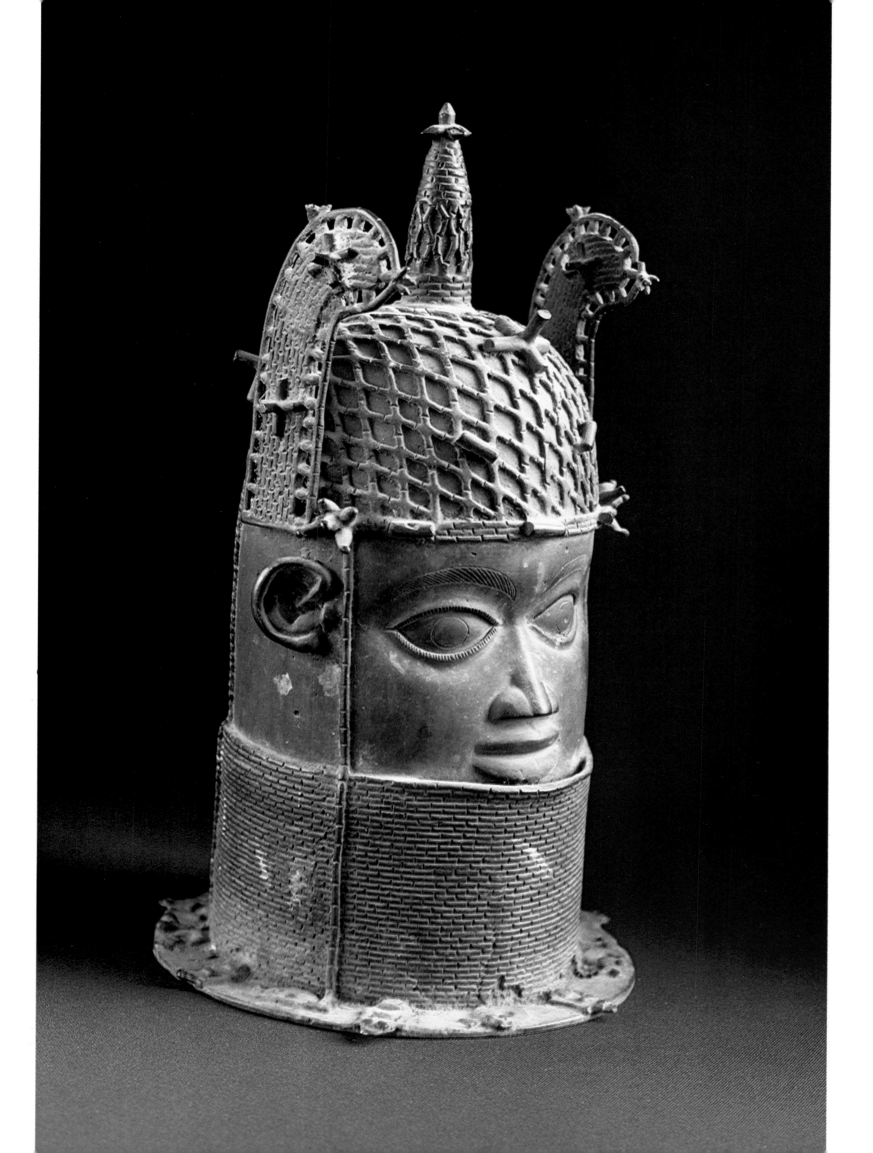

92 Benin bronze bird

23 cm, Nigeria. This faultlessly cast bronze represents the cock okpa. Its back is adorned with a snake motif. It was placed by the Oba of Benin on his mother's ancestral altar.

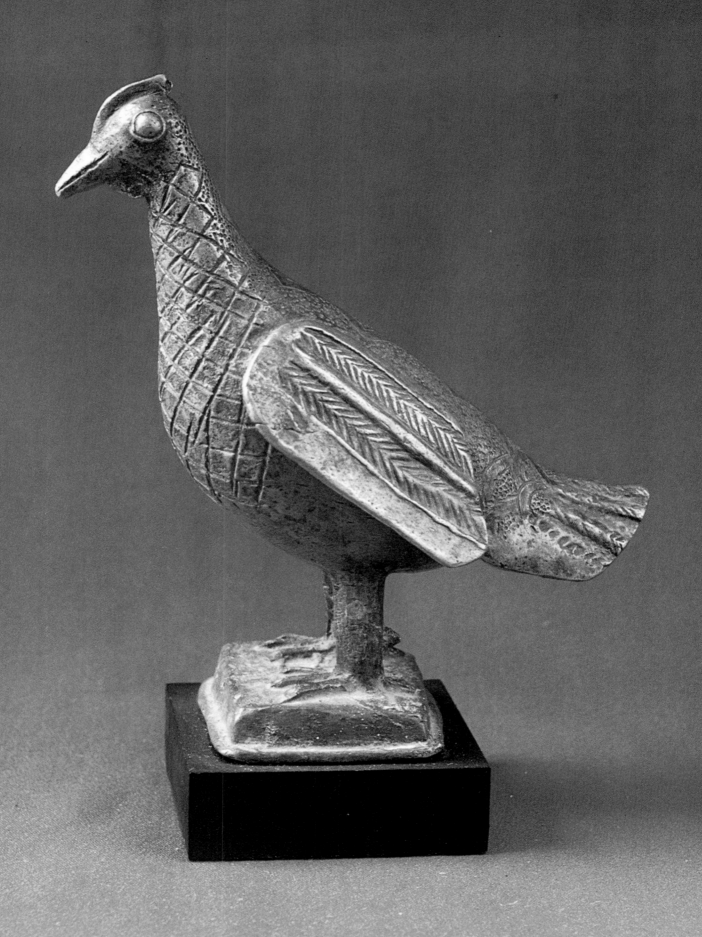

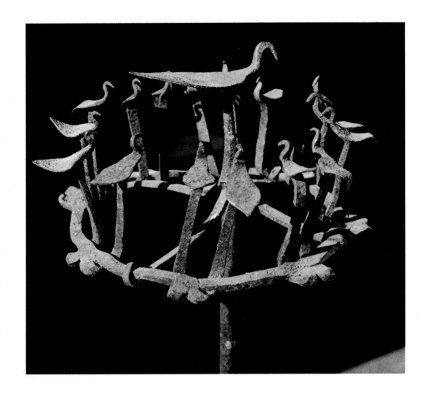

Yoruba

The Yoruba, the true heirs of the earlier kingdoms of Ife and Benin, live in south-western Nigeria, in the most densely populated part, and in eastern Dahomey. Formerly a rural people, they have largely developed into urban communities, of which Oyo and Ife are the most powerful. Their religion is polytheistic, and each of their innumerable gods (Orisha) has a consecrated figure, mask, or cult object. Every aspect of individual and family life is governed by these Orisha. Counter-balancing the spiritual and worldly rulers there are powerful chiefs, the Oba, then the Ogboni secret society, which occupies an

93　Yoruba iron altar

67 cm, Nigeria. This altar, dedicated to the life spirit, and called Asen, is planted in the ground. According to an ancient legend, the god of creation, Osanyin, worked with two helpers and sixteen chickens which had to dig up the sea-floor.

94　Yoruba mask

Wood, 32 cm, Nigeria. An attribute of the Guelede society, which drives away witches – a necessary task to ensure fertility and happiness. The classically beautiful, typical Yoruba face is topped by an elaborately curving, asymmetrical hair arrangement. The mask could easily be taken for a portrait of a Yoruba beauty.

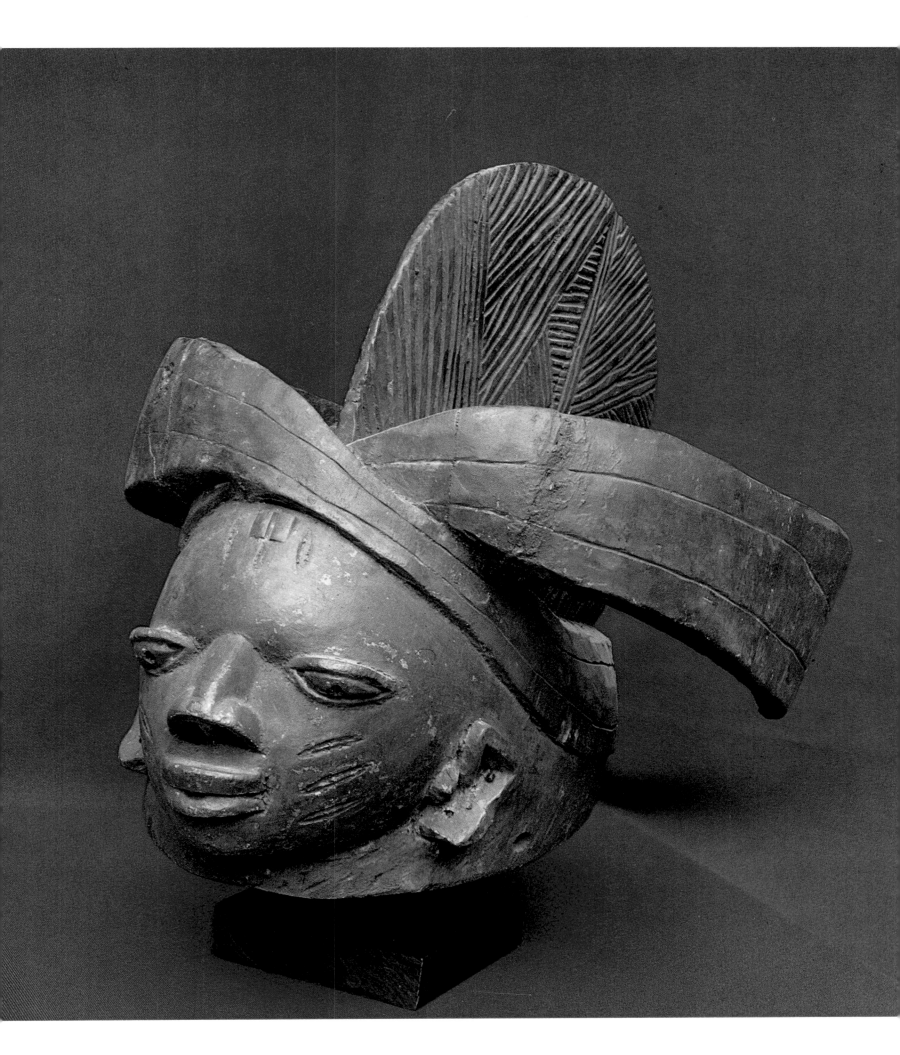

important position and is also responsible for justice. The regional and numerous other secret societies have innumerable figures, masks and cult and ceremonial objects at their disposal.

The Yoruba are not only famous for their masks and figures. They have also produced exquisite drums, brass oracle and cult objects, carved pillars for chiefs' palaces, ironwork, ivory carvings and so on and so forth. Their style has barely changed over hundreds of years, so that it is not all that difficult to identify Yoruba work. The following plates give a better indication of their artistry than any mere description.

95 Yoruba mask

Wood, 45.5 cm, Nigeria. Used by the Egungun society, from the Abeokuta area. At burials it formed a link between the living and the dead. Through its mouth the will of the dead was made known. The originally red face was later coloured to resemble bronze. The large hare-ears with their pronounced plaited patterning are very colourful inside. The hourglass drum in front of the ears, the animal on the back of the head, and the row of medicine phials on the brow are all peculiar to this type of mask, and demonstrate the power of the great spirit. A beautiful, classic Egungun mask.

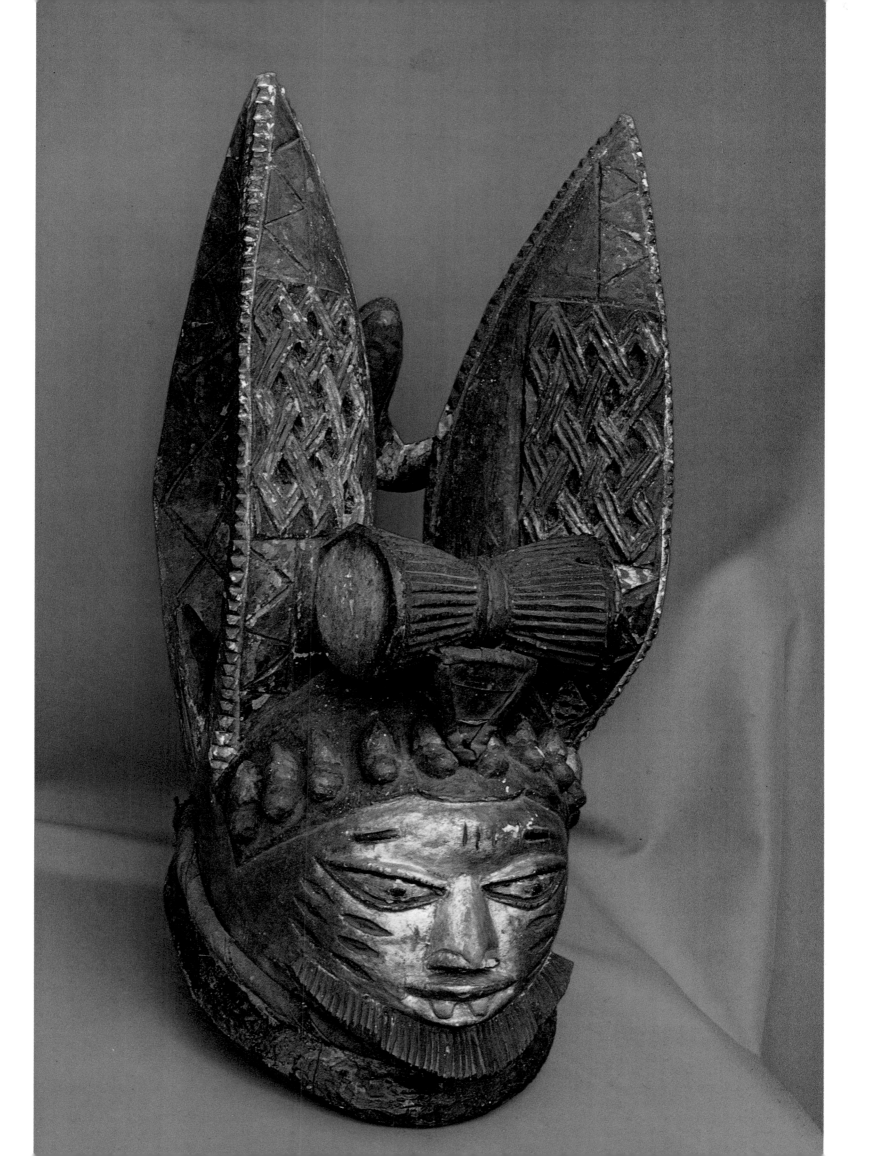

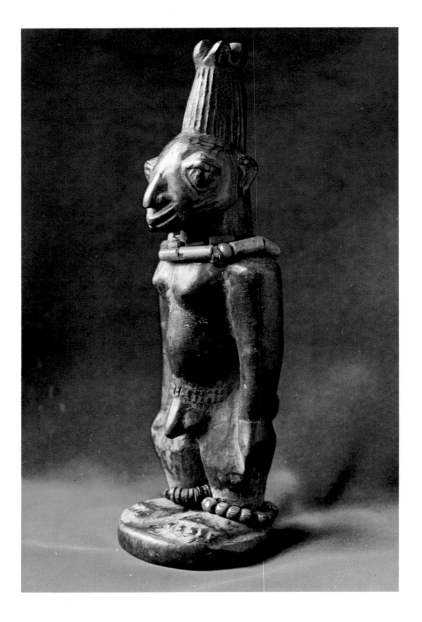

96 Yoruba, Ibeji figure

Wood, 26 cm, Nigeria. Curiously, twins are born far more often in Nigeria than in the rest of Africa. While elsewhere twins mean bad luck and are killed, among the Yoruba they are definitely lucky. Special care is taken of them therefore. Should one of them die, this figure, known as Ibeji, immediately takes its place and is tended like the living child. The wandering soul of the dead twin finds a refuge in it, and so provokes no misfortune. This old custom is still maintained today. The Ibeji are often lovingly passed down from generation to generation. Strength of form and a tall hair-arrangement characterize this male twin figure. Around the neck are two glass bead necklaces, and around the ankles beads of various materials.

97 Yoruba mother and child

Wood, 42 cm, Nigeria. A lovely image of a young mother with her child on her back, secured to her with a cloth according to the custom of the country. The bowl she is holding in front of her is for receiving small gifts.

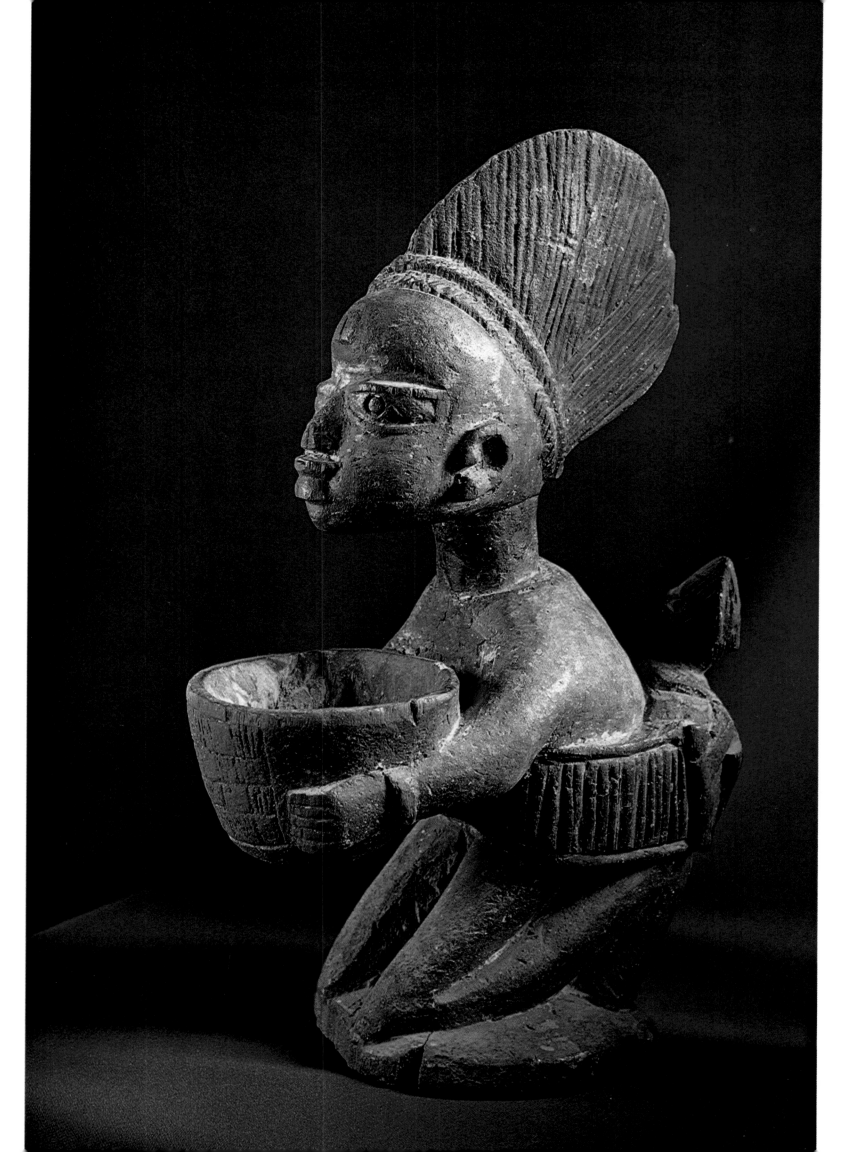

Ibo
Izi
Urhobo
Ibibio
Oron

Many large, important peoples, all forming one artistic complex, live in the Niger delta.

The Ibo, a powerful tribe north-east of the Niger delta, are important in every respect. Despite a certain partial conversion to Christianity, traditional and religious rites, and various secret societies, still continue. Artistically they are particularly significant. The war in Biafra during the sixties revealed the wealth and tremendous power and vitality of their very varied work. The upheavals of war caused many hitherto unknown works of art to be taken abroad, to Cameroon and elsewhere. Their powerful polychrome ancestral statues, the Mmwo men's society white masks representing the spirits of the dead, Ikenga cult figures, embodiments of manliness with giant pairs of horns, completely abstract and unreal masks, and much else besides reveal them as a people with a rich, personal artistic tradition.

The Urhobo, in the north-west of the Niger delta, south of Benin (now named Bini), are little known. Their figures convey a certain aggressiveness. The Ibibio, in the eastern Niger delta, are governed by the powerful Ekpo secret society, whose sinister masks and figures, outwardly representing diseases against which they ostensibly provide protection, are well known. They also, however, have gentler, less ferocious masks and figures.

The Oron, a secondary Ibibio tribe, also deserve a mention here for their severely weather-worn, abstract ancestral figures, which they would appear to have made only until the end of the last century.

98 Ibo ram mask

Wood, 32 cm, Nigeria. An important mask in the fertility cult. The superb curving ram's horns are the symbol of the thunder god, who appeared to men in the guise of a ram.

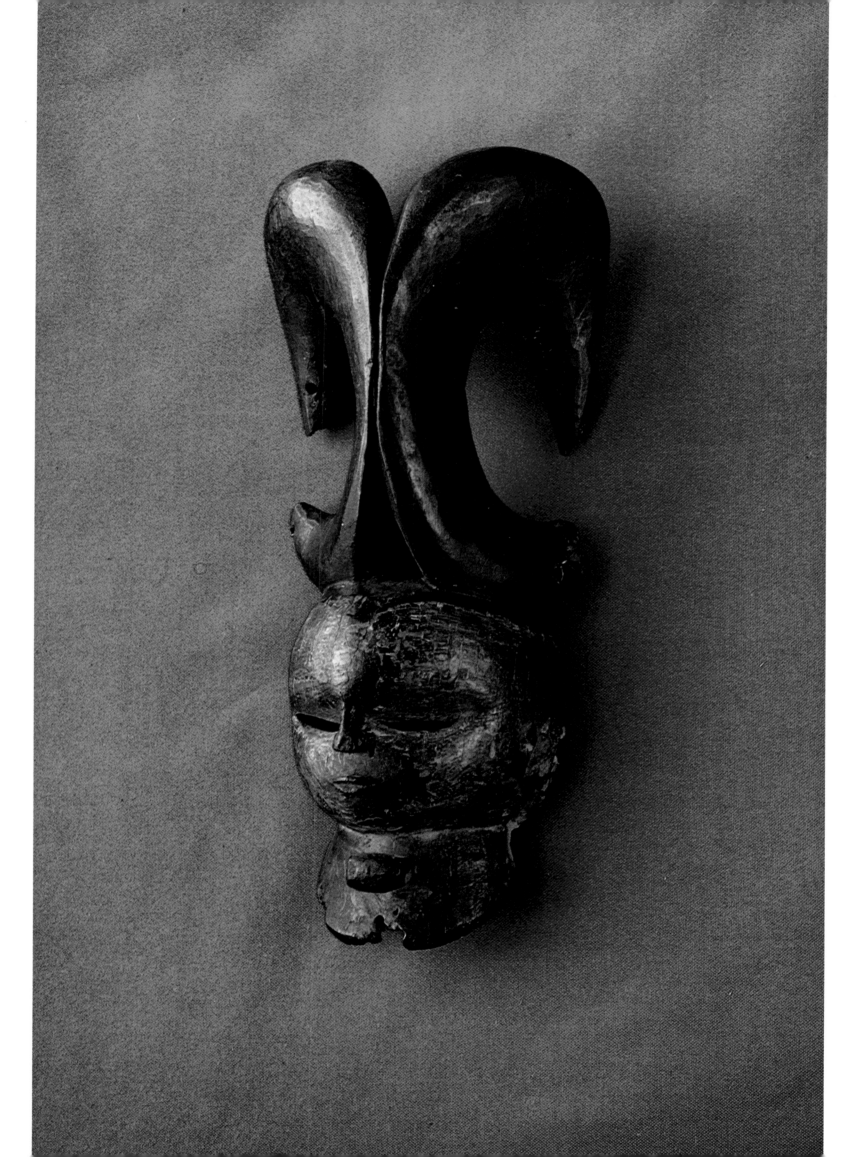

99 Ibo-Izi mask

Wood, 52 cm, Nigeria. This mask, worn slightly diagonally on the head, is a purely cubist work, an unreal composition suggestive, in its details, of an elephant. As well as the two heads on the sides, a third head appears on the back. Its traits are impressive and strong — certain of them similar to Akwanshi features (p. 152).

Izi work (the Izi are a secondary Ibo tribe), was used at the yam harvest and, less often, on the death of a chief.

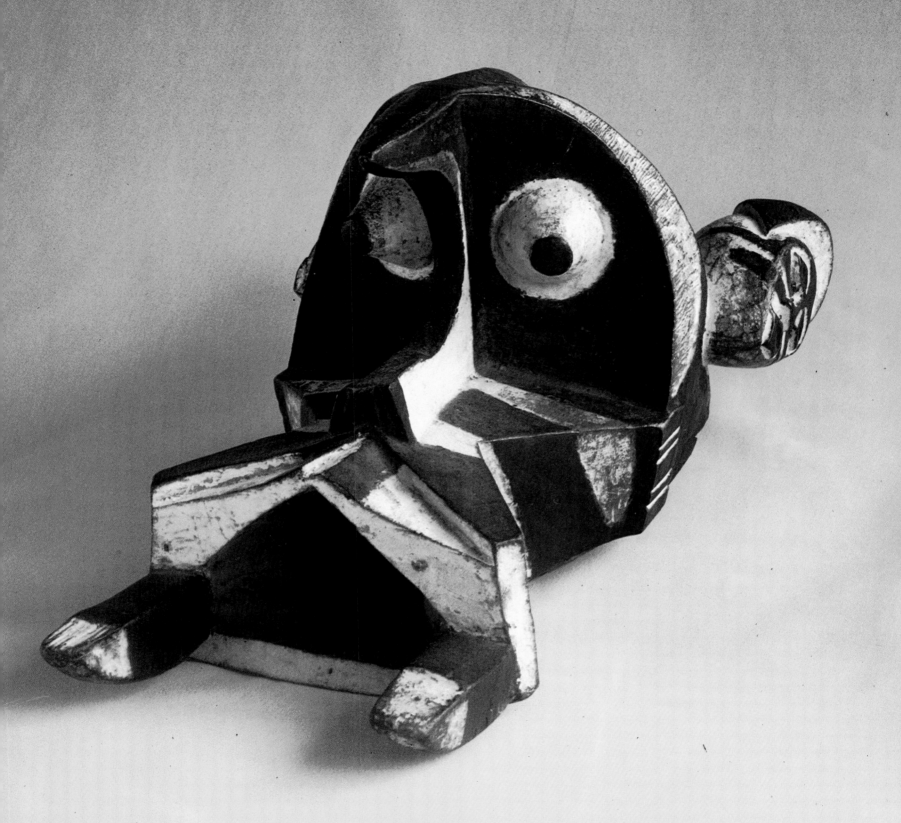

100 Urhobo mother and child

Wood, 155 cm, Nigeria. This powerful, bulky, yet altogether monumental carving from the Niger delta is in the classic style of the Urhobo – a tribe which, until not so very long ago, was barely known. According to the museum notes, it was until recently in the possession of a great chiefdom. It was used principally in the fertility cult, and all women of the tribe (a neighbour tribe to the Ijo, it should be mentioned) had access to it. After any successful birth thanks were given it for seven days in sacrifices of water mixed with manioc.

Manioc, one of the most important cultivated plants on earth, is more familiar to us under the name tapioca or sago. The manihot utilissima belongs to the spurge family. Its roots are boiled and ground into flour.

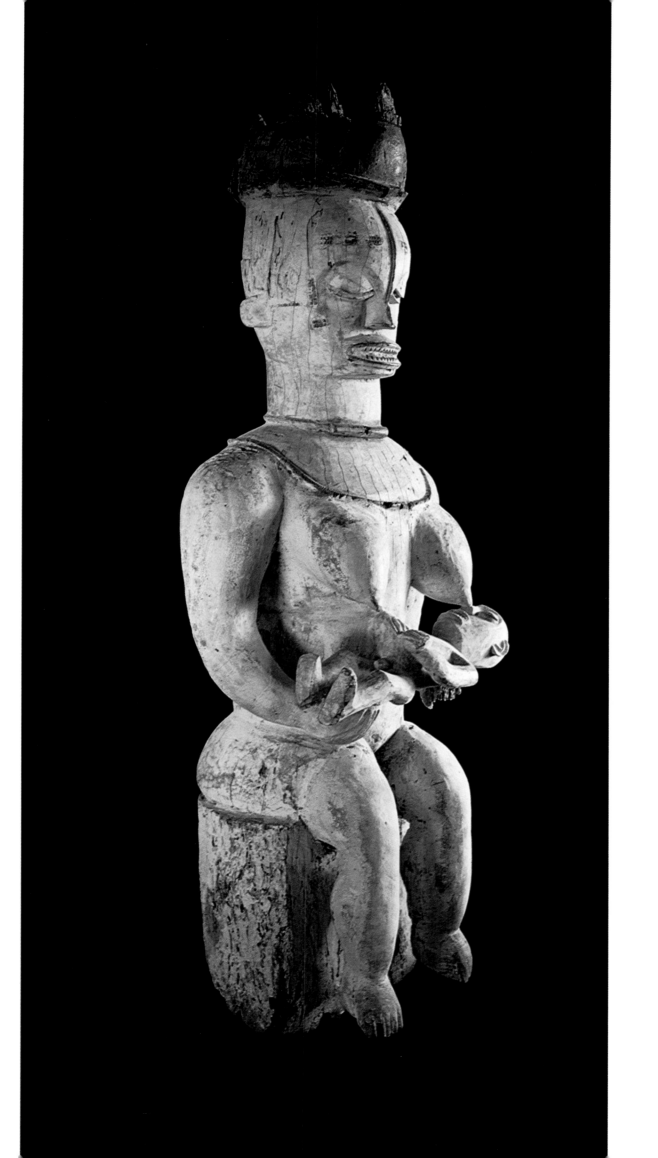

101 Ibibio figure

Wood, 62.5 cm, Nigeria. A rare ancestral figure in classic Ibibio (eastern Niger delta) style. It is a masterly cubist work. Covered with a rough, almost black patina, with occasional patches of red, it conveys dignity and authority.

148

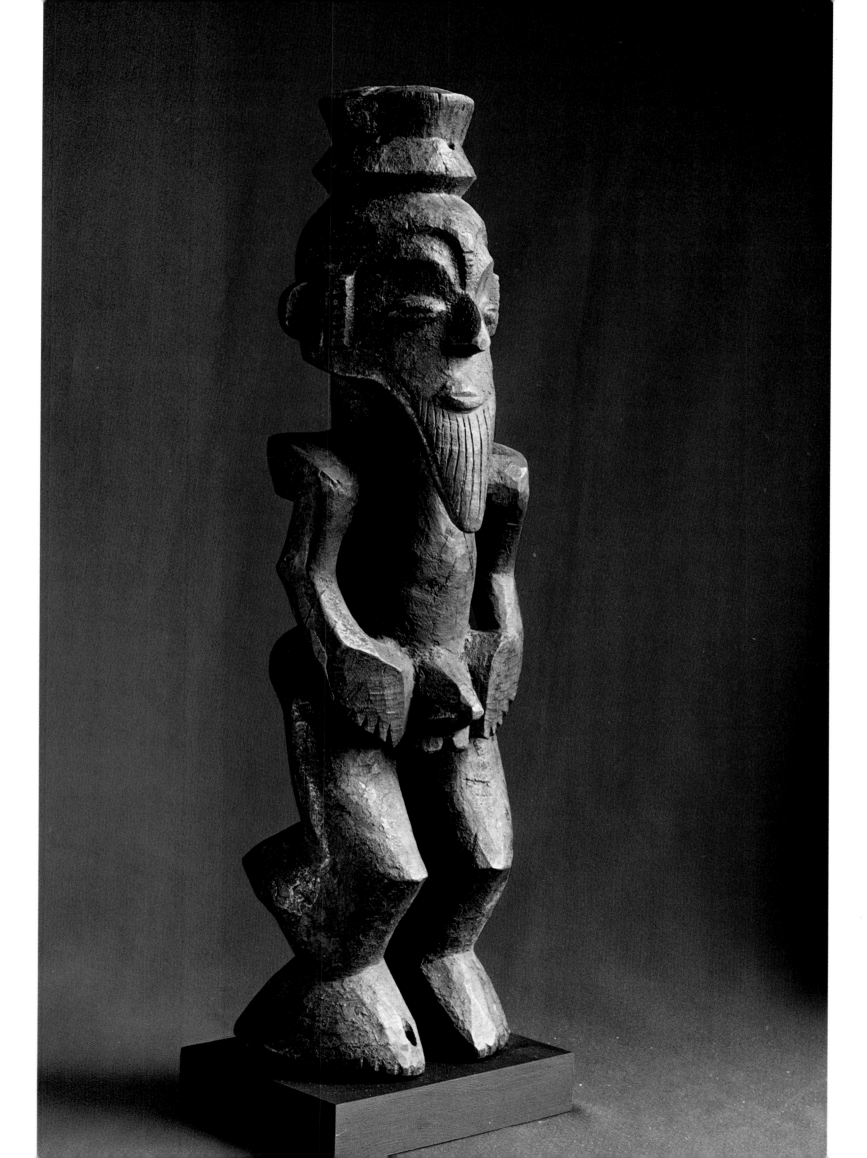

102 Oron bronze horse

20 cm high, 22.5 cm long, Nigeria. A magnificent piece in every detail, with sumptuous saddle blanket and bridle. The pommel of the saddle is in the form of a snake poised erect.

Vaguely reminiscent of Indian art in shape, it is nevertheless a pure and extremely rare example of Oron work.

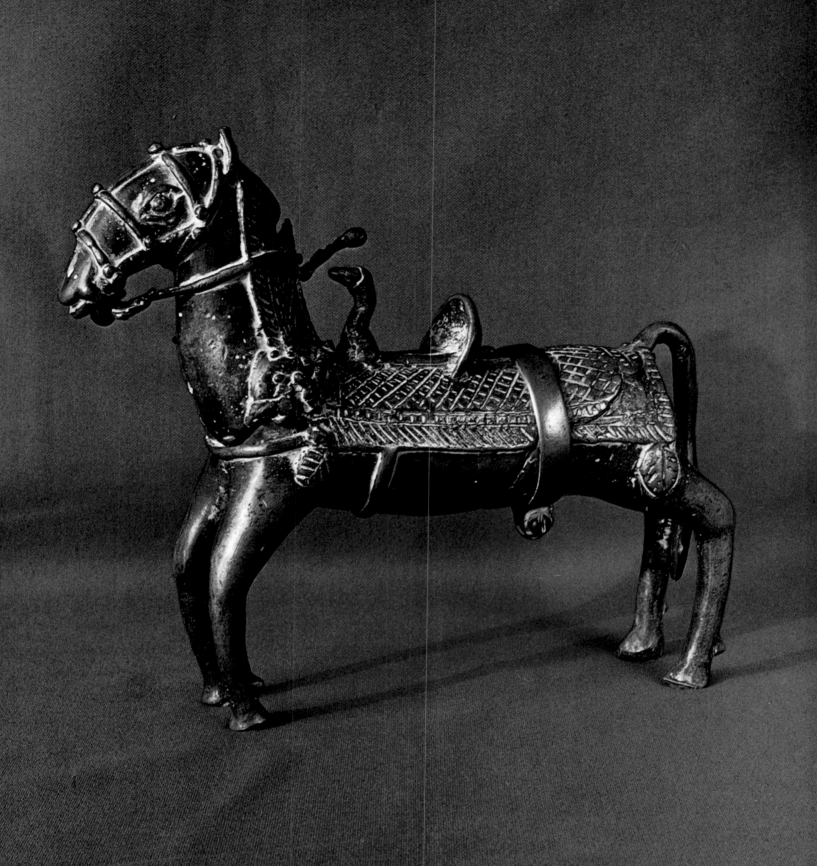

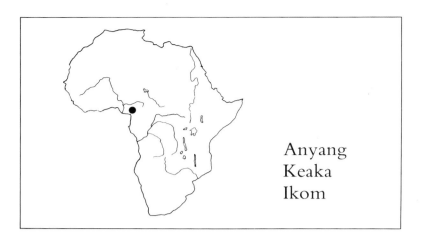

Anyang
Keaka
Ikom

beauty. This is the tradition of the Ekoi – famous for their dance headdresses (probably at one time covered with human skin) shaped to represent the heads of slaughtered enemies – the closely related Anyang, Keaka, Ikom and others.

With few exceptions they produce more or less realistic mask art. This is not the case with the Keaka, who live on the Nigerian border and over into Cameroon, and who are known for their highly expressive figures.

Not long ago several phallus-like stones, often of considerable size, were discovered around Ikom, in Ekoi territory. Little is known about these figures (called Akwanshi). The Ekoi venerate them, and say they are in memory of their long dead priestly forbears. Their approximate age is estimated as three hundred years.

In the River Cross area east of the Niger delta and in south-western Cameroon – thus in the humid savannas immediately bordering on the rain-forest region – we find an artistic tradition that produces on the one hand fearsome, almost hideous works, and on the other works which are fascinating both in their wealth of ideas and their

103 Keaka ancestral figure

Wood, 32.5 cm, Nigeria. Head of a surrealistic figure, monumental in its expressive force. The Keaka are related to the Ekoi, and live around the source of the River Cross and over the border into Cameroon.

152

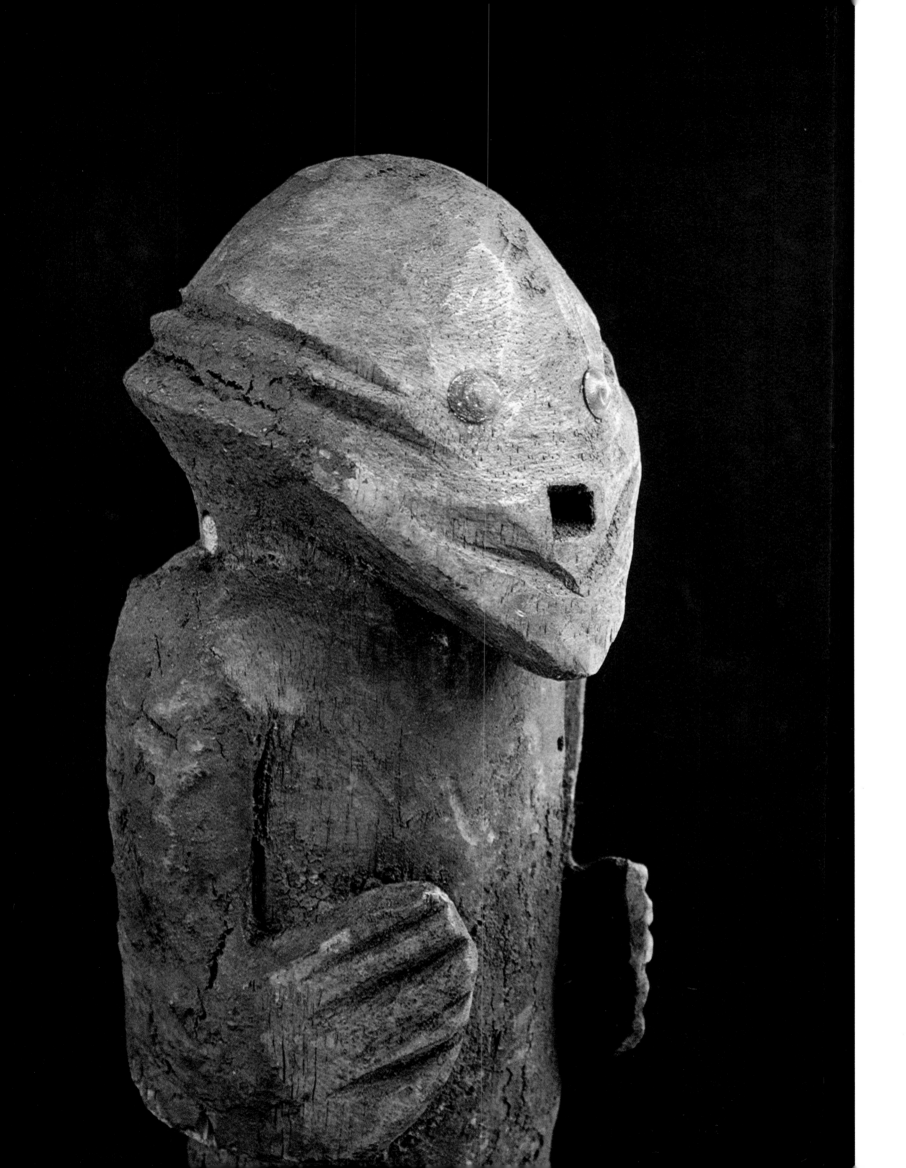

104 Anyang mask

*Wood, 44 cm, Nigeria/Cameroon. This mask –
covered with antelope hide where once there
would have been human skin – had an
important role in the Ekpo society. A
stylistically beautiful piece of Anyang work.*

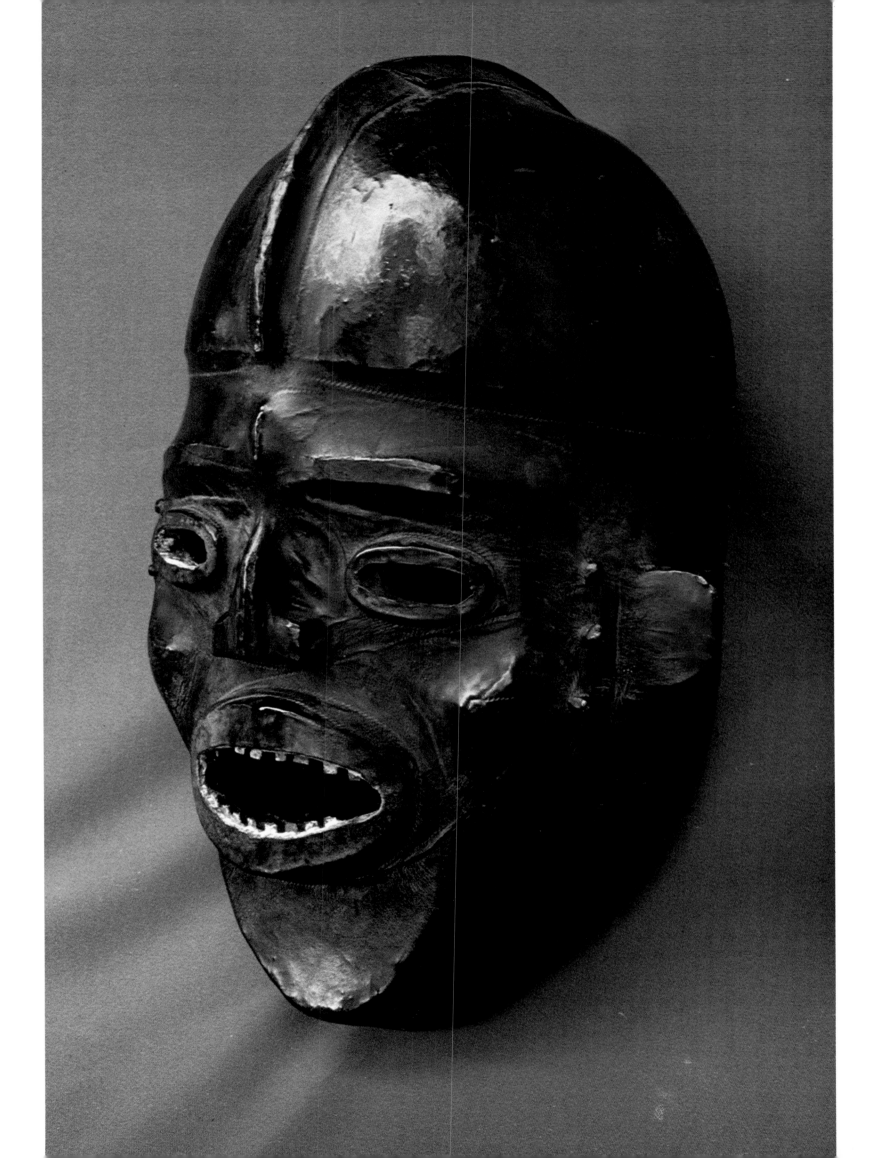

105 Ikom (? Mambila) dance headdress

Wood, 38 cm, Nigeria. An unreal composition of human face and an animal. In form this highly original and very imaginative carving shows traces of the exuberant imagination of the nearby Cameroon grasslands.

An unusual and impressive work from the Ikom area.

Montol
Mama
Waja

Around the middle reaches of the Benue, and north towards the source of the Kaduna there lives a group of smallish peoples with a vigorous artistic heritage. Although they cannot be truly grouped together, and although each tribe has produced highly original carvings, the mutual influences are unmistakable.

Sometimes they are brought closer by similar secret societies. Sometimes they provide carvings for their neighbours – as happens, for instance, between the Montol and their immediate neighbours the Ankwe-Kemai (Goemai) and Gurka. Mention should also be made of the Afo, Mama, Jukun and Waja.

106 Montol figure

Wood, 29 cm, Nigeria. Despite its relatively small size, this starkly carved figure, with its round head, exercises no small fascination. Various medicines hang from plant-fibre string around its waist, and lend it strength. It has an iron ring around its neck, and a copper wire ring in its nose.

An unusual piece of Montol artistry.

158

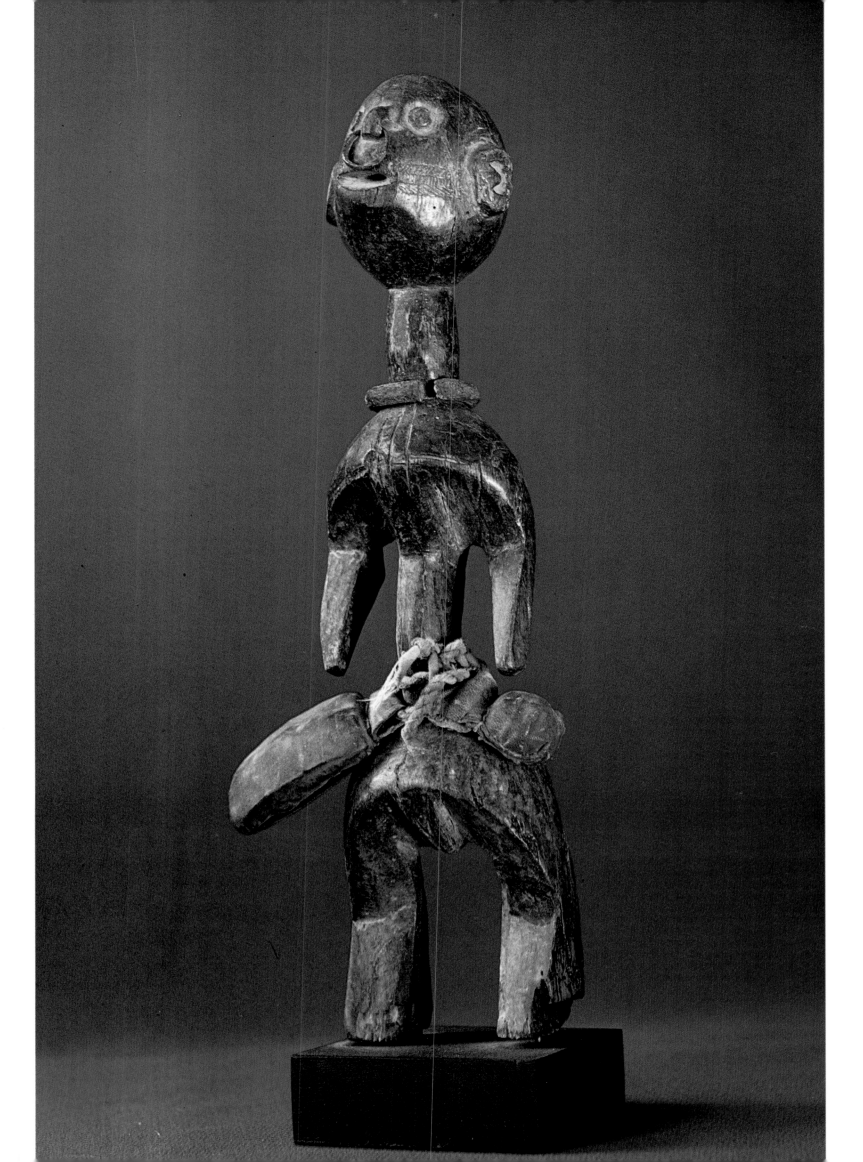

107 Mama figure

Wood, 30 cm, Nigeria. A rudimentary carving of primordial power. This example shows how distortion of anatomical details may occasionally be more expressive than realistic representation.

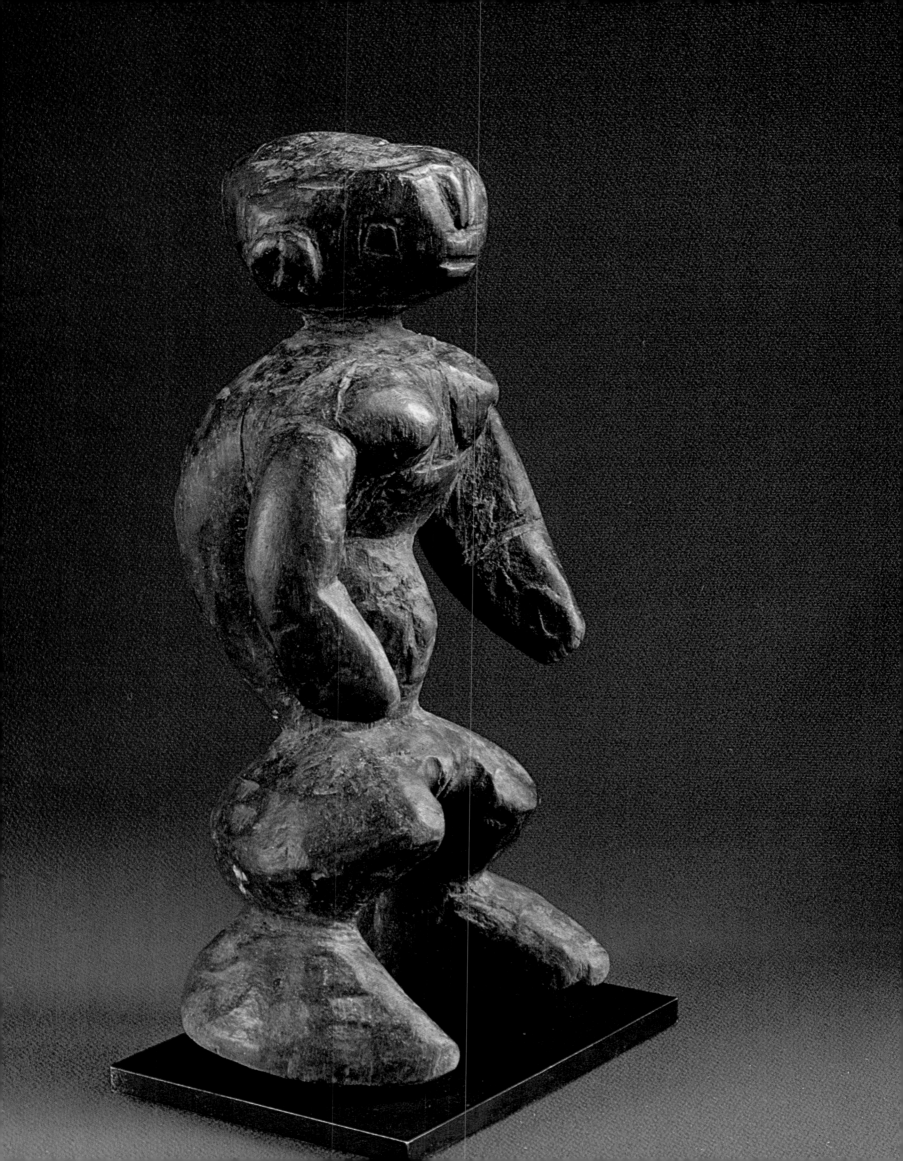

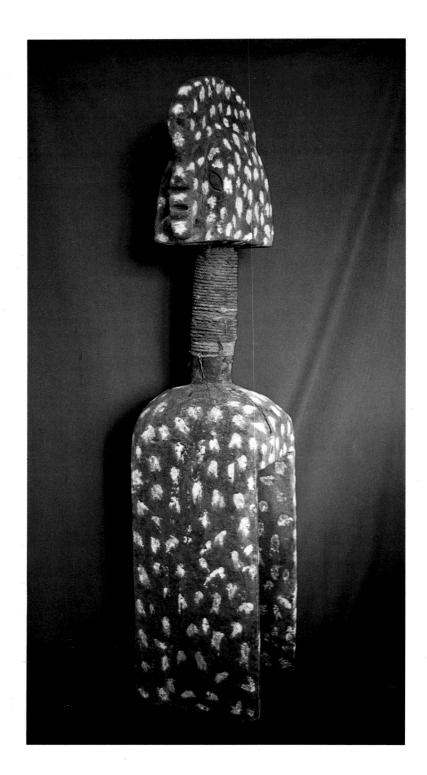

108, 109 Waja cult figure

Wood, 165 cm, Nigeria. West of where the Rivers Gangole and Benue meet lives the small Waja tribe, which collectors discovered only relatively late.

This figure, imposing in size, plays an exceptionally important role in Waja medicine. On the one hand it acts as power 'charger' to other figures, which are placed between its two board-like legs and so infused with strength; on the other it heals, for instance in cases of eczema. Potions are poured over it, and then caught and used as remedies. The white spots are in imitation of panther skin (the prerogative of notables), and every chief who visited the figure had, as a special honour, to add a dot.

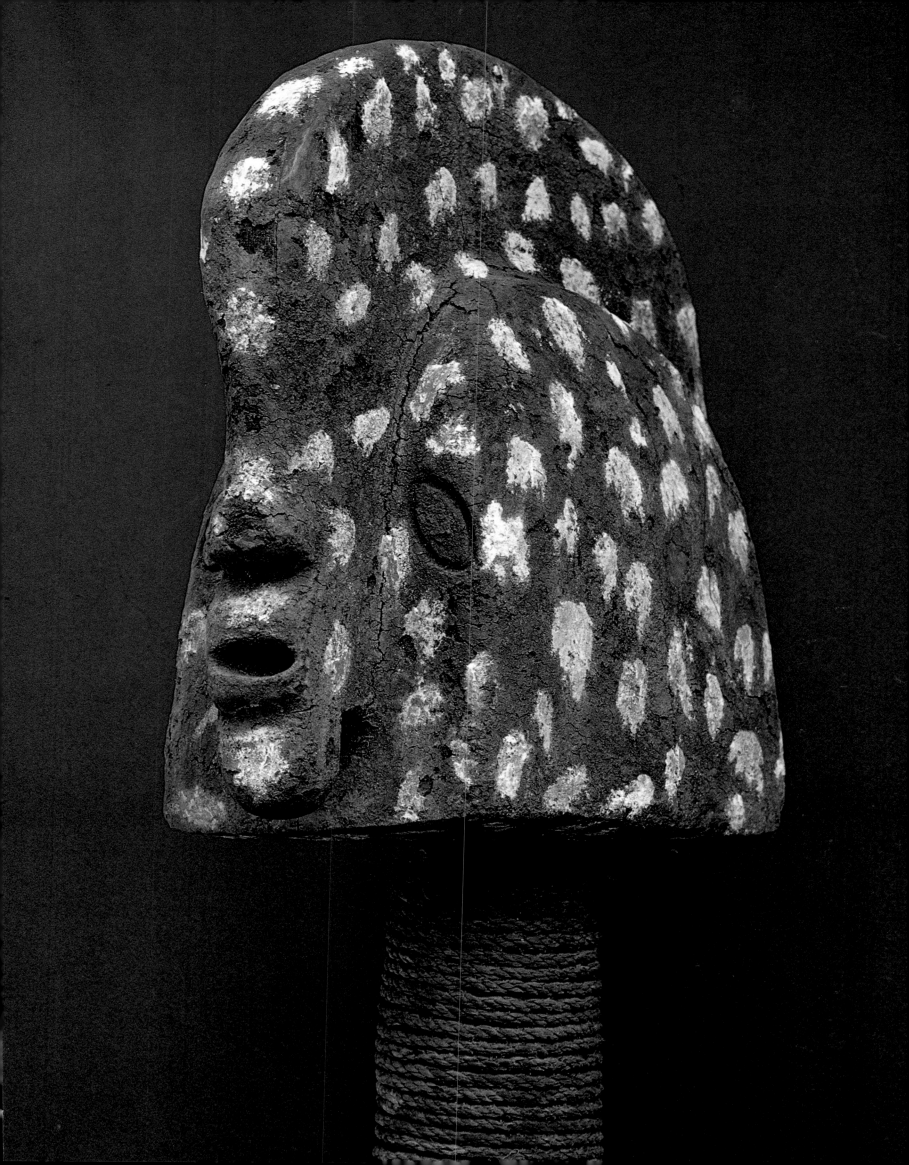

Sao

South of Lake Chad in Cameroon and neighbouring Nigeria and Chad there once lived peoples whom today we know as Sao. Through excavations, the odd rare written testimony, and the oral heritage of the supposed main descendants of the Kotoko we have been able to form a reasonably accurate picture of Sao culture and history. Sao means 'men', in the sense of 'men of former times'. It also, however, means 'unbelievers'. Some of the Sao would appear to have arrived from the north and north-east as early as 500 BC. In time the once independent kingdom was destroyed by endless fighting with the Moslems. The need for food and the gradual transformation of the country into steppe and desert also

110 Sao terracotta

16 cm high, 38 cm long, Cameroon. This terracotta, representing the mythic Original Creature, was dug up at Niamey a few years ago. All the forms are utterly simple. Around the neck are traces of a decorative band of cowries. The decoration on the back and sides was achieved by application of fabrics – a technique that has also been used outside Africa. The age of this piece is uncertain, but it must be between 600 and 800 years old.

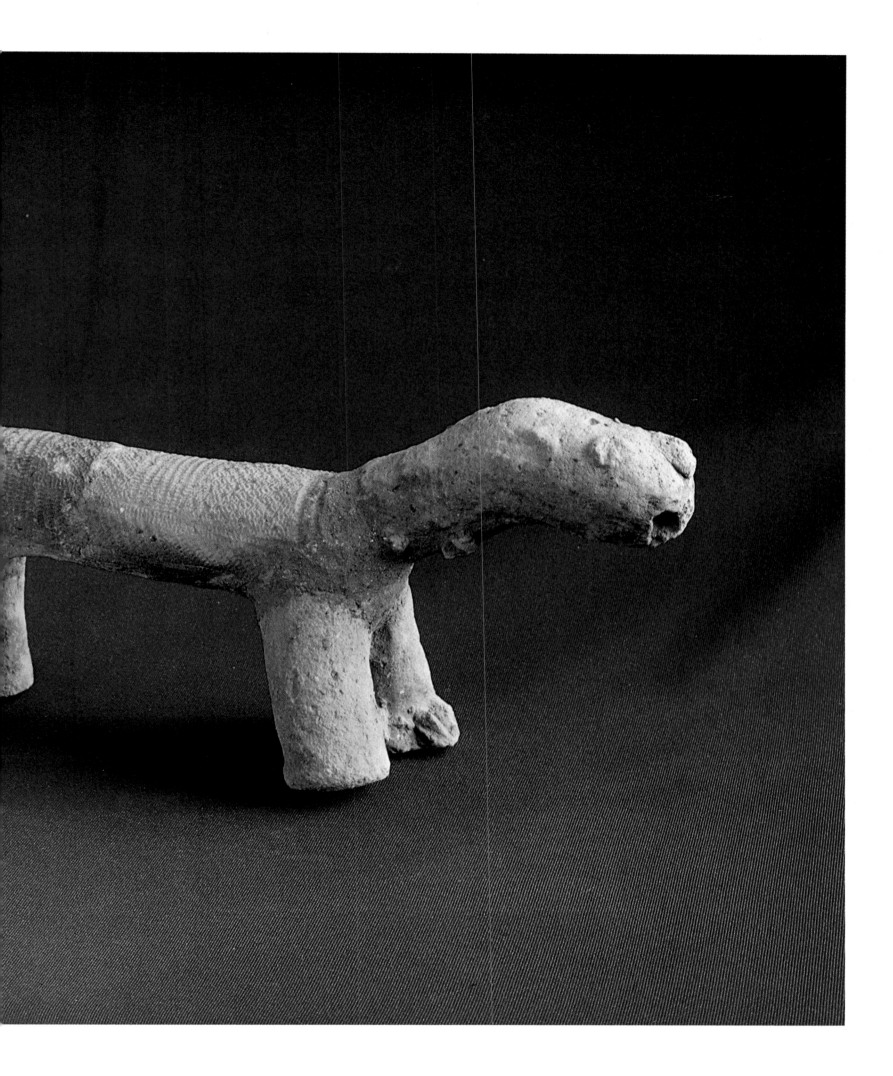

probably contributed to its collapse. The Sao scattered, and their influence is detectable right down to the southern reaches of the River Benue.

Recent investigations show that their heyday must have lasted more than 2000 years. The final traces date from the mid-19th century. Their zenith was roughly from the 10th century to the 16th.

Apart from human and animal figures for ritual use, the finds include bowls, jugs, pipe-bowls, even bells, clay pipes, and iron armlets and arrow heads. The Sao were skilled metal-casters, as is clear from their bronze bowls (1–2 mm thick), figures and animals etc. Stone, ivory and glass (bead) work has also been found.

Vere

111 Vere figure

South of where the Benue crosses the Nigeria/Cameroon border, in the Shebshi mountain area, lives the small Vere tribe. Artistically it is not very prolific. We know of wood and brass figures (mostly small), though their function remains obscure.

Wood, 65 cm, Nigeria. Large ancestral figure with highly stylized torso and head. The huge, heavy ears look like appendages. The round holes and big notch that indicate eyes and mouth, and the general tenseness of the figure make this an uncommon, but stylistically true Vere work.

166

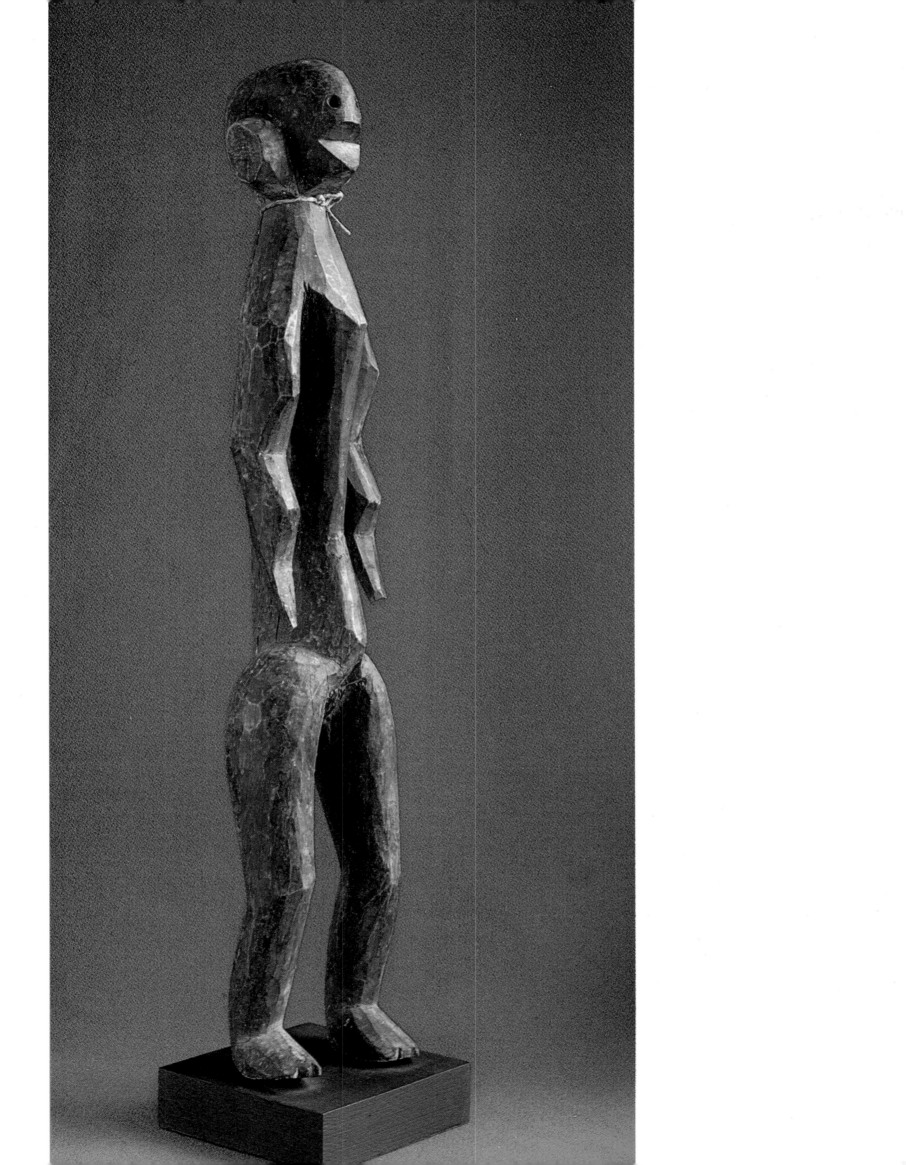

Mumuye

The Mumuye, in the River Benue/Cameroon border triangle, were only discovered in the sixties through their stylistically highly original ancestral figures, which had previously been attributed to the Chamba. They protected houses, were guardians of law, and were responsible for the life-giving rain. One almost never comes across Mumuye masks.

Mumuye influences have left their mark round about.

112 Mumuye ancestral figure

Wood, 92 cm, Nigeria. Long, powerful arms, short, stylized legs, a small head on a long neck, and hair hanging on the sides, away from the head are all characteristic of this fascinating figurative style.

Paint – here white, black and ochre – is unusual. The neck is adorned with hemp string and an attractive pendant skilfully made of coloured glass beads and cowrie shells. The same rhythmic movement is repeated three times, in the hair, the shoulders and arms, and the legs, thus lending the figure a certain tautness.

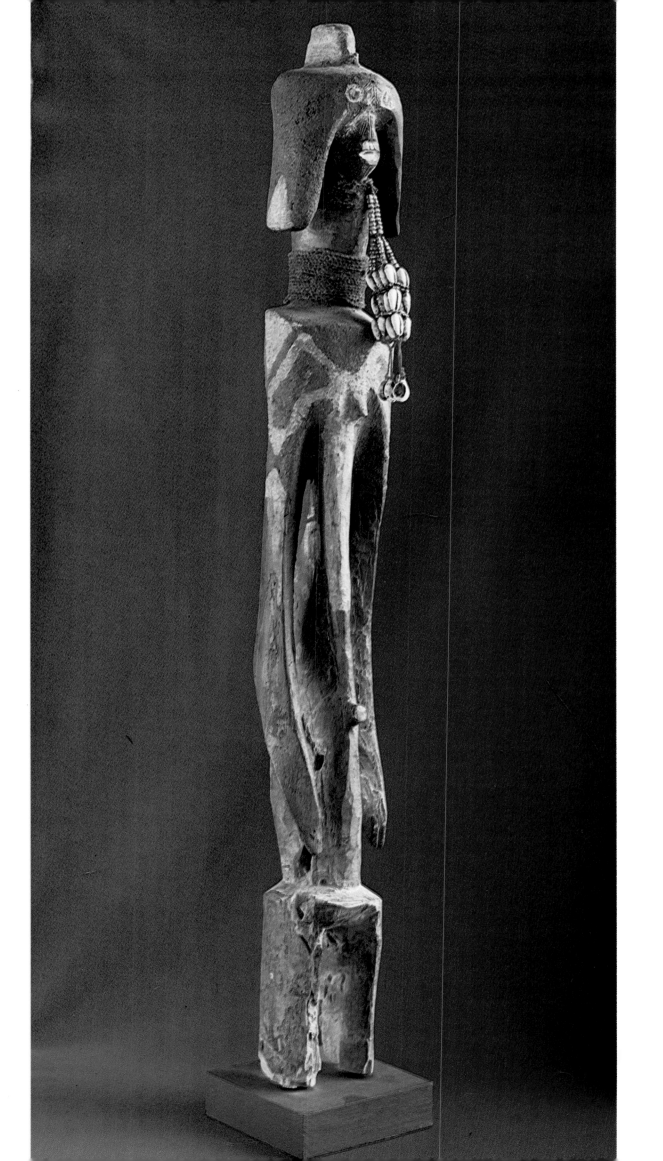

113 Mumuye mask

42 cm, Nigeria. A bush cow from the village of Pantisava in north-eastern Nigeria. Slight traces of colour indicate that it was once painted red and white. It would appear that this somewhat rare mask was carved by the Yakoko, a small tribe settled east of the Mumuye. The left horn was missing, and has here been replaced.

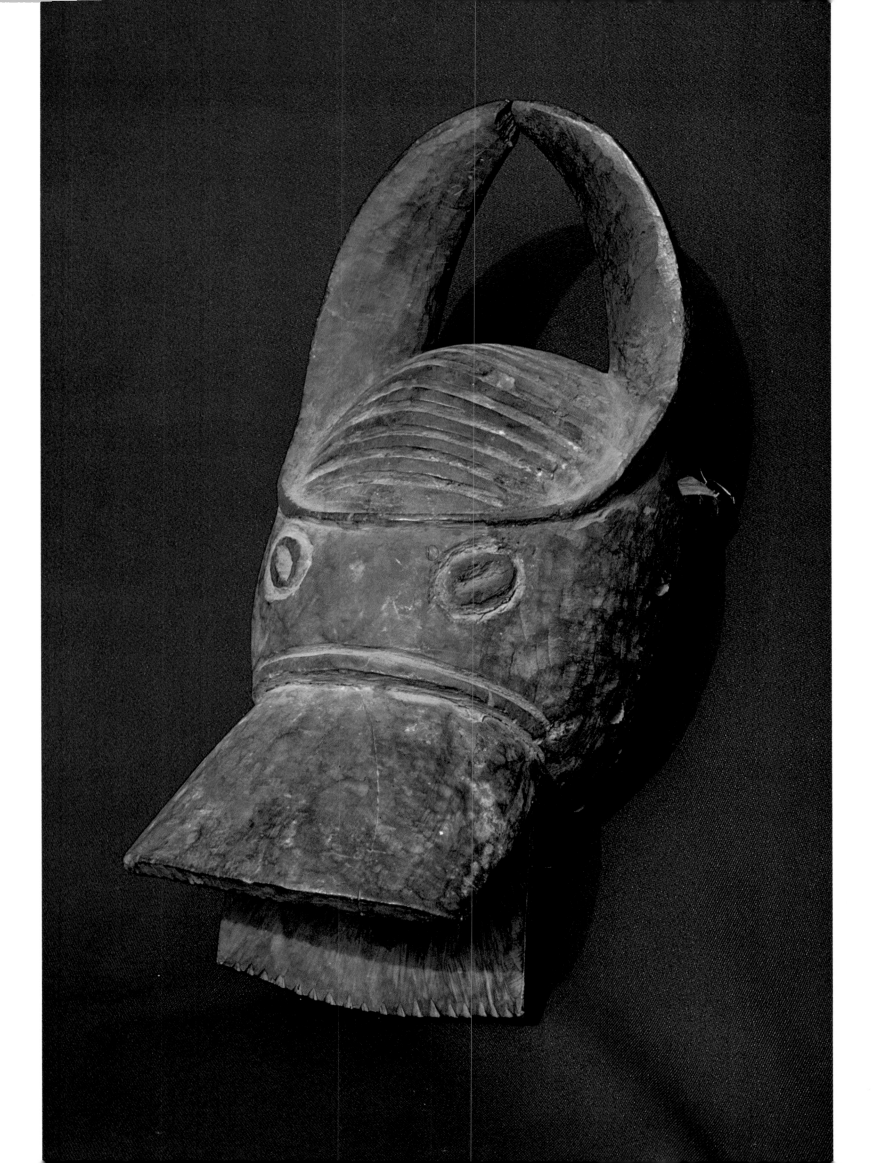

Mambila

Between the upper reaches of the Rivers Donga and Taraba in Nigeria, near the Cameroon border, and south of the Jukun, live the Mambila, who have their own style, yet who, not surprisingly, also betray many influences from the carvings of surrounding tribes. They seem very fond of camwood powder, as most of their figures and masks are coloured with it.

114 Mambila figure

Wood, 33 cm, Nigeria. A splendid cubist work. The concave, heart-shaped face and the 'brush' hairstyle (created with small pegs) are particularly striking. A rare, stylistically pure Mambila ancestral figure.

172

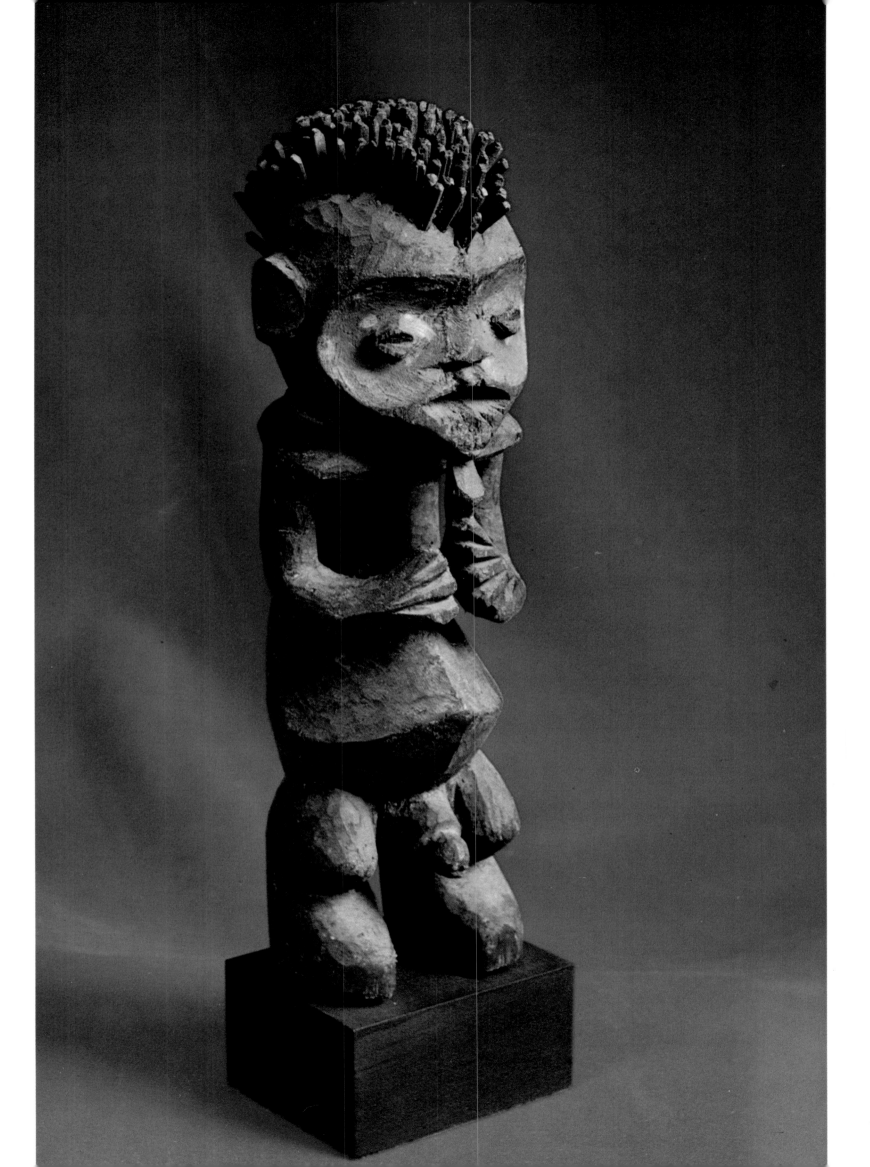

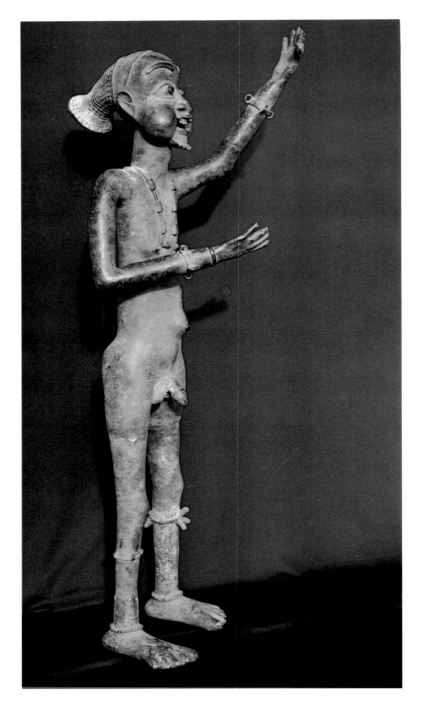

Bamum
Bamileke
Bagam
Bacham
Kossi

Cameroon is a land of many contrasts, and of startling beauty. In the north of it lie the humid and dry savannas, in the south the rain-forest. And corresponding to this geographical variety it (or more precisely the Cameroon grasslands in the south-west) boasts wide and impressive artistic variety which, stylistically, is outstanding in the overall context of African art. This is thanks largely to the royal courts, which attracted artists and provided them with constant encouragement. Thus many works serve a purely representational purpose. In many ways Cameroon art has a liveliness of expression and a generosity of imaginative conception that seem to derive directly

115, 116 Bamileke bronze figure

147 cm, Cameroon. A forceful figure full of almost overwhelming life. Such movement is to be found, in more restrained form, in many Cameroon figures. An ancestral figure, this was housed with a family of notables in a specially constructed house. The puffed-out cheeks are a sign of wealth and vitality. A certain Bafum/ Kom influence is detectable.

A very fine, rare, good-quality bronze of early Bamileke work.

174

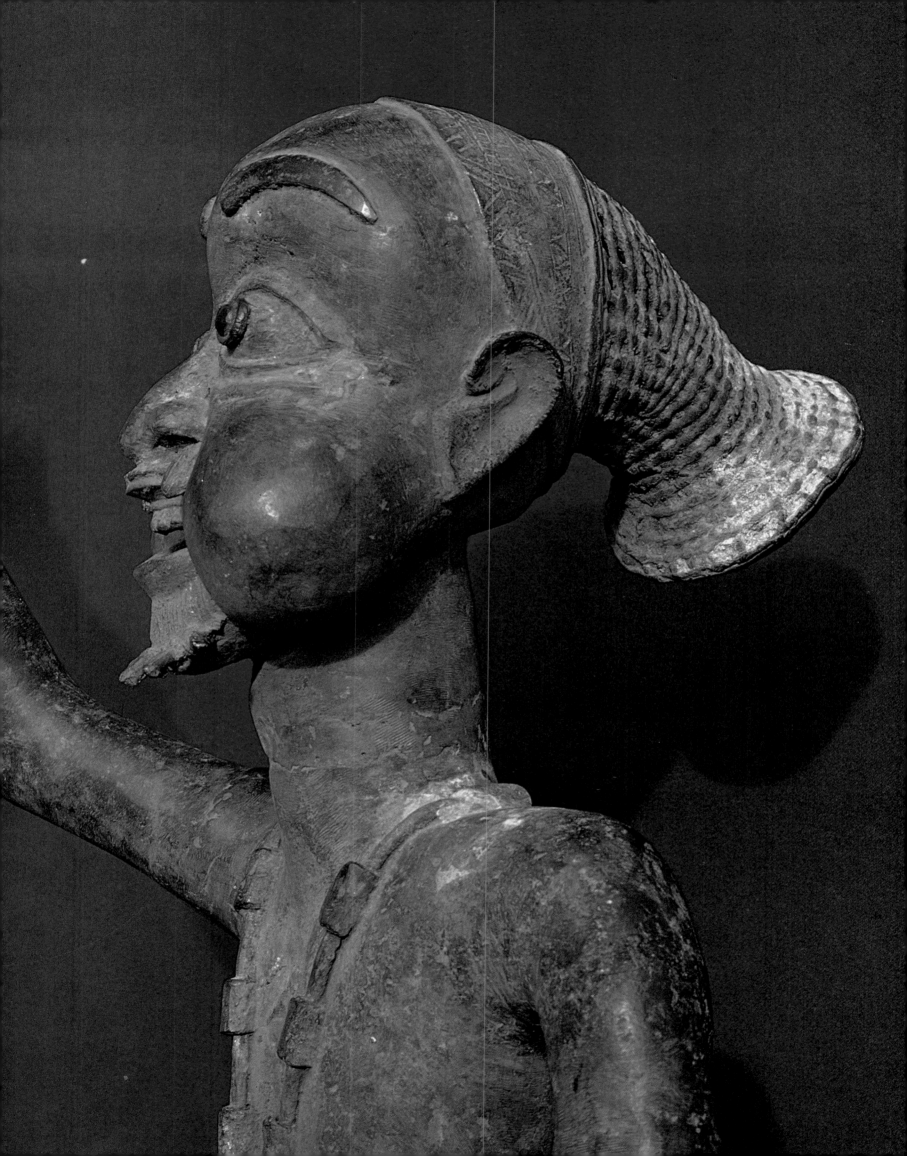

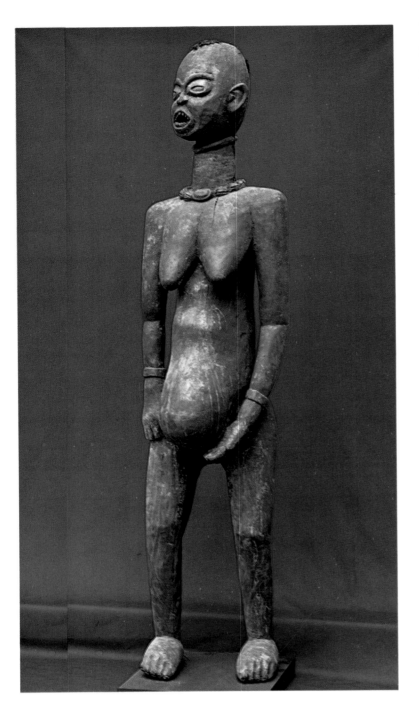

from the luxuriance of the natural surroundings. As well as the figures and masks, the functional everyday objects bear eloquent witness to the vitality of this country's art (inspired, we are fairly certain, by the Tikar, who at one point had arrived from the north).

The most important peoples in the Cameroon grasslands are the Bamum and the Bamileke groups; then come many confederations of smaller tribes, such as the Bagam and the Bacham to the east.

It is often hard to attribute individual art works to this or that people, as the most disparate styles occur throughout the country. This uncertainty is enhanced by the fact that exchanges are often made. It is not therefore surprising that attributions are often followed by a question mark.

South-west of the Bamileke group lives the Kossi group (Bafing and Balong). There are only few works by these peoples.

117, 118 Bamileke figure

Wood, 152 cm, Cameroon. This figure of a very pregnant woman, dedicated to the fertility cult, and preserved in the greatest secrecy, could only be seen and touched by women who were shortly to give birth. Touching it helped them to a smooth birth and a healthy, beautiful child. The hair on the head and private parts is real human hair. Traces of sacrifices are clearly visible, together with patches of red camwood powder.

A very large, stylistically superb figure.

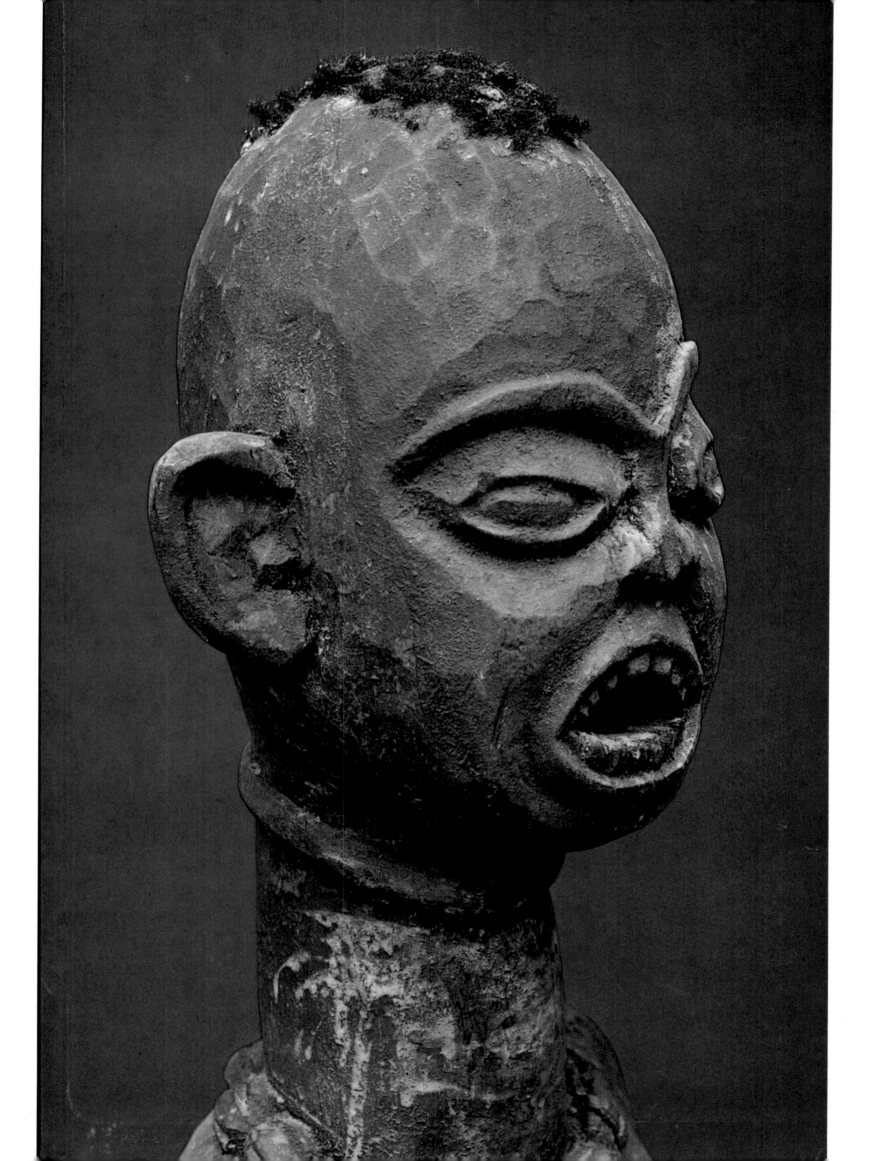

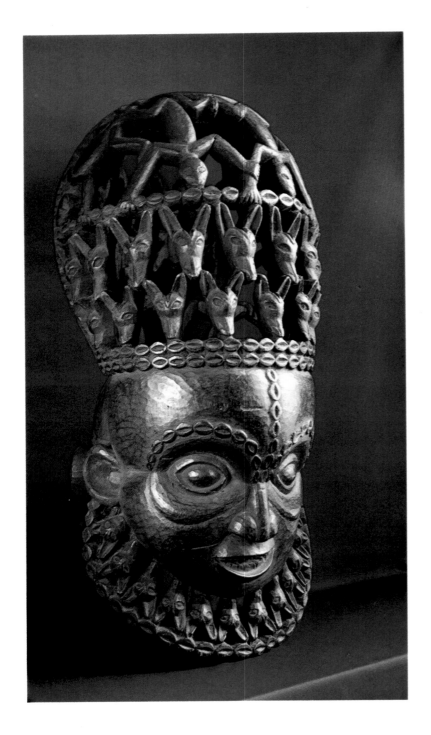

119 Bamileke Janus mask

Wood, 85 cm, Cameroon. A product of court art, of great beauty and representational power. The lower section of the skilfully managed headdress consists of two rows of heads belonging to some kind of canine – jackal or fox. Above these is a pyramid of animals, possibly frogs. Between the two sections a row of cowries. Elements of the headdress are mirrored in the beard. The back of the mask bears a female face. Overall an elegant carving.

120 Bacham mask

Wood, 101 cm, Cameroon. This extremely interesting composition is monumental in conception and cubist in actual realization. Artistically speaking, Bacham masks are among the most important cult objects in African art. They are in every inch a classic product of the Cameroon grasslands. One can easily imagine the effect on people in the dark.

178

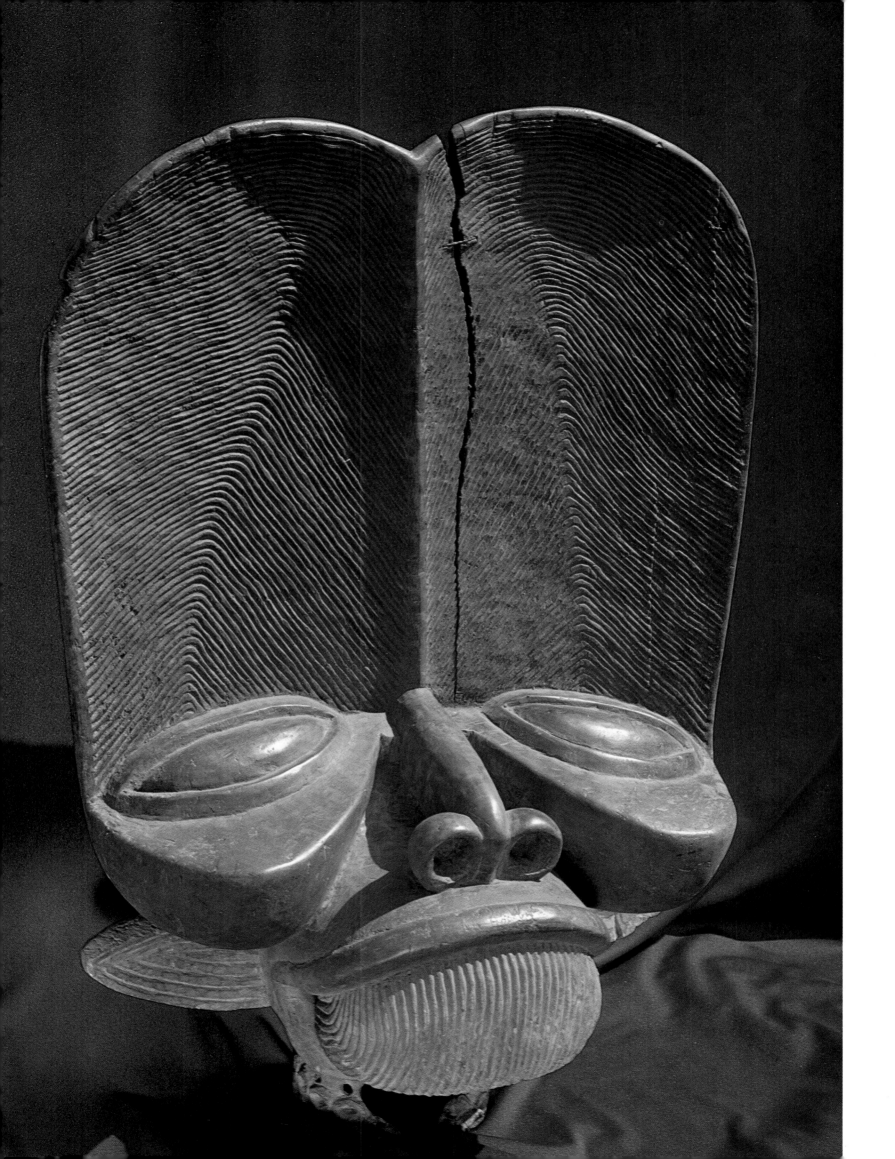

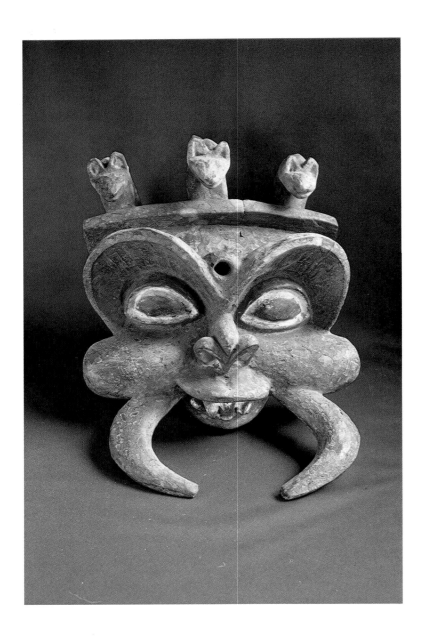

121 Bamileke mask

*Wood, 42 cm, Cameroon. This mask bursts
with life and imaginative force. The eyes, under
their heavy projecting arches, are wide awake.
Between them is a bump with a round hole in it,
in which there was once a leaf-shaped wooden
horn. The open mouth with its pushed out lips
reveals white, pointed teeth (ideal of beauty).
Powerful boar's tusks emerge from the corners
of the mouth. Surmounting the roof-like head
are three ant-eaters. Many details here are
reminiscent of the masks of the Bacham to the
east (pl. 120).*

122 Bamum helmet–mask

*68 cm, Cameroon. This mask from Fumban, the
royal capital, was acquired by Germans in the
1880s. The typical Bamileke face, with its flat
nose and swollen mouth, is covered with
delicately hammered sheet copper, while the eyes,
eyebrows, and whole of the rest of the head and
mask are adorned with (then very valuable)
cowries and glass beads. A rare, and in its way
compelling mask, testifying to the quality of
Cameroon art.*

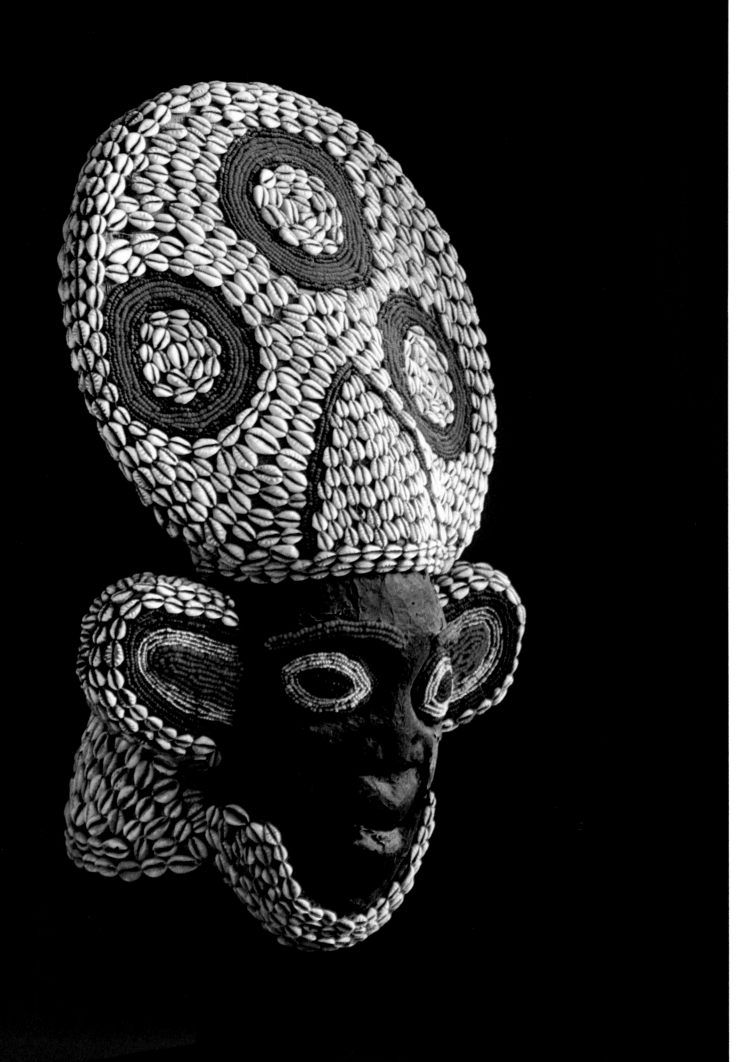

THE BODY In looking at African carvings it becomes apparent that certain parts of the body are often exaggerated in size in relation to the body as a whole. This is due to a very definite symbolic understanding of life, which also appears among many other peoples, and which we shared up until Romanticism.

The head: the seat of the intelligence and of spiritual power. Sometimes the most commanding feature of the figure (pls. 3, 130, 157, etc.).

The navel: except in cases of umbilical hernia (relatively frequent among primitive peoples), which result in an enlarging of the navel, it is viewed as the agent of contact with the ancestors, and hence with life. Through it the individual was connected to the mother, the life-giver (pl. 167, etc.).

The sex organs: exaggeration here has primarily practical, philosophical and spiritual motives, and has nothing to do with our often too one-sidedly erotic awareness

123, 124 Bamum figures

Wood/glass beads, 168 cm and 170 cm, Cameroon. These large figures once flanked the royal throne. They are probably both by the same artist. The glass beads which totally cover the wooden bodies are threaded on strings and sewn on to cloth stretched over the bodies.

The dark blue-green glass beads on the left hand figure were not produced after the end of the last century: thus these figures must really be fairly old. The thinness of these rare sculptures is arresting.

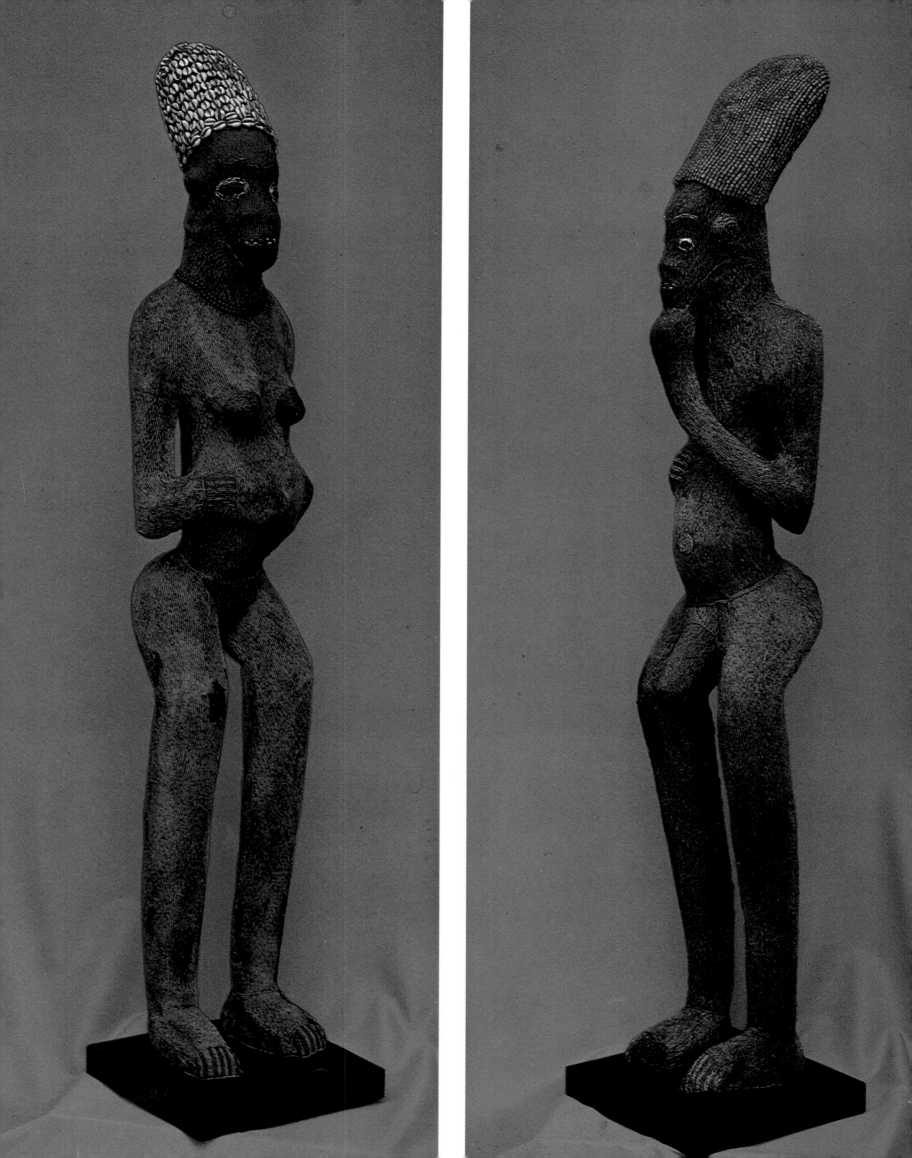

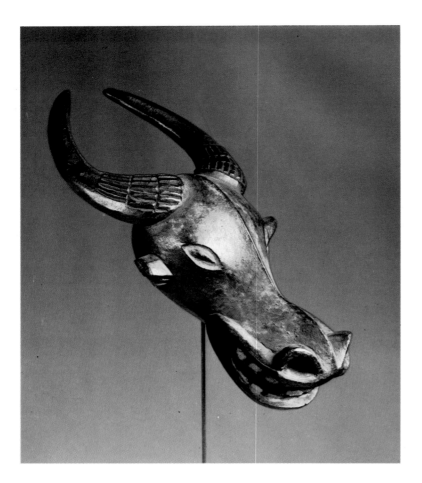

of the genitalia. High infant mortality rates and a low life expectancy make numerous children imperative. Only thus can a people or tribe survive. Fertility is thus a necessity of life. It is a gift of supernatural powers (pls. 123, 129, 143, etc.).

125 Bagam dance mask

Wood, 77 cm, Cameroon. Before the Bagam go off hunting they dance with buffalo-antelope masks like this, in order to bring good luck to the hunt. This mask is a particularly large and impressive example, and is an outstanding illustration of the liveliness of Cameroon grasslands art.

126 Kossi fetish figure

Wood, 29 cm, Cameroon. A delicate female figure on top of a small calabash. With her dark eyes set wide apart, her narrow nose, her red painted, expressive mouth, and her to us familiar, homely hairstyle, she appears almost European. The medicine container in the stomach with a mirror closing it is startling in contrast. An unusual work of great sensitivity, very unlike the vigorous, ebullient forms typical of grasslands art.

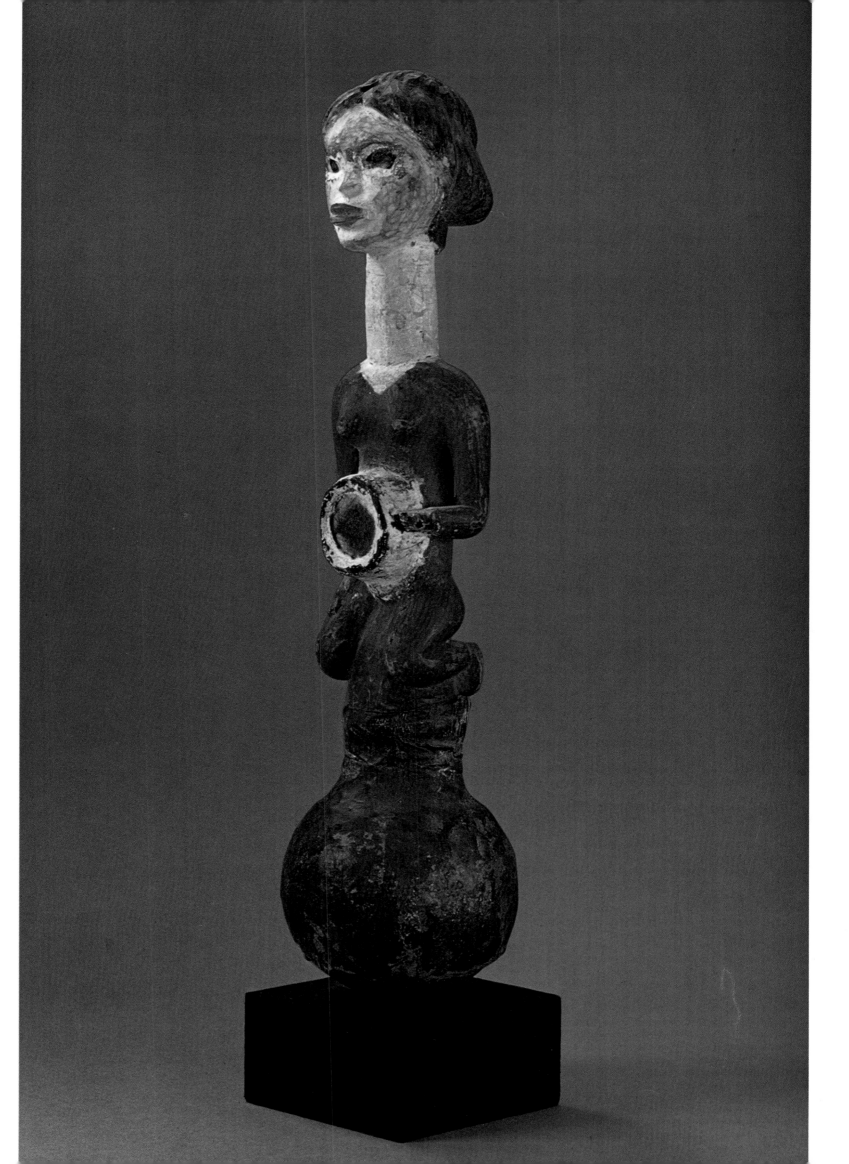

Fang
Bulu

Gabon – sliced in two by the Equator, and largely covered in rain-forest – is the centre of white masks and figures bearing the famous heart-shaped face.

The Fang are the most important and best known sub-group of the southern Pangwe – indeed today the name Fang is used to describe the whole people. They live mostly in Gabon, southern Cameroon, and Rio Muni (Equatorial Guinea), and the Republic of Congo to the east and south. Their cultural influence is widely felt. A warlike and relatively small people, their art has become famous for its reliquary figures and heads and its masks. Almost any keen collector would snap up one of their long white Ngil society masks, or one of their many different dark shiny guardian figures.

The scalps and bones of distinguished ancestors or founders of the tribe are stored in covered receptacles (known as bieri) made of bark sewn together. On the bieri are placed heads or figures which the whole family venerates as reliquaries, givers of strength, and protective powers. So powerful are they that they can cure illnesses. These reliquary figures rank among the best of Central African works of art.

The Bulu in and around Equatorial Guinea belong to the northern Pangwe.

127 Fang mask

Wood, 44 cm, Gabon. This mask, used against sorcerers and witches, comes from the village of Adzuge, in the River Abanga area, south of Equatorial Guinea. The heart-shape and white colour of this face mask with its hollowed-out features are typical. The two small masks, similar in style, on the sides make this a very rare and stylistically highly revealing example of Fang art.

186

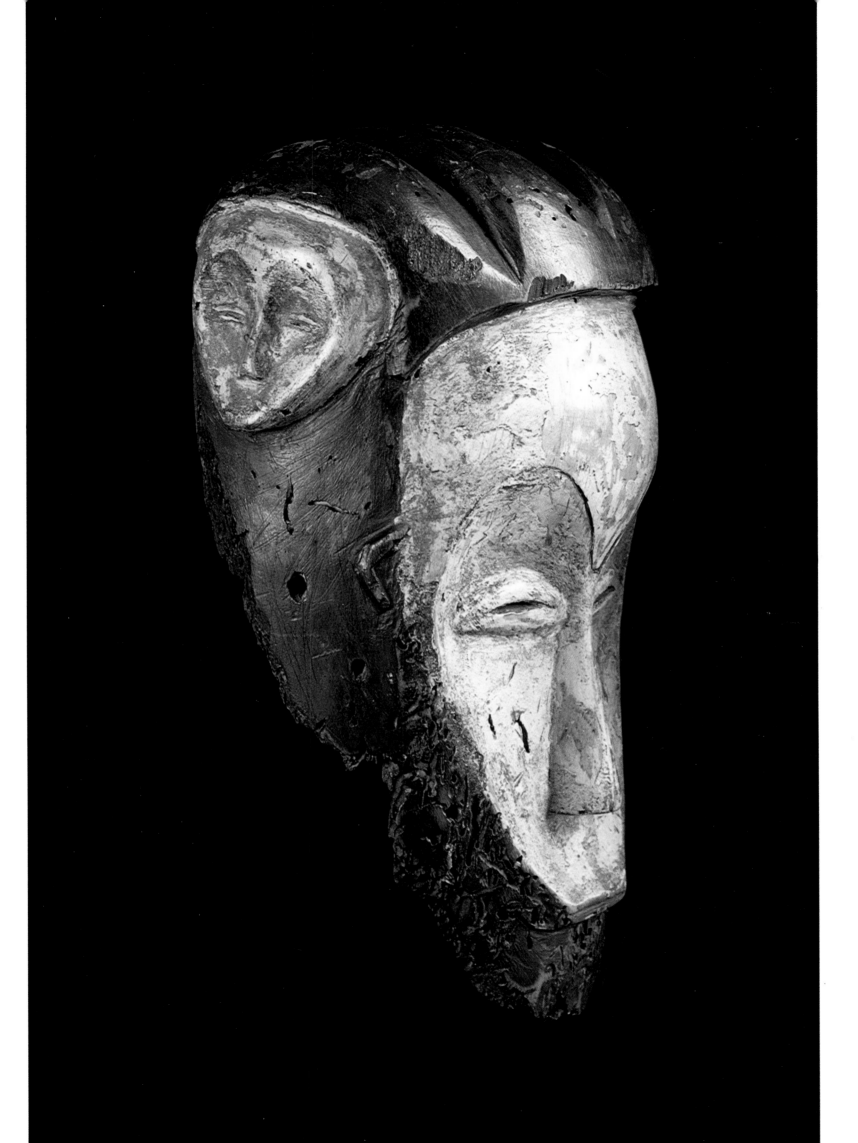

128 Fang reliquary head

Wood, 29 cm, Congo. Like the guardian figures, this bieri head was placed on top of the reliquary. Of great dignity and gravity, it is a good illustration of the spiritual quality of Fang work. The hair at the back falls in long tresses.

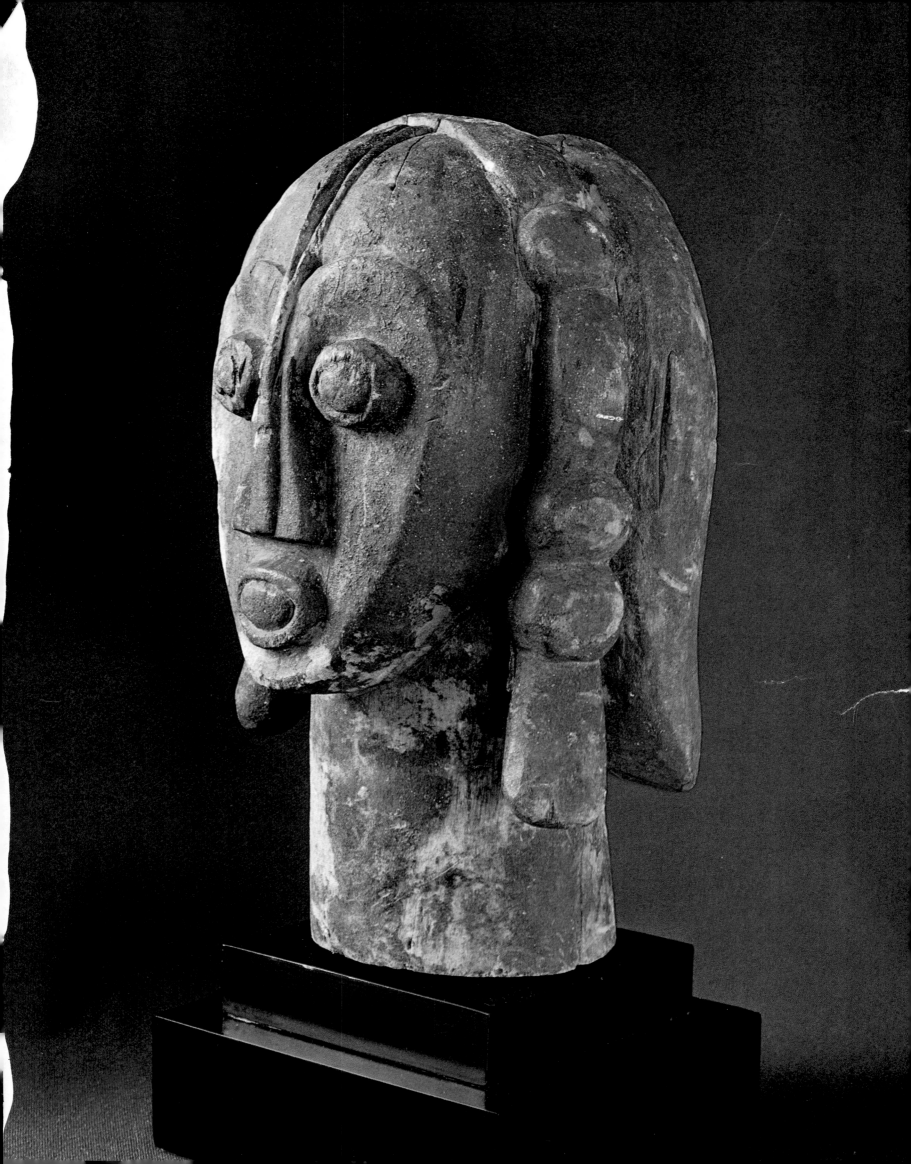

129 Fang reliquary figures

Wood, 45 cm and 51 cm, Gabon. The female figure on the right, from the border region of the Ntumu and Mvai in northern Gabon and Equatorial Guinea, is an extremely unusual example of the quite justifiably famous bieri figures. The upper part of the figure, with the round eyes in the heart-shaped face, the hair slightly curving out at the back, and the shrunk arms, is turned about 35 degrees to the left.

The slim male figure, with the brass eyes, comes from around Oyem, south of the Ntumu. The protruding navel and powerful thighs are typical.

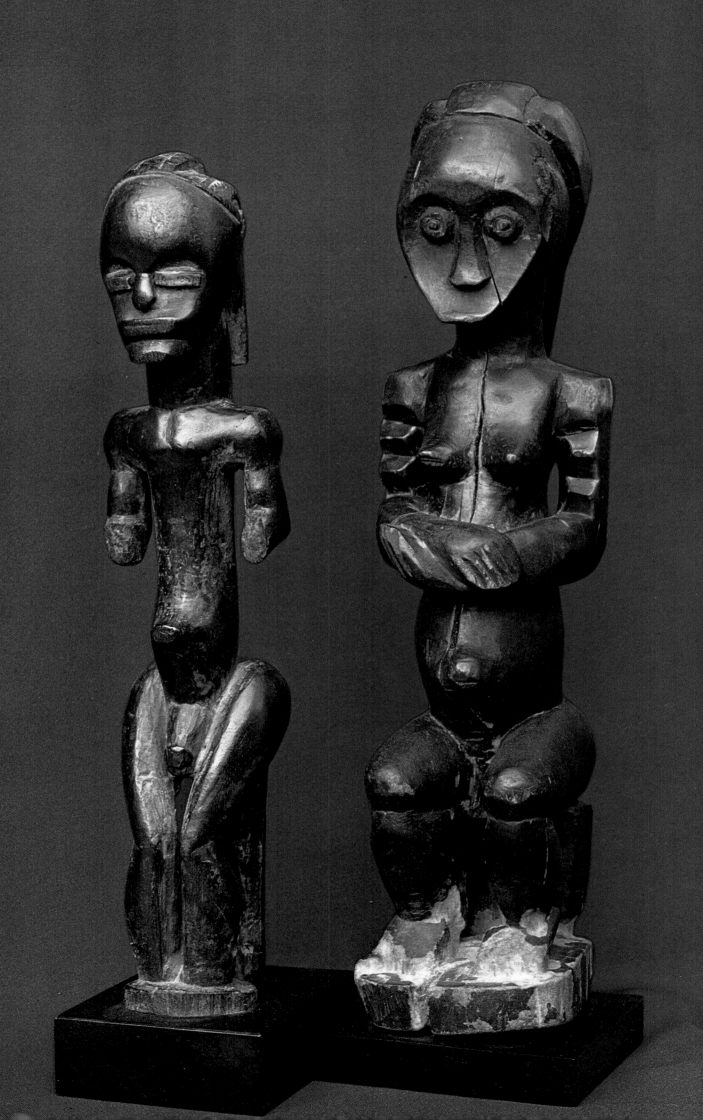

130 Fang reliquary figure

Wood, 40 cm, Gabon. The head, with its highly expressive face, from which the eyes look angrily, piercingly out, forms almost half of this monumental bieri guardian figure. The hair, arranged in two pronounced tresses, falls to the base of the short neck.

A beautiful carving, taut, powerful and very alive.

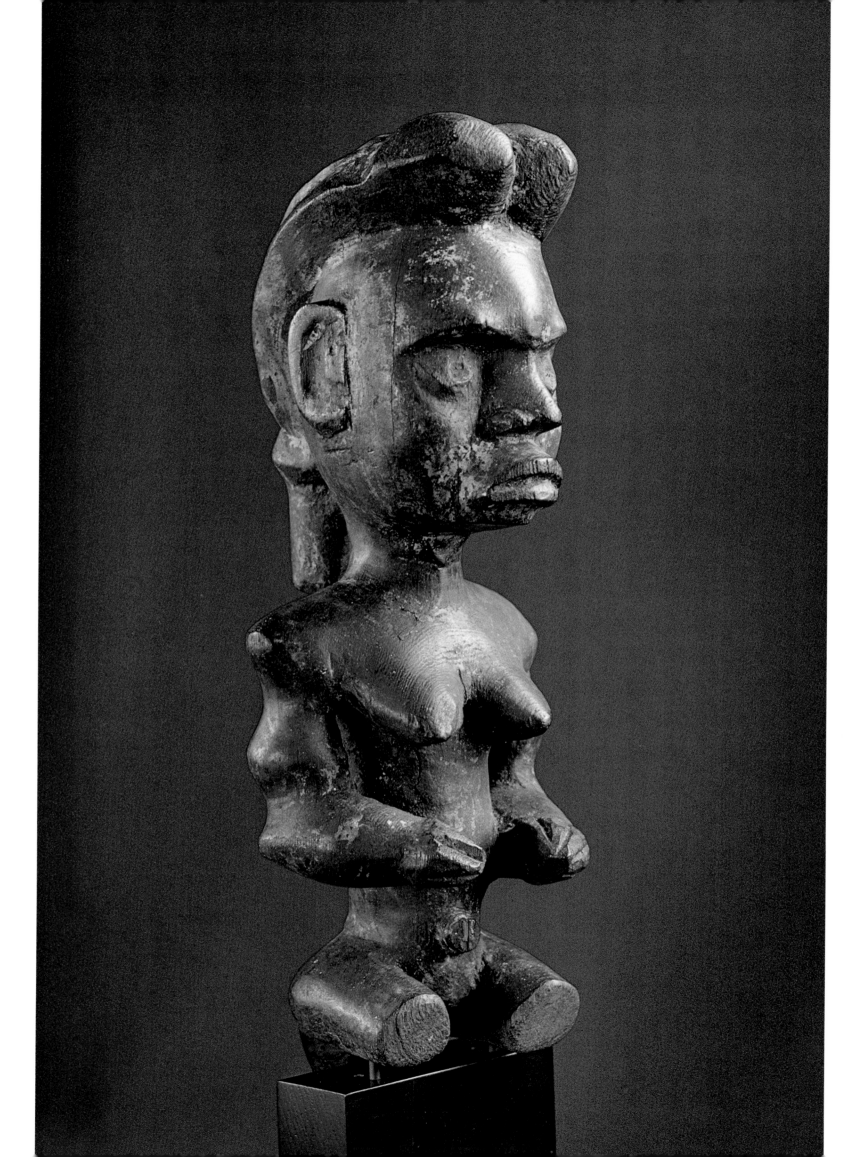

131 Bulu reliquary figure

*Wood, 40 cm, Equatorial Guinea. This figure
had the same cult function as the preceding
guardian figures. Vertical scratch marks are
clearly visible on the mouth, forehead and
breasts. For a long time no one was able to
explain these. Hungry mice were only too
pleased to take the food left as a ritual sacrifice
on the mouth. The riddle was solved when
certain of the offenders were caught red-handed.*

*The figure is remarkable for its rounded,
finished forms.*

194

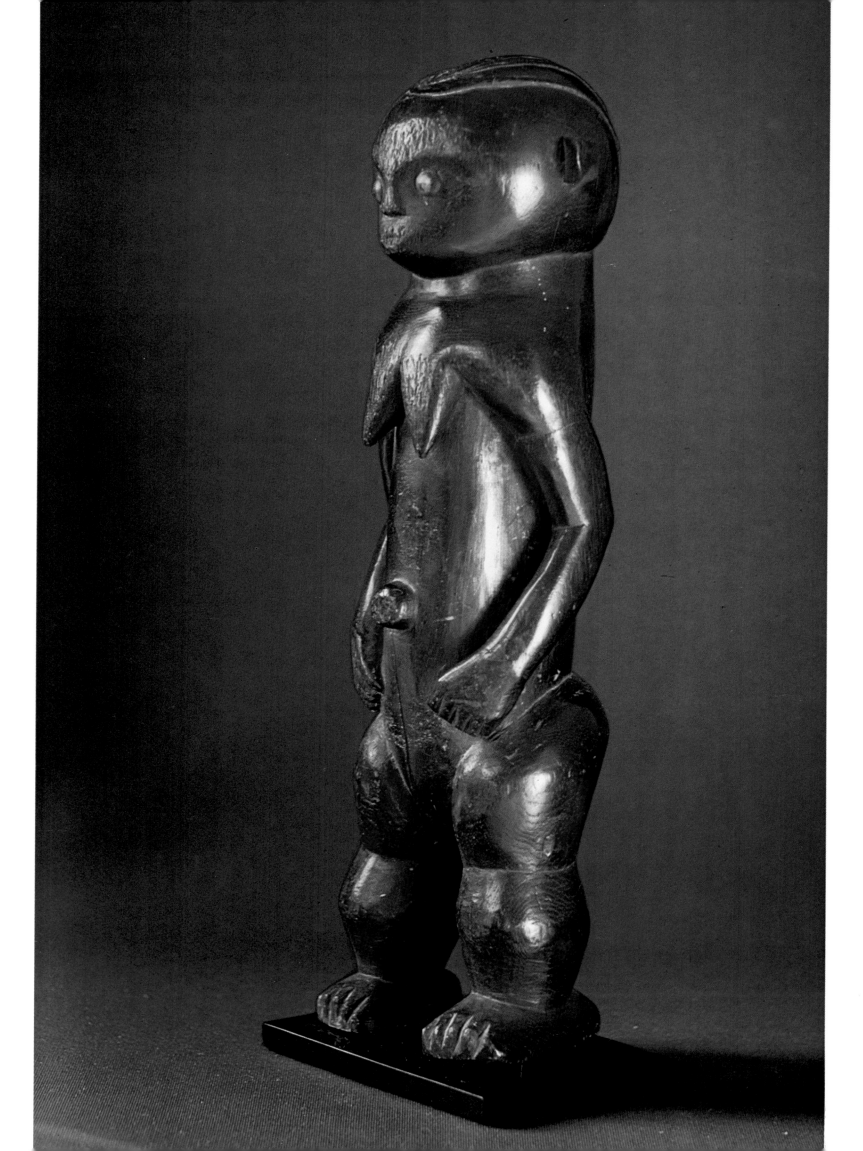

Kwele
Kota
Hongwe

The reputation of the Kwele in the north of the Republic of Congo, on the south-eastern Cameroon border, and in Gabon, is due to their severely stylized, startlingly simple masks. They are all particularly beautiful examples of the heart-shaped face style. The same is true of their figures, but these are even rarer than their masks.

In eastern Gabon and the south of the Republic of Congo live the Kota, whose reliquary figures, like those of other Gabon peoples, serve the cult of ancestors and appear in many different variants, though always along the same basic lines. They are divided into a southern and a northern group.

The Hongwe (formerly known as Kota or Ossyeba) are artistically closely related to the Kota. Recent research has shown, however, that there is not the same ethnic relationship. Their guardian figures are still few and far between. Stylistically all three share much in common and are related to the Fang in northern Gabon.

132 Kwele mask

Wood, 45 cm, Gabon. A classic, very beautiful mask, worn over the head. The horns, joining together at the bottom to form a characteristic heart shape, perfectly frame the stylized heart-face. A magnificent work of great aesthetic value – a consummate modern sculpture. It was collected by Philipp Guimiot, who lived in the country for many years.

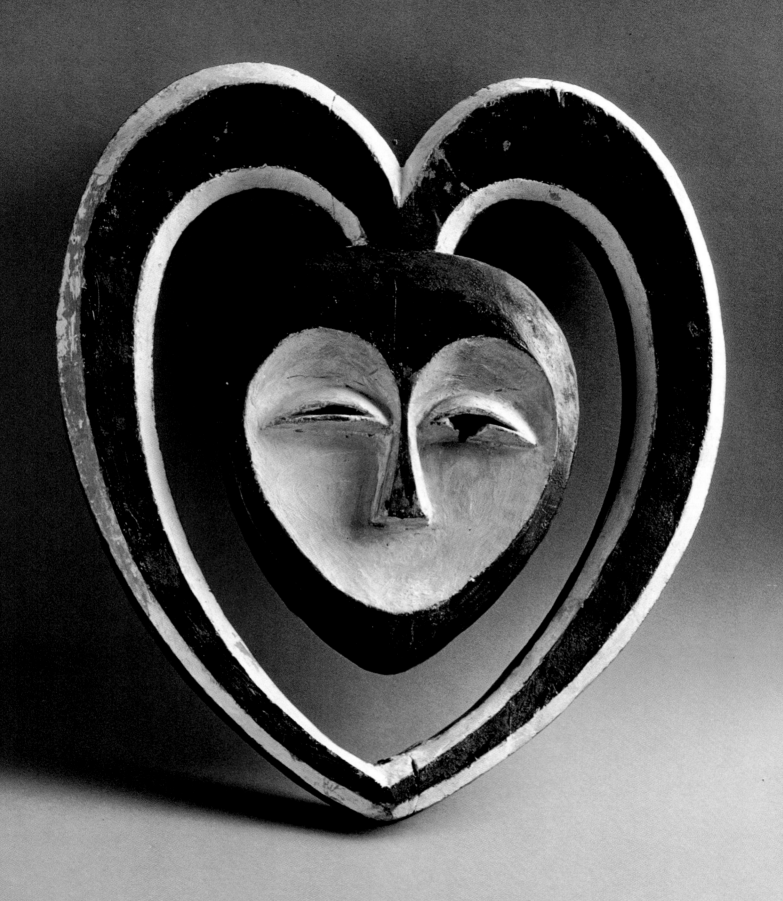

133 Kota reliquary figure

Wood/metal, 43 cm, Gabon. A very fine Mbulu-ngulu guardian figure. It is remarkably satisfying in form, with its heart-shaped, concave face, and slightly convex forehead (all of which points to the Shamaye/Obamba secondary style). Very thin sheet brass and copper was used for this figure. The shape of the eyes, the extension of the narrow nose up to the hairline, and the tiny, half-open mouth are all typical of this secondary style.

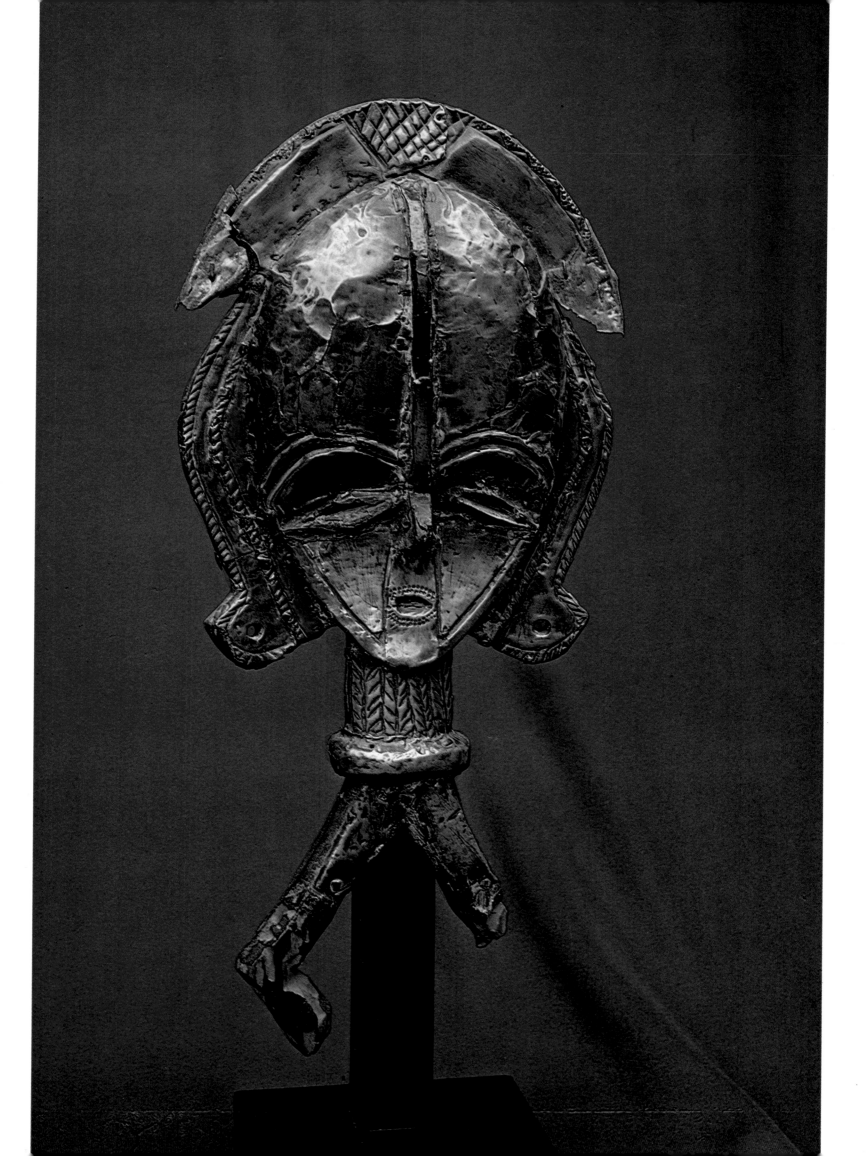

134 Hongwe reliquary figure

*Wood/copper, 50 cm, Gabon. This figure
served the same purpose as Fang or Kota
guardian figures. In contrast to the complex
conceptual ideas, the style is very uniform –
though by no means monotonous. The interplay
of the pointed oval, concave shape of the head
and the curvature of the profile offers great
possibilities. In the hands of a gifted artist the
Hongwe Bweti can be brought to a supreme
pitch of perfection.*

*The face is covered with fine copper strips.
Identical strips, inset into the copper covering
sheet, form a charming pattern on the back.
Knob-like eyes, a knife-edge nose, and a
vertical band form the few features of this face,
above which rises the traditional Hongwe
topknot. The downward curving copper wires
below the eyes are signs of tears.*

*The piece comes from Makoku, and the
materials, techniques and strengthening agents
used all indicate that it is about a hundred years
old, if not more. Its excellent condition is due to
careful looking after, the hardness of the wood,
and its having been kept under shelter.*

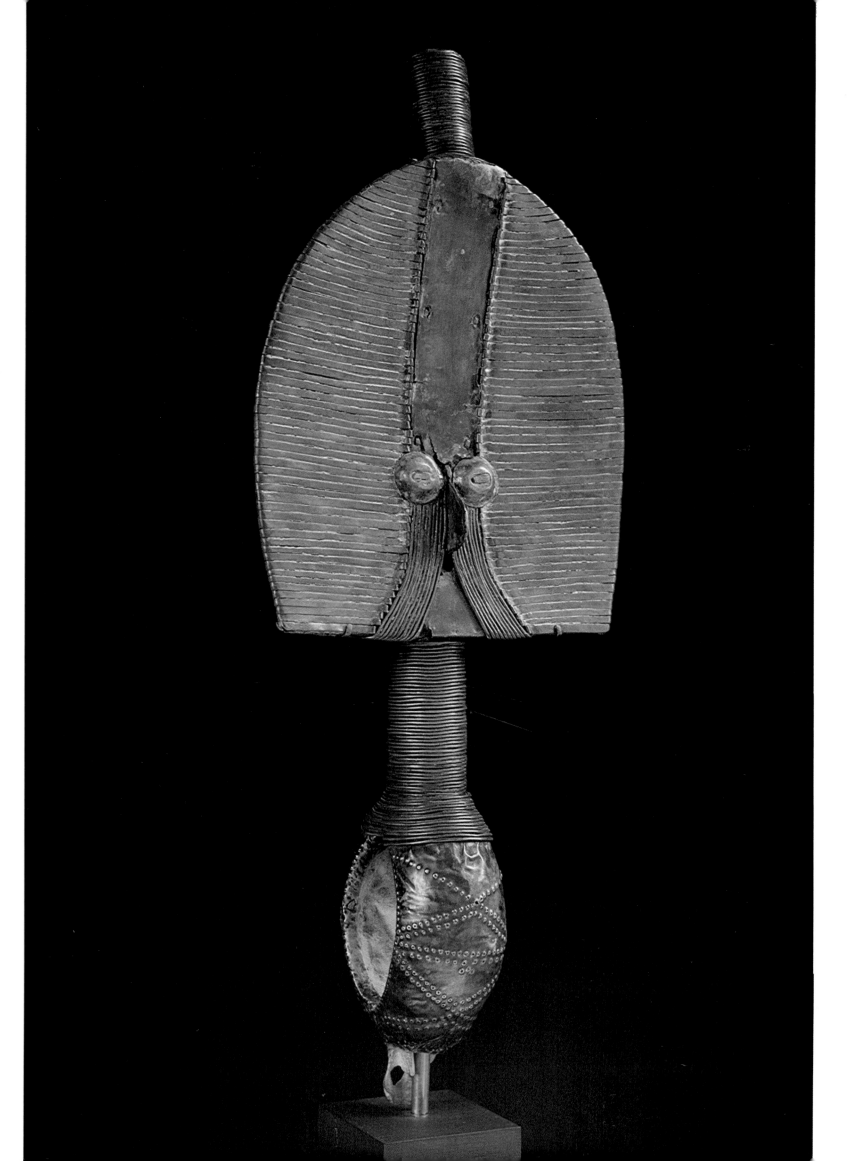

Kuyu

The Kuyu, in the Likuala area in the Republic of Congo, have developed a style that clearly distinguishes them from the surrounding peoples. They are known for their dance staffs, which as a rule are adorned with multi-coloured painted heads (very occasionally with whole figures). These staffs are used in the Kebekebe snake dance, danced in honour of the mythical snake Ebongo, creator of the first man.

135, 136, 137 Kuyu dance staff

Wood, 53 cm, Republic of Congo. Belgian missionaries came across this double-headed dance staff in 1927 near the source of the Ogowe – thus some distance from its native home. The white face with the strongly stylized tear marks stands for death and grief, the ochre for life and joy. This rare carving indicates that all is visible, nothing can remain hidden. With the use of a little imagination a third face can be seen on the side.

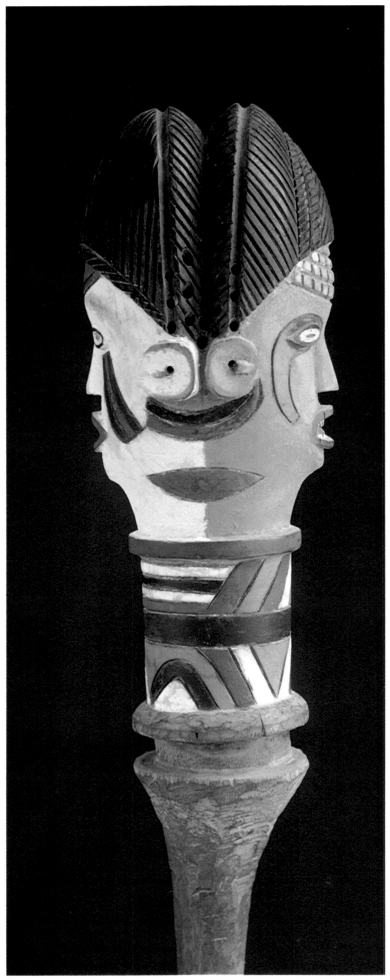

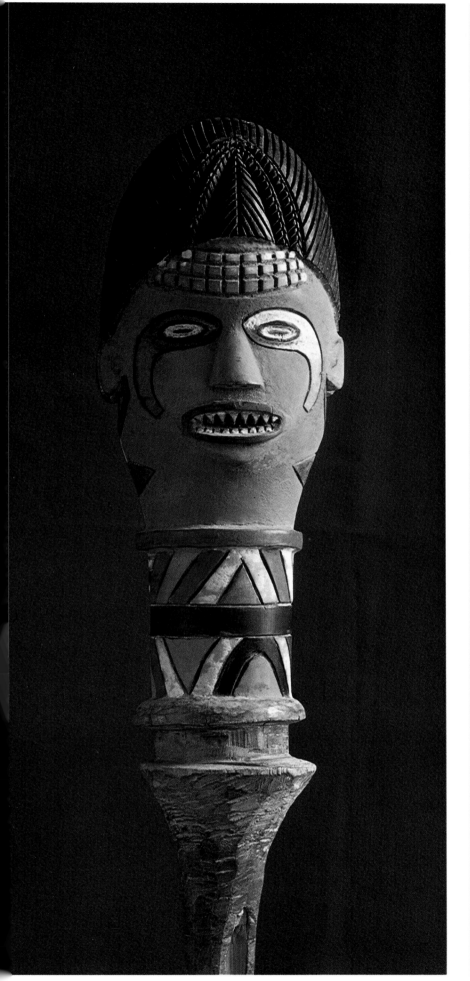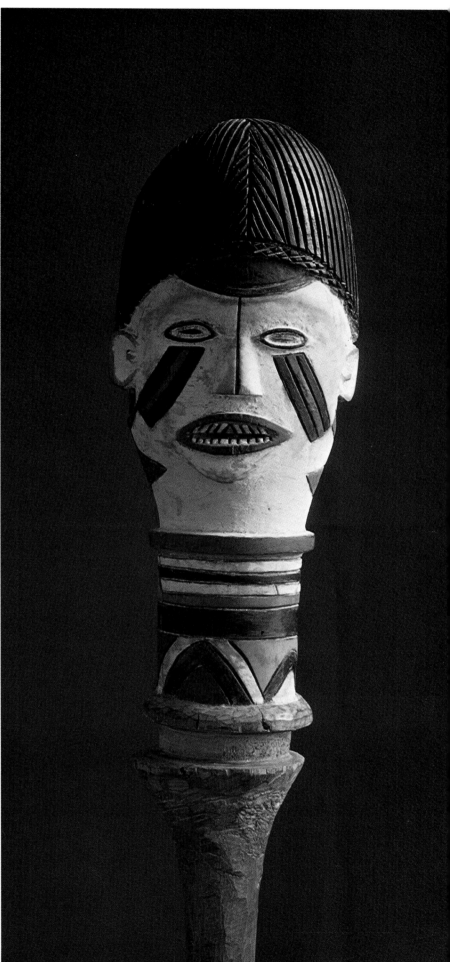

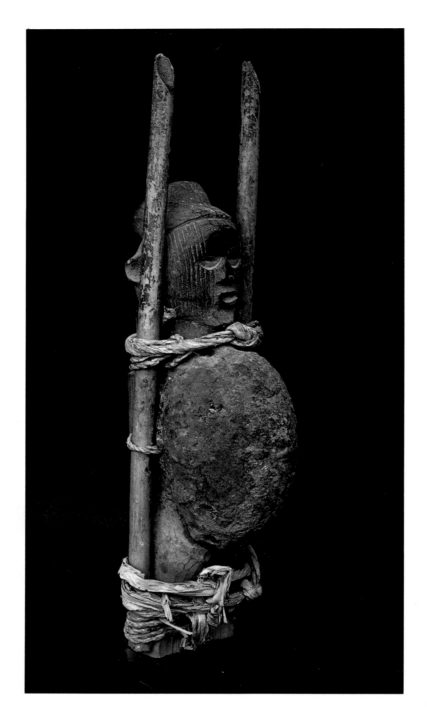

Teke

In the Republic of Congo, east of the Rivers Lovesse and Niari and as far as the Sanga, which flows way off eastwards, live the Teke. They are split into various sub-tribes. All produced figures, but only the Tsaye, as far as we know, produced masks (these masks show considerable originality). Their magic figures often seem unfinished, except where magic substances are not to be

138 Teke fetish

Wood, 21.5 cm, Republic of Congo. This magic figure was made at the birth of a child as protection for him until he reached maturity. Some kind of magic substance – in this case probably a piece of the umbilical cord or the placenta – was applied to the body for this purpose. It is supported by bamboo sticks on either side. The face, the vertical scarifications (made with an iron comb), the hair and visible parts of the body are all typical of Teke style.

139 Teke-Tsaye mask

43 cm, Republic of Congo. This unreal, disc-shaped Tsaye (north of the River Niari) Mossenjo dance mask is a symmetrically balanced, aesthetically fascinating composition of great symbolic expressiveness. It was used by the Kidumu society. Painted red, white and black, it might be described in our modern artistic vocabulary as 'more modern than modern'.

Different interpretations can be given to the markings on the mask, but none with any certainty. Thus the horizontal strip across the mask symbolizes the horizon. The upper four semi-circles represent the phases of the moon, the lower the Congolese days of the week. The semi-circular areas touching the horizon perhaps represent heaven (above) and the earth (below).

The smaller symbols have also been variously interpreted.

204

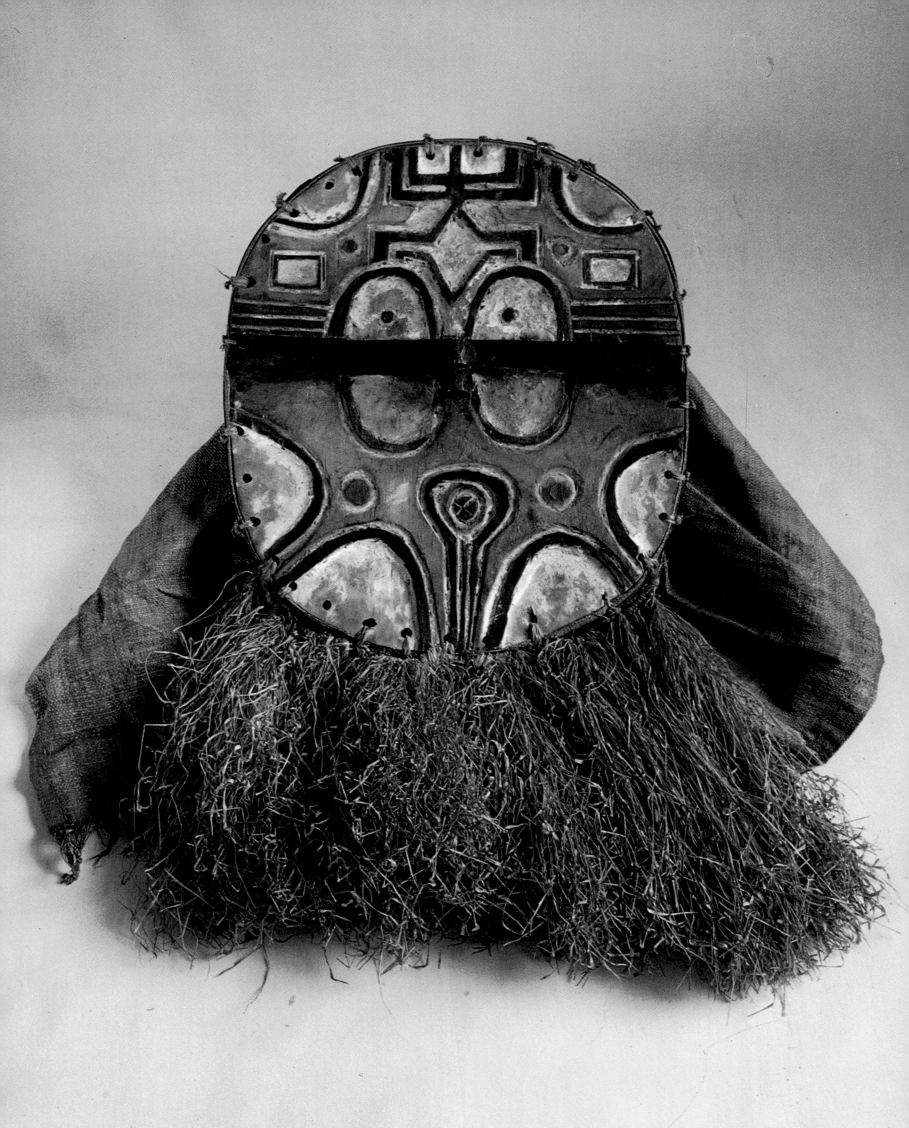

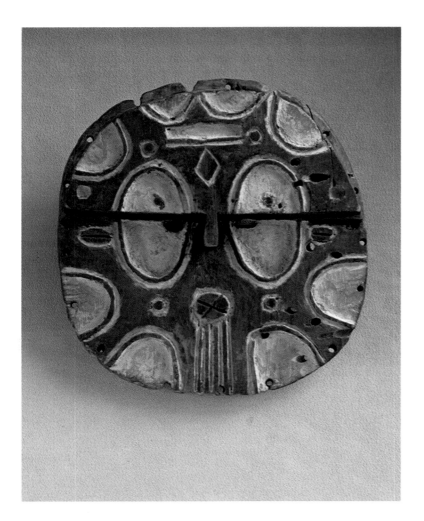

applied – the head, and often also the limbs, for instance. They have several functions: they provide protection from sorcerers and evil spirits, they preside over the hunt, and they ward off illnesses. They are cubist in style, and their faces bear the characteristic vertical linear scarifications.

140 Teke-Tsaye mask

32 cm, Republic of Congo. Similar to pl. 139. Here the red – symbol of immortality or blood – is replaced by ochreous brown. The symbols are almost the same, and may be similarly interpreted.

141 Teke helmet-mask

Wood, 44 cm, Republic of Congo. A powerful helmet-mask, quite different from the figurative work. Two pin-shaped eyes, with nails for the iris, stare out of round eye sockets in a somewhat abstract face. The broad nose, the up-ended rectangle forming the mouth, and the extended chin developing into a beard combine to give the work a surreal stamp. The opening in the head is stoppered with a blue cloth containing medicine.

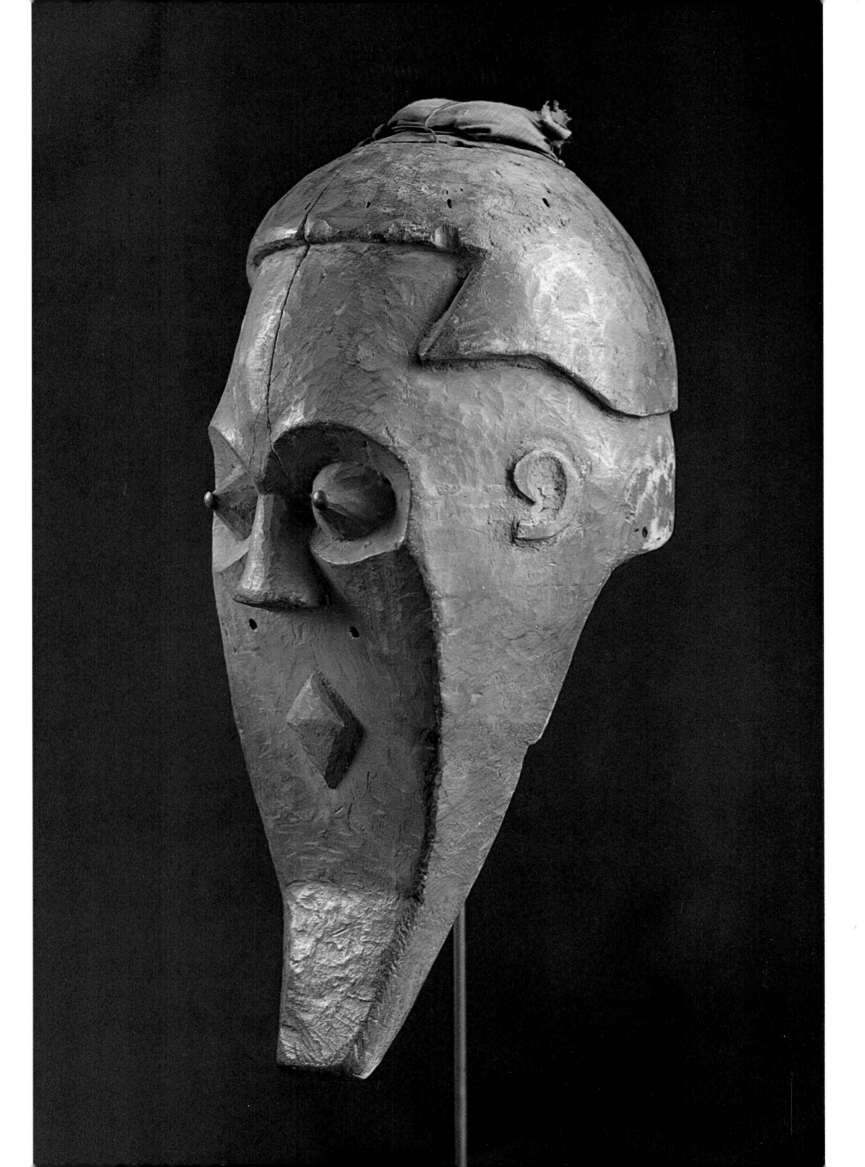

Tsogho
Punu
Vuvi

The Fang group includes the Tsogho to the south, whose figures are painted white or red, or both. Their cult bells, steles, bellows, millet pestles etc. are generally decorated with little human heads. The expressive eyebrows on these make their heart-shaped faces particularly delightful. The Punu, who belong to the Tsogho, and the Lumbo and Shango, all of whom live south of the Tsogho, are known above all for their white masks. Another member of the group is the Vuvi, south of Kula-Mulu, whose masks have starkly simple features.

142 Puna mask

Wood, 34 cm, Gabon. This white mask from the River Ogowe area has an apparently quite un-African beauty, yet is an expression of pure native art. The square-shaped scarifications on forehead and temples are suggestive of the neighbouring Lumbo, and the scarification mark crossing the whole face reminds one of the Shango. These masks were worn by people on stilts, who then became spokesmen for the spirits of the dead in communication with the members of the tribe. An uncommonly beautiful and graceful Punu mask.

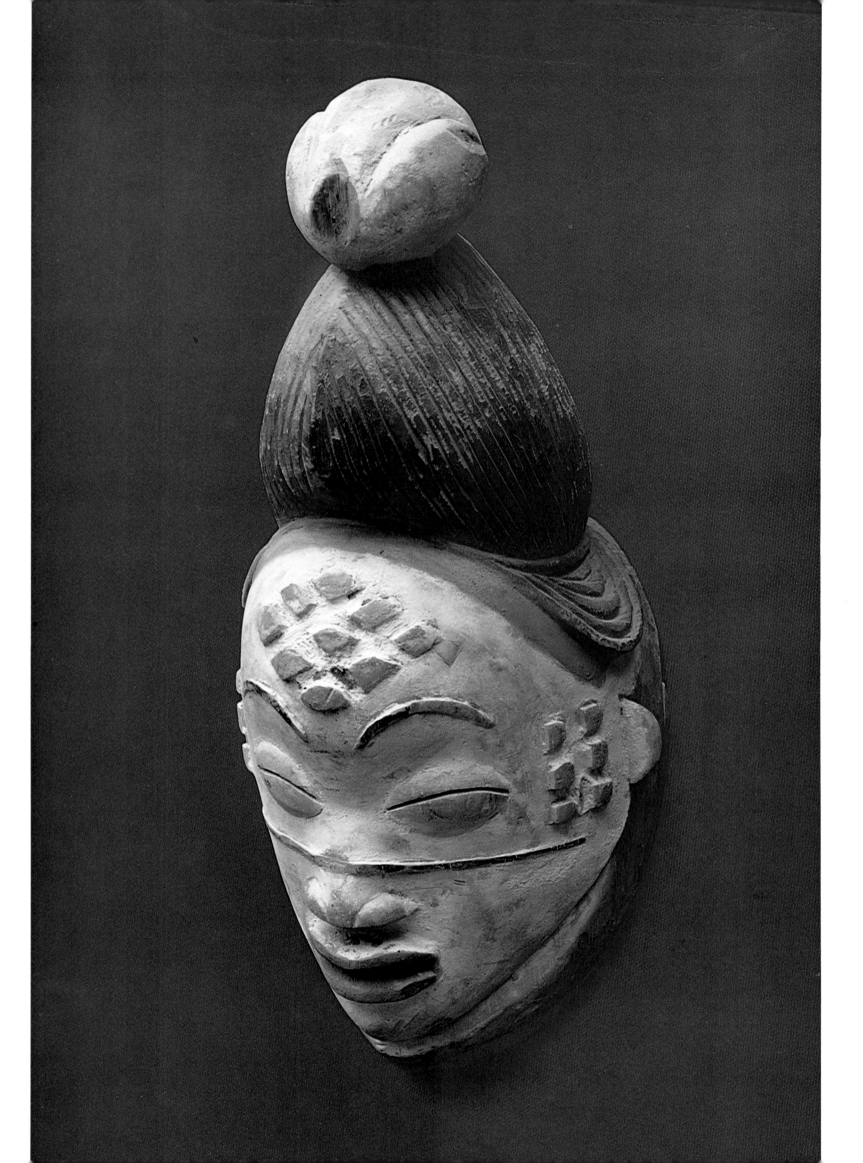

143 Tsogo ancestral figure

Wood, 72 cm, Gabon. Apart from the hair, and the sex and sensory organs, this heavily stylized figure is completely covered with white kaolin. The two-dimensional face, slightly hunched shoulders, and long neck combine to make it a beautiful and characteristic example of Tsogo (central Gabon) artistry.

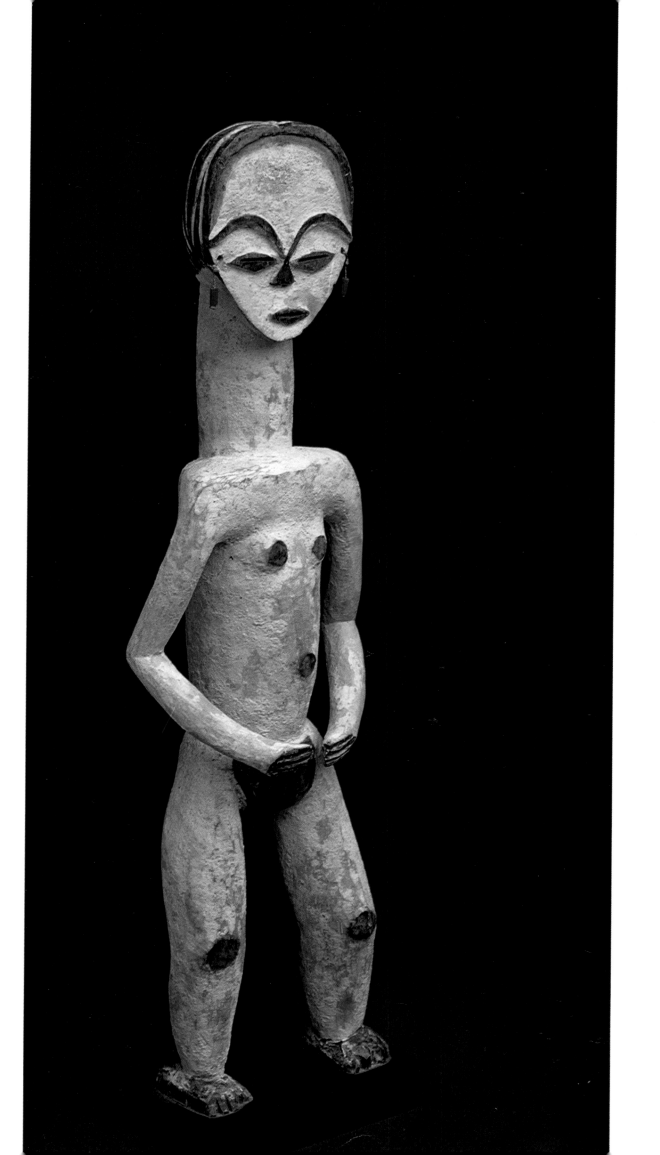

144 Vuvi-(Fang) bellows

Wood, 61 cm, Gabon. This unusually large and beautiful carving (the head in pure Vuvi style) was used as a blacksmith's bellows. Skins were stretched over the stylized breasts of the figure, and the smith's assistants pumped these quickly, rhythmically up and down. The air reached the primitive forge through the long, pipe-like body.

Acquired by a collector at the beginning of this century.

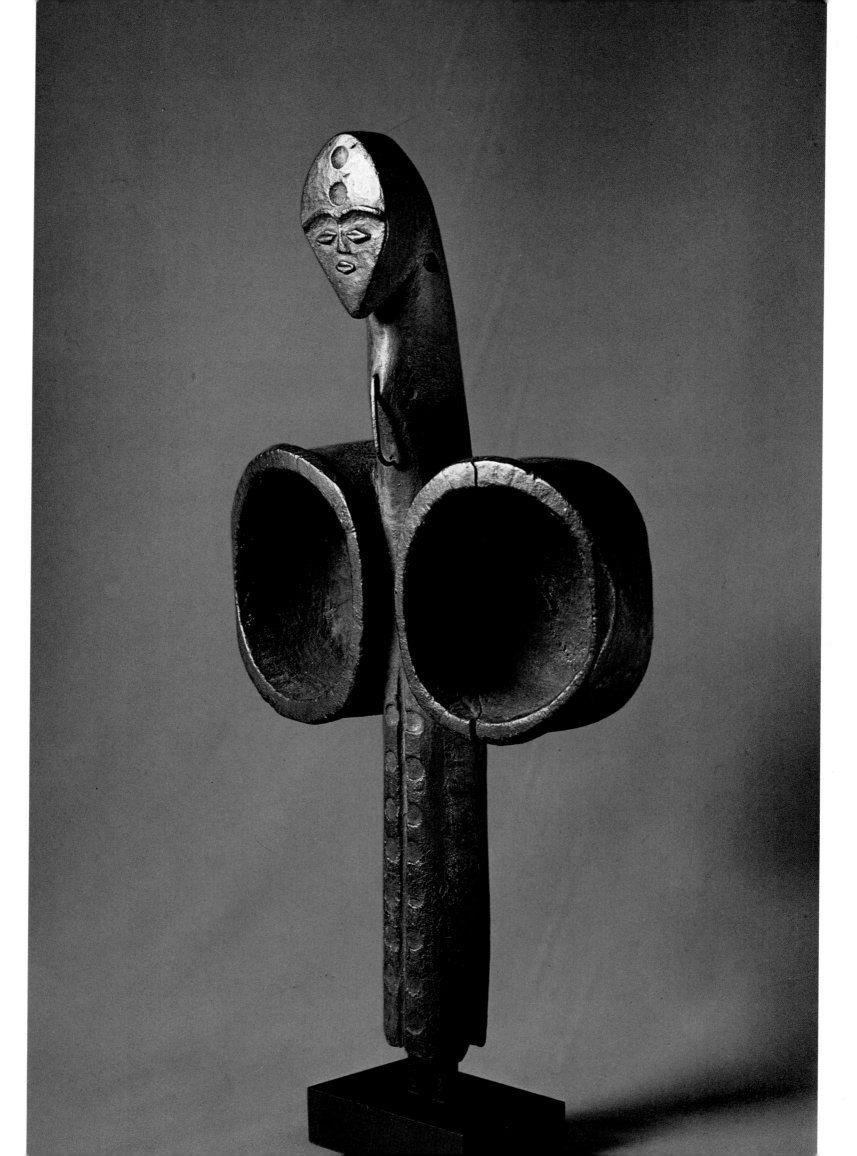

Kongo
Vili
Yombe
Sundi

When the Portuguese discovered the mouth of the Congo at the end of the 15th century they found a divine kingship at the height of its glory, and with its own sophisticated artistic sense. Included along the lower Congo are the Kongo and subsidiary tribes sharing similar artistic traditions. These occupy the country between Cabinda and the Republic of Congo, and between modern-day Zaire and the Kasai and Angola. Portuguese missionaries were so active that shortly before the end of the 15th century the Kongo kingdom became Christian. It was a relatively superficial conversion, however. Subsequent rulers soon became hostile to Christianity, and after about two hundred years the old beliefs returned. Christianity had no significant influence on

145 Kongo-Ntadi stone figure

27 cm, Zaire. From the village of Banussa on the lower Congo, in the Boma/Matadi district. A particularly beautiful and old example of the 'fumani' 'thinker', with finely worked, spiritualized features. The noble head, slightly inclined, is solidly supported by the vertical prop constituted by the right hand, forearm, knee and lower leg. The left arm slopes parallel with the head, and the leg is bent to lie flat on the seat. The forearms and lower legs are decorated with natural bands. The most beautiful of the Ntadi were originally used as ancestral figures, and were held to be dwelling places for the spirits of the dead. They offered protection (Ntadi means protector), but only so long as sacrifices continued to be offered.

Similar stone figures were taken to Rome around the end of the 17th century.

214

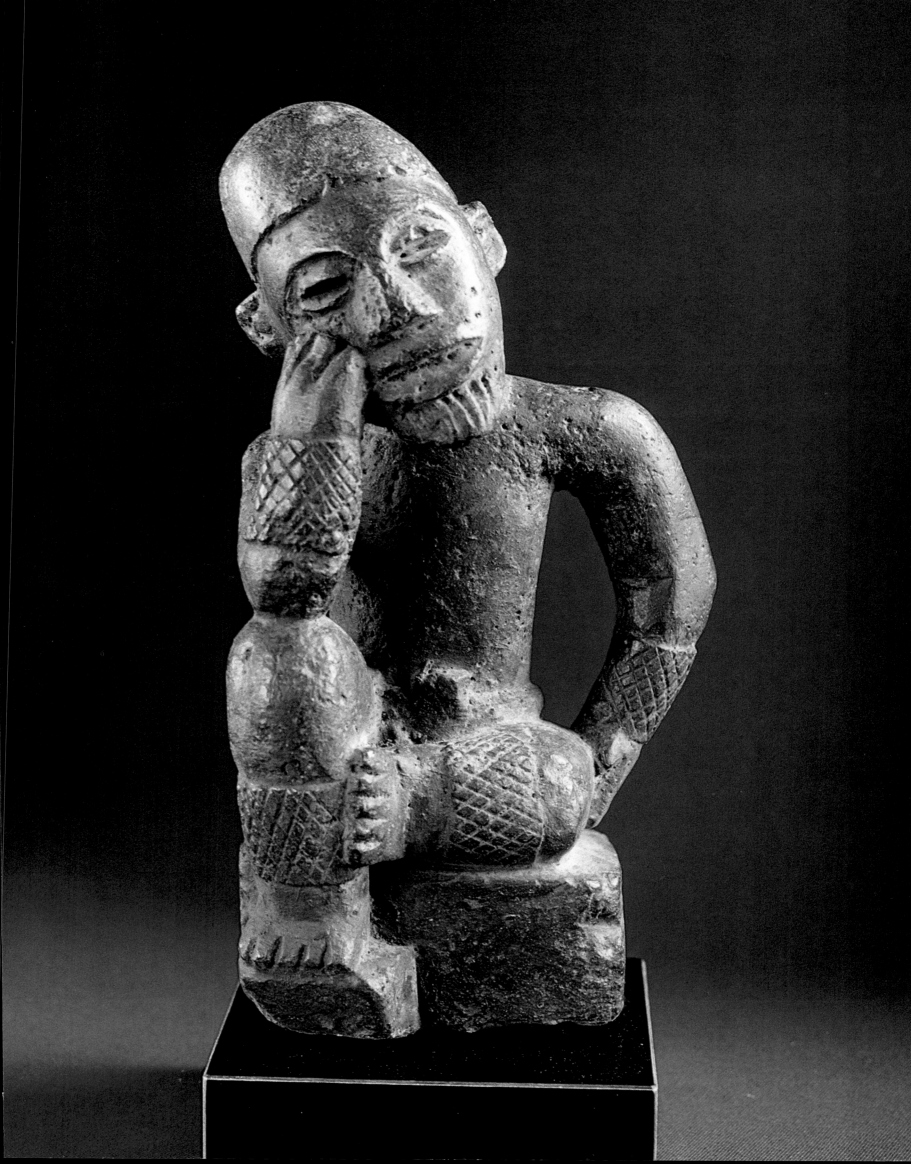

the art of the peoples of the lower Congo, including the Kongo, and the Vili, Sundi, Yombe etc. A few Christian symbols remained, and became totally integrated into the art of the old beliefs. It is sad that many valuable works of art were lost to us owing to missionary zeal and the growth of sectarianism.

The Congo basin is known above all for its fetish and ancestral figures, which convey a liveliness of movement that is to be found only here and there in the rest of Africa. The Vili on the coast north of Cabinda, and the Yombe and Sundi, both north-east of Cabinda in the Republic of Congo and Zaire, share similar stylistic traits.

146 Kongo mirror fetish

44 cm, Republic of Congo. This fetish figure, exhibited at the Exposition Coloniale in Paris in 1937, was collected at the beginning of the 20th century by the Mission des Orphelins d'Auteuil. Much was expected of such magic figures. The substances incorporated into it received their power from the fetish holder. This important figure has been restored in various places.

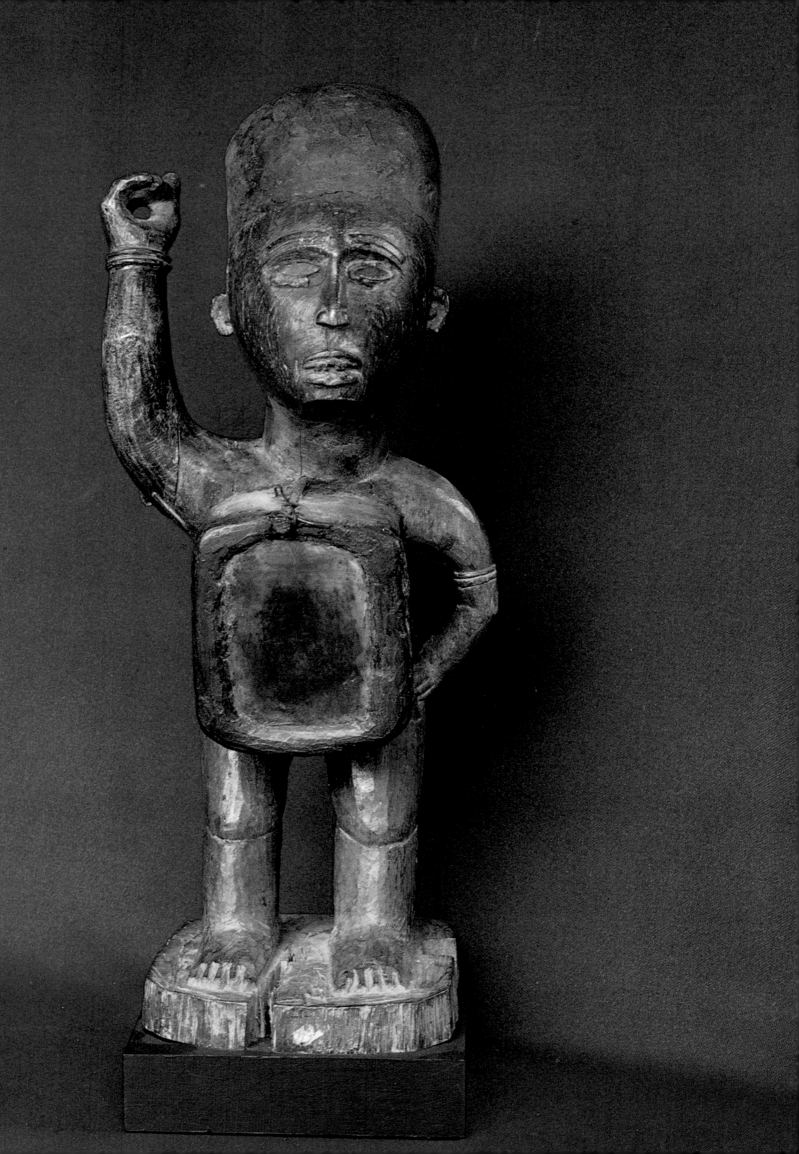

147 Kongo side-blown horn

Ivory, 49 cm, figure 8 cm, Zaire. An exquisite example of a side-blown horn, made from an elephant tusk. The very beautiful dark red, shiny patina is the result of much use, sweating hands and palm oil (which is orangey-red in colour). The figure on the top of the horn is a miniature masterpiece. It shows a man playing a side-blown horn.

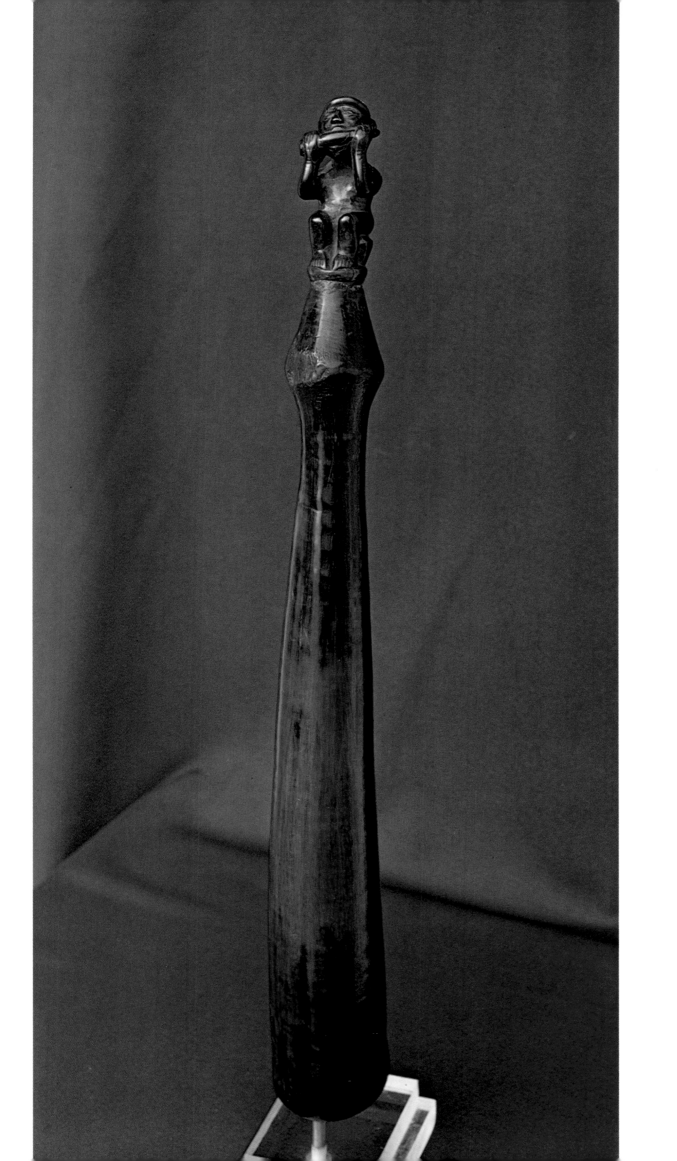

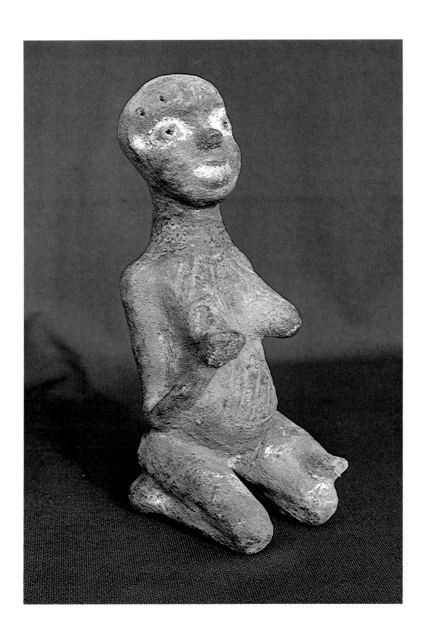

148 Kongo terracotta

21 cm, Zaire. Kneeling female figure in lightly baked clay. The front of the body and the head are decorated with stroke-like scarifications. The sensory organs are clearly marked with white. It is hard to put a date to it.

149 Yombe ancestral figure

Wood, 64 cm, Republic of Congo. The mitre-like hair arrangement on this large Phemba figure indicates high rank. The line of the neck where it joins the body, and the marked scarifications on back and front are typical. The eyes are mussel shells or ceramic. The object held between the figure's hands is no longer identifiable. An important carving, showing a typical breast-band, it dates from the last century.

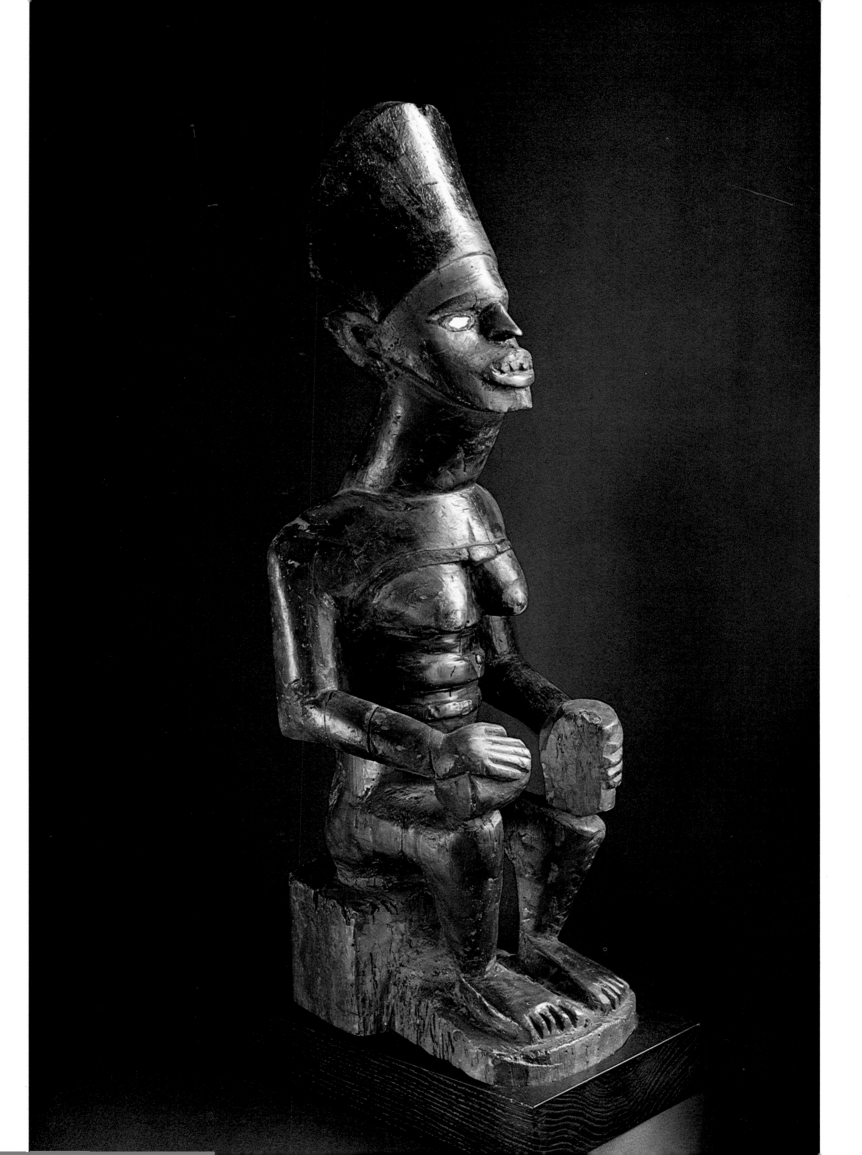

150 Vili fetish figure

Wood, 28 cm, Republic of Congo. This Nkisi fetish figure, bearing an iron blade and many other magical substances, comes from the Loango area. Everything about it has power. It was collected at the beginning of this century by the Mission des Orphelins d'Auteuil.

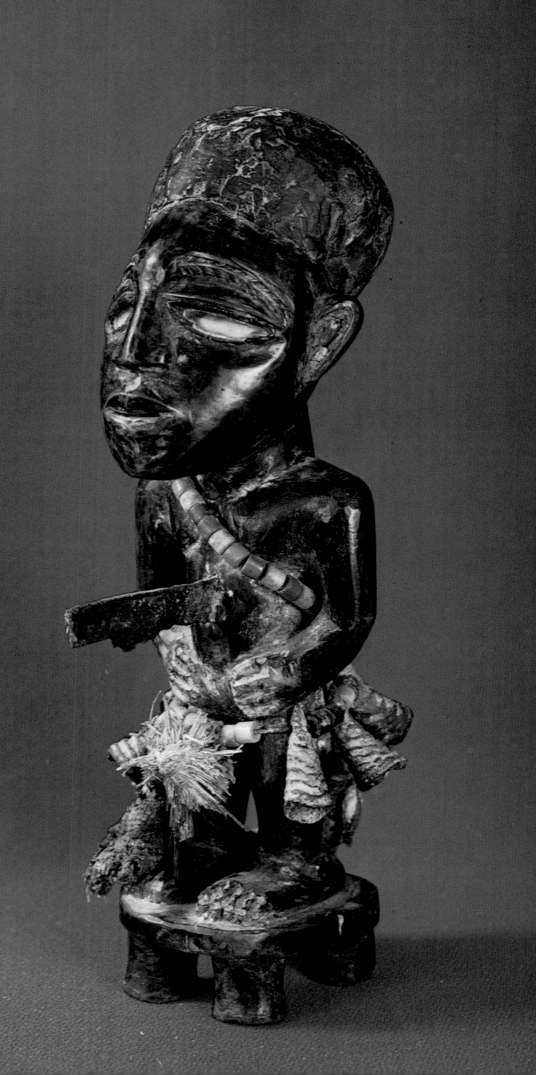

151 Vili mask

Wood, 34 cm, Republic of Congo. A very beautiful mask with commanding features. Eyebrows, nose and mouth are powerful in their effect. The kaolin, ochre and black colouring is skilfully balanced. Collected in 1925, it represents a rare type of mask.

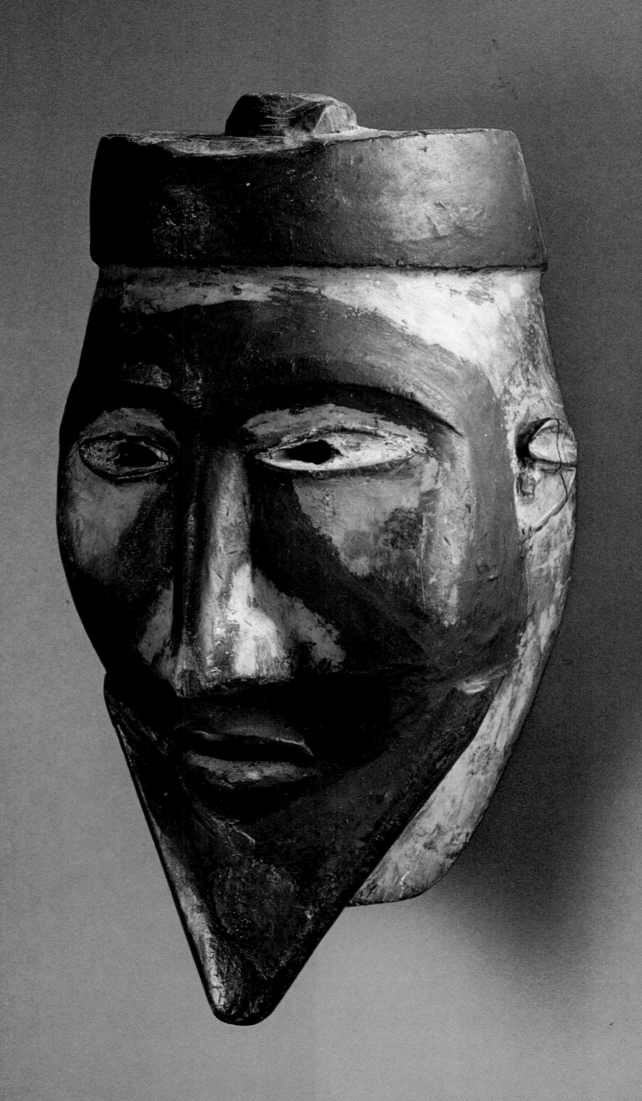

152 Sundi figure

Wood, 51 cm, Republic of Congo. A funerary figure, originally painted white, wearing a dignitary's cap. The figure as a whole is vaguely suggestive of Egyptian art. Typical of this kind of figure are the white paint (here only partially remaining), the decorative band above the full breasts, and its general position. The dark dots are thought to represent panther skin – the wearing of which was the prerogative of persons of high rank. The figure is wearing decorative armlets and anklets.

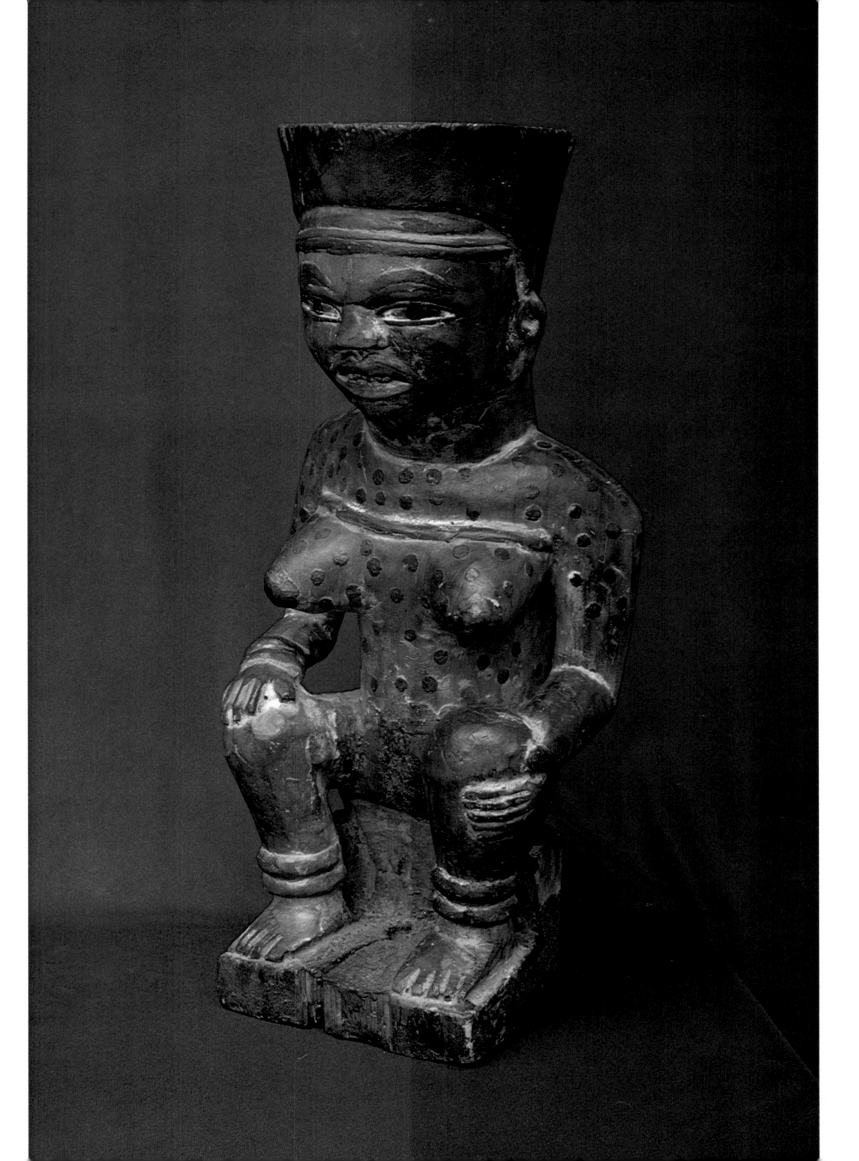

Yaka
Pende
Suku
Nkanu
Mbala

Between the Rivers Kwango, Kwilu and Kasai live peoples whose art in ways differs sharply from that of the Kongo group and represents a separate, individual tradition. The Yaka, whose masks show unbelievable, and often almost clownish imaginative sensibility, are the most important of these. After feasts, ceremonies and circumcision celebrations many of their masks were destroyed. This explains the constant appearance of new forms. Their style is quite distinct from that of their neighbours, and it is impossible to confuse it with any other. It is characterized by colourfulness, great variation in head adornment, and above all the upward curving nose, often reaching up to the forehead. It has greatly influenced their neighbours. On the other hand their figures, with thick noses, rather betray outside influences themselves. The Pende live east of the Yaka, in the River Kasai district, and have two main artistic styles. The western Pende, separated from their eastern fellow tribesmen by the Loango, produce face masks with gentle lines, while the eastern Pende concentrate on more geometrical forms.

Suku art used to be ascribed to the Yaka, who live immediately to their west. However, except for the great Katundu masks, which are common to most peoples in the area, and which are employed for initiations, their works do not have the characteristic Yaka upward-shooting nose.

Closely related to the Yaka are the Nkanu on the Angola/Zaire border. Meanwhile north of the Yaka and the Suku, and with, despite various external influences, an independent style of their own, we have the Mbala.

153 Yaka terracotta

16.5 cm, Zaire. Collected in 1920 by the former governor of the province of Kasai. Investigations at Tervuren show that this mother and child is the only Yaka terracotta so far known about. Everything about it is typical of Yaka style: the exaggeratedly thick nose, the large mouth, the flap-ears and the fat bottom.

228

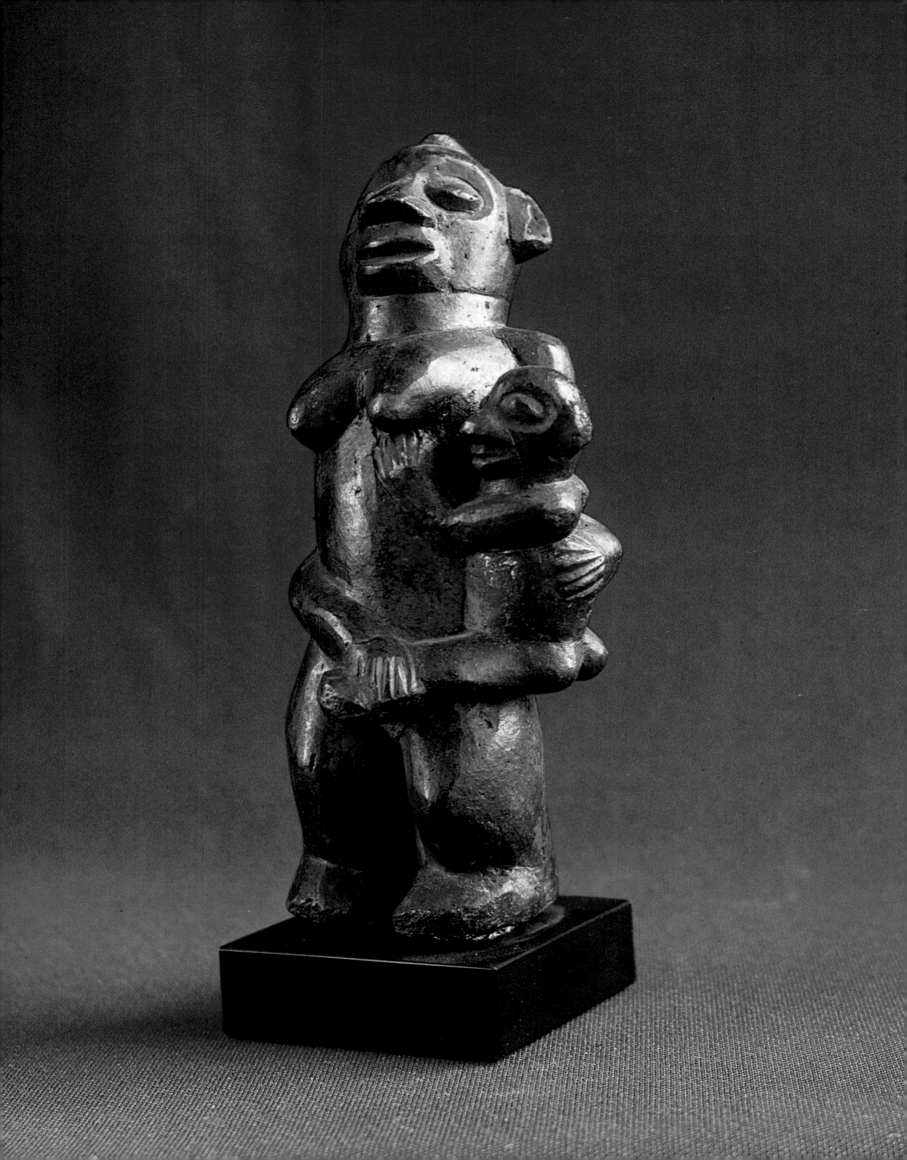

154 Pende ancestral figure

Wood, 47 cm, Zaire. The lower part of this carving has been destroyed, but this in no way detracts from its beauty. It is an eastern Pende work, and differs from western Pende productions in its decisive modelling and its red colouring (only partially preserved), which appears more commonly on their masks. The hair above the impressively peaceful-looking face is arranged like a crown.

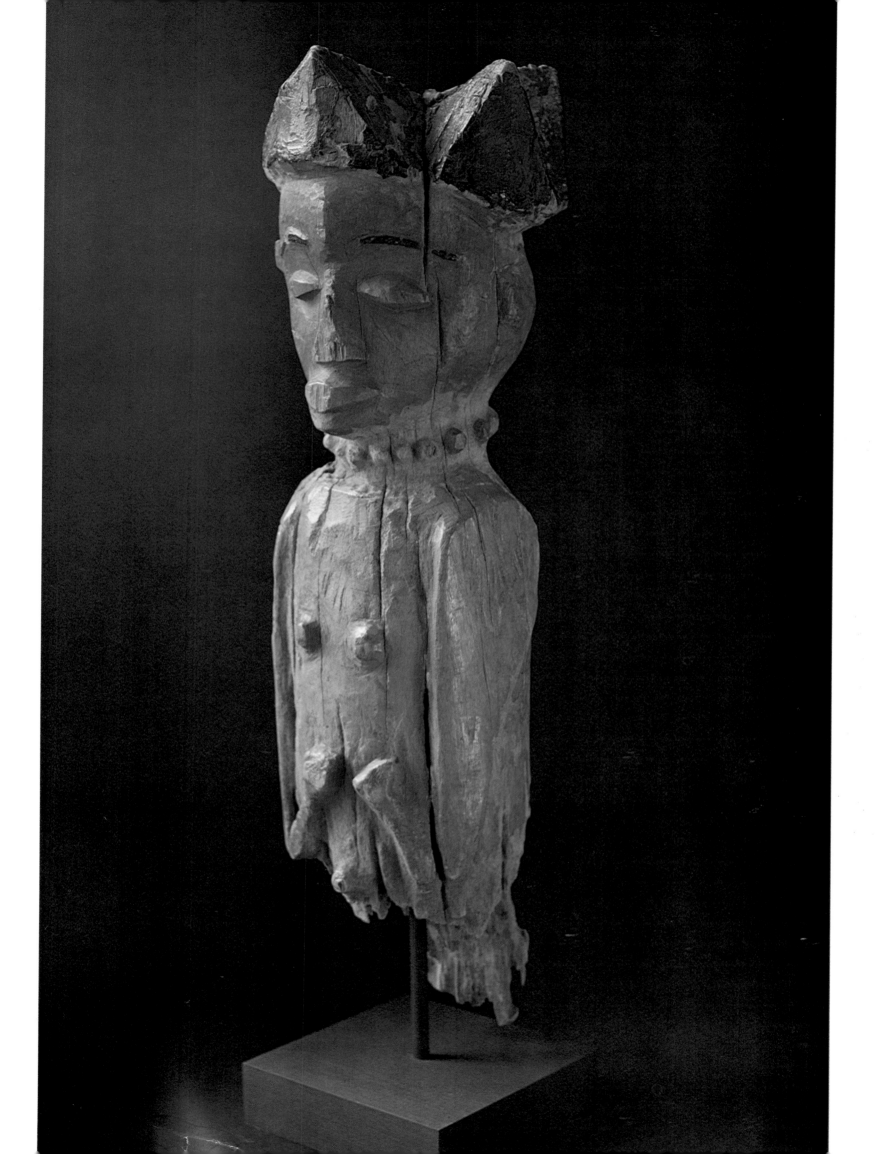

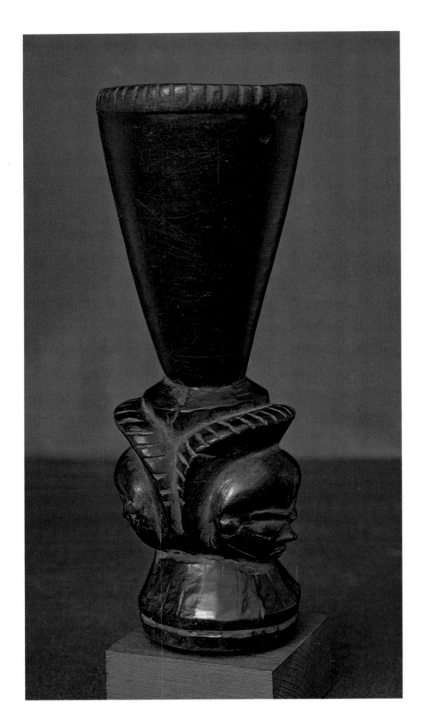

155 Pende mortar

Wood, 19 cm, Zaire. Any medicine-man has to have a mortar. The two faces on this one illustrate the style of the western Pende, from the Katundu region. The lines are predominantly gentle: sunk, heavy eyelids, long curving eyebrows meeting in the middle, elegant, slightly up-turned nose, part-open mouth, all are characteristic of the famous Katundu 'school'. The medicine-man would pound and prepare his potions in the conical beaker. A small masterpiece.

156 Suku mother and child

Wood, 41 cm, Zaire. This magnificent figure of a mother and child seems to rise up from a base formed, as it were, by the mother's crossed legs and the baby, towards the powerful head at the top. Decorative rings around the thick neck and the right forearm, as well as the general proud bearing of the figure, indicate that this is someone of some importance. A superb, masterly Suku piece.

232

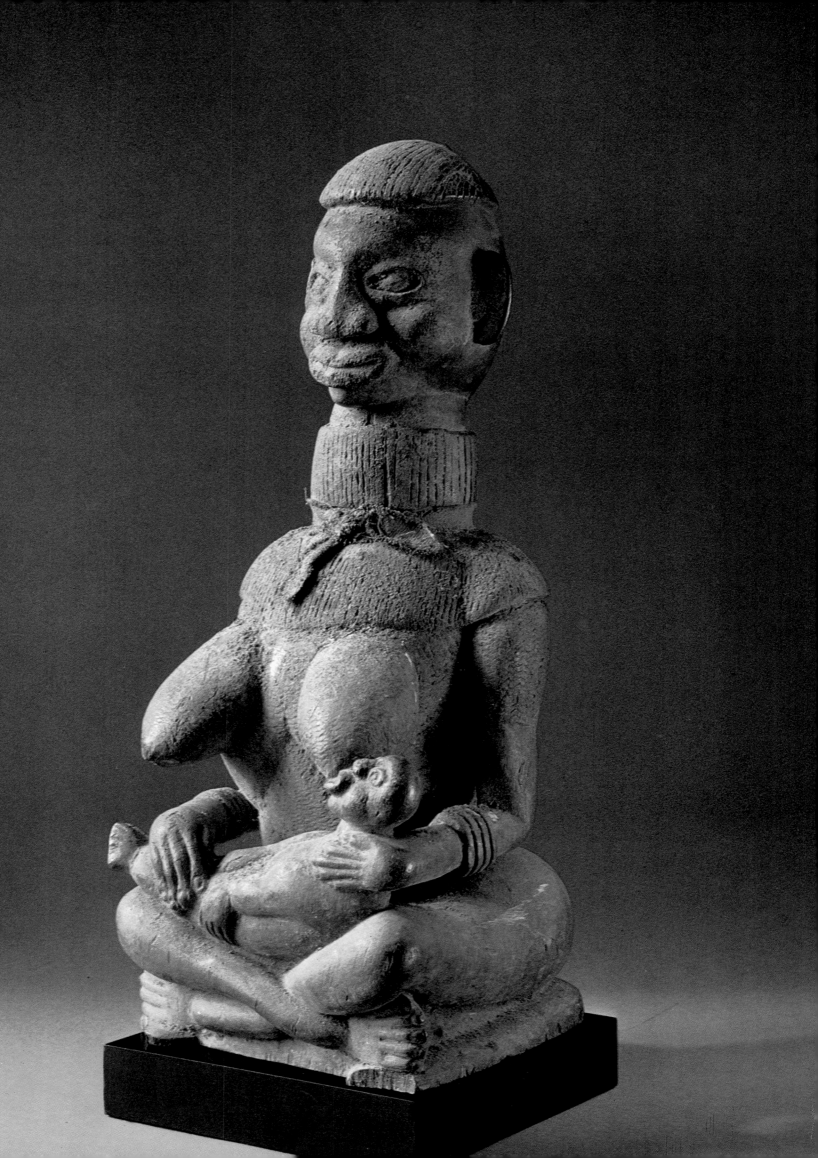

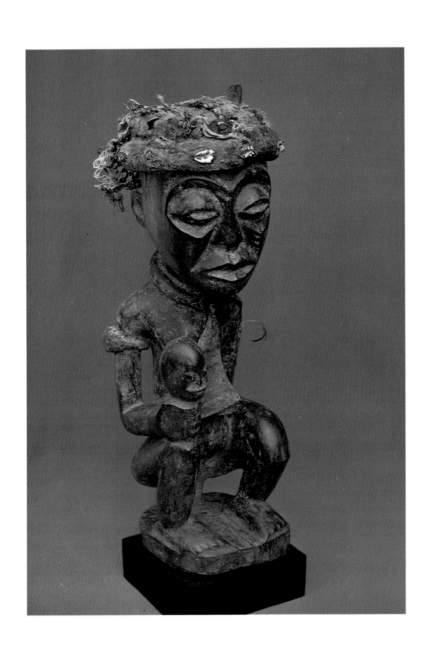

157, 158 Nkanu fetish figure

Wood, 46.5 cm, Zaire. This powerful fetish, with its expressive face, is a moving, grand carving. It had above all a magic function. Aesthetically a unified, satisfying work, it is a vision of an active demonic force given physical embodiment by a gifted artist. Nkanu fetishes are extremely rare, and to find a beautiful one is all the rarer.

234

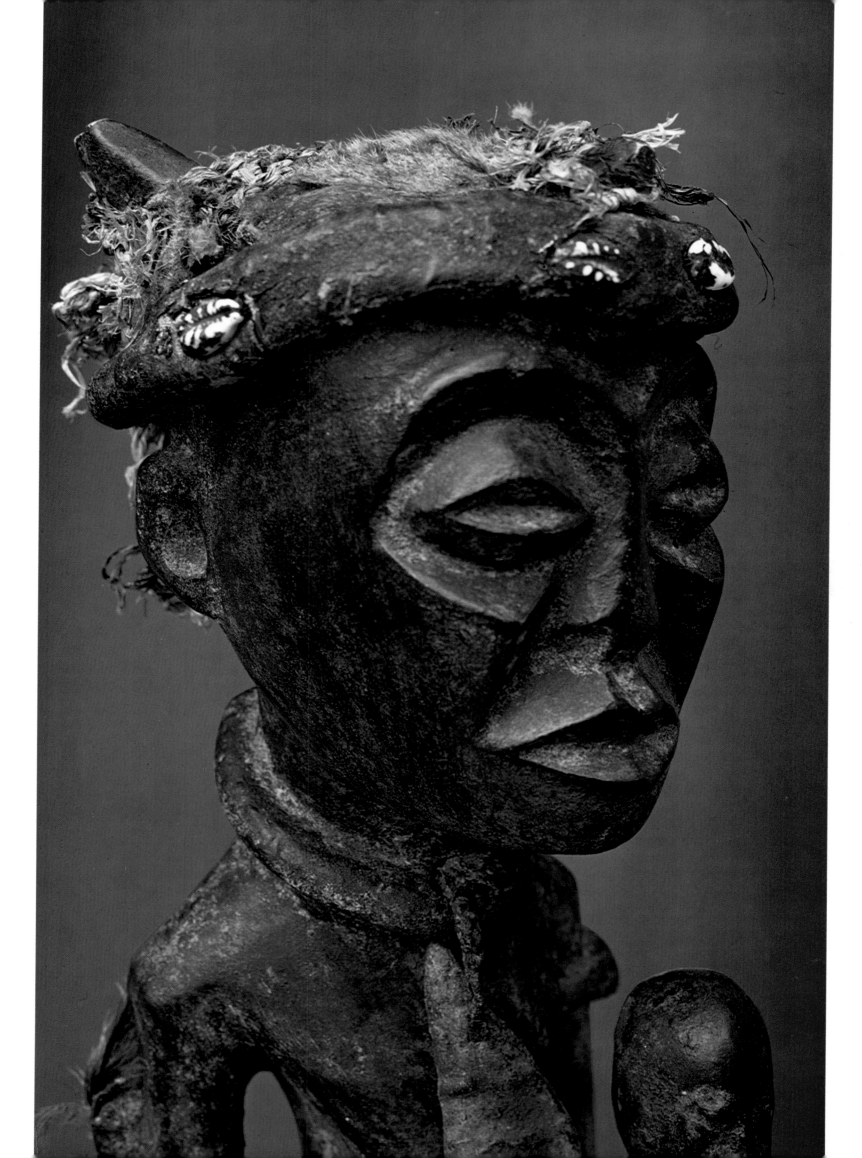

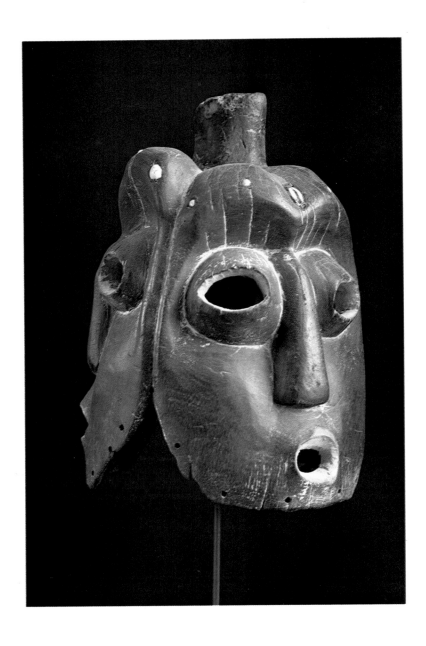

159 Suku helmet-mask

Wood, 39 cm, Zaire. These three faces with their bulging, wide open eyes, white on the insides, their puffed hair arrangements, and the topknot in the middle, look like some exotic fruit. The whole construction is pleasing, and is a good example of Suku art. It reveals a decorative sense further borne out by their cult objects and objects for everyday use.

160 Mbala figures

Wood, 29 cm and 31 cm, Zaire. Two different styles are represented in this plate. The mother and child convey great strength and movement, and in their outlines hint at Cubist art. The child loosely supported on the mother's hip is counter-balanced nicely by the curve of the right arm. The composition – typical of Mbala work, with its crested hairstyles – is fascinating.

The male figure by comparison shows what diversity of style can exist within the art of a single tribe.

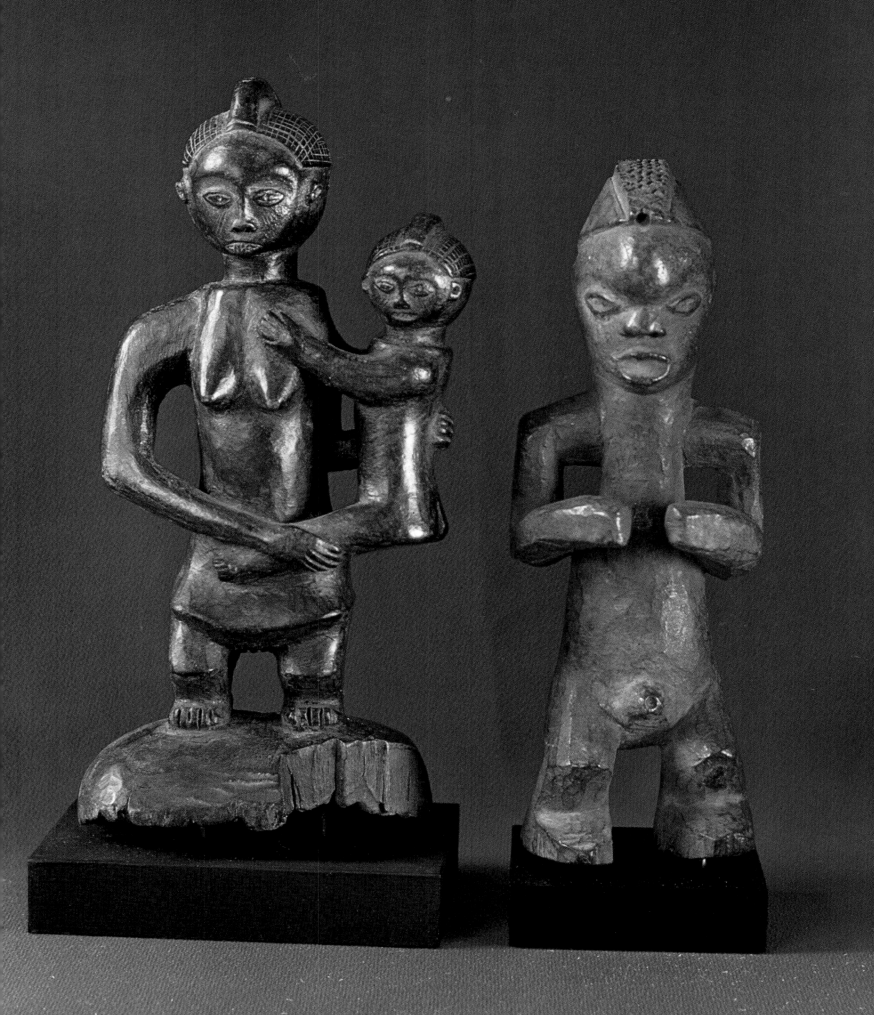

Kuba
Lele
Nkutshu
Ndengese

The Kuba between the Kasai and the Sankuru may quite reasonably claim to be among the best and best-known artists in Zaire. A whole host of subsidiary tribes is grouped around them, within the sphere of their influence, yet each with, to a certain extent, its own tradition.

The Kuba are famous for their figures, which often serve as status symbols. Well known too are their portrait figures of kings, which can be traced to as far back as the 16th century. Of approximately 120, perhaps only a quarter still survive.

Kuba art is primarily court art, and is concerned with beauty. Nevertheless it still preserves a certain religious content. It is 'humanistic', and is often reminiscent of Benin or Baule art in the magnificent sense of style and decoration applied to the production of everyday objects. Their appreciation of beauty was mentioned in the very first reports to reach Europe. However,

161 Lele mask

Wood, 36 cm, Zaire. A symbiosis of the artistic styles of the various neighbouring peoples. The slightly upward-pointing nose suggests the Pende to the west. The four-pronged, crownlike hair-arrangement identifies the figure as a person of some rank.

162 Kuba ancestral figure

Wood, 47 cm, Zaire. One of the few Kuba cult figures, in typical style, and with the characteristic camwood patina. Every detail, from the hair, to the scarifications, to the toenails, is delicately and skilfully worked.

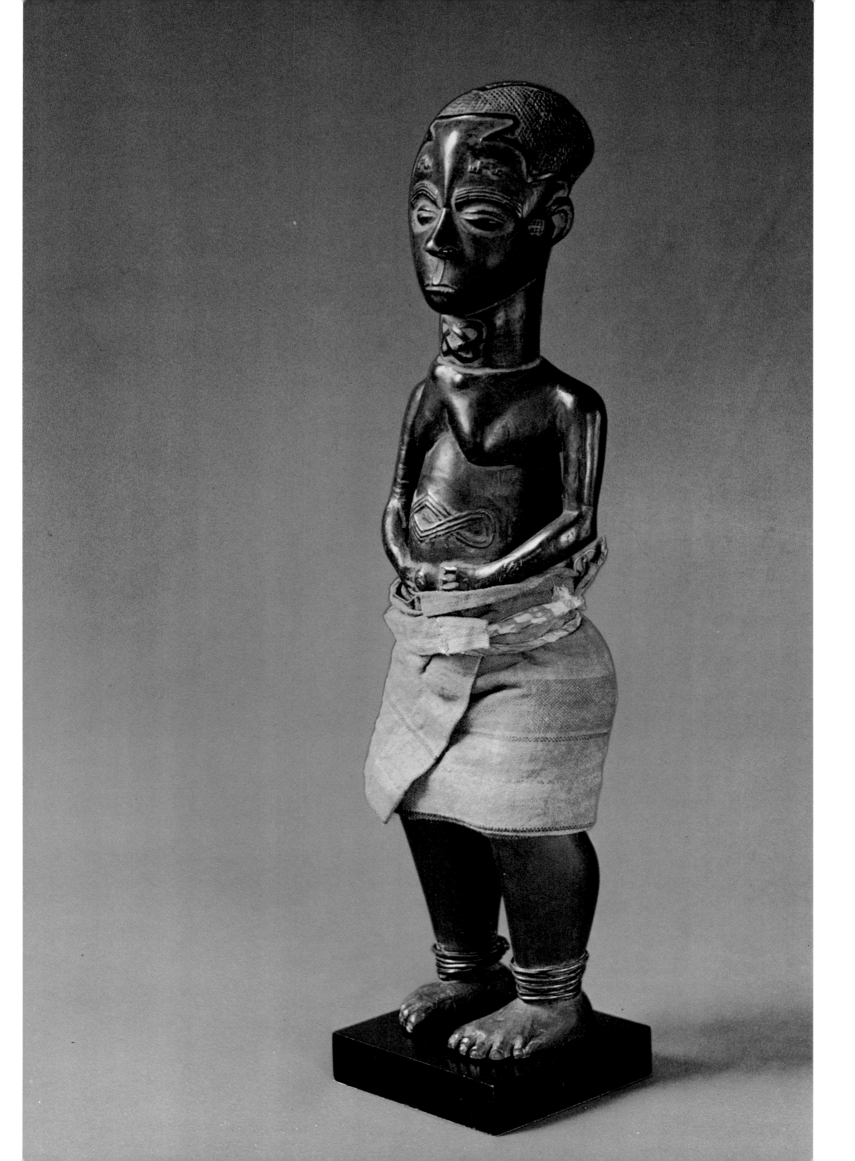

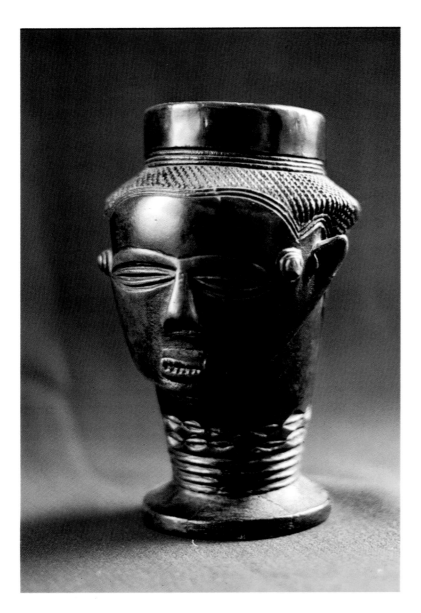

these were treated as mere fables. Leo Frobenius reported at the beginning of this century that splendour and refined artistic taste were manifest everywhere, even in the most insignificant things. Even kings had pretensions at being blacksmiths, carvers, weavers and creative artists.

The ancestral cults were somewhat overshadowed by court art. Cult figures are thus rare, and in many respects are very different from the royal figures. Kuba anthropomorphic beakers, boxes, drums, musical instruments etc. are famous. Their beautiful, velvet-like raffia weaving was known as far back as the 16th century.

The cups carved to resemble human figures are probably the work of the Lele, to the west of the Kuba. Their art is very close to that of the Kuba. North of the Kasai, and north-east of the Kuba are the Nkutshu. Then, belonging to the Nkutshu, the Yaelima and Ndengese. The latter are known for their polychrome human figures (head and shoulders only) with ornate scarification designs.

163 Kuba cup, in the shape of a head

Wood, 16 cm, Zaire. These cups, used at feasts, well illustrate how marvellously the Kuba artists were able to work on a small scale. The woolly hair is represented in a superbly stylized way. Such goblets were not only used for palm wine, but also for 'ordeals by poison' (judgment by the gods).

164 Kuba helmet-mask

Wood, 42 cm, Zaire. Everything about this mask is stylized, from the hair to the geometrically patterned chin. Two conical eyes look out from deep eye-sockets, and these, together with the pinched mouth, give the mask an almost contemptuous look. A stylistically interesting example of Kuba work.

240

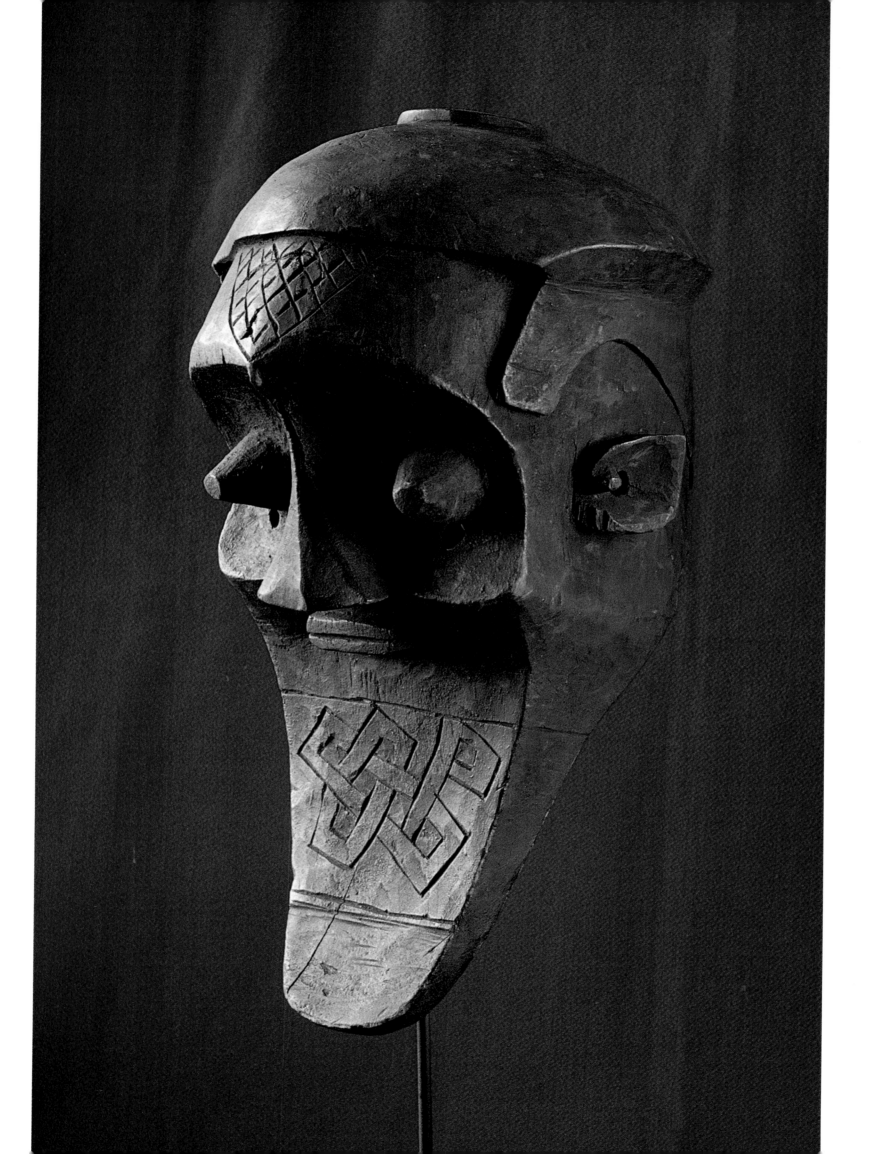

165 Nkutshu mask

Wood, 38 cm, Zaire. This mask, surrounded by a ruff of brown bird feathers, might almost have come from some Greek theatre. In its own fashion it has a beautiful simplicity, and the dreamy eyes and open mouth seem to have something to tell us about the primeval forest.

242

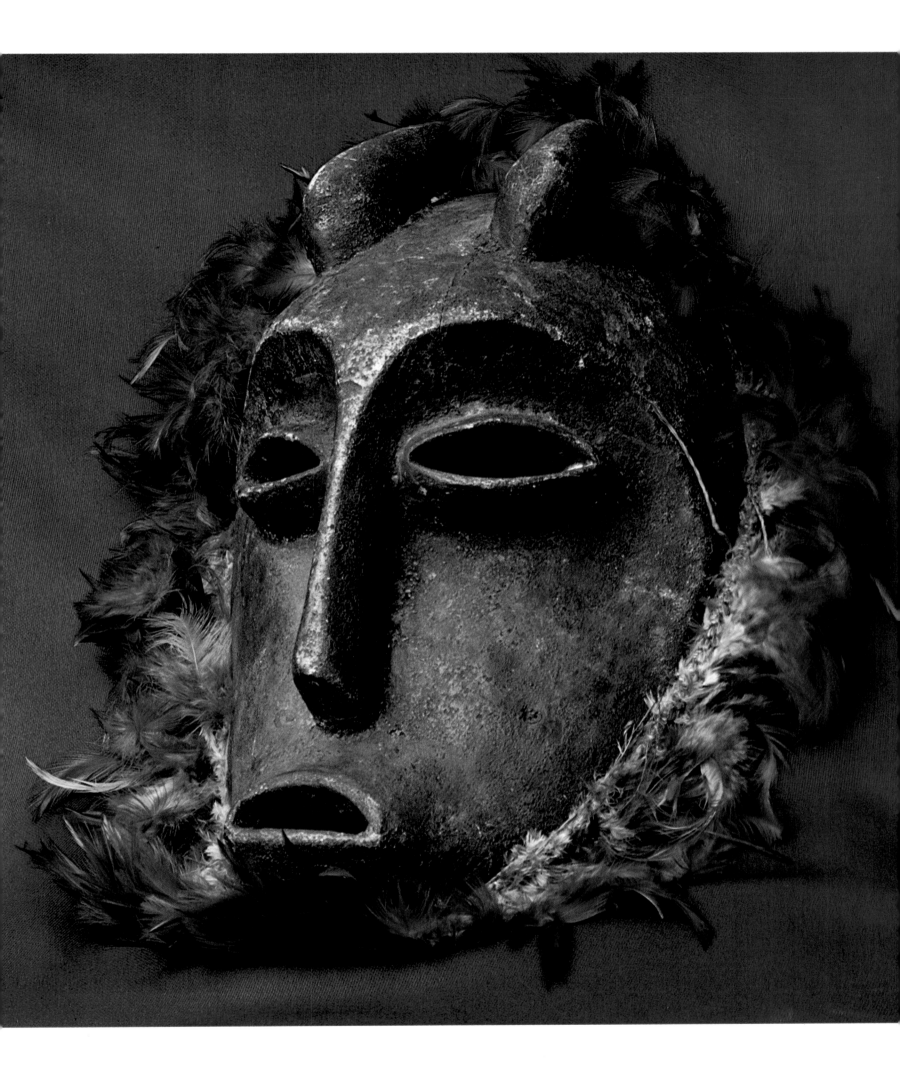

166 Ndengese cup, in the shape of a head

Wood, 23 cm, Zaire. An interesting palm wine beaker. The exaggeratedly long face would appear to owe something to the nearby Kuba.

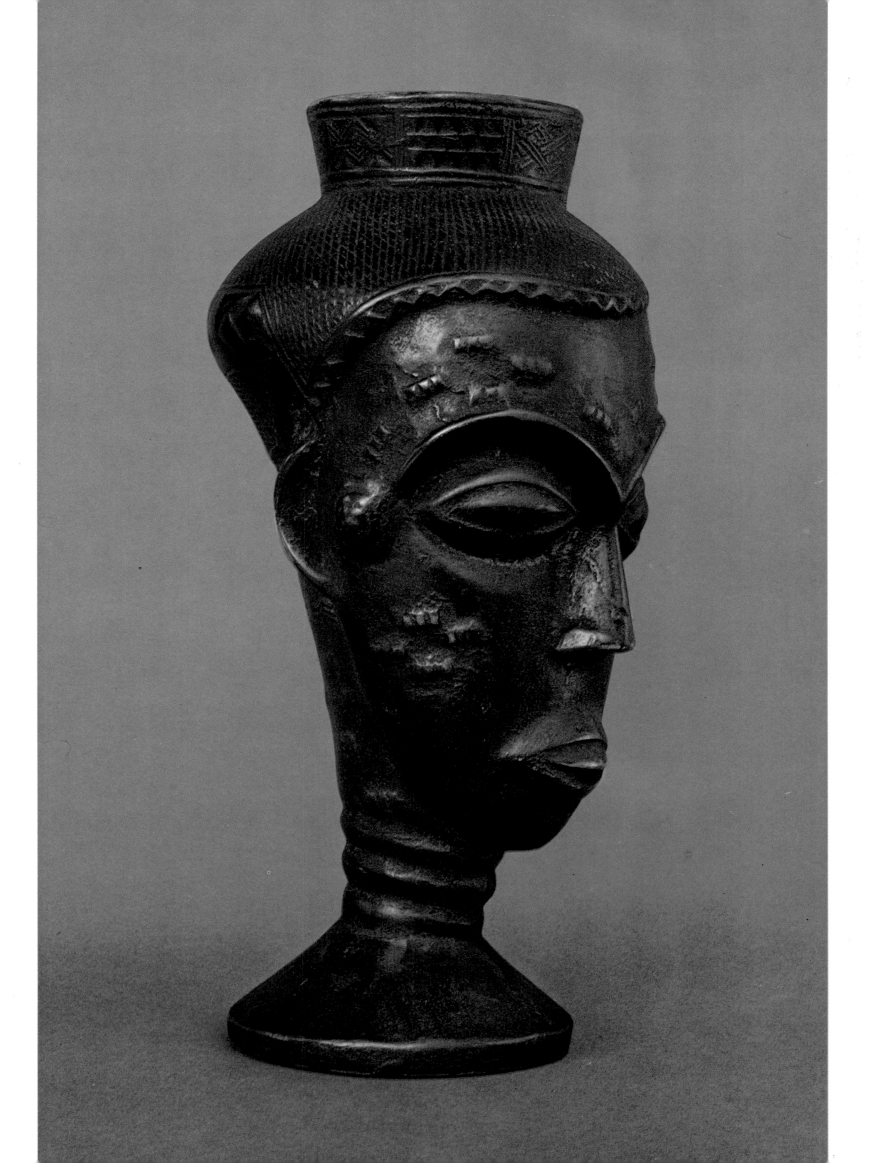

Lulua

In the River Lulua area, with the Kasai as their western boundary, live the Lulua (the tribe named after the river). Only relatively late, on the withdrawal of the Luba, who had to a certain degree ruled over them, did they form into any real political entity.

Despite the lack among them of any indigenous court art (such as that of the Kuba, for instance), Lulua figures acquired a great reputation. With scarifications over the whole body, they are among the richest of African art styles. Tiny votive figures, large ancestral and warrior figures, and figures of all sizes in between, express both naturalistic realism and severe stylization. They had various purposes. There is also a fine Lulua mask tradition, which unlike the figures is abstract and multiform.

167 Lulua mother and child

Wood, 60 cm, Zaire. Mother and child figures are made from a special wood, regarded as sacred, and have a very important role. They count among the finest of Lulua works of art.

This figure, rising up through powerful feet and legs towards the large head at the top, is a strong, carefully balanced work. Particularly subtle is the breast and shoulder section, with the child harmoniously integrated into the main pattern of the carving. Triangular, hanging breasts indicate many births and much suckling of children. Very fecund women were accorded special reverence.

Typical of these splendid figures is the protruding navel and the arrangement of the hair into a small topknot. The scarifications too are characteristic. All in all a very fine, stylistically beautiful example of Lulua figurative art.

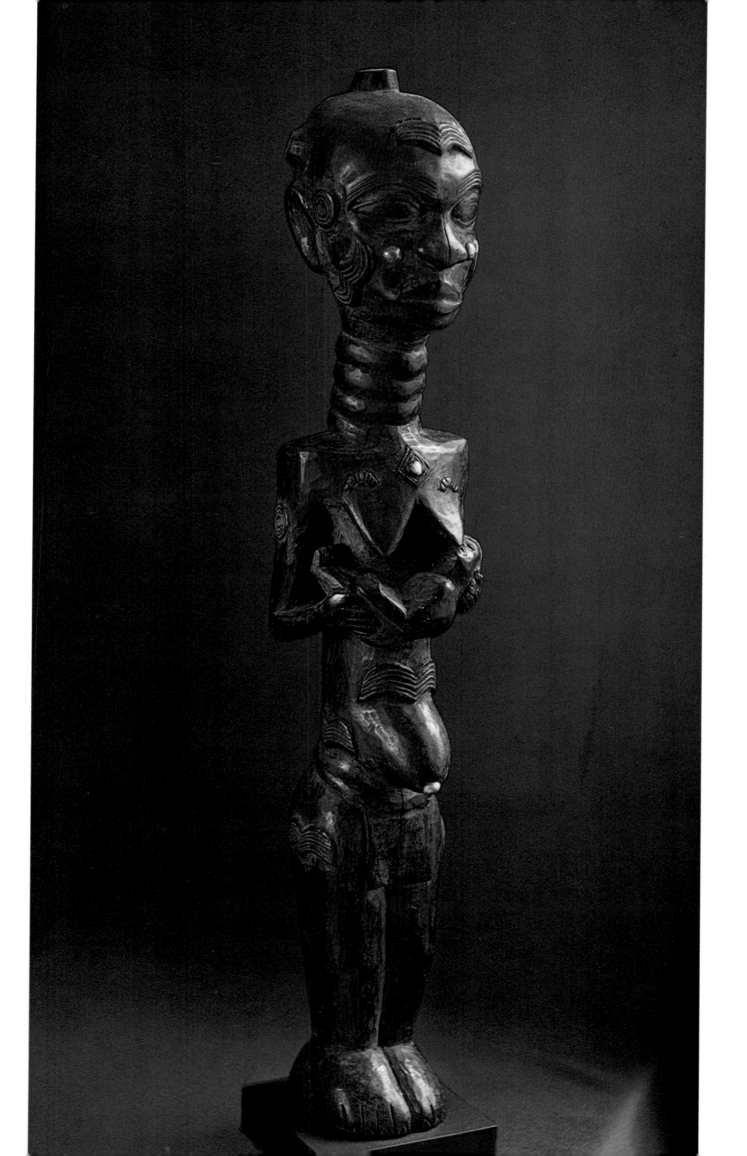

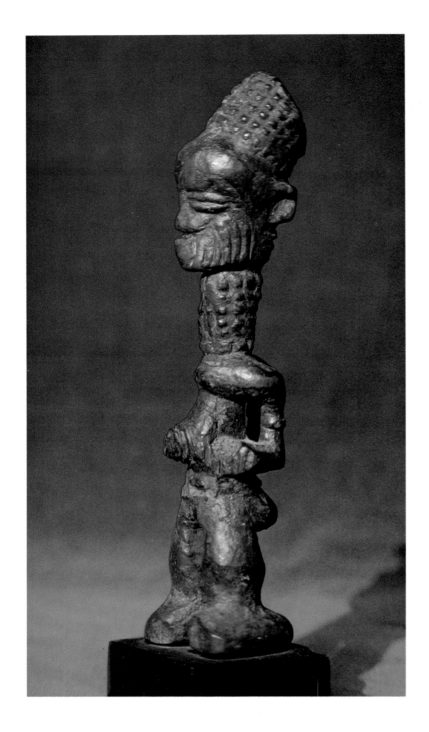

169 Lulua mask

Wood, 33 cm, Zaire. This helmet-mask clearly shows the disparity between the masks and the refined, highly worked figures. In every detail of this somewhat abstract mask, where every stroke made by the carver leaves a visible mark, in the great, camwood-stained hollows of the eyes, with the bullet-like eyes themselves, in the similarly bullet-like mouth, and in the ears, there is more of the mystery of the primeval forest than in many 'beautiful' figures. Such contrasts within the art of a single people are a constant source of wonder!

168 Lulua figure

Wood, 16 cm, Zaire. It is reliably known that already by the early 1880s there were no more Luluas whose whole body was covered with scarifications. Scarification was made illegal by royal decree, in a successful attempt to put an end to the often fatal infections that resulted from this painful operation. Little figures of this sort were for happiness and beauty, and played an important part in many secret societies.

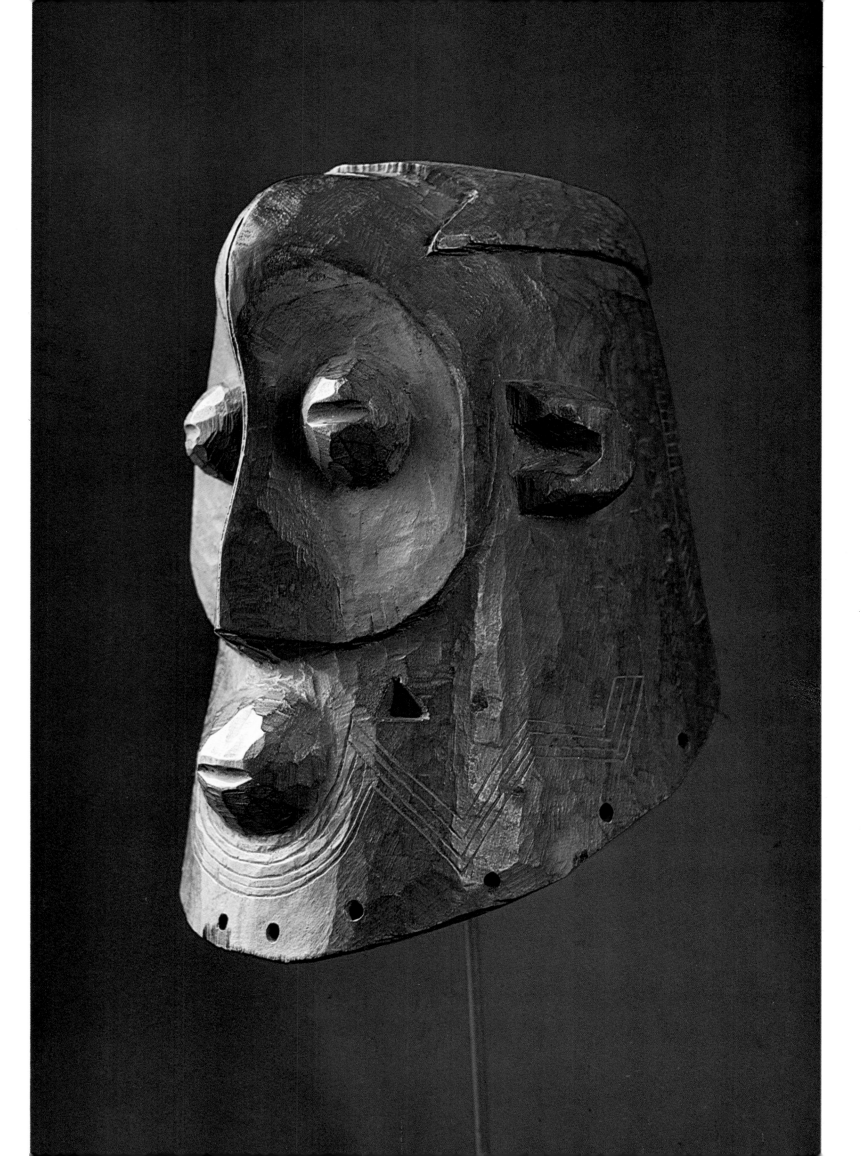

Binji
Biombo

Very little indeed is known of the Binji, or Mbagani, between the Kasai and the Lulua in south-eastern Zaire. Their beautiful masks and small figures, both influenced by the nearby Chokwe, are rare.

Their neighbours, the Biombo, between the Pende and the Kuba, produce extremely beautiful masks. Their figures, however, are so few and far between that they are hardly worth mentioning.

170 Binji mask

Wood, 20 cm, Zaire. The clean-cut features, lovely rounded forehead, wide nose, pointed chin, and semi-circular ears here create an abstract mask illustrative of pure Binji style, although the scarifications, adorned with studs, on the brow betray the proximity of the Chokwe.

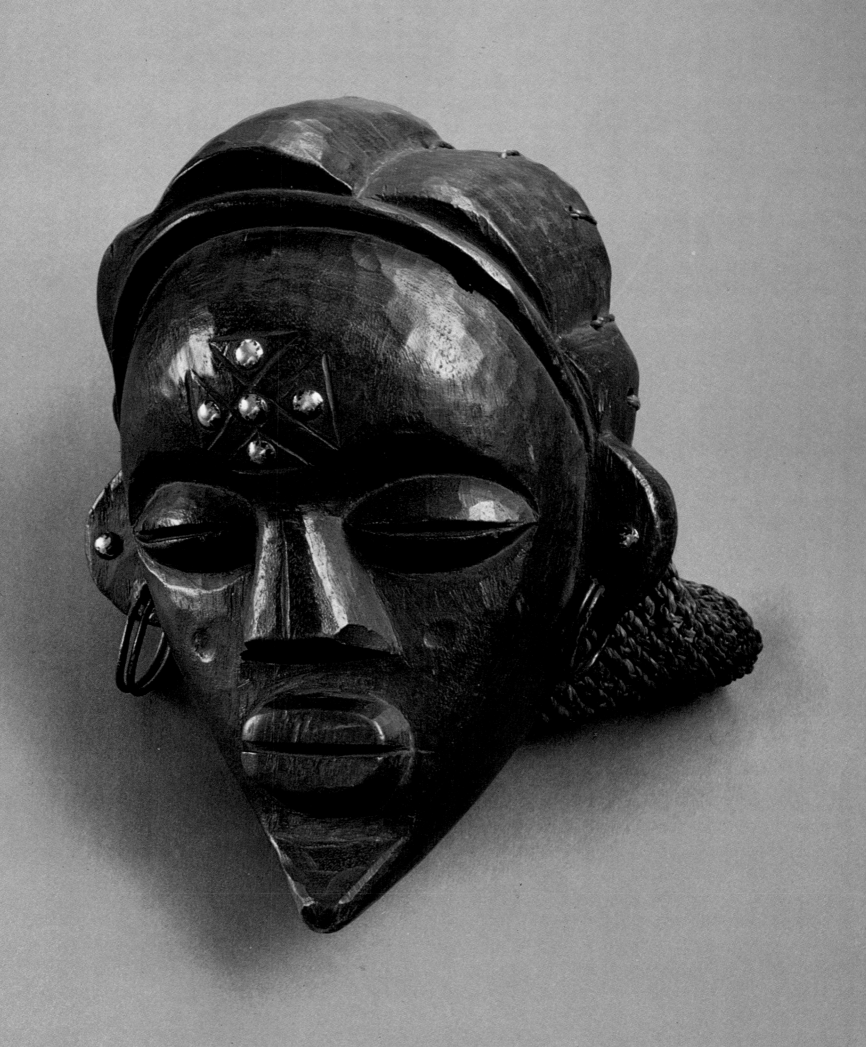

171 Biombo mask

Wood, 37 cm, Zaire. This predominantly reddish coloured mask was used at circumcision ceremonies. The pointed 'hair' is made of material attached to the mask by copper pins. In its colouring it is reminiscent of eastern Pende work, although it is in fact entirely Biombo in style.

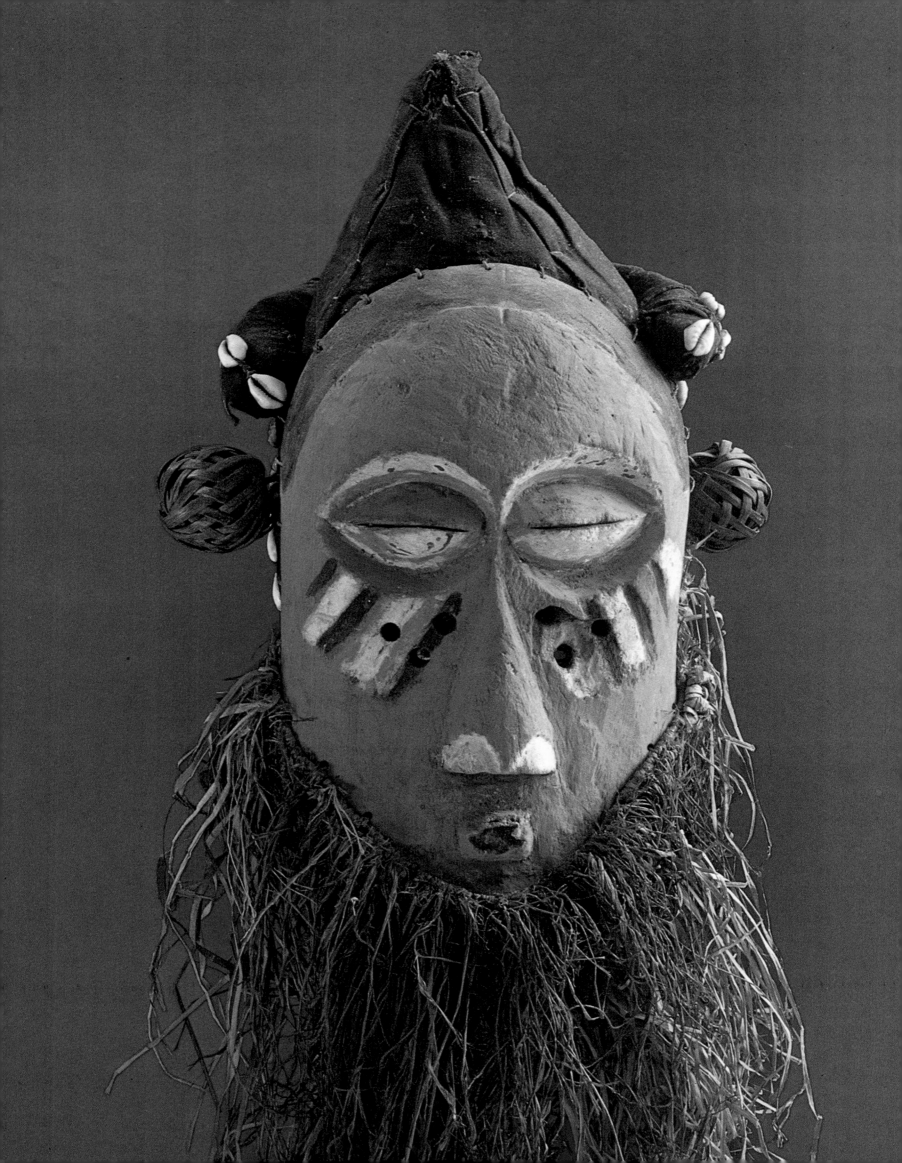

Salampasu
Lwalwa

The powerful Salampasu tribe lives in
Zaire, between the Kasai and the Lulua,
right on the Angolan frontier. They make
striking masks, but less remarkable figures.
To the south-west, in the border area
between Zaire and Angola, are the Lwalwa,
who are also to be found in Chokwe and
Lunda country. They are known for their
abstract masks, rather than for their figures,
which are less common and so less commonly
receive attention.

172 Salampasu dance mask

*Wood, 28 cm, Zaire. Used at initiation
ceremonies. With its bulbous forehead, triangular
nose and rectangular mouth displaying pointed
teeth, it is typical of Salampasu art. Its
expression is decidedly alive and aggressive.*

254

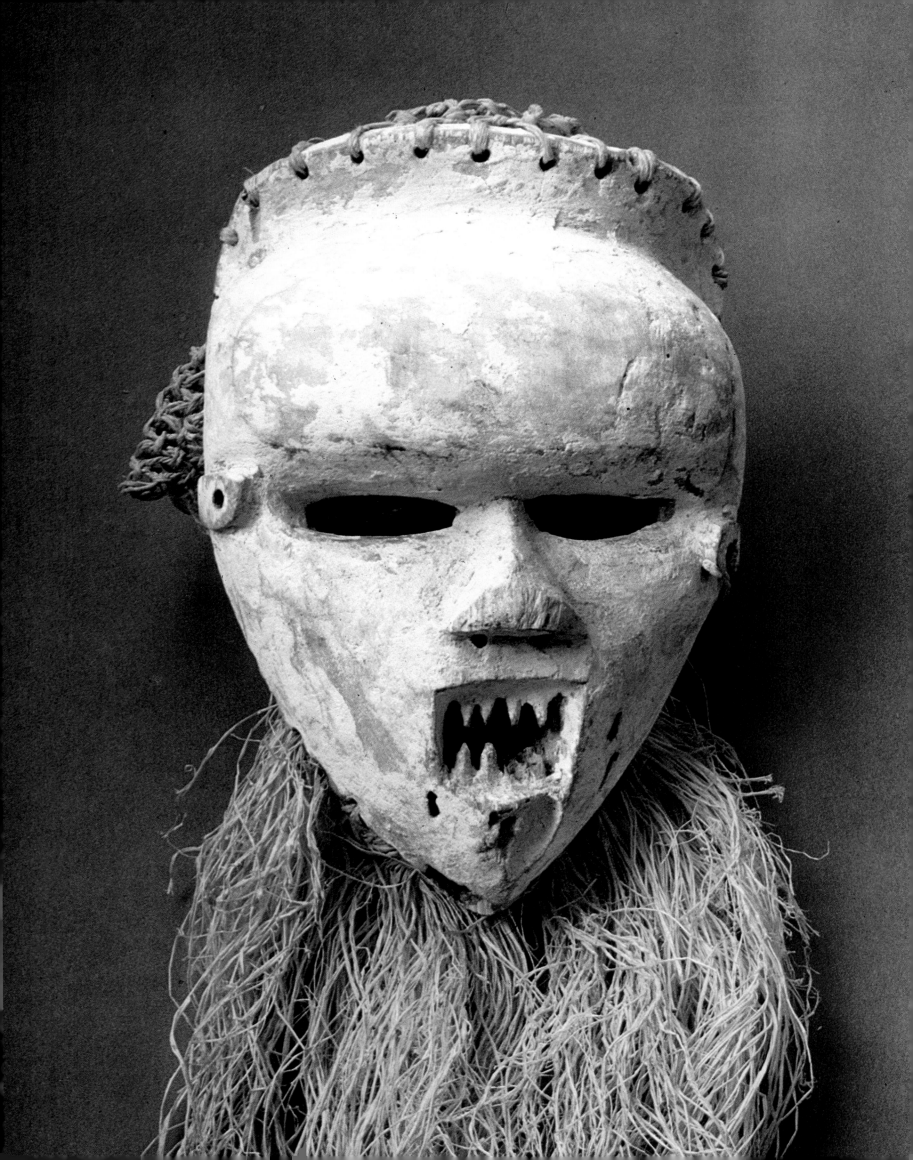

173 Lwalwa figure

Wood, 31 cm, Zaire/Angola. A rare, tightly constructed figure, legless, resting on a conical base. Certain details are suggestive of the distant Luba, who earlier came westwards in small groups, leaving traces of their influence behind them. The beautiful, warm brown, highly polished patina on this figure indicates that it was probably carefully looked after.

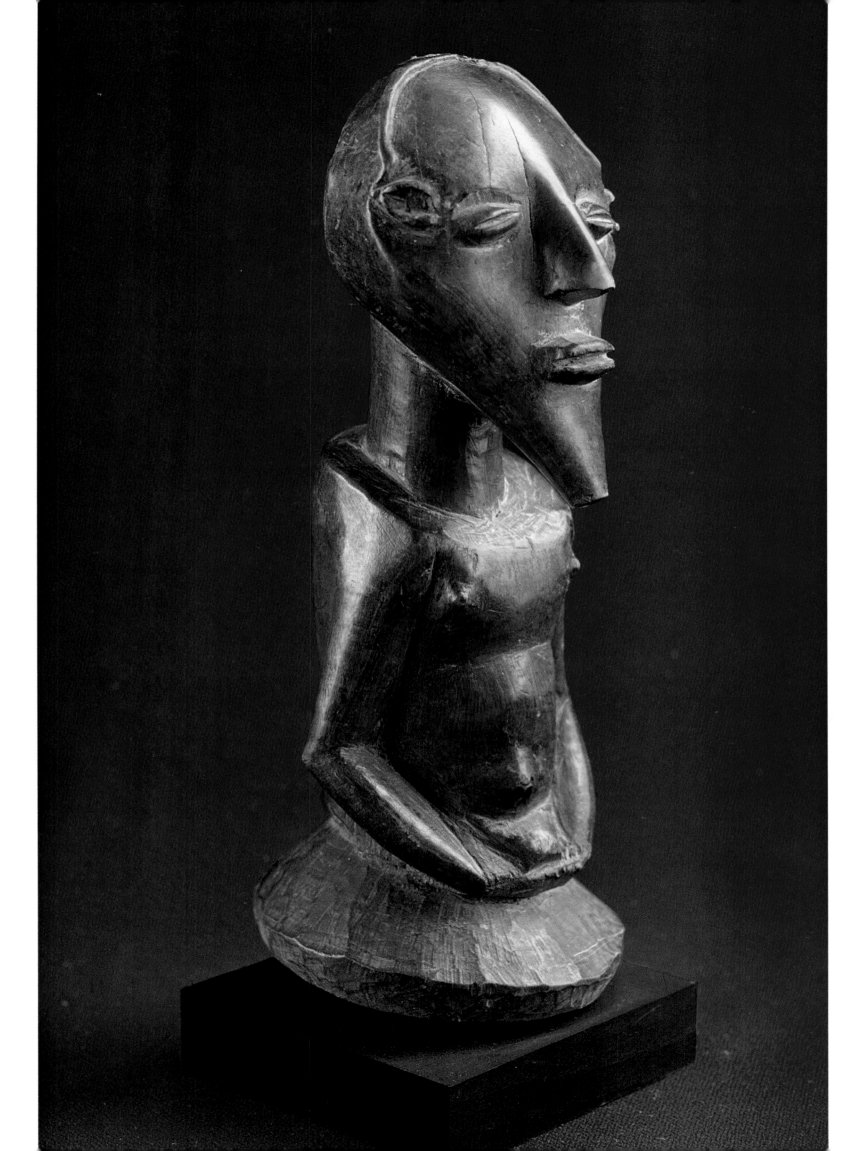

174 Lwalwa dance mask

Wood, 42 cm, Zaire/Angola. This deep (12 cm) hollowed-out mask, with its stylized, almost abstract face, is a fine example of Lwalwa art. The tall hair arrangement is decorated with a trellis pattern of diamond shapes.

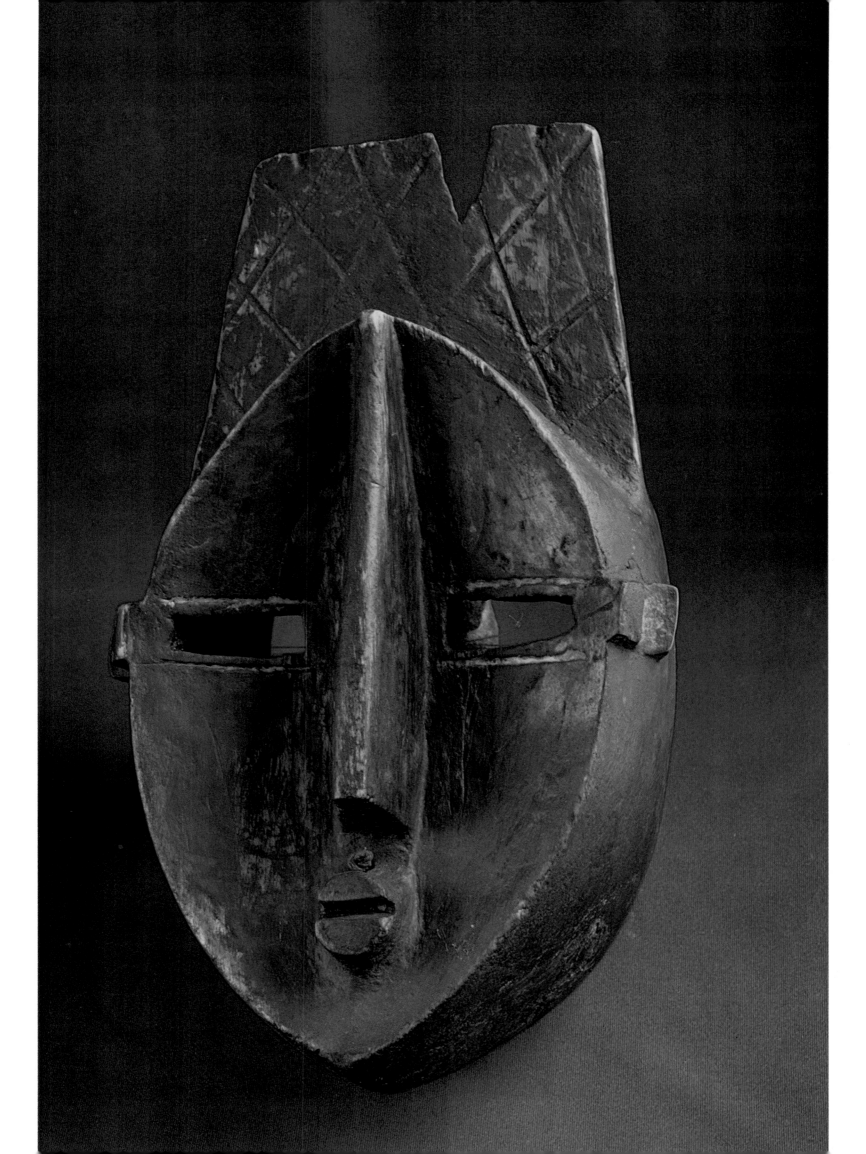

Chokwe

About two-thirds of the Chokwe live in
Angola. The rest are scattered in odd groups
around Zaire, where they live together with
the Pende on the Kwilu and with the Lunda
east of the upper Kasai. Originally natives of
Shaba (formerly Katanga), they migrated
north, where they met resistance from the
peoples already settled there, and were split
up. This therefore explains why they are to
be found over such a wide area today.

Their art is characterized by a predominance
of figure carvings – which for Africa is
exceptional. These are remarkable for their
dynamic movement and sometimes
exaggerated naturalism. They are famous too
both for their royal figures and their masks,
which fall into various styles and categories:
ritual masks for initiations and enthrone-
ments of kings, and simple dance masks.
Their everyday objects show proof of good
taste, often superior to that of their
neighbours, on whom they have some
influence. Their fine sense of aesthetic values
appears in the smallest day-to-day objects –
hunting pipes, tobacco boxes, ceremonial
staffs, or musical instruments. Nor is this
confined only to the rich. It applies at every
level of society. Finally they are renowned
for their chairs which, though closely
modelled on European designs, are eclectic
and genuinely African in their decorative
figure groups and scenes.

175 Chokwe mask

*Wood, 17.5 cm, Angola. A wonderful
representation of a beautiful girl, truly expressive
of girlhood, which was probably used at
initiation ceremonies. The scarification on her
forehead has been identified as a remnant of the
temporary Christianization of the country long
before. The hair, often rendered in plaited bast,
is here skilfully conveyed in wood.*

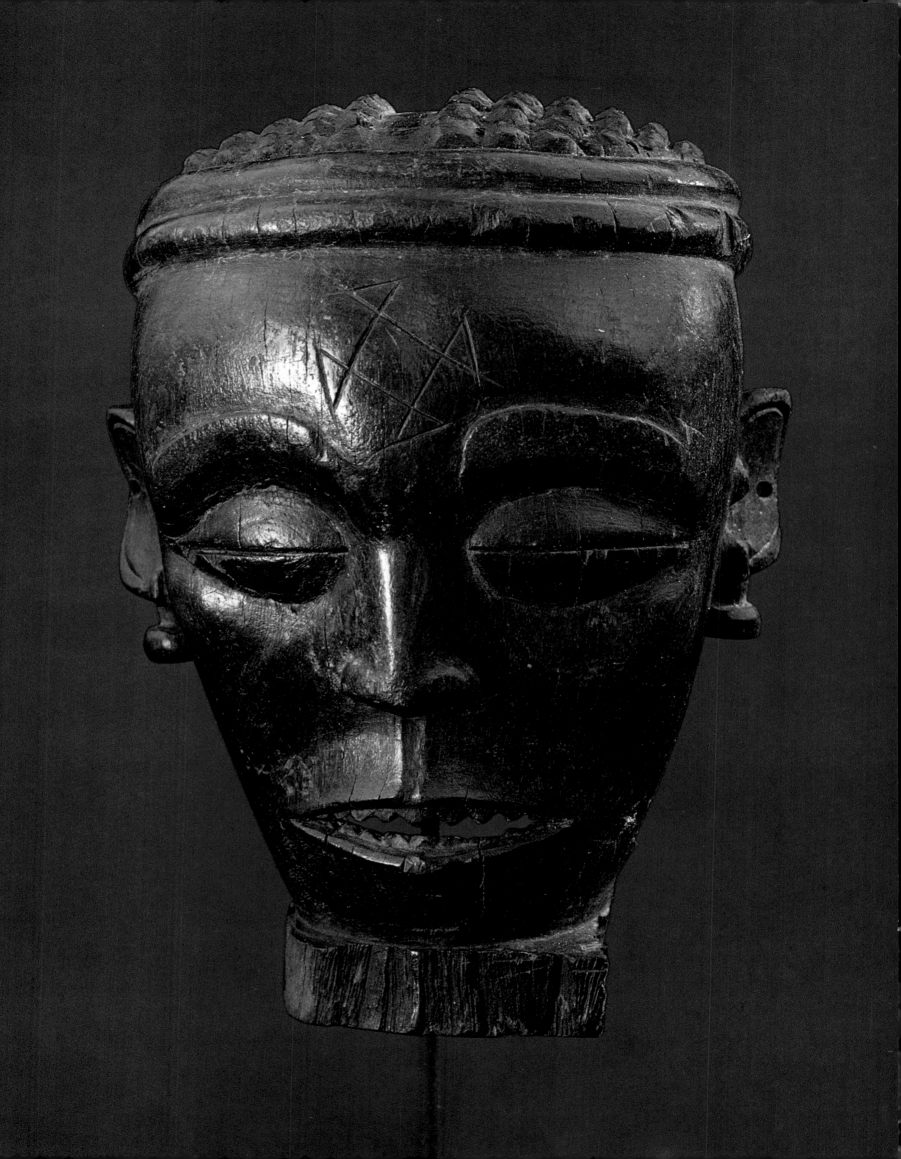

176 Chokwe mask

Wood, 23 cm, Angola. This 'Mwana Po'
(maidenhood) mask is treated rather differently
from the preceding one. The face is schematically
constructed, and the prominent scarifications,
extreme stylization of the eyes, and tripartite
arrangement of the hair all suggest the proximity
of the Luba.

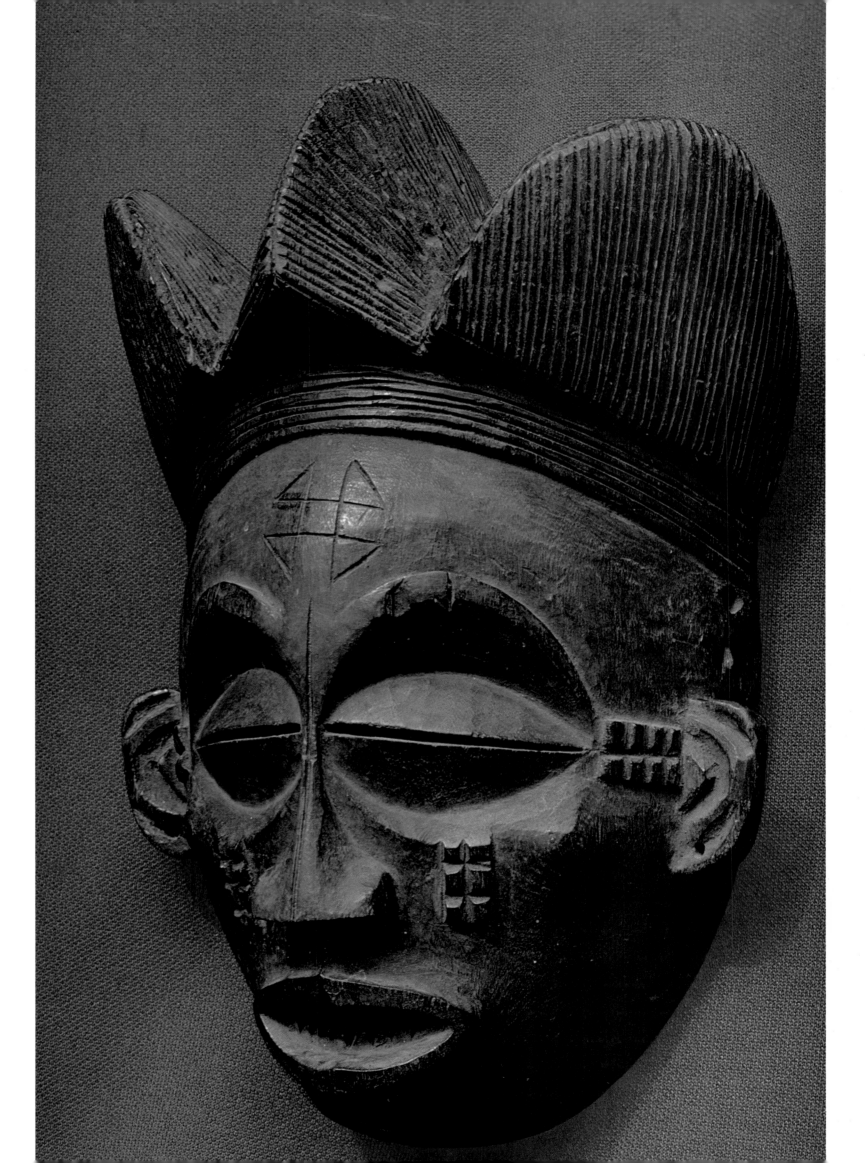

177 Chokwe head

Wood, 15 cm, Angola. A forceful male head in typical Chokwe style. Beautifully carved (though some of the hair is missing here), it once adorned a chief's ceremonial staff.

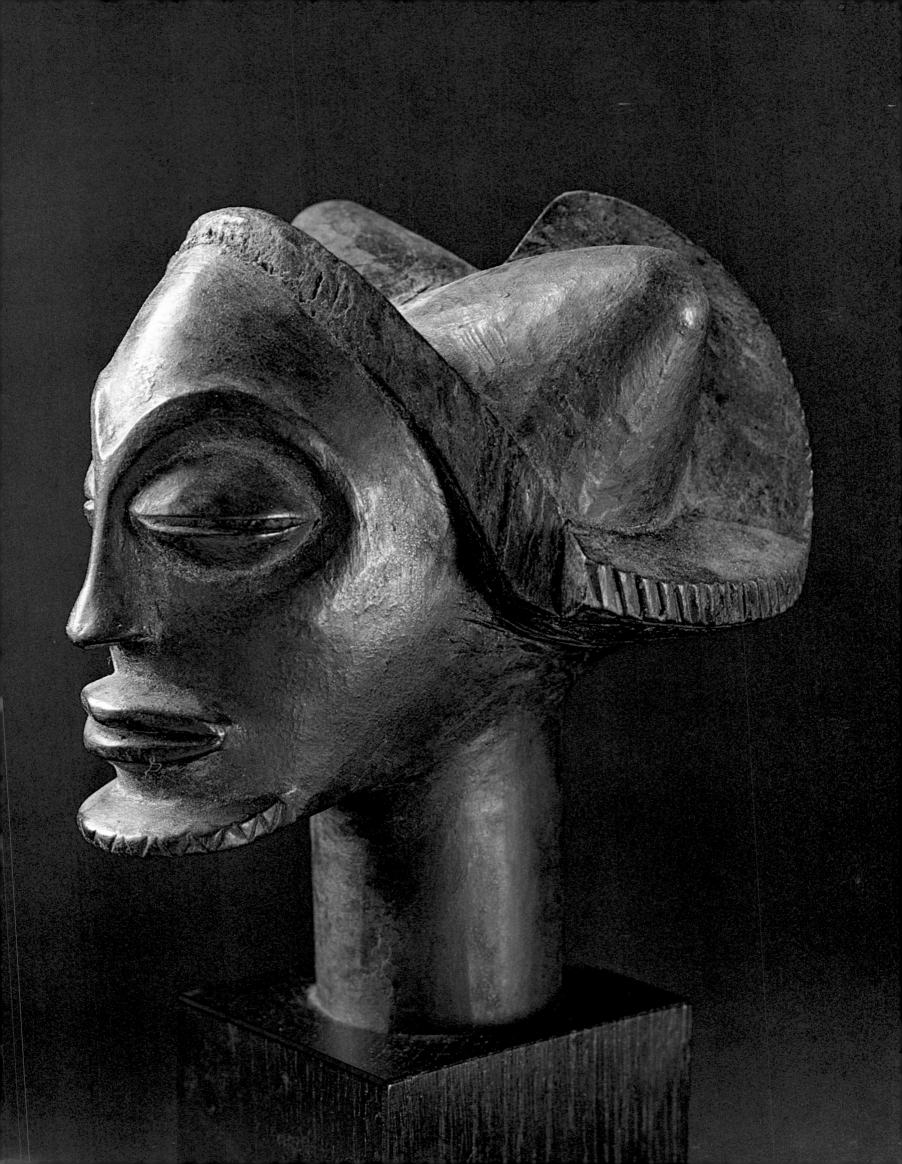

Luba
Hemba

Luba territory in southern Zaire approximates more or less to the province of Shaba (Katanga), with the Lualaba to the east and the Lubilash to the west. The northern boundary runs from Kongolo to around Kabinda, and the southern roughly to the line between Likasi and Musangu. The scattered nature of Luba communities makes it difficult to give a precise geographical location for them.

Early on, and right up until recently, Luba groups moved north, settling among their northern neighbours, without, however, completely integrating with them or losing their own identity.

Their court art has great serenity, which prompts one to try to draw parallels with Baule work. Both traditions include an approach of the 'art for art's sake' type. The Luba number among those peoples whose art has become known all over the world.

Attempts have been made to divide them into areas according to style, but they have not met with complete success, owing to the great variety of the many secondary styles, and their constant overlapping. Today they may be split into two main groups: the Luba proper, west of the Lualaba, and east of it the Hemba. Both have distinct styles of their own, but again, even here, there is overlapping.

Women have an unusually important role in Luba life, and so feature prominently in their carvings. Of note are their ancestral figures, caryatids, neck-rests, box bases, drums etc., and of course their often delightful ivory and bone figurines.

178 Luba celaphopod mask

Wood, 31 cm, Zaire. From Shaba, the Ngoi Manim chiefdom, Mwanza territory, and used in the bush schools and the Mbudye initiation rites. Its job was to ensure that no unauthorized person entered the area of the bush school, and was carried by the two feet sprouting directly from it. Around the eyes and mouth are tufts of genuine hair – severely thinned out by use. Overall an impressive work, that commands respect.

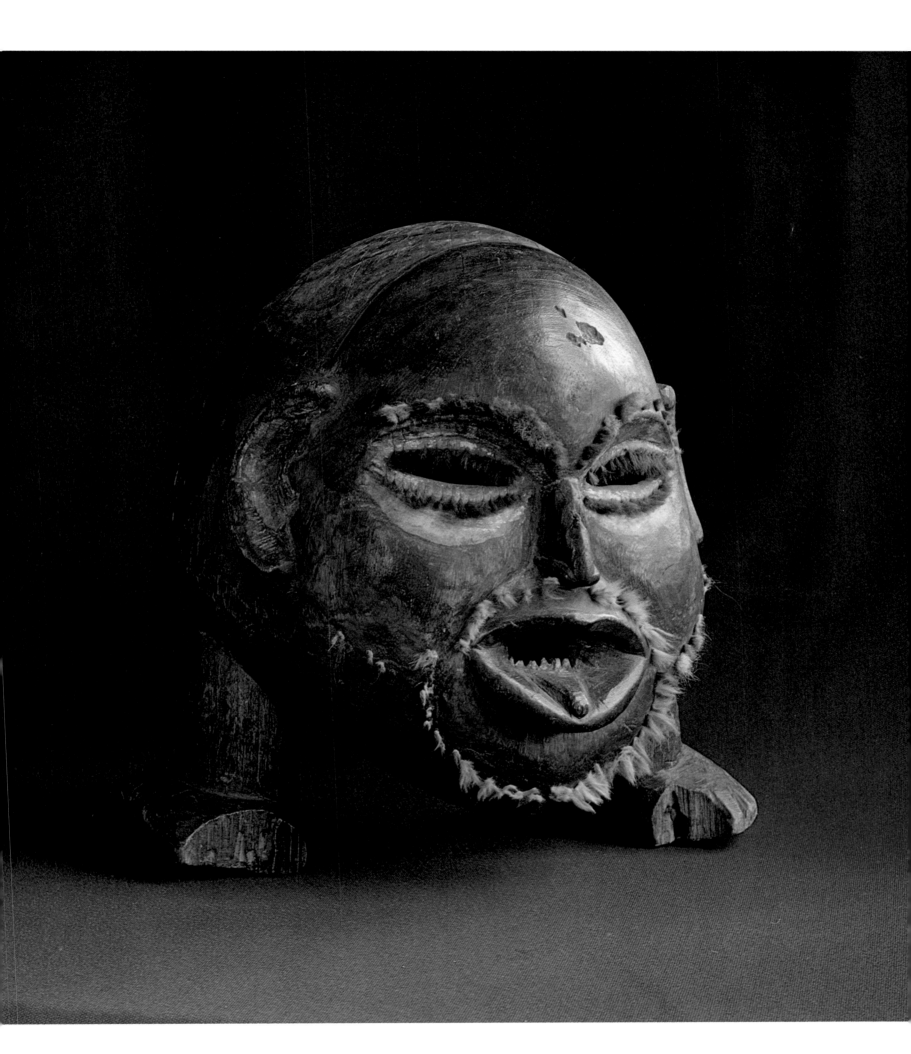

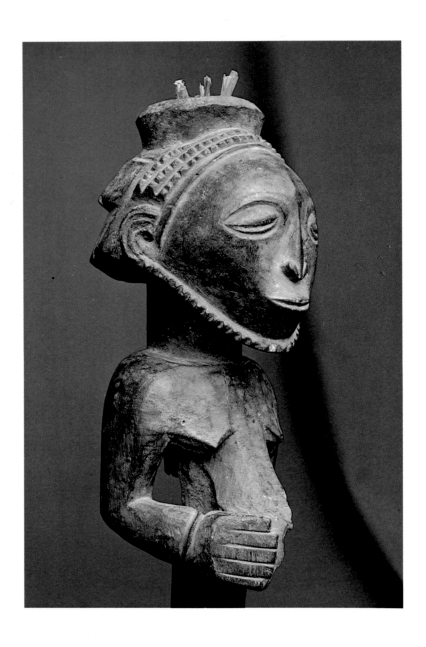

179 Hemba fetish figure

Wood, 30 cm, Zaire. The magic substances in the hollowed-out head of this fetish figure (of which only the top part survives) are clearly scraps of cloth and pieces of bamboo. Still discernible on the back is a rectangular cut-out section which probably also contained magic substances. The falling hair is striking, and the ear and beard stand in subtle relation to the three ridges of hair above the forehead.

180 Hemba Niembo ancestral figure

Wood, 51 cm, Zaire. This powerful ancestral figure was found in the south of Hemba country, between Mbulula and Kayanza, in the river area of the middle Lufwango, where the Niembo live. The fine head is finished at the back by an extended arrangement of hair, ending in a richly decorated cross shape. The torso is anatomically correct, with collar-bone, chest and shoulder-blades clearly delineated. The legs are startlingly foreshortened, as if seen from above, and the flat feet are scarcely more than suggested. A regal, classically beautiful Hemba figure.

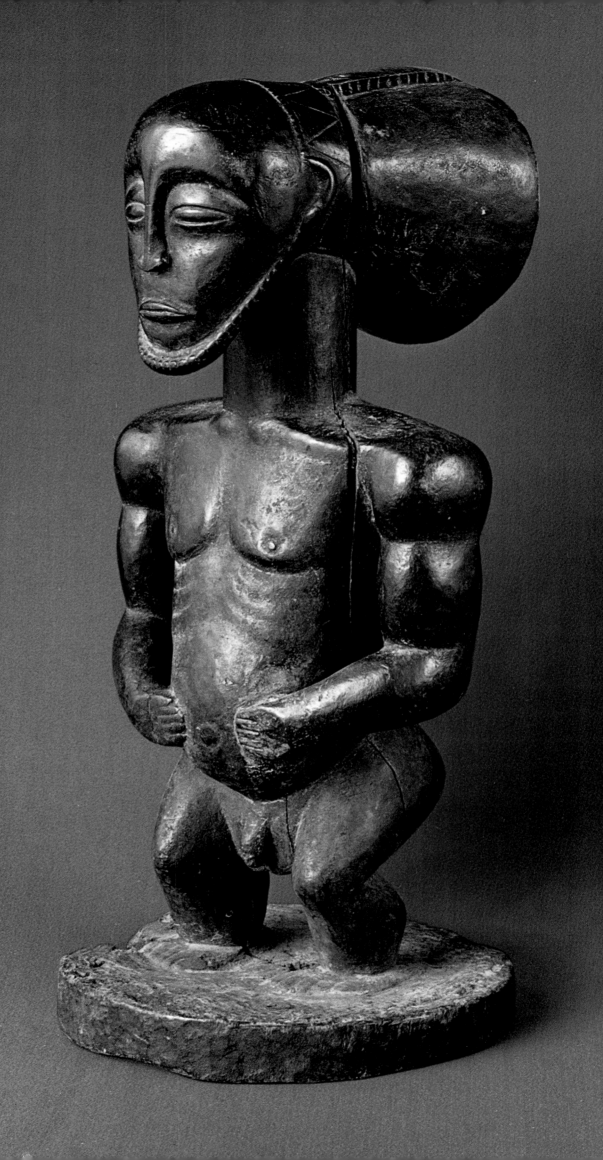

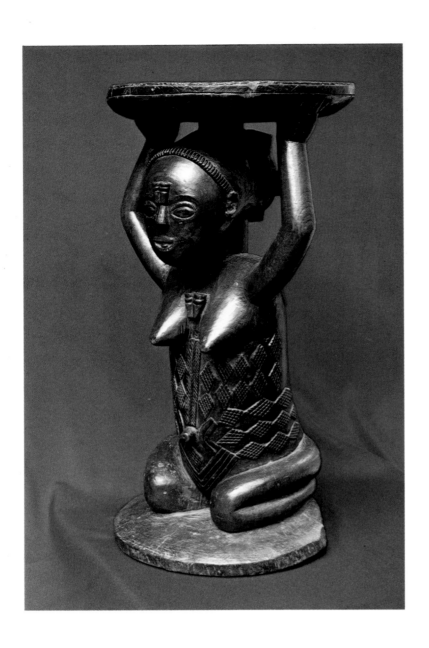

181 Hemba caryatid

Wood, 53 cm, Zaire. These stools supported by female figures are a very special kind of status symbol, reserved exclusively for dignitaries. The figures are shown kneeling or standing, mostly with anatomical distortions due to functional necessity. The scarifications, which provide a clue to provenance, are particularly elaborate and beautifully rendered on this stool.

182 Hemba ancestral figure

Wood, 56 cm, Zaire. Various details about this figure make it ascribable possibly to the Luika. Any attempt to classify it according to F. Neyt's work on the Hemba will meet with only partial success. This shows how hard it is to produce precise classifications.

It is a very unified work, with stern facial expression and beautifully modelled breast. The hair ends at the back in a 'claw' cross.

270

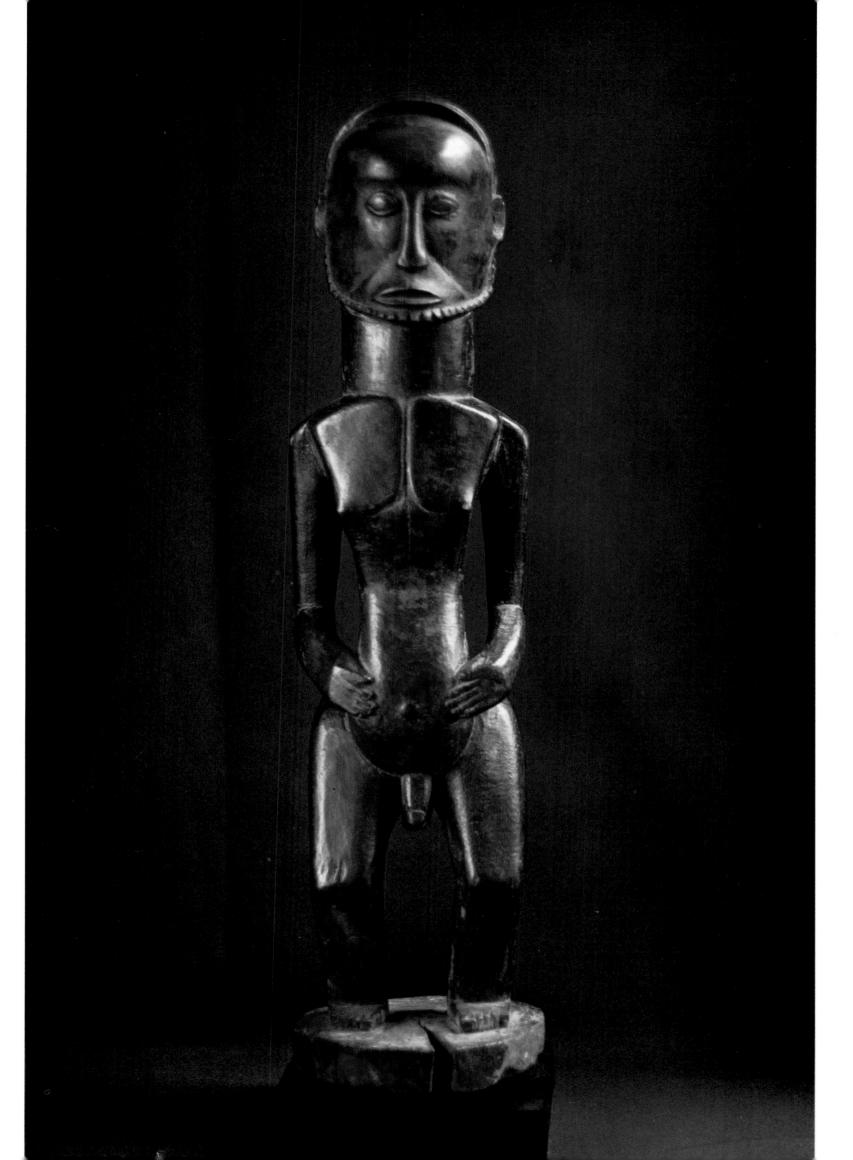

183 Hemba ancestral figure

45 cm, Zaire. Cubism and realism can be harmoniously combined, as this powerful composition demonstrates. The stylized head, with its delicate equilibrium of eyes and nose, is placed above a strong, angular, formally highly unusual torso. The hair ends in a delicately ornamented cross.

184 Hemba ancestral figure

57 cm, Zaire. This figure, with its beautifully modelled torso, probably belongs to the Niembo sub-style. The face is typically Hemba. The hair arrangement is smoothly ended-off at the back.

185 Hemba ancestral figure

Wood, 48 cm, Zaire. In this figure, unlike the others, all the lines flow gently together. The expressive face, tense with concentration, rises out of what is almost a child's body.

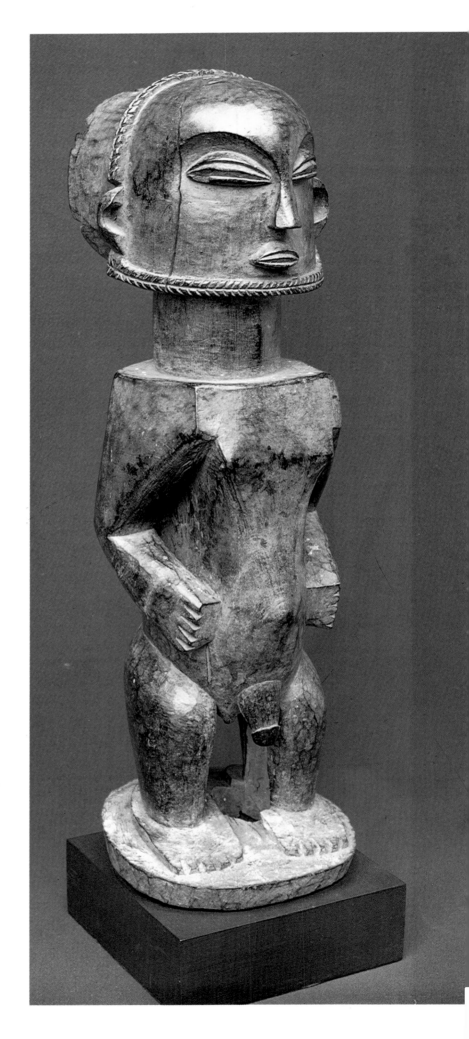

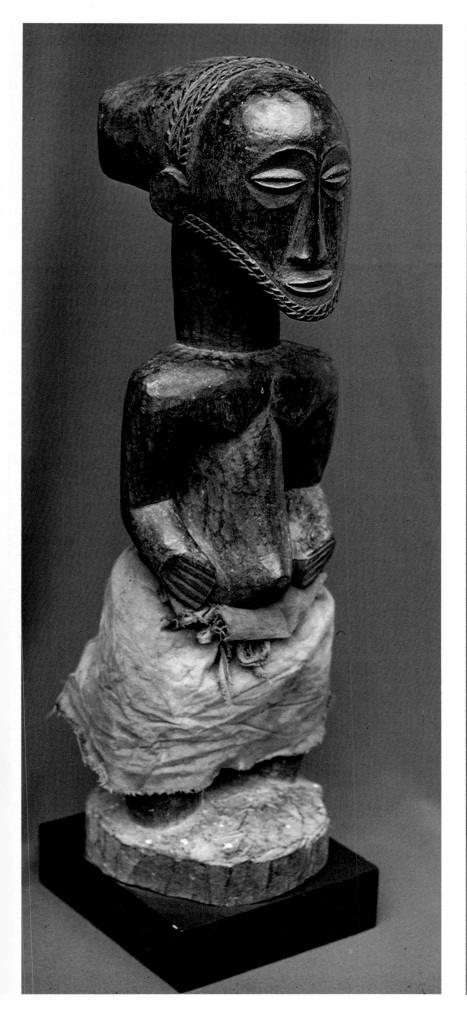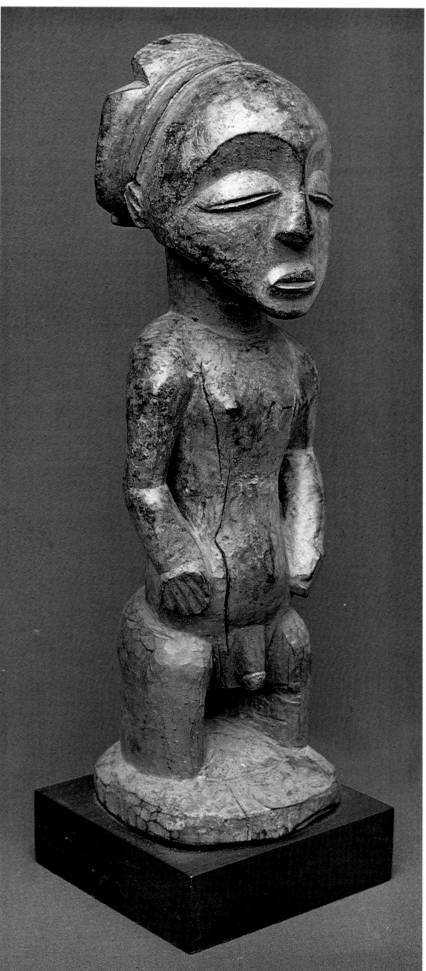

Bembe
Sikasingo
Boyo–Buye

North-west of Lake Tanganyika we find the Bembe and the related tribe of the Sikasingo (often known as the Boyo or the Buye). Their style is especially influenced by the Luba. It has produced exceptionally beautiful works.

186 Bembe mask

Wood, 42 cm, Zaire. This totally abstract face mask (known as Kalunga) was used at initiation ceremonies. The geometrical markings are curious: a similar pattern repeated, in the negative form on the right side of the face, and the positive form on the left, and a variant of it crossing between them, uniting both in a different form. A truly remarkable, stylistically pure example of Bembe (not to be confused with the Bembe in the Republic of Congo) workmanship.

274

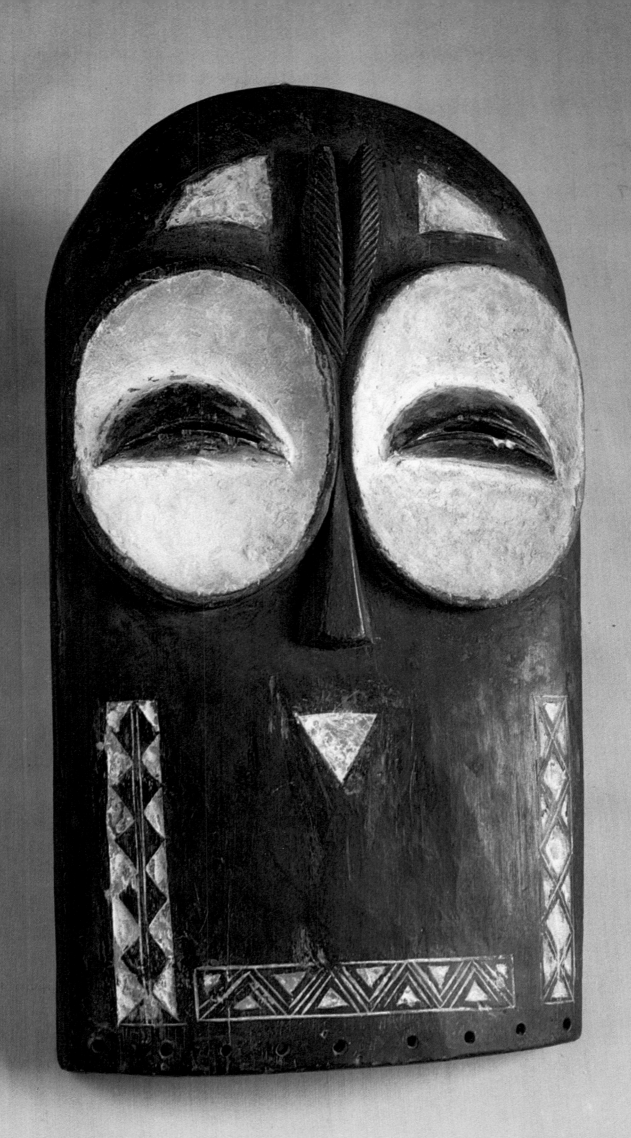

187 Sikasingo ancestral figure

Wood, 45 cm, Zaire. With this figure-type the small Sikasingo tribe in the Boyo-Buye district makes an original contribution to African art. In the chin, half sunk on to the breast, the abstract quality of the head, the angular, curving body, and the whole effect of the piece, it represents a very considerable work of art.

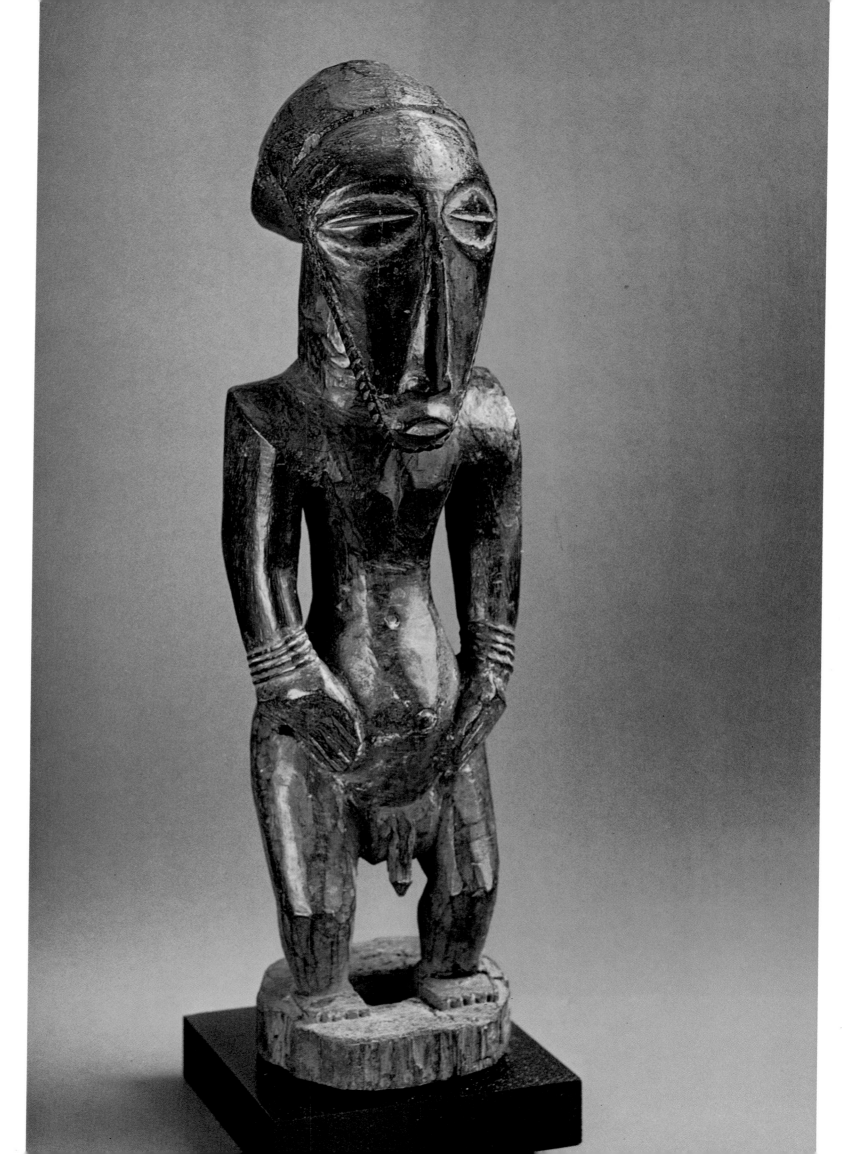

188 Buye–Boyo ivory figure

17 cm, south–eastern Zaire. According to authentic reports, this exquisite hunting fetish was used before and during hunts (especially elephant hunts). As animals can smell humans from a long way away, the medicine-man made up a strong-smelling powder that neutralized the human scent. The hunter's forehead was then covered with this powder. Symbolically there is a powder container on the figure's back. The horn on the head symbolizes its use.

A highly unusual example of Buye-Boyo carving.

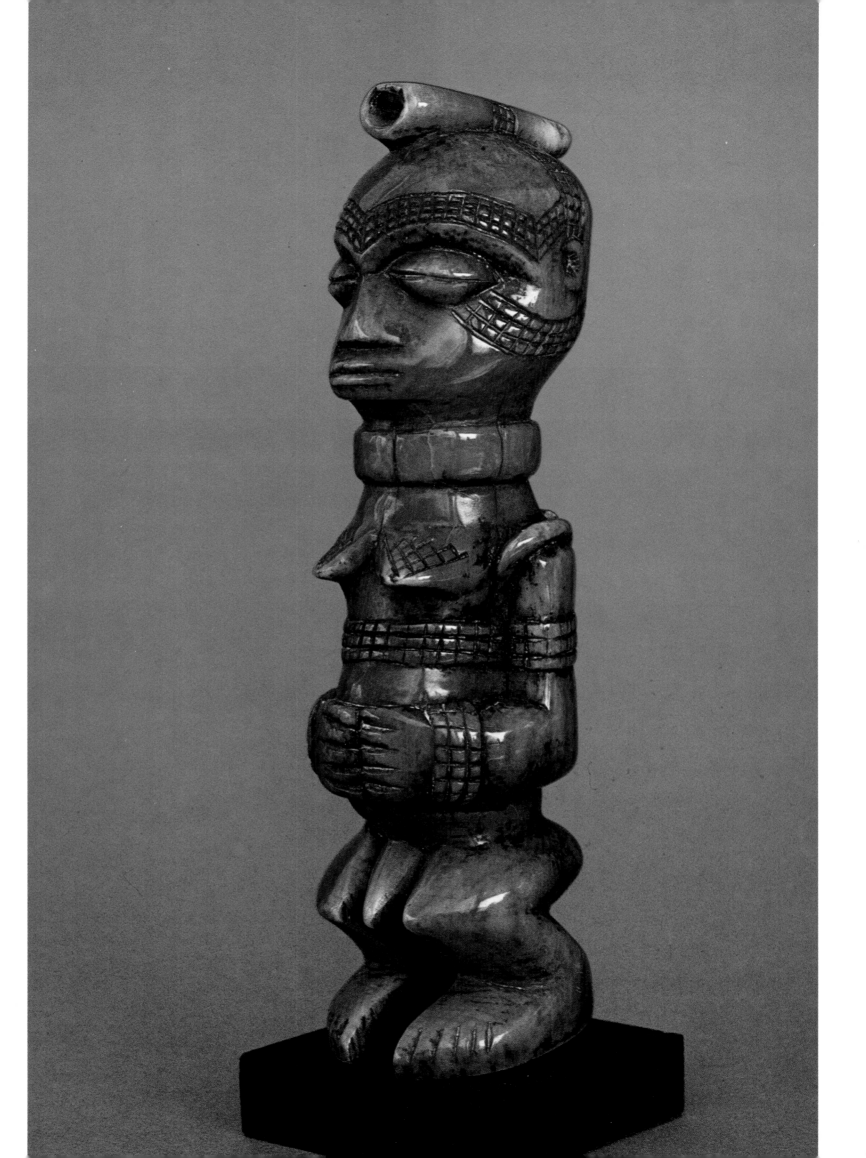

Tabwa

Between Lake Meru and the southern end of Lake Tanganyika, far removed from the Luba (to whom, however, they belong ethnically), we find the Tabwa. Little is known about them, and only a few works by them have been discovered.

189 Tabwa (?) mask

Wood, 38 cm, south-eastern Zaire. A powerful polychrome helmet-mask, with pronounced heart-shaped face. The tripartite hairstyle is reminiscent of those in Gabon. The look of concentration and spirituality, together with the still intact fibre 'dress' make it an important and rare work.

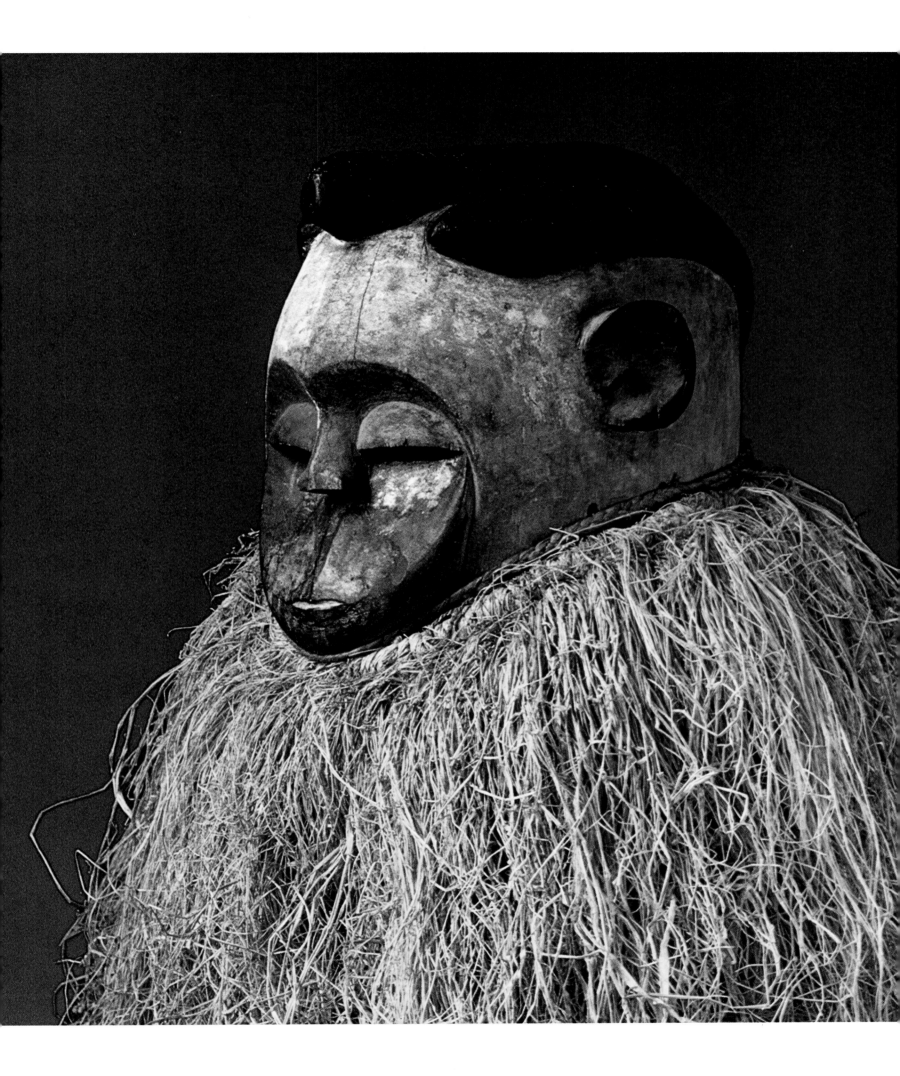

Songe

The Songe live north of the Luba, and are governed by a king himself influenced and, if necessary, dictated to by powerful secret societies. Songe figure art – mostly fetishes, which can serve either the group or the individual – is thus highly developed and extremely varied. Classification is made difficult by the innumerable variations of style. In most cases Luba influence can be traced. Ancestral figures are less common. On the whole heavily stylized, the fetish figures are only properly completed where they are visible – the rest being hidden by the magic substances. Fetishes are important as means of protection against evil spirits and sorcerers, as fertility symbols for society, and as personal guardians. The Songe are also known for their masks, neck-rests, caryatids, chairs and many other objects besides.

190 Songe fetish figure

Wood, 33 cm, Zaire. A splendid, well-proportioned magic figure. In the small antelope horn on the head is stored the medicine intended to protect the society or individual from evil.

Collected at the beginning of this century. A classic example of Songe style.

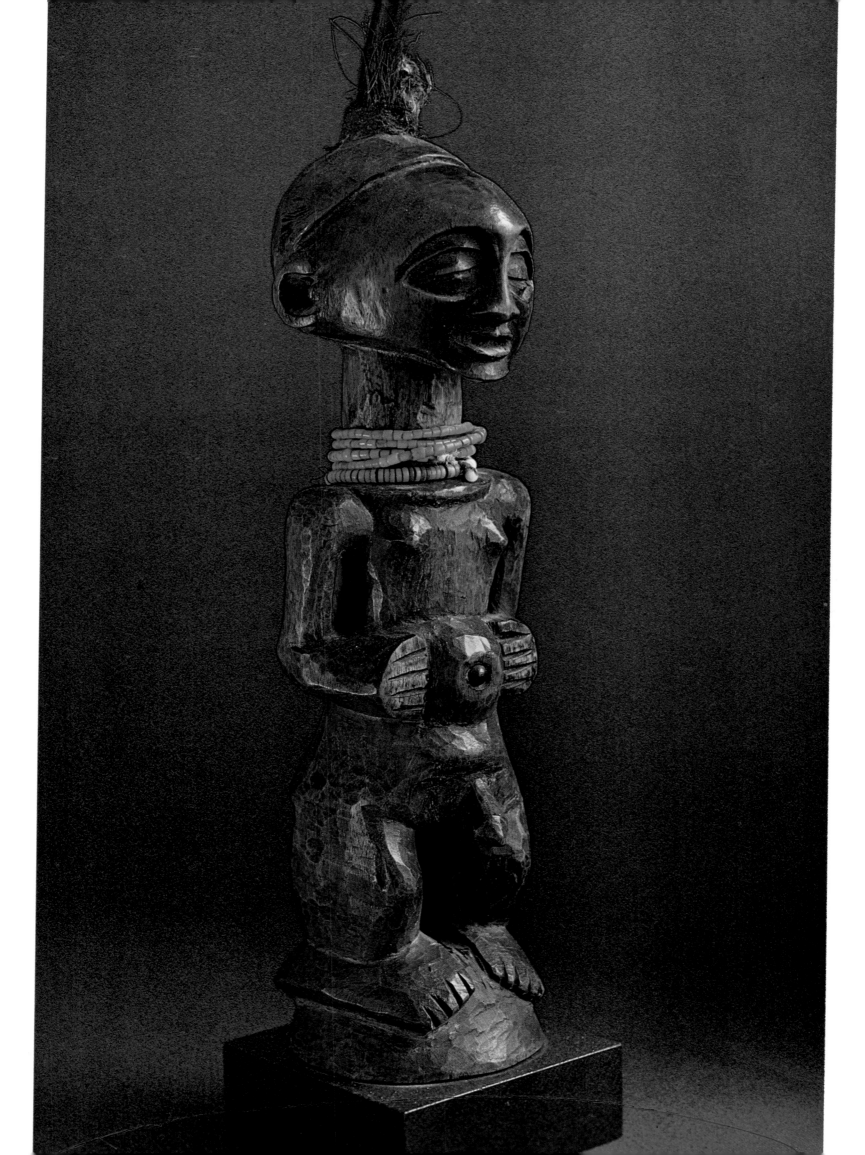

191 Songe chief's shield

Wood, 47 cm, Zaire. The purpose of this unusual piece cannot be known for certain. It probably served as a sign of rank for some person of quality. The gouged-out patterns are their natural colour, against a jet black patina. The face is a typical example of a Songe Kifwebe mask.

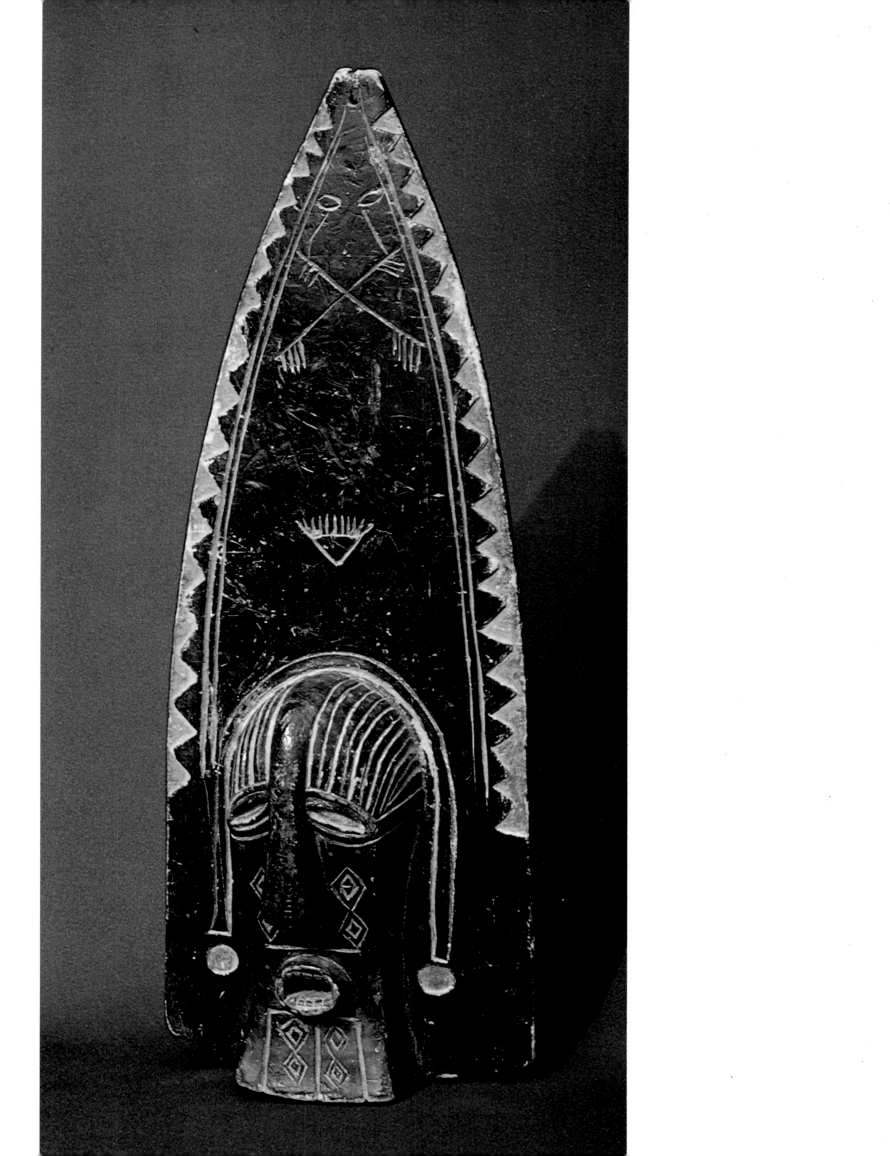

192 Songe Kifwebe mask

Wood, 40 cm, Zaire. The masks of the Kifwebe society are among the very finest that Africa has produced.

A very old polychrome mask, cubist and surreal to a remarkable degree. It can be identified as male by the comb coming down over the forehead. Various suggestions are given as to the function of the mask. One is authentic: that it was used for curing madness. The sick in mind would put it on, the requisite dances would be performed, and the medicine-man would work his psychic magic. This treatment was successful in 75 per cent of cases!

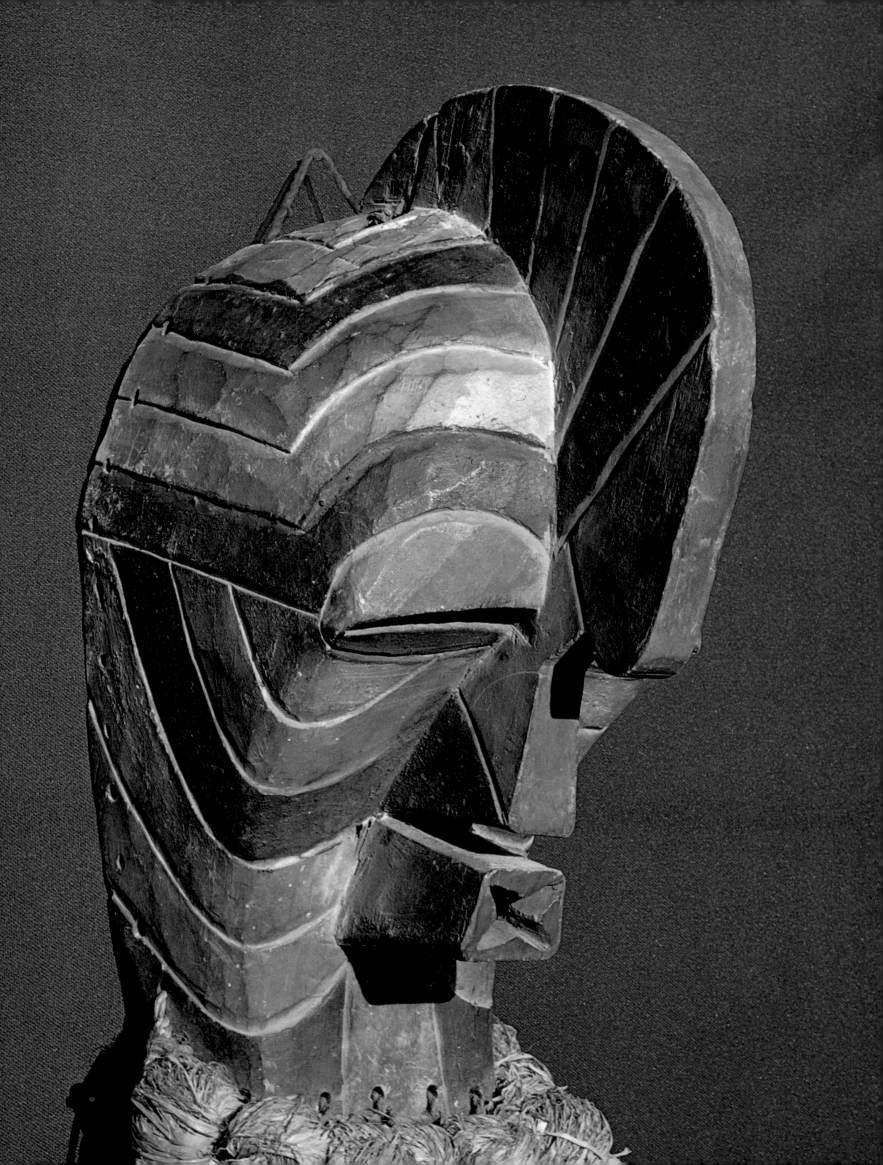

Goma

At the north-western end of Lake Tanganyika, near the Boyo-Buye, lives the small Goma tribe. Their masks bear a strong resemblance to those of other neighbours of theirs, the Bembe – for which, in fact, they may have been responsible.

193 Goma fetish figures

Wood, 40 cm and 47 cm, Zaire. An unusual pair of figures, the smaller with a medicine horn decorated with cowries on his head, and fur around neck and body. The angle at which the head of the larger figure is turned is extraordinary, and highly unusual. So too are the legs on both figures, with their powerful thighs leading directly into the back, without buttocks. The face of the left-hand figure shows traces of white (kaolin), whilst that of the right-hand figure is coloured red. The arms are pressed tight to the bodies, those of the one reaching down to his thighs, and those of the other bent so that his hands come to about his navel.

288

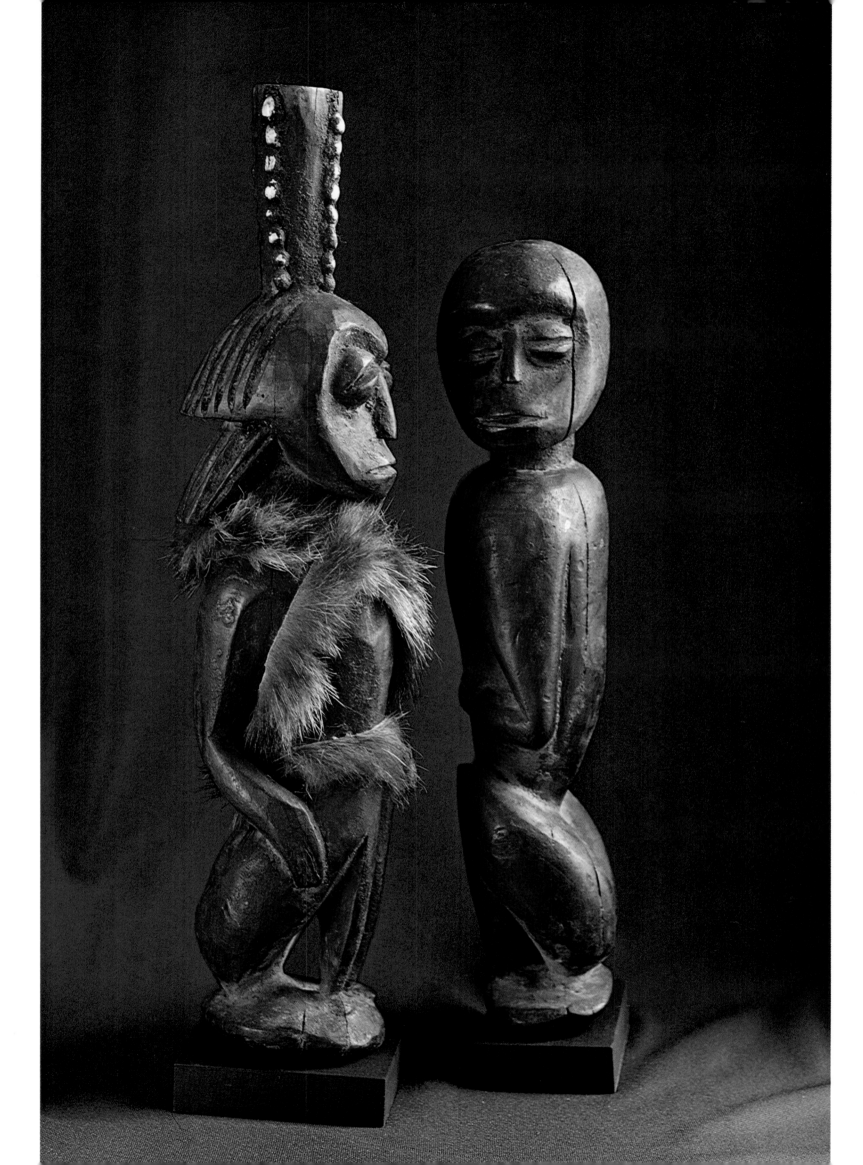

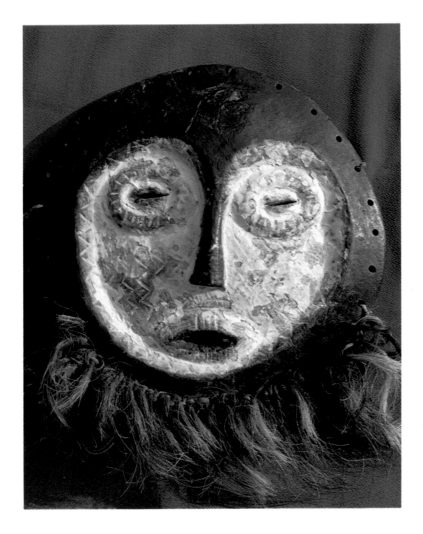

Lega
Mbole

Between the Lualaba and Lake Kiwu live
the Lega, who settled there on their way
south from Uganda, where they are thought
to have originated. Their life is governed by
the Bwami society, which is open to both
men and women and is characterized by its
many ranks. Unfortunately this society was
outlawed by the colonial authorities shortly
after the Second World War, and this more
or less meant the end of Lega art. Even the
attempts to resuscitate it after independence
could not save it. However, the Lega still
retain their sense of beauty and form, as the
popular products they make for the tourist
market show.

Their great variety of styles can be
accounted for by the fact of their being so
widely scattered. It is now considered that
there was a mutual influence between the

194 Lega mask

*Wood, 32 cm, Zaire. The white face of this
mask, with its zigzag decoration, looks out
from a dark frame. The heart shape here is
particularly clear. The beard is made of animal
hair.*

195 Lega figure

*Wood, 24 cm, Zaire. Abstract representation of
the human body is here taken to its extreme.
Arms and legs are no more than suggested.
Cowrie shells are set in the large head for eyes.
The nose – fragments of mussel shells – climbs
like a column up over the forehead, while
below, in the vaguely shaped mouth, there is a
long red glass bead.*

A rare Lega work.

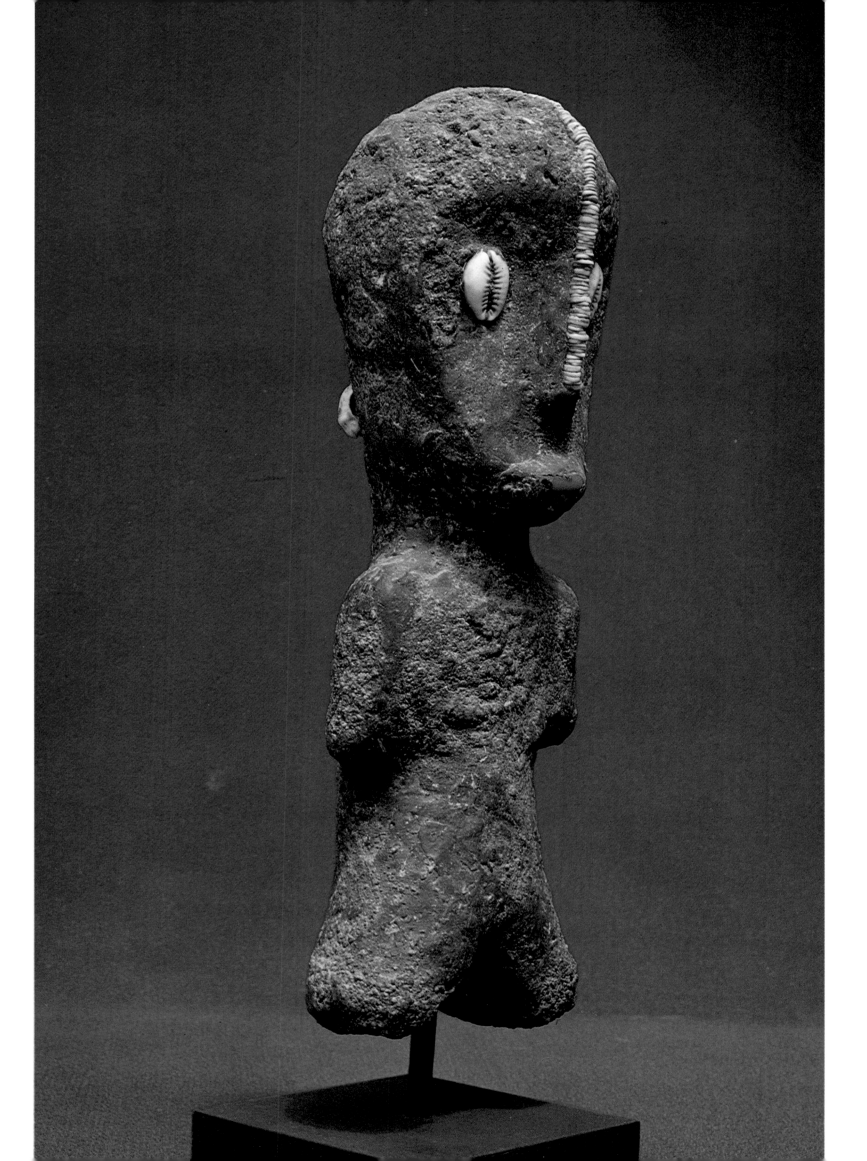

Luba and the Lega without either one or the other preponderating.

The figures are purely symbols of rank, rather than representations of ancestors, and do not derive from religious worship. Their masks and beautiful, often tiny, ivory figurines are famous worldwide.

Under the artistic influence of the Lega are the Mbole, on the Lomami to the north. This tribe has a leopard society (Lilwa nkoi) which is open only to persons of high rank.

196 Lega mask

Wood, 17.5 cm, Zaire. This beautiful small mask is an embodiment of pure Lega style. It belonged to the third from top rank of the Bwami society. The expressive stylization is extremely fine. The beard is made of vegetable fibre.

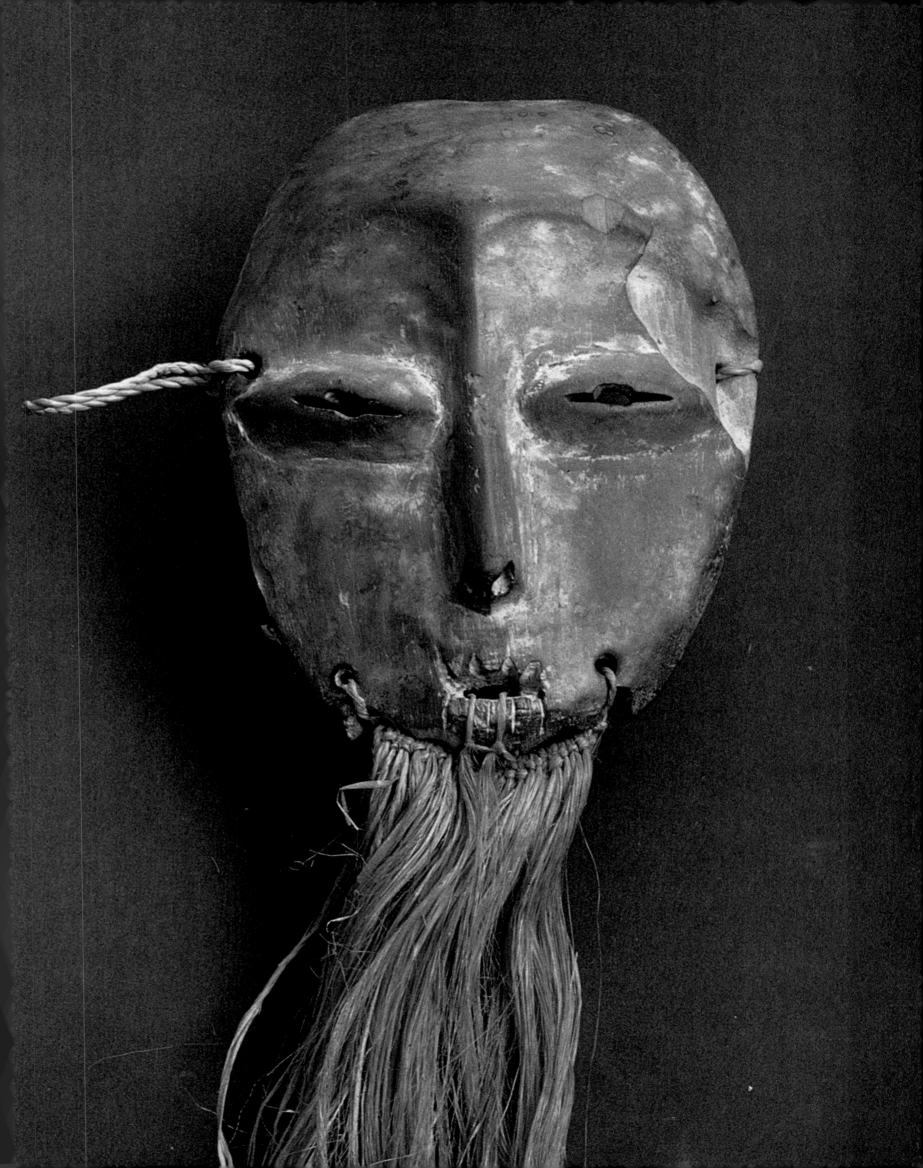

197 Mbole figure

Wood, 52 cm, Zaire. A heavily abstract leopard-society mask, with heart-shaped face, used at initiation ceremonies and the like. It represents a hanged man – as a discouragement to dignitaries' sons to betray the society's secrets. The forward-leaning stance and forward, angled bend of the arms are characteristic. It hung from a string passed under the arms (this explains the posture). Attrition under the right arm clearly shows this.

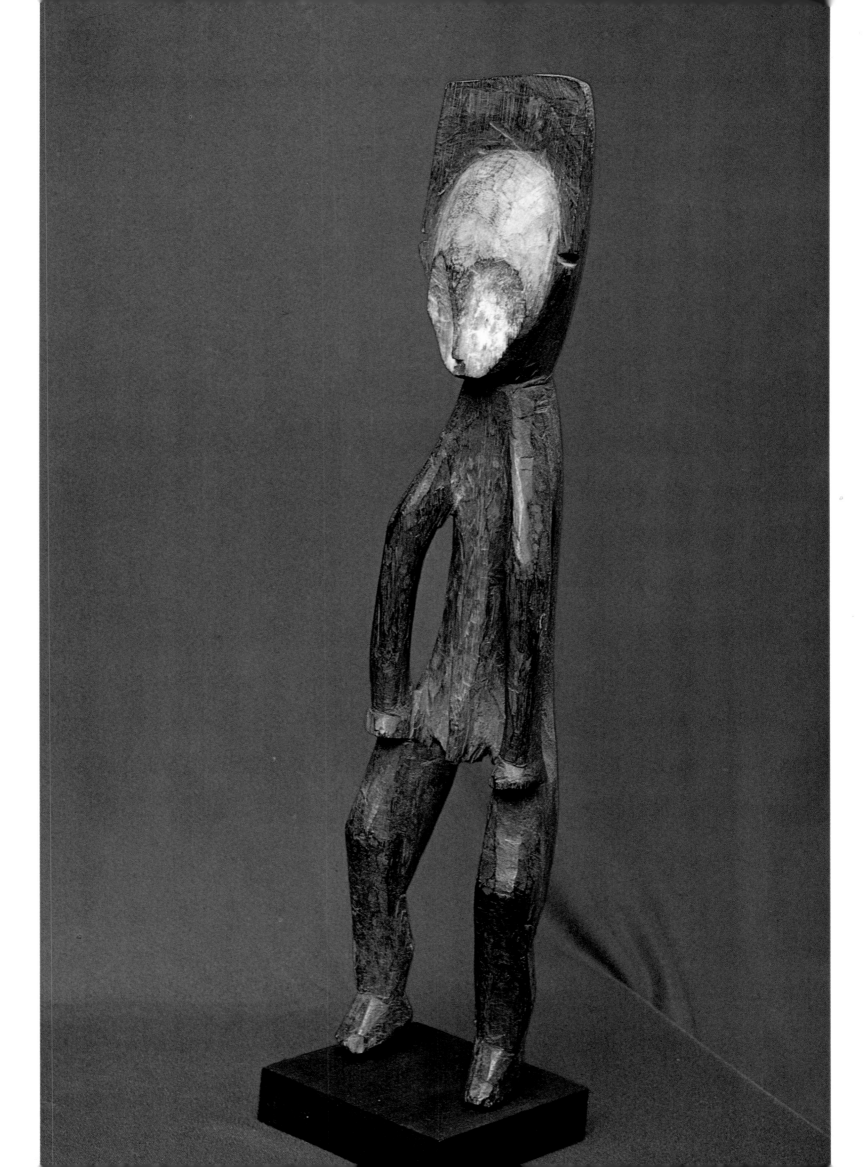

Mangbetu

In the north-eastern corner of Zaire, in the Bomokandi area, live the Mangbetu. North of them live the Zande. Their art differs fundamentally from that of the Kongo. A typical feature among dignitaries is deformation of the back of the head. This corresponds to an ideal of beauty. As very young children they have their heads bound up with bast, to provoke this deformation. The women on top of this tie up their hair in a basket-like arrangement opening out at the back. They are known for their figures and ceramic pots, all of which show this peculiar head shape.

198 Mangbetu harp

Wood/ivory, 92 cm, Zaire. A 'kundi' harp with four pegs and bast strings. The body of this very beautiful instrument is covered with snake skin. The graceful ivory neck is fashioned in the shape of a woman displaying the characteristic long, oval back of the head. It comes from the Bomokandi area.

296

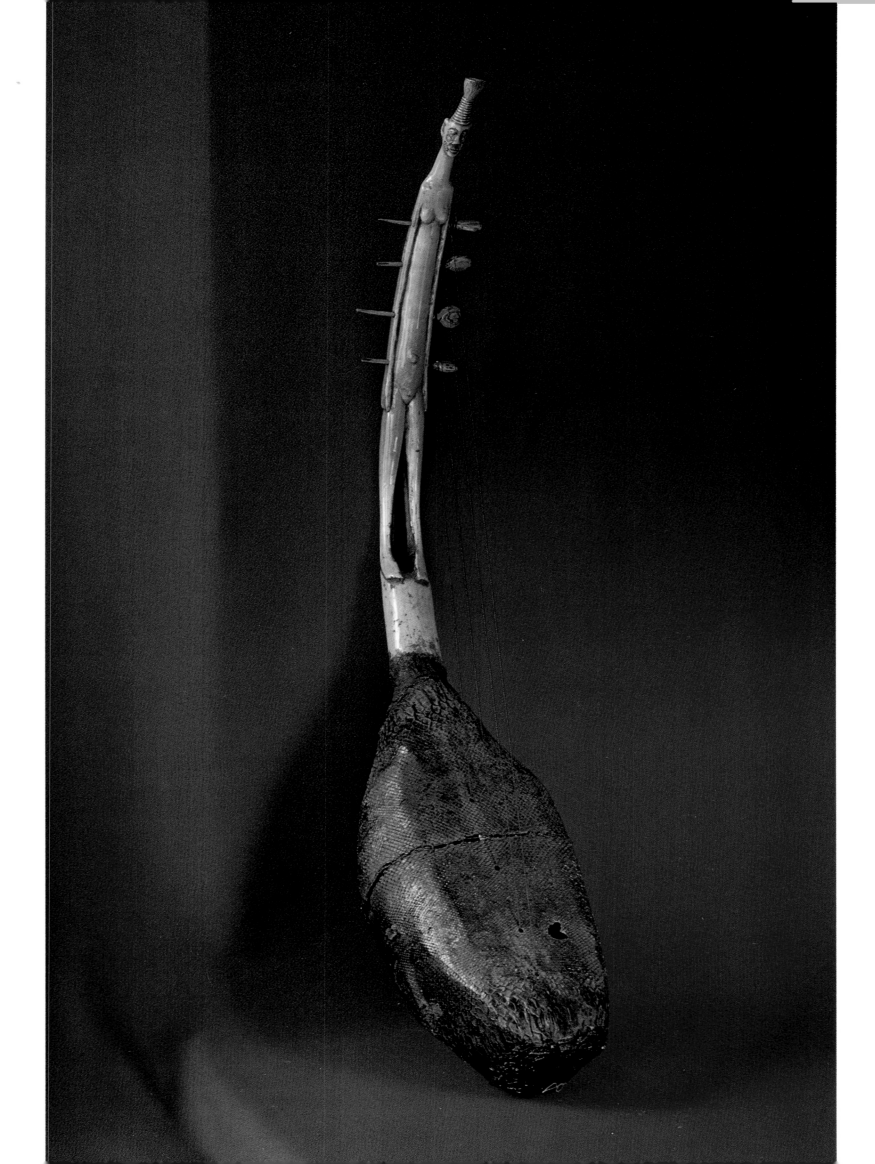

199 Mangbetu figure

Wood, 30 cm, Zaire. A very subtle female figure with extended oval skull and zigzag scarifications on the cheeks. A beautiful, stylistically pure Mangbetu carving.

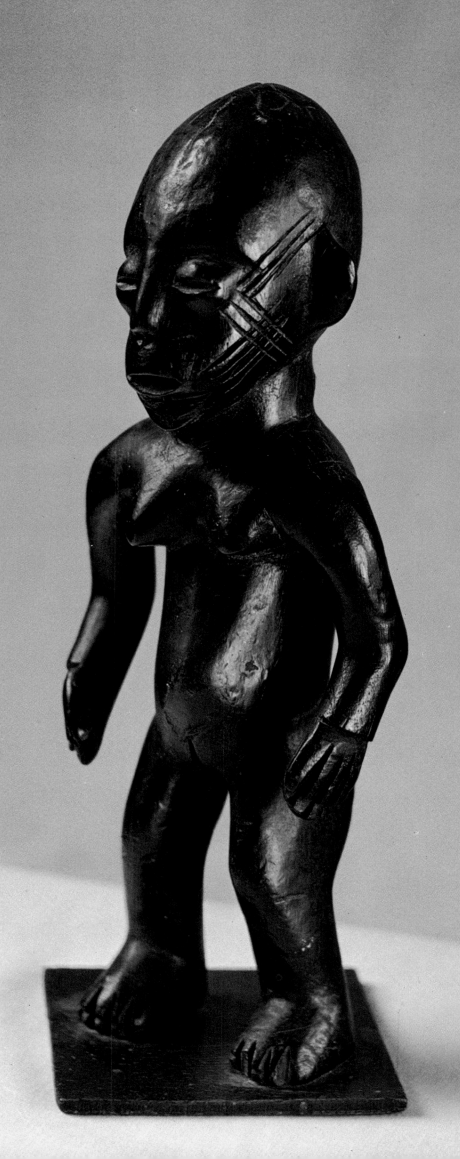

Aloala

MADAGASCAR

Living as minorities on the island of
Madagascar, off the east coast of the
continent, we find the last African tribes:
the Mahafaly and Antandroy in the south,
and the Tsimihety in the north. They are the
carvers of the grave figures known as
Aloala, which are the easternmost represen-
tatives of a remarkable tradition of tribal
art. These often tall figures were to be found
in large burial places, serving as a final resting
place for the souls of the dead.

200 Aloala grave figures

*Wood, 80 cm and 86 cm, Madagascar. Through
exposure to all weathers the surface of these
figures has been heavily worn away. However,
this, together with the revealed graining of the
wood, lends them a certain charm. From the
point of view of style there are two extremes.
One – highly abstract – conveys great dignity,
the other – holding a male penis in her left hand
as a fertility symbol – is very feminine, with
its round, full forms. The feet on both figures are
missing, as they were sawn hurriedly, under
cover of night, from the wooden grave enclosure
of which they were part.*

*These two superb figures, in a way symbolic
in their very state of decay, represent a last
moment of glory for the wonderfully varied,
fantastically rich and fascinating tradition of
African religious art – now doomed perhaps to
extinction. The creative genius of Africa, which
for centuries has found eloquent expression, may,
however, yet survive its present profound
crisis. We can only hope.*

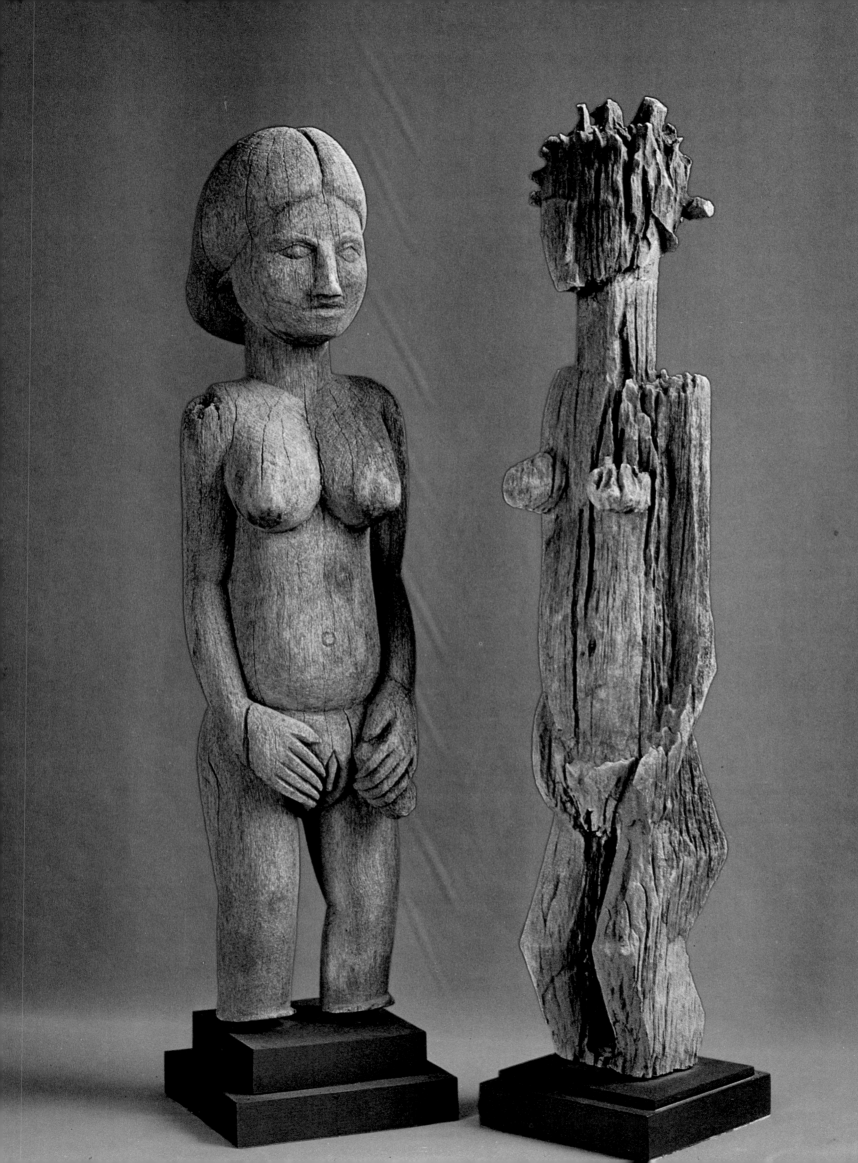

GOLD-WEIGHTS Both the Baule in the Ivory Coast and the Ashanti in Ghana (Akan peoples, both of them) produced little bronzes which, up until the end of the last century, fulfilled a very particular purpose. They were used as weights for weighing gold dust and small gold nuggets. Anyone who comes across these little works of art is astounded by their variety of form. While the carver of ancestral figures was bound by old traditions and the physical restrictions imposed by his raw material, the creator of gold-weights was able to give free rein to his imagination. For a long time gold, the symbol of the gods and the sun, was panned in (what was formerly) the Gold Coast, on the Gulf of Guinea. And for both Akan peoples this gold was used as money. Unlike our dull weights – equally destined soon to disappear! – these gold-weights are fascinatingly varied. With us a two-ounce weight is always a two-ounce weight. African gold-weights are different. Sometimes they are little men or animals, sometimes inanimate objects such as weapons, fruits, or tools, or (by comparison) restrained geometric shapes – rectangles, cubes, pyramids, triangles etc. Their intrinsic symbolism and, with the figurative weights, proverb-like significance are continually surprising and exciting. A contributing factor of this is the realization that two totally different figures are in fact exactly the same weight.

Recent gold-weights, intended for sale, and of no interest to the collector, are also always made by the same technique, with various alloys. Pure bronze consists of roughly nine-tenths copper and one-tenth tin, pure brass of roughly eight-tenths copper and two-tenths (cheaper) zinc, both with discrepancies either way. Some two hundred years ago brass was produced for the first time with four-tenths zinc. Later weights are mostly in this proportion, and are recognizable by their light colour, their sharp edges, or their (mostly fake) signs of wear. However, the Africans also had other metals at their disposal, such as lead and iron. Thus there is great variety of colour in these weights. A lot of copper produces a reddish colour. More zinc, lead, or iron, or even gold or silver, produces a more or less yellow or silver hue. The artist simply cast in whatever metals were immediately to hand. In very rare instances one even finds bronze in its metallurgical sense. Properly speaking one should refer to 'yellow metals'.

For the actual casting the artist would carve or shape the piece in beeswax, finishing it off (decoration, eyes, ears, hair etc.) with the wax thread technique. One or more 'filler caps' – slightly conical wax 'antennae' – were then added, after which came the first coating of (rather liquid) clay. To relieve the pressure of the gases

302

given off during the casting process, the clay outer mould incorporated pounded straw, palm fibre, cow dung, or charcoal, which left tiny burnt open pores. Further layers of clay followed, to provide the necessary solidity. Left to dry and harden in the sun, the form was then heated until the wax melted and ran out. In small pieces the wax was lost – hence the name 'cire perdue'. By the filler 'antennae' was a clay crucible with the correct amount of metal, in small pieces, in it. Now followed the melting process. The form was heated (with the crucible at the bottom) over a charcoal fire which assistants continuously kept at a high temperature with bellows until the alloy was molten. It was up to the experienced smith to judge the precise moment here (the smiths belonged to a highly privileged caste, and were the only people apart from kings to be allowed to wear gold ornaments). As the form was up-ended the metal flowed into the mould. When it had completely cooled he broke the mould, removed the filler 'antennae', and cleaned up the now finished cast. If the weight was incorrect adjustments were made by the application of lead, on geometric shapes, or brass wire, on figures. If the weight was too heavy details could be cut off or shortened.

This manufacturing technique explains why one never finds two identical weights, although many are very similar.

A set of weights numbered about sixty pieces, and only the owner knew what each one was. He always carried them with him, wrapped in cloth and an antelope hide, and was always pleased to exhibit them as a sign of his material wealth. The grading of these weights is interesting. There is nothing like our decimal system, although certain weights may well have been influenced by the trade contacts with Europeans, which started very early on. Both the Anyi and the Baule took the 'ba' as their unit of weight. This was the weight of two beans of Abrus precatorius (a papilionaceous plant), which come to roughly 0.16 grams. The Ashanti and the Akem in Ghana used the 'taku', which corresponded to three Abrus beans, or roughly 0.25 grams. The progressions are arithmetical in principle, and follow the Pythagorean tables. Many attempts have been made to impose some kind of system on the different weights. But given the enormous variety, the task is somewhat tricky. No doubt there was some specific relationship between weight and pattern in the geometrical forms, but any such significance has been lost to the present-day heirs of the tradition. The same is partially true of the symbols.

Finally it should be mentioned that a set of weights was not complete without at least one balance – two round, often chased

303

plates on a balancing arm, several usually richly decorated and shaped spoons for scooping the gold dust, and last but not least various sheet copper or brass containers (shaped and embossed, or cast by the *cire perdue* method) for the gold.

Yellow metal-casting is a very ancient technique and is to be found elsewhere than in Africa. With the Akan peoples it can be traced back to the 11th/12th centuries. Bronze weights found in the Near East and other places date back, it is thought, more than 3000 years. It is not impossible that the African tradition should have been influenced from outside.

Baule
Ashanti

201 Baule and Ashanti gold-weights

Mudfish, 60 × 48 mm. A particularly beautiful gold-weight in the shape of a stylized mudfish. This example illustrates the heights of artistry achieved on a small scale. It takes a sure, sensitive hand to work wax so that it seems to breathe.

According to one proverb, everything the mudfish swallows is for the use of its master the crocodile.

If you offer someone smoked mudfish, he will ask for stew, or 'whatever you do you're wrong'.

The following gold-weights are all their actual size.

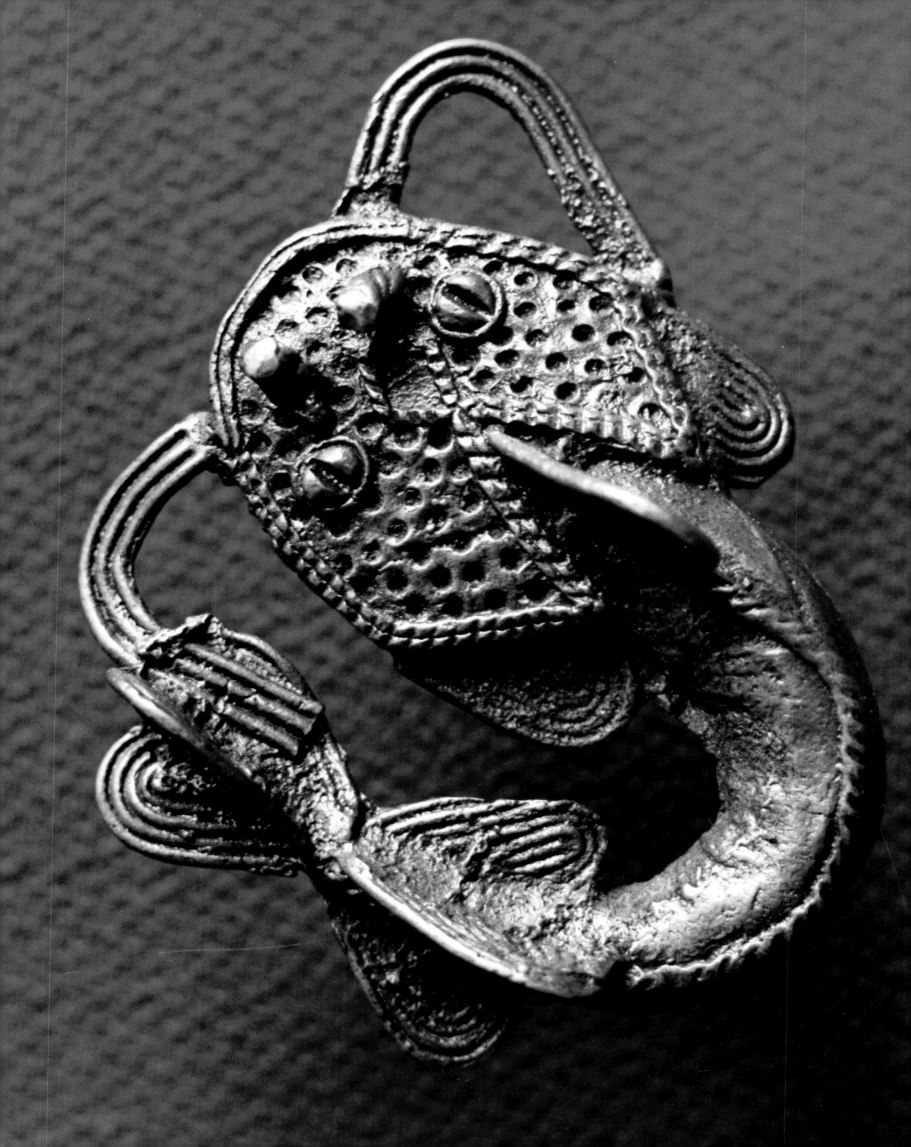

This page is devoted to fish – rendered in every possible way, from realistic representation to the fantasy-inspired swordfish. Included are the heads of four slain enemies, identifiable as warriors by their hairstyles. Their victor would take on their strength and intelligence.

Centre left: two elegantly entwined snakes or batrachians (as the tail fin on one of them indicates).

Lower left: a kind of tadpole in adult stage.

Folklore deems that the place over the fire is no very cosy place for a fish.

A fish is never thirsty. When fishes cry you can't see their tears because of the water.

Never be tempted to wash a live fish in the river.

They say snakes are frightening even when they mean no harm.

The scorpion: a scorpion sting hurts for as long as it takes the embers of a fire to cool.

The scorpion stings, and its victim dies.

If a scorpion stings you, sting it back.

The scorpion asked the frog to carry it across the river. The frog suspected the scorpion would sting him and drown them both. But when the scorpion promised not to sting him he took it on his back. As they reached the middle of the river, the scorpion stung the frog, and they both drowned.

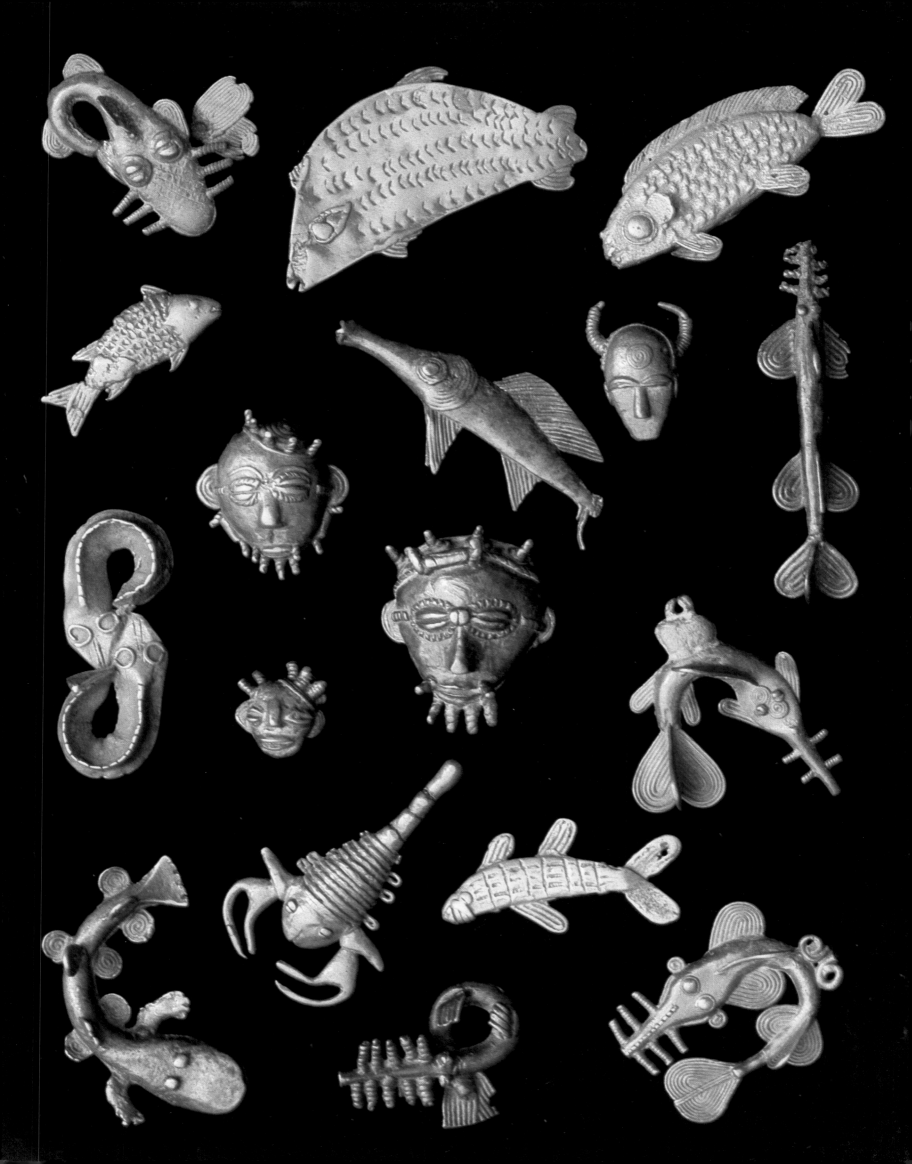

203

A colourful display of different weights. Top centre: a sword. Left: an antelope (the antelope's strength was said to lie in its horns). Right: antelope horns – symbol of the male principle. In Egypt two horns meant shine, radiate, illuminate (Champollion). The fly-whisk in the middle was the emblem of a chief, carried by his vassals. The frog symbolizes fertility and fertilization. Among certain peoples the woman put a frog between her breasts during coition.

The beetle, bottom left, itself served as a model. The saying goes that fire even gets into the beetle's hole in the wood.

The spirals in the geometric weights suggest the rolling up and unrolling of the circle. In another version the spiral represents god as female principle, or the symbol of strength.

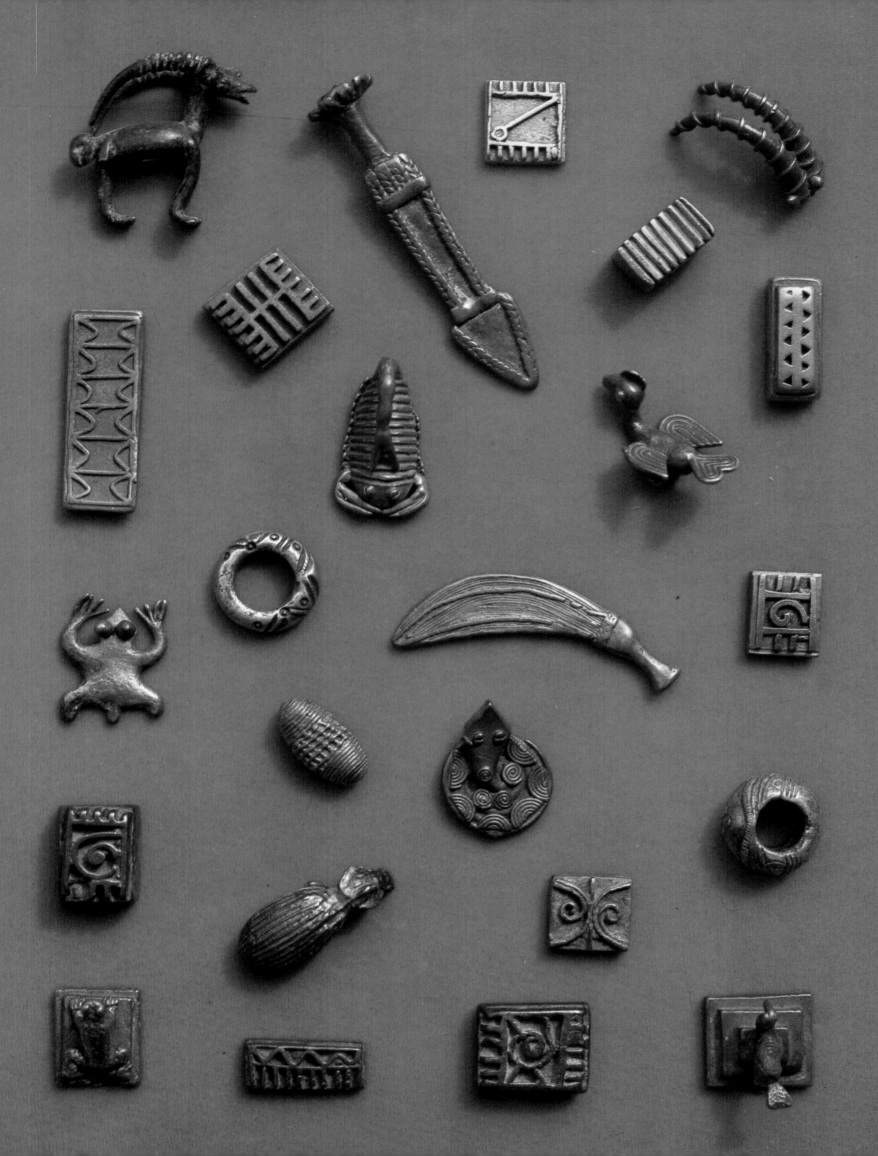

Decorative swords, richly and variously made,
were emblems of kings and chiefs, and were used
for enthronement and swearing in ceremonies.
These weights are true copies of originals. Four
are hung with trophies, in the form of animal
skulls, one with a magnificent ram's head.

Centre left: two crossed, heavily stylized
crocodiles. Two snouts and two tails mean that
there are many mouths in the family, but only
one belly. The hunter should not keep what he
caught for himself, it belonged to the community:
in this case the common good came before private
interests.

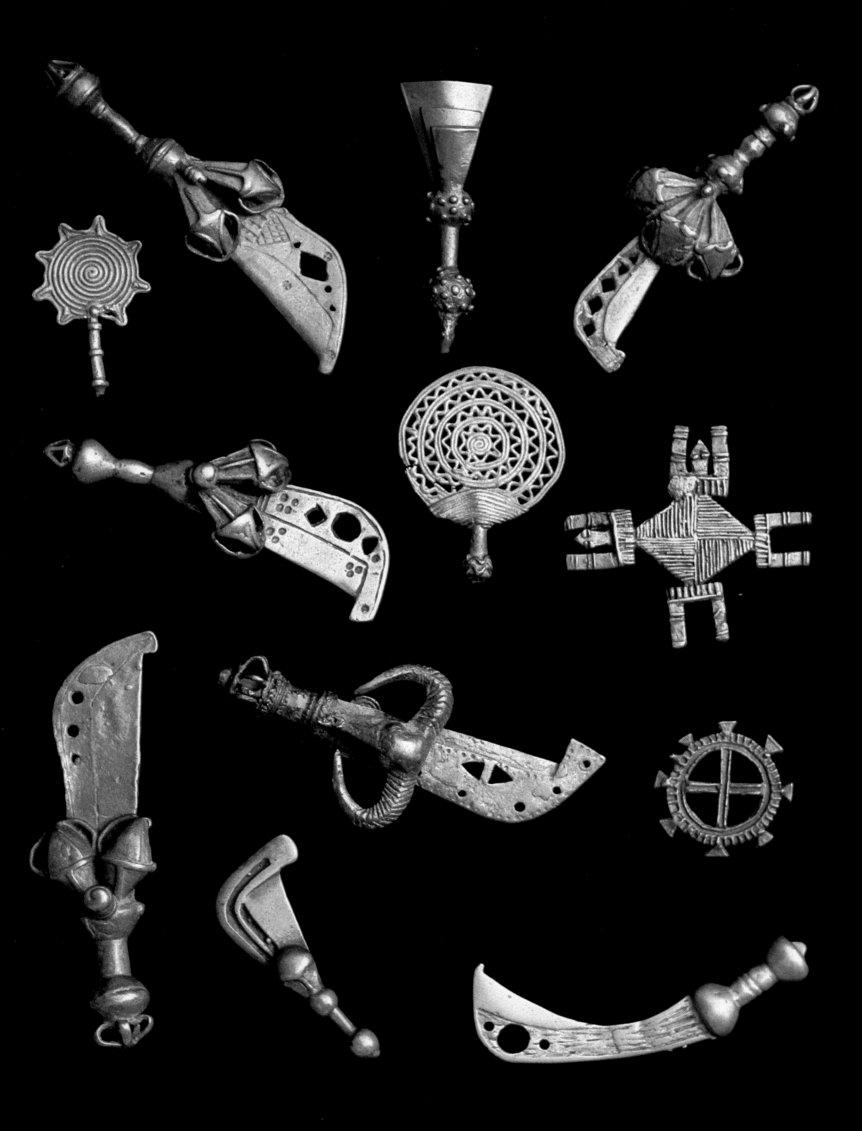

The upper row shows men engaged in different jobs. These 'narrative' figures provide scholars with a rich source of information. From them much can be learnt about former customs, types of tools, dress, and so on and so forth. On the left a magician is sacrificing a chicken; next to him stands a tree with a bird caught in a raffia snare (proverbs recount how a bird will sing its sweetest when it is trapped, to be set free, or that even a clever bird will eventually be snared). Shooting is an old African theme. The warrior in the middle holds the head of his enemy in one hand, and in the other the sword with which he killed him. The horn-blower is another favourite theme. Then we see a bark-cutter (another saying has it that the bark-cutter is no good on his own, he has to have an assistant to gather the bark). Second row, left to right: leopard with prey ('the rain soaks the leopard, but can't wash off its spots'). Then an antelope of an unknown kind, with next to it what is possibly a cow antelope of the Alcelaphus variety (the back legs shortened quite simply because the weight was too heavy). Far right: a reed buck (Redunca redunca). My strength is in my horns. Another old proverb warns that an animal that is about to bite you will not show you its teeth first. The four birds on the branch illustrate that 'birds of a feather flock together'.

The five geometric gold-weights at the bottom are at the same time gold dust containers. The drawings on them presumably have some symbolic meaning, but what is no longer known.

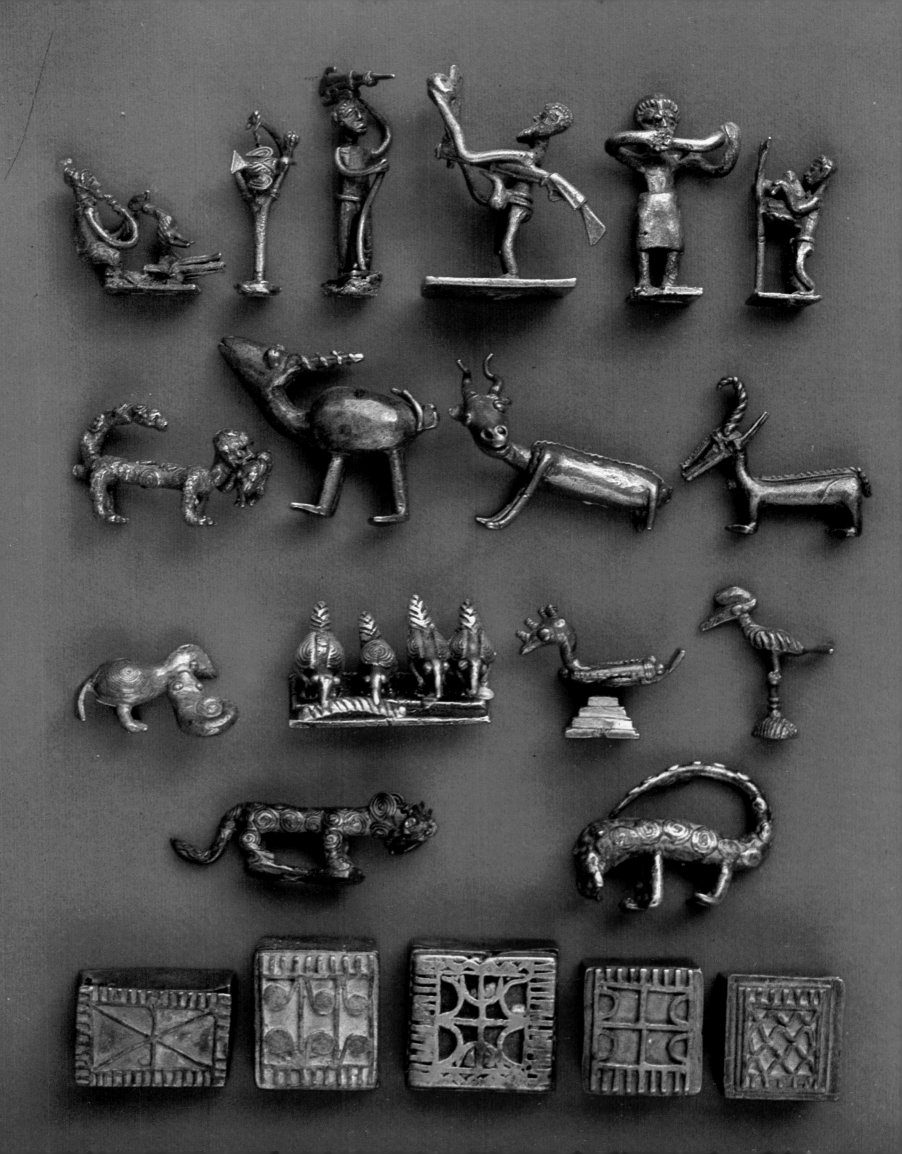

206

The shields at bottom right and bottom left, and the shield frame at top right were part of the warrior's official equipment until the beginning of the 18th century. Today only few remain as signs of rank. The coiled snake with the bird in its mouth (top) illustrates the proverb about how the disadvantaged creature yet, thanks to its cunning, manages to trap the careless bird. Below it to the left is a male inflorescence of the oil palm, which, like the seven breastplates with beetle heads arranged on the tube below the 'claw' cross, served directly for the casting. Top left and centre left: two weights which, because of the eyelets on them, could be worn for decoration. The top one is possibly a sun symbol.

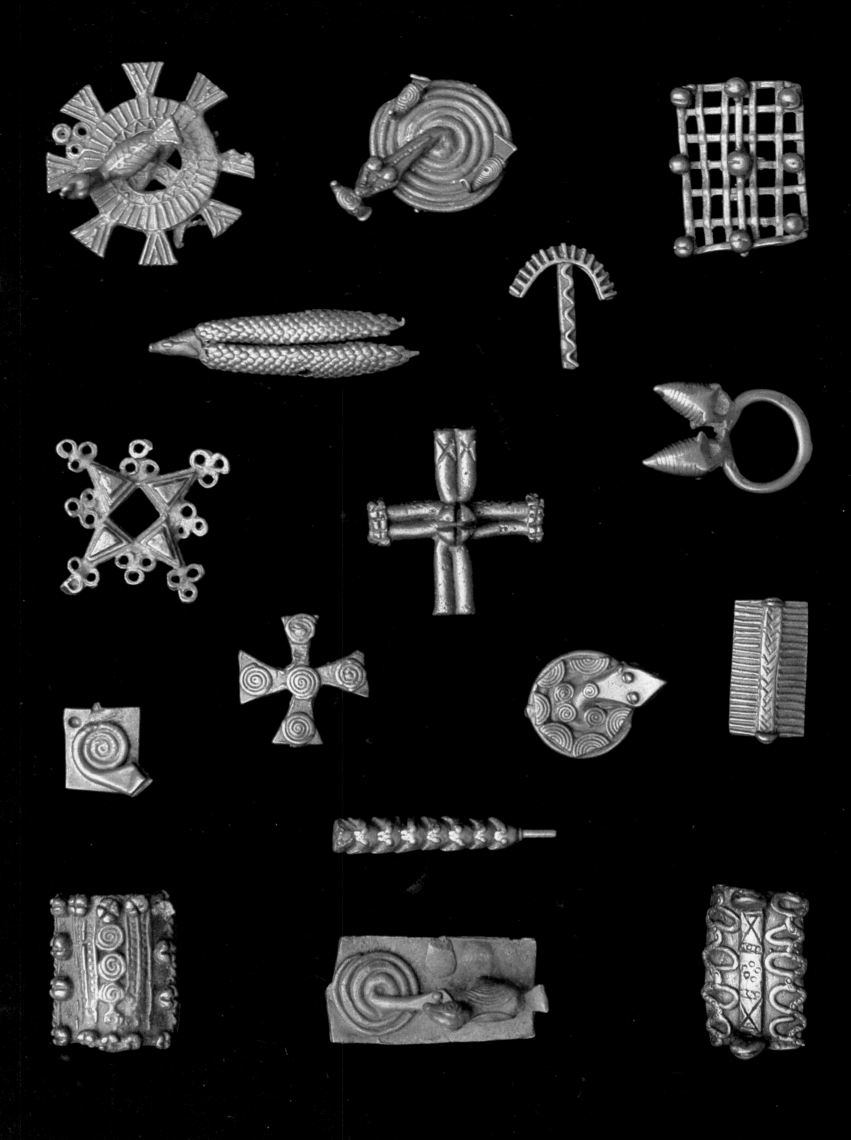

Top right: copy of the golden stool of the Ashanti, which fell from heaven many years ago, and which must never touch the ground or be sat on. A symbol of rank, therefore.

Elephants are a popular subject for gold-weights. Follow an elephant, and the dew will never settle on you.

There are numerous proverbs about porcupines (bottom right). Who dares attack a porcupine with all its protective quills? Never rough the ground with a porcupine, and never get into an argument with someone who can hurt you more than you can hurt him. You can tell from the porcupine's quills whether it's ready to fight. When the porcupine has some unpleasant work to do, the hedgehog should never get up and say goodbye.

The chameleon (above the porcupine) is said to be 'slow but sure'.

The side-blown horn in the middle is decorated at its base with trophies – the stylized jaw-bones of enemies.

The cross and gold dust casket (bottom left) were made by the cire perdue method, like the weights, while the oval container is sheet copper, decorated with a punch.

The design of the fish shows great imagination and a fine sense of beautiful proportion.

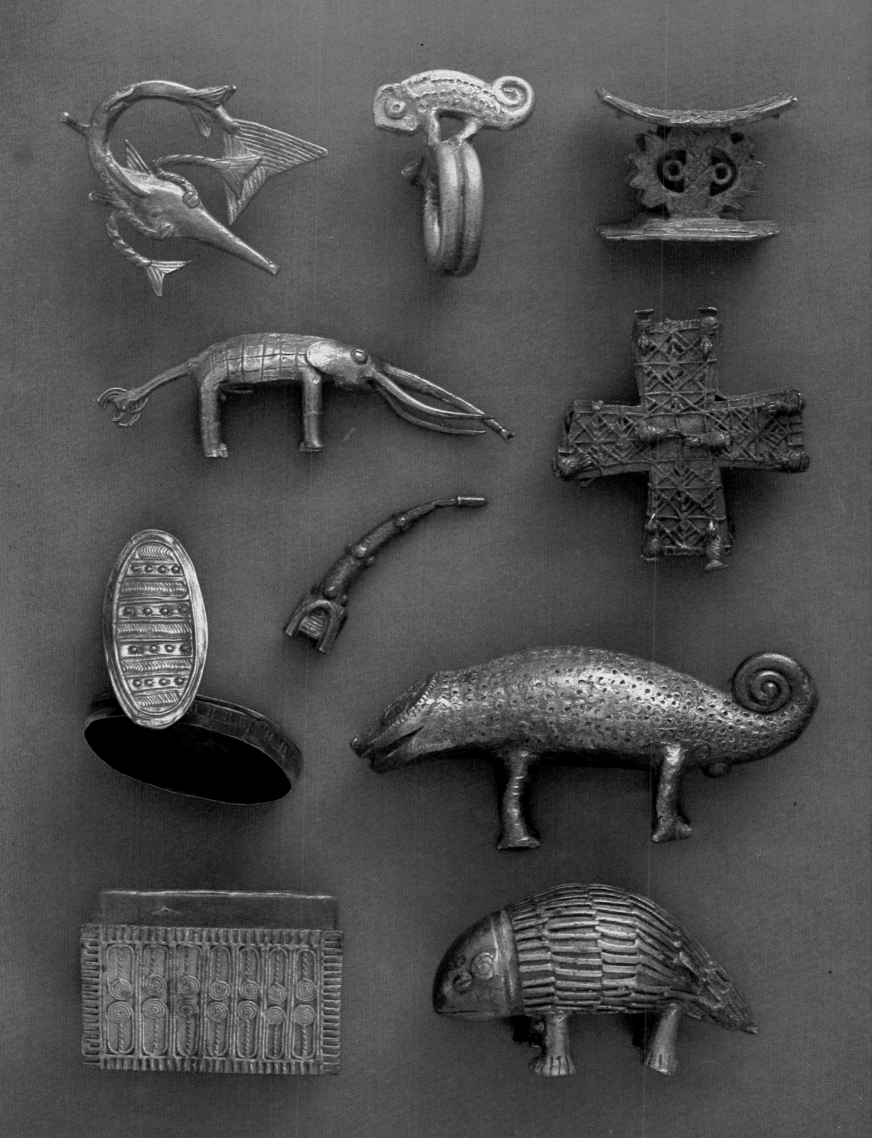

Crocodiles (sacred animals and symbols of power, tenacity, longevity and cunning), tortoises and lizards appear here in both naturalistic and stylized guise.

The tortoise is said to carry its coffin around with it on its back, because it does not want to join a clan. It strives for independence. Another adage says that it is a good thing to be quick, but an even better thing to work slowly.

Lizards cannot be caught without the jug's (into which they scuttle) being broken.

Don't upset the crocodile when you're in the middle of the river. Again: the crocodile lives in the water, but don't forget it has to breathe. The crocodile with the fish in its mouth symbolizes the queen mother.

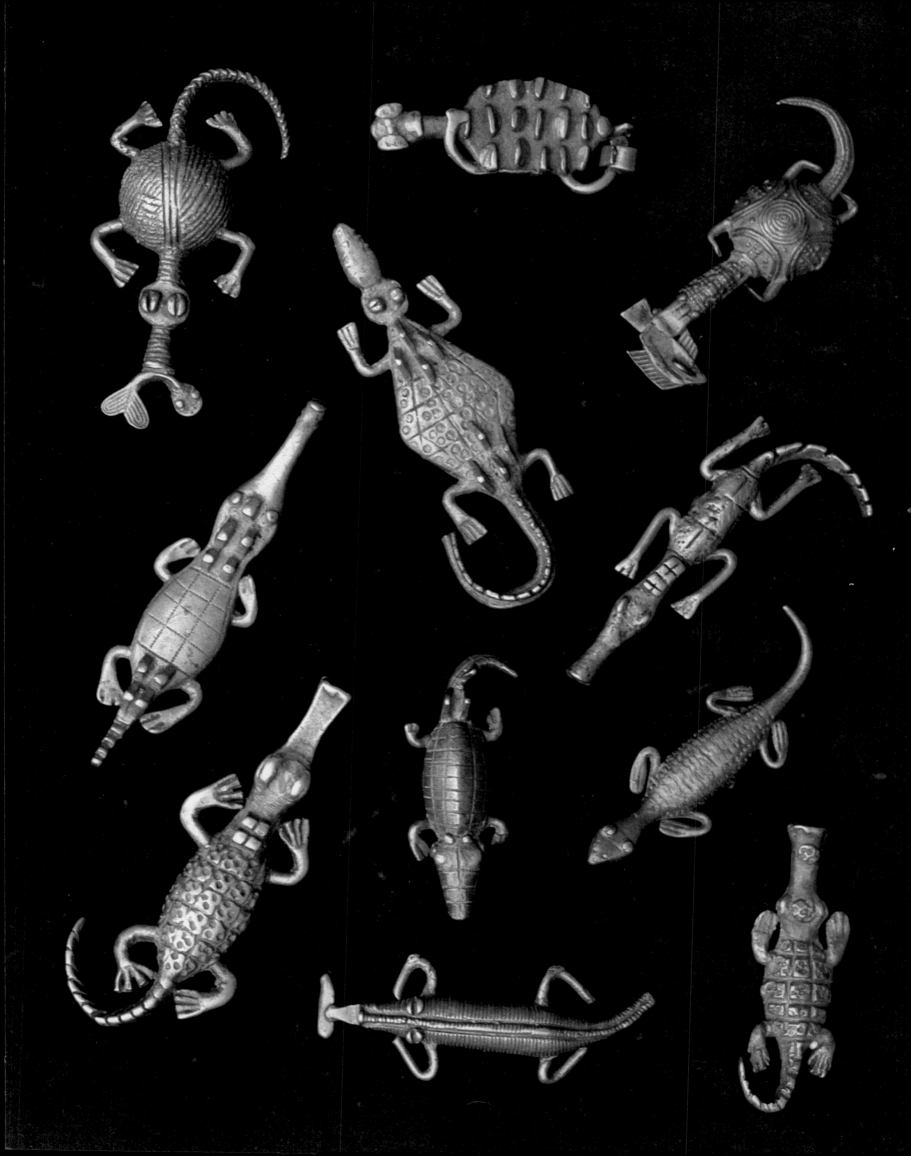

209

The figure on the far right is Senufo work, and is not a weight. The pair on the left shows two Ashanti on their travels. Bottom right: two very beautiful seated figures, one with a fly-whisk and monkey-skin cap, the other holding his beard in his hand. The mudfish (bottom left) is a chieftain's ring (the ring itself is not visible).

The cock (to its right), according to popular legend, forgets about the bird of prey when it is drunk.

The triple fins on the three-stepped pyramid were too light. The weight was made up by adding brass wire.

The two displaced cannon barrels on the four-step pyramid possibly hark back to earlier times, when the Portuguese and others were taking control.

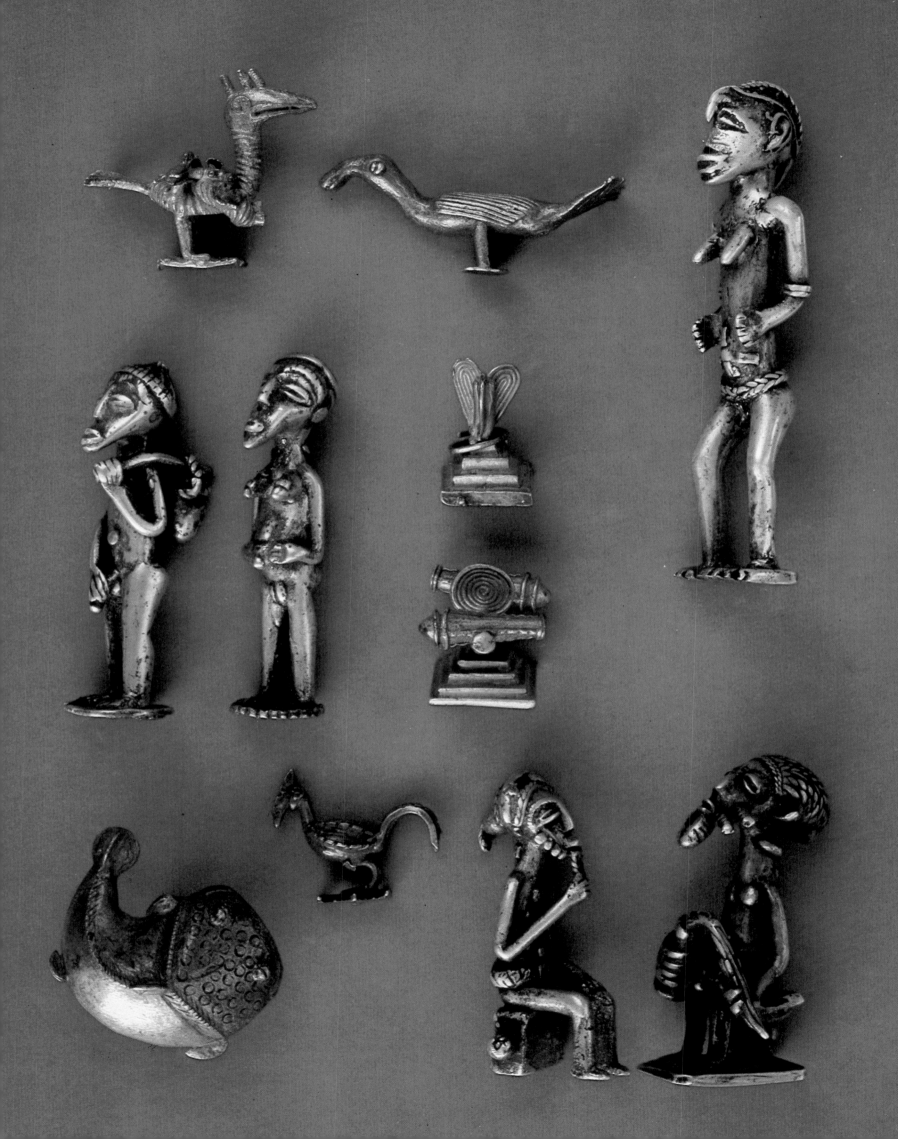

210

Here, together with the six geometric gold-
weights and the two shields (bottom left and
right), we have four pieces of jewellery. The
pendant (above centre) could be either a stylized
buffalo head or a man with arms raised, the
ring from which the piece hung being his head.
Around this, three pendants looking like
bucklers, all almost identical. The top two
shields could be sun symbols. The symbolic
meaning of the swastika has been variously
interpreted. Some see it as a purely decorative
pattern, others as a kind of broken meander. The
Ashanti call it the hand of the Colobus monkey
(the Colobidae guereza monkey family),
because to them it resembles that animal's
footprints. Some see it as a protective sign
against thieves, and others again as a version of
a certain hairstyle adopted by the queen's
ladies-in-waiting. Anti-clockwise swastikas
bring bad luck. It was already known throughout
the world a very long time ago. It almost
certainly originated in the north. The significance
of the other geometric weights cannot be
definitely stated. Wavy lines can, however, be
taken to represent water and sky, 'combed' lines
the rays of the sun, and spirals, as well as the
female principle, the fruitful earth or the under-
world, conception and fertility generally.

Among the Dogon, spirals symbolize the
perpetual expanse of the universe. Many
African peoples used it, probably unconsciously,
possibly because of its intrinsic beauty.

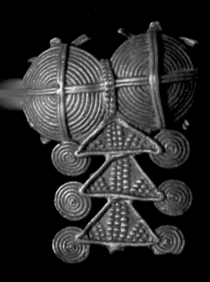

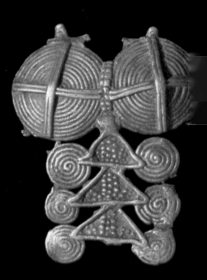

POSTSCRIPT The complementary text, together with the captions to the plates, are intended to make this book (planned as a simple collection of photographs) a succinct and informative document on the artistic sensibility and heritage of Africa. As a keen admirer and collector, I have tried to capture the beauty and expressive power of African art in pictures. The book also represents a cross-section of what the African continent has produced in the sphere of art.

I am indebted to various collectors who enabled me to publish rare works of over a hundred tribes. I am equally indebted to my friend Luitfrid Marfurt who, after more than twenty years in Africa, was able to give me valuable advice, and who read over the manuscript. Dr Elsy Leuzinger also very kindly contributed to the successful completion of the book with many helpful suggestions.

I was lucky to find in Walter-Verlag, the originating publishers, enthusiastic people who always produced what I wanted with great understanding.

I owe special thanks to Gottfried Künzi, who assisted me throughout with his encyclopaedic knowledge and unerring sense of the beautiful, the genuine, and the stylistically correct. Much of the information in the captions to the plates is due to him. While working on my book, my best friend tragically died.

In order to forestall inevitable questions: I took the pictures with Kodachrom-Dia-Film, 19 DIN, all in daylight. As a guide for the printer I produced colour enlargements (format 20×25 cm) in my own private darkroom, using the most modern materials (Cibachrome-A Print System). The camera I used was a 35 mm single-lens reflex Topcon RE Super camera, with Topcor lenses of 35, 58, and 100 mm focal length and the Schacht (Ulm) 50 mm M-Travenar-lens adjustable from infinity to $1:1$.

BIBLIOGRAPHY

BASTIN, MARIE-LOUISE — 'Statuettes Tshokwe', *Arts d'Afrique Noire* (Arnouville), 1978

BERNATZIK, HUGO — *Im Reich der Bidjogo*, Aare-Verlag, Berne 1950

CARNOCHAN, F. C. and ADAMSON, H. C. — *The Empire of the Snakes*, Hutchinson, London, and Frederick A. Stokes, New York 1935

CHAFFIN, ALAIN and FRANÇOISE — *L'Art Kota*, A & F. Chaffin, Meudon 1979

CORNET, J. — *Art of Africa: Treasures from the Congo*, Phaidon, London, and Praeger Publishers, New York 1971

CORNEVIN, R. — *Bronzes et poudres d'or*, Paris 1972

DITTMER, KUNZ — 'Steinfiguren aus Sierra Leone und Guinea', Bässler-Archiv (Berlin), XL, no. 1, 1967, p. 183

ELISOFON, ELIOT, and FAGG, W. — *The Sculpture of Africa*, Thames & Hudson, London, and Praeger, New York 1958

FAGG, WILLIAM — *Afro-Portuguese Ivories*, Batchworth Press, London 1959

FISCHER, E. and HIMMELHEBER, H. — *Die Kunst der Dan* (exhibition catalogue), Museum Rietberg, Zurich 1976
———— — *Das Gold in der Kunst Westafrikas* (exhibition catalogue), Museum Rietberg, Zurich 1975

FROBENIUS, LEO — *Kulturgeschichte Afrikas*, Phaidon, Zurich 1933

GAISSEAU, P. D. — *The Sacred Forest: the Fetishist and Magic Rites of the Toma*, Weidenfeld & Nicolson, London 1954

GLÜCK, JULIUS — *Die Goldgewichte von Oberguinea*, Winter, Heidelberg 1937
———— — 'Die Kunst des Gelbgusses in Afrika', *Das Kunstwerk* (Baden-Baden), no. 17, n.d.

GRIAULE, M. and DIETERLEN, G. — *Le Renard pâle*, Musée de l'Homme, Paris 1965–

HARTER, PIERRE — 'Les Masques dits "batcham"', *Arts d'Afrique Noire* (Arnouville), no. 3, 1972

HIMMELHEBER, HANS — *Negerkunst und Negerkünstler*, Klinkhardt & Bielmann, Brunswick 1960
———— and ULRIKE — *Die Dan*, Kohlhammer, Stuttgart 1958

HOLAS, B. — *Les Sénoufo*, Presse Universitaire de France, Paris 1966

HOMMEL, L. — *Art of the Mende* (exhibition catalogue), University of Maryland Art Gallery 1974

KLEVER, ULRICH — *Bruckmann's Handbuch der afrikanischen Kunst*, Bruckmann, Munich 1975

KRIEGER, KURT — *Westafrikanische Masken*, Berlin 1960
———— — *Westafrikanische Plastik*, I–III, Museum für Völkerkunde, Berlin 1965

LEBEUF, JEAN-PAUL and ANNIE — *Les Arts des Sao*, Société Nouvelle des Etudes du Chêne, Paris 1977

LEHUARD, RAOUL — *Statuaire du Stanley-Pool*, *Arts d'Afrique Noire* (supplement), Arnouville 1974
—— 'de l'Origine du masque "tsayé"', *Arts d'Afrique Noire* (Arnouville), no. 4, 1972
—— *Les phemba du mayombe*, *Arts d'Afrique Noire* (supplement), Arnouville 1977

LEIRIS, M. and DELANGE, J. — *African Art*, Thames & Hudson, London 1968

LEUZINGER, ELSY — *Africa: the Art of the Negro Peoples*, Methuen, London, and Crown and McGraw-Hill, New York 1960
—— *African Sculpture: a Descriptive Catalogue*, Atlantis Verlag, Zurich 1963
—— *The Art of Black Africa*, Studio Vista, London 1972

MALER, THOMAS — 'Austreibung der Geister', *Merian* (Hamburg), XXIX, no. 3

MAQUET, J. — *Civilizations of Black Africa*, rev. and trans. J. Rayfield, Oxford University Press, New York 1972

MARFURT, LUITFRID — *Musik in Afrika*, Nymphenburger Verlagshandlung, Munich 1957
—— *Pipes du Cameroun*, Cahors, Quercy 1966

MEAUZÉ, PIERRE — *African Art: Sculpture*, Weidenfeld & Nicolson, London, and World Pub. Co., Cleveland, Ohio 1968

MENZEL, BRIGITTE — *Goldgewichte aus Ghana*, Museum für Völkerkunde, Berlin 1968

MUSEUM FÜR VÖLKERKUNDE, BASLE — *Schwarzafrika*, *Plastik* (guide to special exhibition), Basle 1969

MUSEUM FÜR VÖLKERKUNDE, VIENNA — *Plastik aus Afrika* (exhibition catalogue), Vienna 1969

NEYT, FRANÇOIS — *La Grande Statuaire hemba du Zaïre*, Louvain-La-Neuve 1977
—— and DE STRICKER, L. — *Approche des Arts Hemba*, *Arts d'Afrique Noire*, Villiers-le-Bel 1975

PERROIS, LOUIS — *Statuaire Fang, Gabon*, ORSTOM, Paris 1972
—— *Le Bwété des Kota-Mahongwe du Gabon*, rev. and augmented edn, ORSTOM, Libreville 1966

PLASS, MARGARET WEBSTER — *African Miniatures: the Goldweights of the Ashanti*, Lund Humphries, London, and Praeger, New York 1967

RACHEWILTZ, BORIS DE — *Black Eros: Sexual Customs of Africa from Pre-history in the present day*, Allen & Unwin, London 1964
—— *Incontro con l'arte Africana*, Martello, Milan 1959

ROY, CLAUDE — *Les Bouéti des Mahongwe*, J. Kerchache, Paris 1967

SALMON, P. et al. — *L'Afrique Noire*, Meddens, Brussels 1976

SCHÄDLER, KARL-FERDINAND — *Afrikanische Kunst*, Heyne-Buch No. 4454, Munich 1975

SCHWEEGER-HEFEL, ANNEMARIE — *Die Kurumba von Lurum*, Schendl, Vienna 1972

SEGY, LADISLAS — *African Sculpture Speaks*, 3rd edn rev. and enlarged, Hill & Wang, New York 1969

SOUSBERGHE, L. DE — *L'Art Pende*, Académie Royale de Belgique, Beaux-Arts, vol. IX, fasc. 2, Brussels 1958

STÄDTISCHES MUSEUM FÜR VÖLKERKUNDE, FRANKFURT AM MAIN — *Plastik der Afrikaner* (exhibition catalogue), Frankfurt am Main 1967?

TEMPLE, ROBERT K.G. — *The Sirius Mystery*, Sidgwick & Jackson, London, and St Martin's Press, New York 1976

WASSING, R. S. — *The Arts of Africa*, Thames & Hudson, London 1970

WILLETT, FRANK — (pubd as *African Art: its Background and Traditions*, H. N. Abrams, New York 1968)

African Art, Thames & Hudson, London, and Praeger, New York 1971

ZELLER, RUDOLF — *Die Goldgewichte von Asante*, Bässler-Archiv, Leipzig and Berlin 1912

INDEX

The names of tribes are given here both in their plural form (as was formerly customary) and singular form (as in the text). The prefixes of the plural form, Ba, Ma, Wa etc, are separated from the root by a hyphen.

Figures in brackets refer to plates.

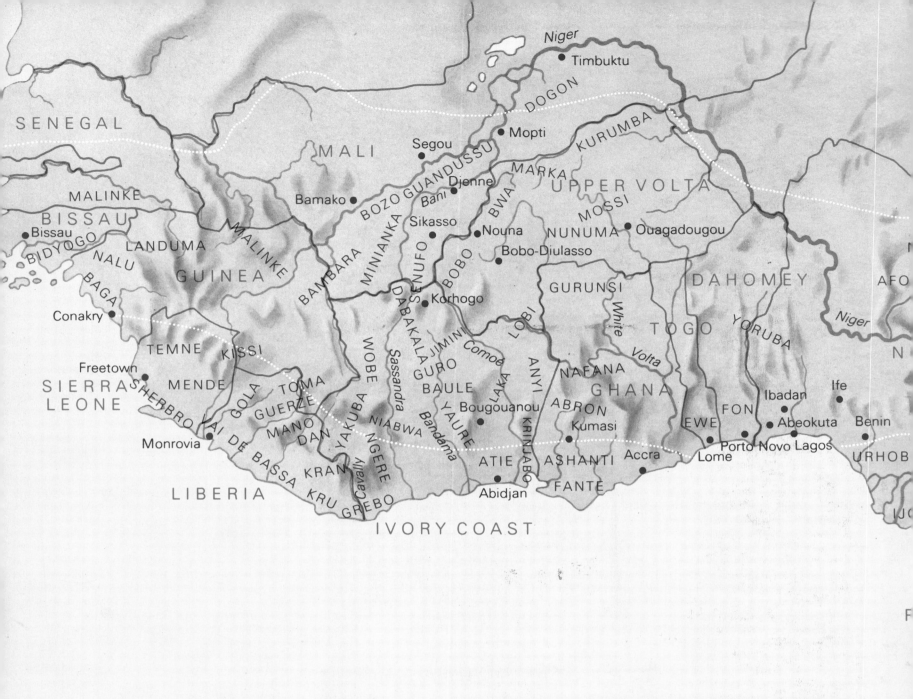

SENEGAL

MALINKE

BISSAU
Bissau
BIDYOGO
NALU
BAGA
Conakry

MALI
Timbuktu
Niger
DOGON
Segou
Mopti
KURUMBA
MARKA
MALINKE
GUINEA
BAMBARA
BOZO GUANDUSSU
Bamako
Djenne
Bani
MINIANKA
Sikasso
SENUFO
BWA
Nouna
Bobo-Diulasso
UPPER VOLTA
MOSSI
Ouagadougou
NUNUMA
DAHOMEY
AFO
Niger

TEMNE
KISSI
SIERRA
LEONE
Freetown
MENDE
SHERBRO
GOLA
KAI DE BASSA
TOMA
GUERZE
MANO
DAN
KRAN
KRU
GREBO
Monrovia
LIBERIA

DABAKALA
WOBE
Sassandra
GURO
YAKUBA
NGERE
NIABWA
Cavally
Korhogo
JIMINI
Comoe
BAULE
YAURE
Bandama
LAKA
ATIE
Abidjan

IVORY COAST

LOBI
ANYI
KRINJABO
Bougouanou
NAFANA
ABRON
ASHANTI
FANTE
Accra
GURUNSI
White
Volta
GHANA
Volta
Kumasi
EWE
Lome
FON
Porto Novo
TOGO
YORUBA
Ibadan
Abeokuta
Ife
Benin
Lagos
URHOB

ATLANTIC OCEAN

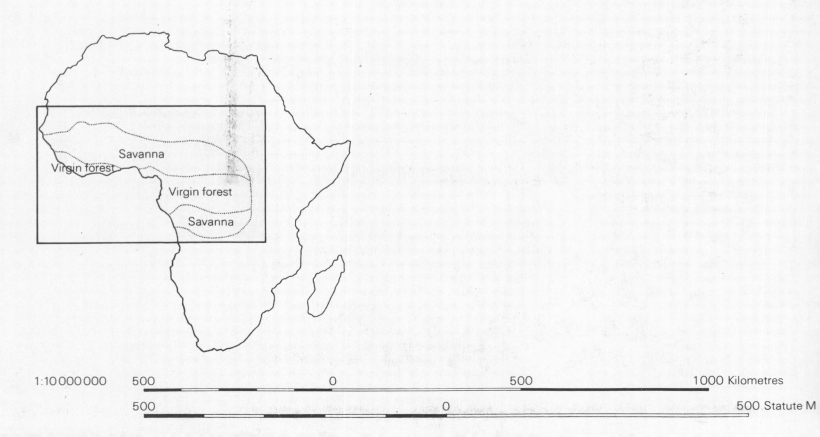

Savanna
Virgin forest
Virgin forest
Savanna

1:10 000 000 500 0 500 1000 Kilometres

500 0 500 Statute M